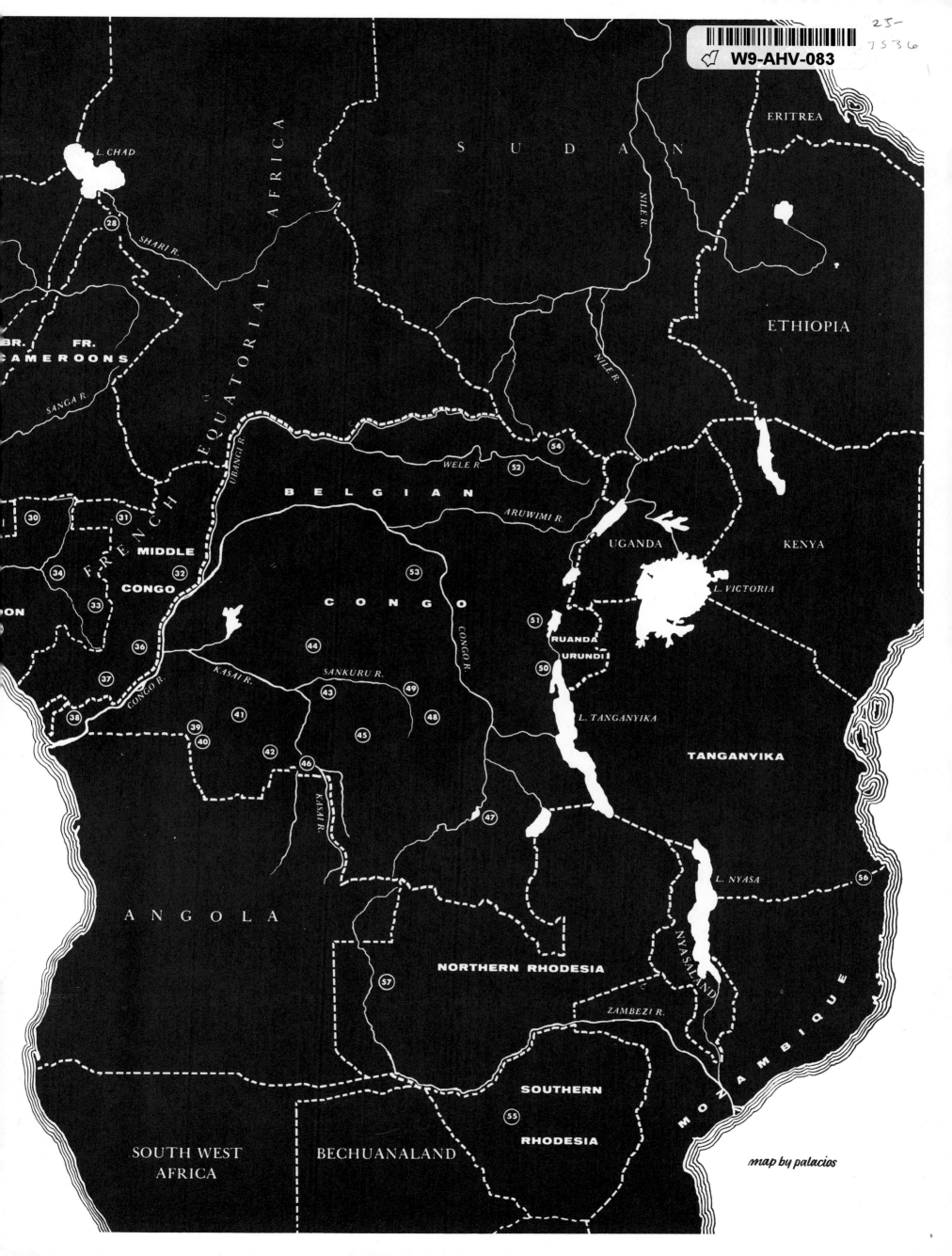

25-
7536

ERITREA

S U D A N

L. CHAD

28

SHARI R.

BR.

FR.

CAMEROONS

SANGA R.

F R E N C H E Q U A T O R I A L A F R I C A

ETHIOPIA

NILE R.

NILE R.

UBANGI R.

WELE R.

52

54

ARUWIMI R.

B E L G I A N

30

31

MIDDLE

32

CONGO

34

33

UGANDA

KENYA

53

C O N G O

L. VICTORIA

36

51

RUANDA

CONGO R.

URUNDI

50

44

KASAI R.

SANKURU R.

37

43

49

CONGO R.

L. TANGANYIKA

38

41

45

48

39

TANGANYIKA

40

42

46

KASAI R.

47

L. NYASA

56

ANGOLA

NYASALAND

NORTHERN RHODESIA

57

ZAMBEZI R.

MOZAMBIQUE

SOUTH WEST
AFRICA

BECHUANALAND

SOUTHERN

55

RHODESIA

map by palacios

The SCULPTURE *of* AFRICA

Homo sum; humani nihil a me alienum puto

TERENCE

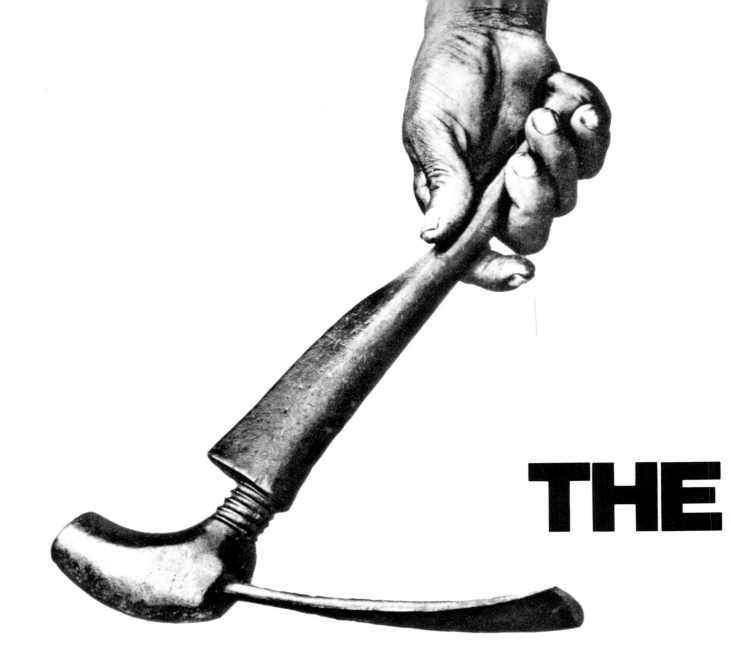

THE

ELIOT ELISOFON

SCULPTURE
OF AFRICA

Text by William Fagg

HACKER ART BOOKS NEW YORK 1978

First published New York, 1958.
Reissued 1978 by
Hacker Art Books, New York.

Library of Congress Catalogue Card Number 76-50293
ISBN 0-87817-210-6
Designed by Bernard Quint

Printed in the United States of America.

CONTENTS

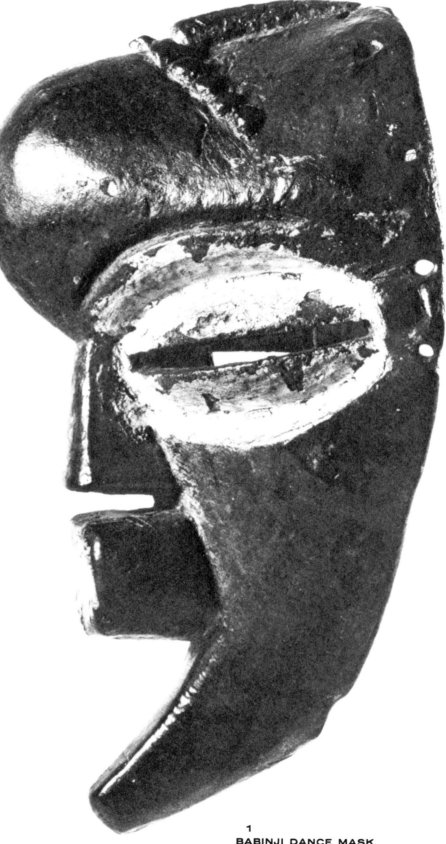

1
BABINJI DANCE MASK

The Babinji are a rather scattered sub-tribe of the
Bushongo of the Kasai. This mask is from a south-
ern group beyond the Bena Lulua.

ACKNOWLEDGMENTS

I would like to thank, first, the editors of LIFE magazine for sending me to Africa on two extensive assignments, thus enabling me to become acquainted with a large portion of the continent and some of its peoples, whose culture created the art illustrated in this volume.

I am also indebted to Mr James Johnson Sweeney and the Museum of Modern Art, New York, for their 1935 exhibition, 'African Negro Art', which served as the initial stimulus to pursue this subject.

When Mr Jack Barrett of the Bollingen Foundation and Mr Sweeney, who were planning the *African Folktales and Sculpture* volume, learned that I was leaving on another African assignment, they kindly commissioned me to photograph sculpture, not only in Africa but also in the museums and private collections of Europe. It was this wealth of material that enabled me to fulfil the requirements of the Bollingen Foundation and an essay on African Sculpture for LIFE (September 8, 1952), of which some material is included in this book. The four hundred and five photographs in this volume were selected after examining approximately twenty thousand objects and taking three thousand pictures.

I especially wish to thank Mr Bernard Quint of LIFE magazine for his part in the formulation of the visual concepts of this book and their embodiment in its design. Mr Quint's collaboration in the editing and organizing of this work has been invaluable.

The reader will, I am sure, feel as I do, that an extremely valuable contribution has been made not only to this book but to the study of African culture by the authoritative and comprehensive text written by William Fagg, Deputy Keeper, Department of Ethnography, British Museum. His scholarly advice in the selection and identification of objects and in the location of tribes is an appreciated addition.

I am also indebted to Leon Siroto for helping in the selection of sculpture and research of captions and map details. In this connection I want to thank Rafael Palacios for his special end-paper map.

The preface was written by the late Ralph Linton, Sterling Professor of Anthropology at Yale University. I shall always be grateful for his friendship, advice and encouragement. The preface is an enlargement of a previous essay on 'Primitive Art' which appeared in the *Kenyon Review* in 1941.

I sincerely appreciate the kindness of collectors and museums for permission to reproduce these sculptures. I wish to make special mention of the following for more than usual co-operation: the late Mr A. Van den Bossche, Director of Léopoldville Museum, and Messrs Coppois and LaBrique of the Information Service—all in the Belgian Congo; M. and Mme Mavrakis, Luluabourg; SEDEC at Kikwit, Belgian Congo; the late Professor

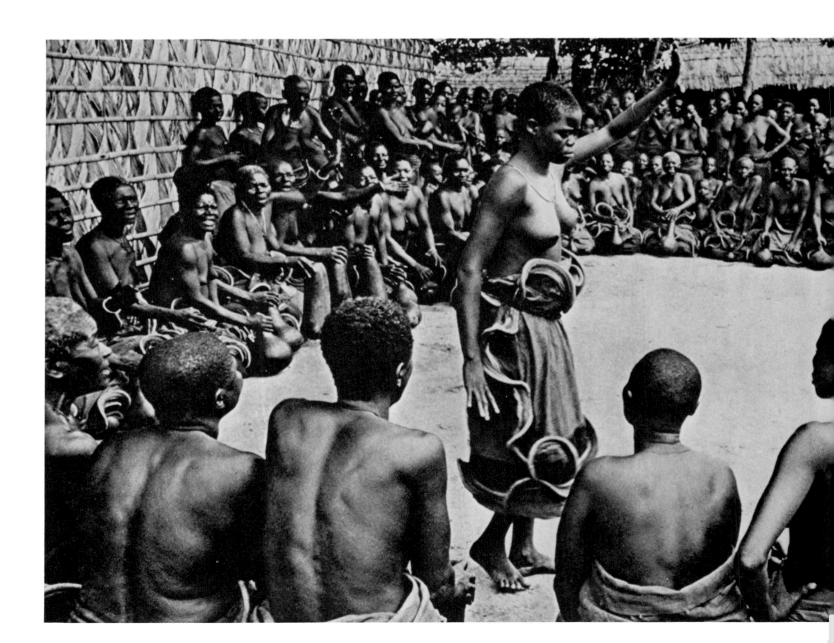

Frans M. Olbrechts, Director of the Musée Royal du Congo Belge, Tervuren, and Dr A. Maesen of his staff; Mme Denise Paulme-Schaeffner, in charge of the African Negro Department at the Musée de l'Homme, Paris; M. and Mme Pierre Verité, Paris; Sir Jacob Epstein, London; Mme Helena Rubinstein (Princess Gourielli) and M. Lem, Paris; M. Charles Ratton, Paris; and Mr and Mrs J. J. Klejman of the Klejman Gallery, New York.

My thanks to M. Hunin, Administrator of Kasai District, for accompanying me to Mushenge, capital of the Bushongo. I am also grateful to Nyimi Bope Mabinshe and the Bushongo, of whom he is titular head, and the Bayaka and Bapende people who were most co-operative in permitting me to photograph some of their rituals.

I wish to thank also the Directors of the Commonwealth Institute, London, for the exhibition 'Traditional Art from the Colonies' in 1951; and Mr Frederick Pleasants, director of the exhibition 'Masterpieces of African Sculpture', 1954–5, at the Brooklyn Museum. Both exhibitions made accessible carefully chosen material. Dr Paul Wingert of Columbia University, New York; and the late Mr Miguel Covarrubias, Mexico City, were generous with advice. Miss Rachel Tuckerman contributed editorial assistance.

I am grateful to my wife Joan for her inspiration and assistance during the preparation of this work not only in America but also in Europe and Africa.

This book is dedicated to the late Mr Webster Plass, a great collector and lover of African art; and to Margaret Plass, whose knowledge, assistance, enthusiasm and friendship have helped this project to its completion.

ELIOT ELISOFON, *Research Fellow in Primitive Art, Harvard University*

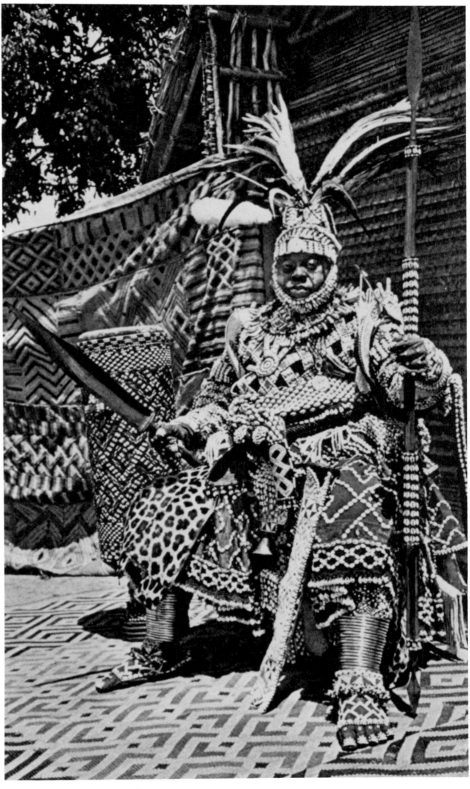

THE NYIMI, HEAD OF THE BUSHONGO

Nyimi Bope Mabinshe, unlike his ancestors no longer an absolute ruler, sits at Mushenge, Kasai Province, Belgian Congo. His dress is a formal costume worn only on state occasions. For generations portrait-statues have been made of each of the Nyimis.

THE WIVES OF THE NYIMI

The Nyimi's three hundred and fifty wives, most of whom are inherited from his predecessors, produce fine raffia work known as velours de Kasai.

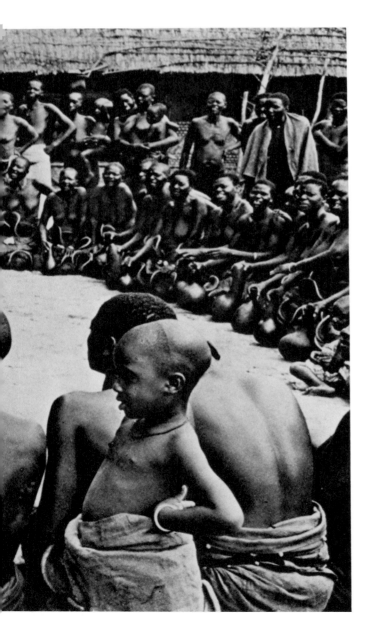

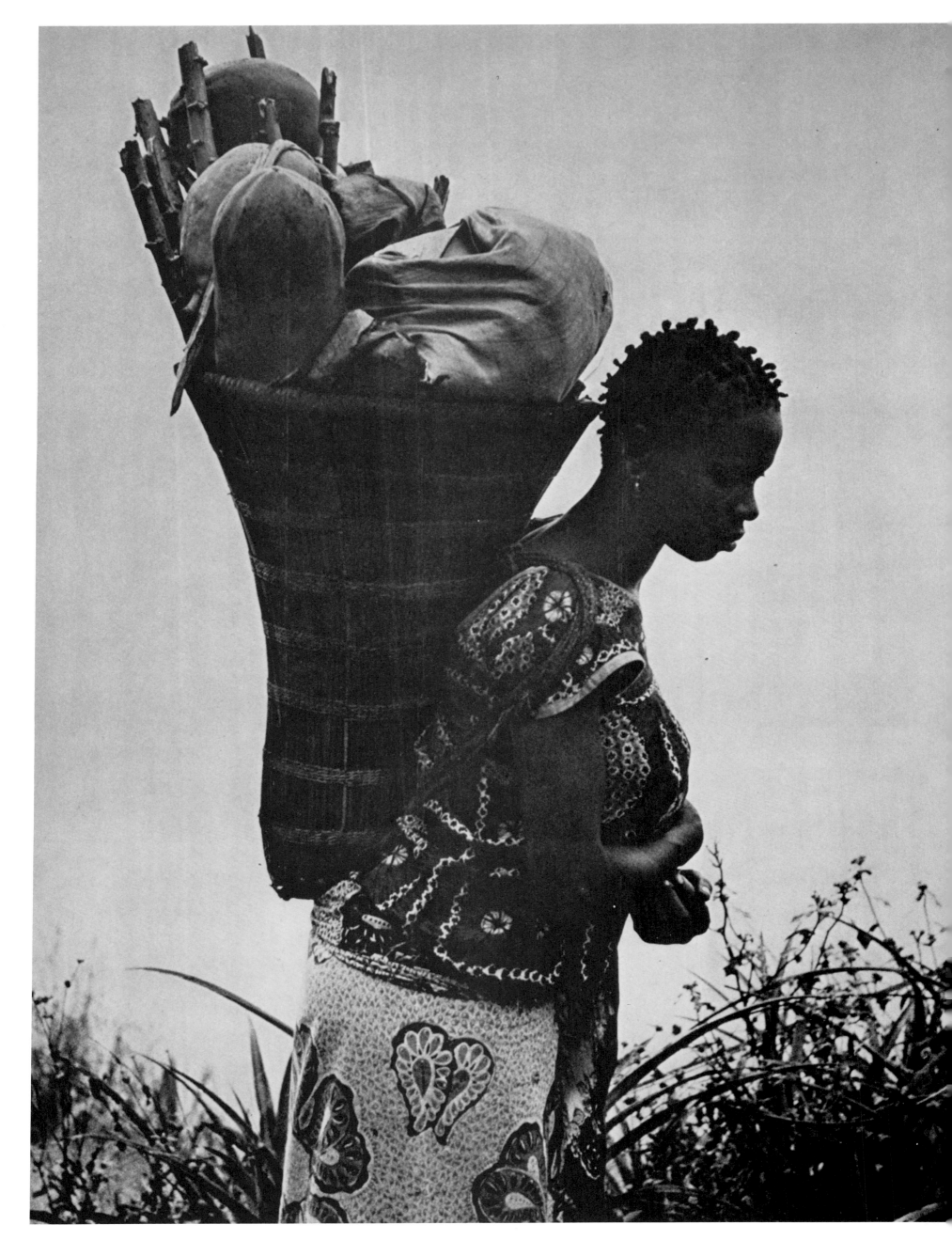

Ralph Linton

Late Sterling Professor of Anthropology,
Yale University

'Primitive'
ART

The term 'primitive art' has come to be used with at least three distinct meanings. First and most legitimate is its use with reference to the early stages in the development of a particular art, as when one speaks of the Italian primitives. Second is its use to designate modern works of art executed by persons who have not had formal training in our own art techniques and aesthetic canons. Third is its application to the art works of all but a small group of societies which we have chosen to call civilized. The present discussion will deal only with the last.

The use of the term 'primitive' to designate most of the world's cultures is an unfortunate aftermath of the ethnocentrism of the nineteenth-century European scientists who laid the foundations of modern anthropology. Elated by the success of the newly enunciated doctrines of biological evolution, they tried to apply these to the development of culture and saw all the simpler cultures as living fossils, surviving stages in a unilinear development of which European culture of the nineteenth century was the climax. This idea has long since been abandoned by anthropologists but, as so often happens with discarded scientific doctrines, it has become a part of the general body of popular misinformation. It still tinges a great deal of the popular thought and writing about the lives of non-European peoples.

Actually, there is no culture extant today which can be regarded as primitive. There are cultures of greater or less complexity and cultures which have a greater or less

smaller number of features in common with our own, but none of them are ancestral to the high cultures which we call civilizations. The way of life of an American Indian tribe or a group of Polynesian Islanders does not represent a stage through which our own ancestors passed any more than a modern dog represents a stage in the evolution of the elephant. Every existing culture has had its own more or less independent evolutionary history.

The use of the term 'primitive' with respect to the art styles developed by various societies is particularly deceptive. All existing art styles are results of long development and even those which appear simplest and least organized usually reveal a surprising degree of complexity and sophistication when one tries to reproduce them. Even the much advertised animal art of the European cave men of twenty thousand years ago shows a high degree of conventionalization and a skill in abstraction comparable to that of the modern Japanese drawings in which the essential qualities of an animal are caught in half a dozen lines.

To call the uncivilized artist 'primitive' is an even worse abuse of the term. Nothing could be more fallacious than to regard him as a retarded individual whose work can be considered on a par with that of a civilized child. He is an adult and often an exceedingly intelligent one. He possesses laboriously acquired skills, extensive technical knowledge, and clearly defined aesthetic standards. His work is never a simple, spontaneous outpouring of his desire for beauty. It is, in most cases, controlled by

CONGO WOMAN

Her simple profile and decorative coiffure
strongly resemble the features of women in
Congo sculpture. She is dressed in cloth specially
manufactured in Europe for the African trade
and carries provisions in a gracefully
shaped basket.

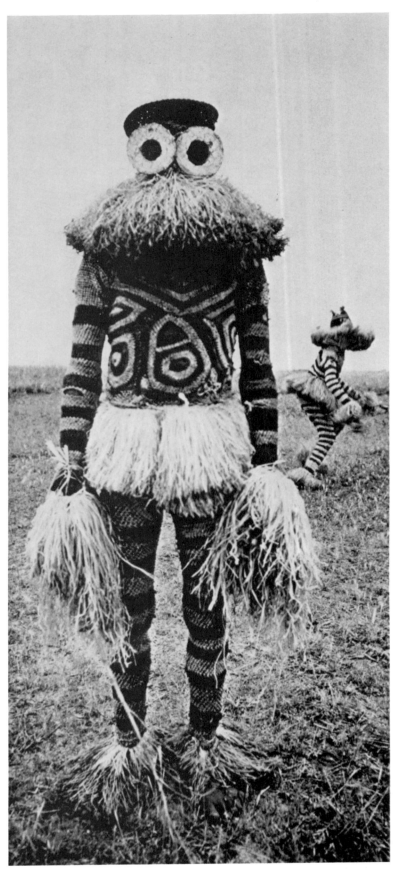

INITIATION CAMP GUARDIANS

Covered from head to foot in woven raffia this Bapende man frightens away women and outsiders from secret puberty rites.

conventions considerably more rigid than those of our own art. If his work sometimes appears naïve, it is because of the interests and values which these conventions reflect. If, in his representations, he ignores certain details of his subject, it is because to his society these details are either unimportant or taboo. Our own Victorian art treated certain details of human anatomy with a reticence incomprehensible to an African or Melanesian. To blame the primitive artist for such omissions is quite on a par with blaming a modernistic painter for not showing the individual leaves on a tree or the weave of the cloth in a subject's coat.

The similarities which have been pointed out between selected examples of 'primitive' art and the work of children in our own society are purely fortuitous and depend upon a very careful selection of examples from both sources. No European child reared in a normal home with its books and pictures can be considered uninfluenced by European artistic conventions. Consciously or otherwise, he adheres to these conventions in his own work, and his 'primitivity' is mainly a result of his lack of technical skill. No child, civilized or otherwise, ever produced anything remotely resembling the intricate grotesques of the New Zealand Maori or the abstract sculpture of West Africa. To find parallels for the first within our own art tradition one must go to the Gothic in its most virile period. The second finds a feeble reflection in the work of some of our modern sculptors working under the influence of African models which they have seen but rarely understood.

Objections of a different sort must be urged against the various attempts which have been made to equate the work of uncivilized artists with that of the insane in our own culture. The psychotic, like the child, has been strongly influenced by European art conventions but, unlike the child, he often has considerable skill and technical knowledge. The main difference between his work and that of the sane European artist is to be found in his bizarre associations of ideas and his use of purely personal symbolism. A particular schizophrenic may develop a configuration of inter-related ideas and symbols which resembles a culturally recognized configuration in some non-European society. If the insane European artist is skilful enough, his product may resemble that of the non-European one. However, this does not indicate that the non-European is psychotic or even indulging in the pre-logical sort of thinking attributed to 'primitives' by one school of social scientists. Every culture has developed configurations of associated ideas and symbols which appear illogical to an outsider. Our own association of lambs, doves and crosses with a death cult, revealed in every cemetery, would look like the purest schizophrenia to an Eskimo.

Actually, the artists themselves provide the nearest thing to a common denominator of primitive and civilized art. That such artists are of different races means very little. In spite of long and eager search, no scientist has been able to demonstrate the existence of innate psychological differences in persons of different racial groups. An individual of any race reared as a member of a particular society will acquire the culture of that society. The differences between individuals are much more to the point. The primitive artist, like the civilized one, may be a genius, a clever and industrious

mediocrity, or a mere copyist. Even if he is a genius, he will have his good and bad days, his successes and failures. Masterpieces are as rare in the art of uncivilized societies as they are in our own and as difficult for their creators to predict. There is plenty of bad primitive art, just as there is much bad civilized art, and the indiscriminate admiration of African or Oceanic sculpture simply because it is different certainly does not aid the cause of art or the development of a universally valid aesthetic.

The primitive artist's motives for being an artist are quite as diverse as those of his civilized counterpart. He may work because of an inner drive towards the creation of beauty, for profit, for prestige or simply because it is part of his social role. There are many primitive societies in which all men of a particular class are expected to paint or carve or dance, much as all Victorian ladies were expected to do embroidery or paint in watercolours. The making of certain classes of art objects may also be a hereditary occupation vested in particular families or kin groups. Persons who thus have the artist's role thrust upon them are helped to acquire the skills needed to make them competent copyists, but there is plenty of evidence that the primitive genius, like the civilized one, is born and not made.

For reasons which will be discussed later, the members of a primitive community are in an excellent position to recognize superior artistic ability and quite ready to reward it. The finest examples of primitive art are, with few exceptions, the work of professionals. Although such work is rarely a full-time activity, the artist augments his regular income by taking commissions and adjusts his product to the demands of the market. The artist who is too radical soon finds himself without patrons. Far from being a free spirit, the primitive artist is subject to much the same pressures as his civilized counterpart.

It is exceedingly difficult to generalize about the primitive artist's attitude towards his work. The cultures grouped under the primitive heading are much too diverse. In all of them the individual tends to be more involved with the supernatural than the average member of our own society but the extent to which this influences the artist's attitudes and working methods will vary not only from society to society but also from person to person. When the artist is a devout animist his relations with his tools and materials take on a mystic quality quite foreign to our own tradition. If he thinks of these as animate, intelligent beings he must also regard them as collaborators in the work of artistic creation. The rituals by which their willing co-operation is assured then become as important for the success of his work as any of his manual skills. Moreover, to the animist his own artistic product has a life of its own and a place in the universe, and part of his task is to arrange for these. Thus, the Iroquois mask maker carved his mask from the trunk of a living tree so that the tree's vitality would be transferred to it.

The highest development of this animistic attitude was in Polynesia. Here a single term, *Tahunga*, was used for both priest and master craftsman and, because of the intricacy of the ceremonial observances surrounding important work, the early writers on the region regarded the craftsman as a priest. Actually, it would be more accurate to regard the priest as a craftsman, one who worked with spirits and *mana* (impersonal supernatural power) as craftsmen of other sorts worked with more tangible materials. Among the Polynesian Marquesans the maker of images accompanied his work by reciting those parts of the Chant of Creation which gave the genealogies of the tools and materials he was using. His act of artistic creation was equated with procreation and while the work was in progress, his procreative powers were protected and strengthened by a strict taboo on copulation. As a final act, after the object was carved, he recited his own genealogy and his finished product stood forth as an independent Being, offspring of the artist and his materials and united with everything else in the universe by ties of kinship. Practices of this sort represent a rare and extreme development of animistic tendencies due to the Polynesian preoccupation with kinship and descent. However, the work of the artist, strictly predictable, tends to be hedged about by rituals and taboos designed to shield it from evil influences and insure its completion. Many of these rituals provide excellent examples of the interweaving of magical and practical elements which characterizes so many 'primitive' activities. The spells to be recited are not infrequently work formulae, keeping in mind the various things which have to be done and the order in which they must be done to get the best results.

In spite of such involvements, the role of magic in primitive art should not be exaggerated. By no means all primitive art serves magical or religious purposes. There are usually non-representational designs which are used simply for their aesthetic effect, while in groups in which sculpture or paintings are well developed, these are often applied to utilitarian objects with no purpose other than their beautification. Even when magical considerations do enter into primitive art they are inextricably interwoven with aesthetic considerations and it is often hard to tell which is dominant. Perhaps the only valid test is that of the extent to which the artist has elaborated and improved his design over and above the minimal magical requirements. The situation is, after all, very much like that which one encounters in European sacred art. A Renaissance Madonna was painted for a religious purpose and according to certain conventions which this purpose imposed, but these requirements could have been met by the crudest daub. Quite different motives lay behind its maker's desire for perfection in colour and line. Similarly, a design carved on an arrow to give it magical power will often be amplified and elaborated to satisfy the 'primitive' craftsman's desire for beauty. Man's search for supernatural aid and his search for beauty have always gone hand in hand.

It is only in those elaborate and self-conscious cultures which we call civilizations that this search for beauty has been intellectualized and made fully conscious. It seems probable that there are, at the foundation of all successful works of art, certain universally valid principles of harmony in form, colour and composition, but our difficulty in defining these is in itself proof of how little they have to do with the intellect. Neither artistic creation nor appreciation requires the intervention of verbal symbols and to try to describe these processes is very much like trying to describe what goes on in one's own subconscious. Primitive artists are, almost without exception, unable to say why they have made a particular

design or why they find one composition more satisfying than another. Many of our own best and most productive artists seem to be equally incoherent about these matters and one suspects that the main difference between primitive and civilized at this point is that the primitive has never felt the need for rationalization after the fact, which has been responsible for our own intellectual involvement with aesthetic problems.

Since we can have no direct access to what goes on in the mind of the primitive artist, the only safe approach to his work is an objective one. The expression of his aesthetic urge is limited and directed by such factors as his techniques and materials, the artistic conventions preferred by his society, the beliefs and values which he shares with it, and the conditions under which he has to work. These things are usually ascertainable, and it is against the background which they provide that the artist's work must be studied and evaluated. The factors which are common to all primitive, in contradistinction to civilized, arts are not aesthetic ones. They derive from certain similarities in the technical problems with which all primitive artists are confronted and in the social and cultural milieus within which they have to function. .

The primitive artist is normally a member of a small, closely knit community. Under ordinary circumstances even the professional works primarily for his neighbours and is strongly influenced by their opinion. Since he is personally known to his audience, it is quite unnecessary for him to sign his work, in the sense of placing any distinguishing mark upon it. The minor differences in style which emerge in even the most rigidly conventionalized art and the traces of his working methods are sufficient identification. In a few places, especially Africa, the primitive community may form part of a much larger social unit, but even so its members have few outside contacts. They are not completely cut off from the rest of the world, but new ideas reach them infrequently and are regarded with the suspicion which characterizes peasant communities everywhere. Minor variations on recognized themes are approved and good work is applauded, but radical innovations are discouraged.

This situation is not unlike that in European peasant communities prior to the modern technological revolution. However, primitive art differs from peasant art in certain respects. Peasant art fills a subsidiary niche in a larger artistic configuration. The peasant artist, even when semi-professional, is keenly conscious of the existence of the fine arts and of their makers. He has a feeling of inferiority and regards his work as common art for common things. Moreover, really talented individuals are likely to attract the attention of the Church or nobility and to be drawn away and trained for the fine art field. The primitive artist has no such feeling of inferiority. The art in which he participates forms a continuum of skill and merit extending from the most precious and sacred objects to casually decorated tools. The artist and his work find their places in this continuum simply on the basis of excellence. Talented

individuals are not drawn away from the primitive peasant community since the lure of cities is lacking. Even if an especially good sculptor is invited to come to a chief's village to execute a commission, ties of kin and property draw him back to his ancestral village as soon as the work is finished.

The societies to which primitive artists belong are usually much more rigidly organized than civilized groups, especially as regards the division of labour. There are always men's and women's crafts and regulations as to what materials may be used by each sex. Thus with very rare exceptions, work in wood, stone and metal is carried on exclusively by men, work in clay and fibre of all sorts by women. No woman can become a carver and no man a weaver, unless he chooses to relinquish his masculinity. In addition, the more advanced 'uncivilized' groups recognize the economic advantages of craft monopolies and often conserve technical knowledge within kin groups. Thus among the Imerina in Madagascar the knowledge of how to make *ikat* cloth was limited to women of the noble clan, while in Africa such skills as brass casting, iron working or pottery making are often rigidly guarded clan property.

These limitations are responsible for the not infrequent phenomenon of two or more totally different art styles coexisting in a single primitive society with little or no influence upon each other. Thus the tribes of British Columbia had a strong and elaborate animal art executed by men in wood, bone and stone. Their totem poles are a familiar example. At the same time there was an only slightly less elaborate angular geometric art whose designs were interpreted as representations of plants and inanimate objects. This was executed by women in basketry. The two arts differed so completely that, if their provenance were not known, they would be ascribed to different North American design areas. Women's designs never appear on men's work while men's designs have influenced the women's artistic products at only one point, in the Chilkat blankets. In these the men painted the designs for the blankets on boards and the women then executed them in textile. The painted patterns made no allowance for the limitations usually imposed by textile media and their execution called for extreme technical skill on the part of the weaver. The whole procedure seems to have been a very late development and must be classed as a bit of virtuosity in no way characteristic of primitive aesthetics.

A somewhat similar situation existed in the North American Plains where an animal art in painting, executed by men, flourished side by side with an elaborate angular geometric art executed by women in quills, beads and paint. Many other examples of such plurality of style could be cited, including even a few cases in which different styles characterize the work of different clans or other groups within a tribe. However, it is a curious fact that wherever a free naturalistic style and an angular geometric one coexist in the same society, the free style will be executed by men, the more constricted geometric style by women. An obvious reason

THE RIVER AND THE JUNGLE

Two little boys next to a dug-out canoe play in the shallow edge of the Wamba River unmindful of the threat of crocodiles. The Wamba flows into the Kasai, the Kasai into the Congo, and the Congo flows into the sea.

for this can be seen in the preoccupation of women with textile manufacture, with its technical limitations, but it is not impossible that there are deeper psychological causes.

Primitive societies make no distinction between the artist and the artisan. With a very few exceptions such as the Chilkat blankets previously mentioned, the same individual both designs and executes and takes an equal pride in both skills. Because of the rigid social delimitation of his activities, he normally works in only one or two media and with a limited range of art forms. However, his technical control within this limited field is often of a high order. The effectiveness of primitive tools is considerably under-rated by those who have never seen them in use. Surprisingly good work can be done with stone, bone and tooth implements and the main difference between these and metal tools lies in the increased time, effort and manual skill required of the craftsman. Since the primitive artist is rarely interested in mass production and has no conception of the value of time *per se*, these limitations do not trouble him. Thus the Marquesans had learned how to cut basalt with rats' teeth and carved small, highly conventionalized images out of this highly refractory material. I was told that the making of such an image would take all of a man's spare time for from six months to a year.

Where, as in Africa, iron is already in use, the primitive artist's equipment is usually little if at all inferior to that of the European artist in Gothic or even Classical times. The local tools may seem ineffective to a European but this is often due to his lack of muscular habits associated with their use. Thus in Madagascar, I was much puzzled by the long handles and seemingly clumsy curved blades of the knives used in carving spoons and other small objects. When I discovered that the handle of the knife was held in the carver's armpit and the object pressed and turned against the blade, the utility of these features became obvious.

It has already been said that in most primitive societies no distinction is made between arts and crafts, and the artist's training is essentially that of a craftsman. The boy picks up a knowledge of how to handle his tools and of the artistic conventions of his group by observing work in progress. If he shows real promise, some established expert, often an older relative, will take him under his wing and put the finishing touches to his technical education. When the expert enjoys teaching or when, less frequently, there is an actual system of apprenticeship in which the master is paid for imparting his knowledge, regular ateliers may develop. In most of the more elaborate and professionalized primitive arts it is possible to recognize various pieces as the work of such and such a master or *one of his pupils* much as one can recognize a Renaissance painting as belonging to the school of so and so.

In spite of the tendency towards professionalism which characterizes all of the more elaborate primitive arts, the artist in such societies is assured of a considerably more intelligent and participant audience than he finds in our own. If one man in a primitive community carves or paints, all other men in his social group will usually do the same. The genius rises from a plateau of fellow craftsmen who may be less gifted but who have an intimate knowledge of his aims and of the techniques available for their fulfilment. Under these conditions virtuosity acquires a new value. The skill displayed with brush or chisel becomes in itself a source of aesthetic satisfaction to those accustomed to handle the brush or chisel. Problems of design and colour arrangement are similarly familiar and the skill shown in solving them becomes in itself a source of intellectual pleasure. The primitive artist really works for an audience of other artists, thus simplifying his problems of communication. All this is in sharp contrast with the European practitioner of fine art whose problems and techniques are almost completely unknown to his audience. The only conscious basis upon which this audience can judge his work is that of the accuracy with which he has reproduced the appearance of things. The extreme stress on naturalism which has characterized European fine art during the last three hundred years must be interpreted at least in part as an attempt to improve communication between the increasingly professional artist and the increasingly technically ignorant layman.

Primitive art is always conventional and stylized. That this is not due to any lack of technical skill on the part of the artist is demonstrated by the ease with which such artists turn out reasonably good naturalistic work as soon as the presence of Europeans provides a market for it. The real problem here is why a particular set of conventions was developed in the first place. While unique factors such as the presence at a particular time and place of a genius whose work influenced subsequent developments must be recognized as a partial explanation of particular conventions, there are more general causes. These fall into two groups, technological and psychological.

Although primitive artists have the skill required for naturalistic representations, it requires much time and labour to reproduce the exact appearance of any object. Moreover, this appearance usually leaves something to be desired from the point of view of artistic composition. The comments on this of one of my Marquesan friends, Hapuani, deserve to be repeated. His reaction to pictures of eighteenth-century European statuary was that it was technically clever but aesthetically barren. He felt that the superior tools of Europeans had made it possible for their artists to avoid the real problems of creative art by retreating into an exact and unimaginative reproduction of externals. What, he asked reasonably, was the point of making something that looked exactly like a woman if it did not feel like one or smell like one. The primitive artist learns to convey the *idea* of woman by a simplified image which is not only easier to execute but which also lends itself better to manipulation in terms of design. The convention becomes both a labour-saving device and a way to heightened aesthetic satisfaction.

The development of conventions is further aided by the fact that most of the representations employed in primitive art are generic rather than individual. They are intended to convey the general idea woman, tree or bear rather than that of a particular woman, tree or bear. Portraiture in primitive art is excessively rare and when it does occur is usually limited to portraits of the dead. Here it strengthens the bond between the image and the original and makes the ghost more readily accessible to prayers and offerings. A similarly close

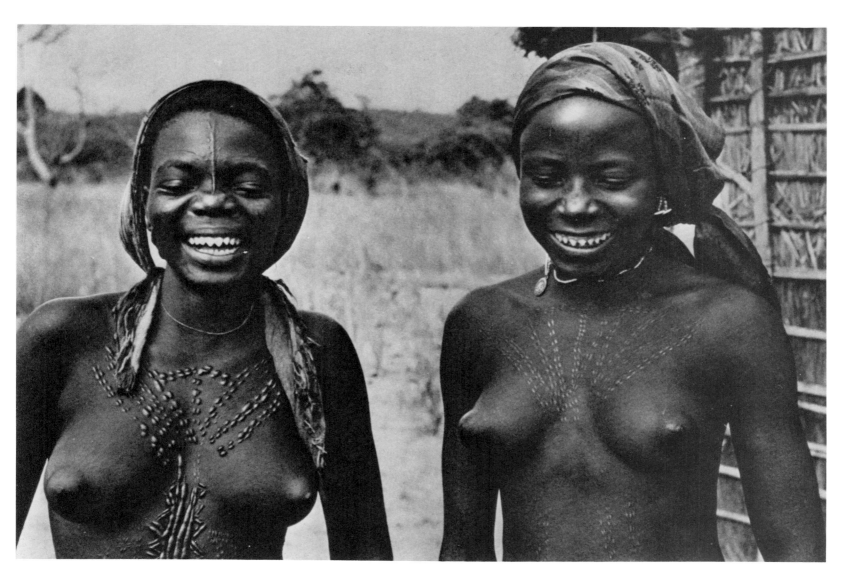

UNMARRIED BAPENDE GIRLS

Filed teeth and body cicatrices help to
identify the tribal origin of these girls.

bond between the image and a living original is fraught
with great danger to the subject since injury done to the
image is likely to be transferred to him. Our own
traditional magic of the waxen man would be a case
in point.

Even if there were no fear of magic, primitive tech-
nology makes the use of models exceedingly difficult.
Primitive artists normally design and execute in the same
final medium, the only significant exception being in
metal casting by the *cire perdue* process. Constant reference
to a living subject thus becomes almost impossible. Even
the most obliging model could hardly be expected to
hold a pose while his portrait was carved from a log with
a stone chisel. The primitive artist has to work from
memory and this in turn leads to a skill in visualization
foreign to most Europeans.

All the primitive artists of my acquaintance have
regarded the European system of letting the design grow
under the hand as nothing short of ridiculous. Before
beginning work they clearly picture to themselves not
only how the object will look from every possible direc-
tion but also how it will look in the particular place or
under the particular circumstances in which it will be
used. A few experiments in changing the lighting and
elevation of almost any primitive mask or figure will
make this clear. The mask which seems dull and in-
animate when lying horizontal on a table becomes

vibrant with force when seen as it is meant to be seen,
standing vertically at the height of a tall man's head
with lighting from above. Moreover, in making his
design, the artist keeps constantly in mind the qualities
of the material in which his work is to be executed. If it
is to be in wood, he thinks in wood, with no intervention
of pencil and paper.

To achieve such clear preliminary visualization of the
finished work takes long practice but it is worth the
effort. Once the composition is clear in the artist's mind
he can proceed to execute almost as a mechanical
matter. Like Michelangelo, his task becomes simply
'freeing the statue from the marble'. The ability to
visualize often becomes in itself a matter of pride and a
basis for exhibitionistic behaviour. If the Marquesan
artist was carving a bowl he would shape the object
completely and give it the highest possible polish before
beginning to carve so that any change of his design as
well as any slip of his chisel would be evident in the
finished work. Both the Marquesans and the related
Maori of New Zealand developed their abilities to con-
ceive and memorize designs without the aid of sketches
to a point rarely if ever equalled by Europeans. In
New Zealand in particular it was not uncommon for the
artist to conceive his design in terms of a field larger than
the object on which the design was to be carved, then
reproduce on the object only those parts of the total

15

design which fell within the outline of the object when this was superimposed on the original imaginary field. As a further bit of virtuosity two or three designs conceived in terms of fields of different sizes or shapes might be superimposed upon each other in the decoration of a single object. To the European the results are often bewildering.

This method of composition opens the way for a subtle type of conventionalization which is foreign to our own artistic concepts but which finds parallels in the arts of Asiatic civilizations. When one attempts to make an accurate copy of any work of primitive art one discovers that, in addition to the obvious conventions of form and design, there is a subtle and illusive convention in the quality of the lines and irregular curves employed by the artist. As far as I can discover, the Japanese are the only people who have been sensitive enough to recognize this fact and to develop an extensive classification of these features as they appear in their own art. Such conventions presumably result from the development of certain muscular habits during the artist's apprenticeship as a copyist of other men's work and are comparable to those embodied in various styles of writing: Gothic, Arabic or Chinese. They are also comparable to the individual tricks of chisel or brush work which aid in identifying the products of our own masters, but in primitive art they tend to be characteristic of an art style itself rather than of an individual. Their influence is so strong that even when the native artist attempts to copy European designs they survive and make his affiliations recognizable. The development of this sort of convention is quite impossible as long as the artist aims at exact reproduction of what he sees, since no two curves in nature are ever exactly the same. Its presence in nearly all primitive arts is an additional proof of the degree to which these arts are consciously divorced from naturalism.

So much for the technological factors leading to conventionalization in primitive art. Turning to the psychological factors, I believe they may be summed up in the simple statement that the primitive artist tries to represent his subject as he and his society think of it, not as they see it. Working from memory as he does, he draws from two sources, his memory of the thing to be represented and his memory of how the work of other artists who have tried to represent the same thing looked. His memory images are only partly visual. They are distorted by all sorts of evaluations based on the relation of the thing represented to the artist's society and culture. Thus the artist's mental image of a bear inevitably exaggerates such details as the teeth and claws, highly pertinent features of the animal if one is hunting him. This image also may include details of the animal's anatomy which are invisible when the animal is alive. Thus many North American Indian pictures of game animals show not only the external features, often caught with considerable skill, but also the heart and aorta. These are included because they are, in native tradition, the seat of the animal's life and also, in practical terms, the hunter's target.

Primitive art is thus abstract art, in the sense that the artist selects or abstracts those features of his subject which seem to him most worthy of emphasis. His work is thus comparable in some respects to that of our own abstractionists, but there is one important difference. The modern abstract artist tends to base his selection upon his personal reaction to his subject and, as a result, his compositions are sometimes unintelligible to the greater part of his audience. The primitive artist's abstraction rests upon the consensus of opinion of his society, and his work is correspondingly intelligible to his audience.

To Europeans, the most striking feature of primitive arts as a group is probably the freedom which they show in the treatment of the human body. Until very recent times our own artists have hesitated to use the human figure as a basis for abstract design, partly as a result of the Classical tradition, partly as a result of religious attitudes. The primitive artist feels free to exaggerate, distort or suppress any anatomical features and to treat the body simply as a starting point in the development of conceptually significant compositions. Thus New Guinea masks and figures from the Sepik River area show fantastic exaggeration of the nose, understandable when one learns that big noses are regarded here as indications of virility. In the Marquesas Islands the heads and faces of images were worked out in elaborate detail while the rest of the body was reduced to a few essential planes and masses. This was because the head was regarded as the seat of the individual's *mana* or spiritual power while the eyes, ears, nose and mouth symbolized the senses. The conventionalized representations of these organs conveyed the idea of man alert in the universe to a native audience, and at the same time permitted of more decorative treatment than an accurate representation of the same organs would have done.

In conclusion, it should be repeated that primitive art is not naïve, nor technically deficient. Its curious associations of ideas are always logical and understandable in terms of the artist's culture. Neither are its tendencies towards abstraction and conventionalization due to failure to perceive natural forms or inability to reproduce them with fair accuracy. The primitive arts represent different lines of evolution in the universal search for beauty. It is even questionable whether their conventionalization detracts seriously from the artist's opportunity for self-expression. The conventions limit him in certain directions but they also serve to focus his creative abilities on problems of pure form, organization and design. He may be permitted to use only a limited number of motifs but, freed from the demands of naturalism, he can treat these with intellectual clarity. The symbolism of the forms which he employs is so familiar to him and to his audience that he can convey innumerable ideas and their emotional effects without detracting from the formal aesthetic value of his work. Since the European observer is ignorant of the symbolic meanings of primitive art, its appreciation is for him an intellectual exercise which helps to clarify his understanding of aesthetics.

BUSHONGO DANCER

He wears a polychrome mask made of wood to which is attached an ornate construction of twigs, cloth, shells and feathers.

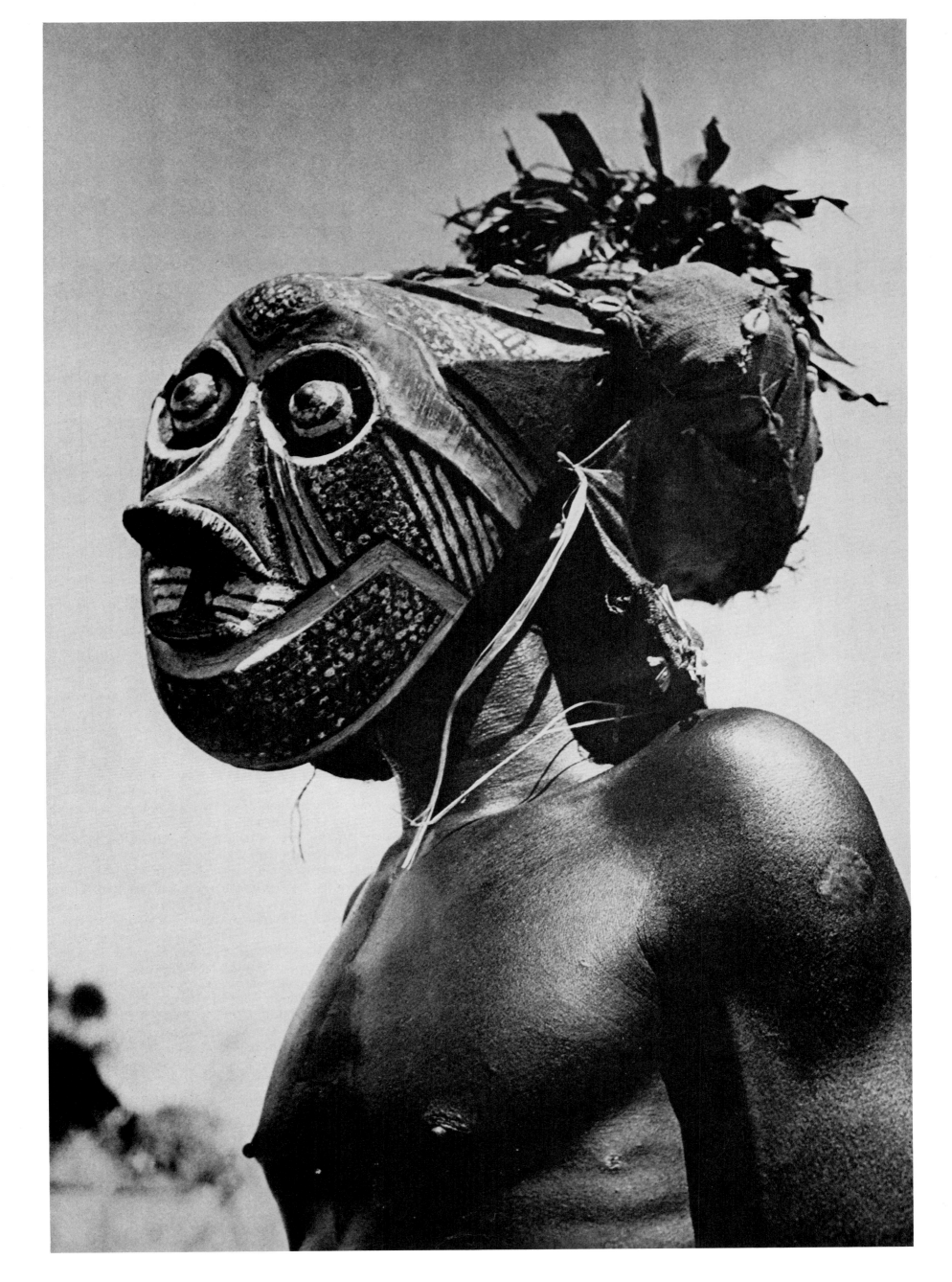

Bushongo
sculptor's adze

William Fagg

Deputy Keeper, Department of Ethnography,
British Museum

The SCULPTURE *of* AFRICA

The art of civilizations, with their elaborate apparatus of continuity both in space and in time, is a great deal more susceptible of general statements than is the art of tribal peoples; for these have their own separate and autonomous art traditions, forming in general an apparatus of differentiation from neighbours outside the tribe, rather than of assimilation to them as in the high cultures of Europe and Asia. In fact, most of the generalizations which we can usefully make about the tribal arts of the world are statements defining the differences between tribal art and the art of the 'higher', that is to say literate or industrial, civilizations; they are, in a sense, negative statements, for our knowledge of what tribal art really is, as distinct from what it is not, is still of painfully small compass. In the brilliant essay which precedes these notes, Ralph Linton—whose untimely death on Christmas Eve, 1953, was so severe a loss to the anthropological world, and above all to that section of it which must somehow come to grips with aesthetics without compromise of scientific objectivity—set forth, perhaps more clearly than they have been set forth before, the most important things which can and should be said about tribal, or 'primitive', art in general. His general statements ring as true for Africa as for the tribal groups in the Marquesas, Madagascar and North America of which he had direct experience; and indeed he was a leading connoisseur of African art, with an appreciation which was enhanced by his own practice of the techniques which he learnt from tribal carvers.

We may now examine certain matters more specifically related to the art of Africa.

The Geographical Distribution of Negro Sculpture

If reference is made to the map, on which have been marked the positions of the tribes represented in this book, it is at once seen that they form a definite pattern which calls for an explanation. Far from being spread evenly over Negro Africa (that is Africa south of the Sahara), they are clustered almost without exception within a vast but compact area of West and Central Africa, bounded on the north by the Sahara, on the east by the Great Lakes, and on the south by the Kalahari Desert and the middle Zambezi. In other words, the sculpture-producing area of Africa comprises, roughly, the two great river systems of the Niger and the Congo. Within this area there are rather few tribes from whom no sculpture is known; outside it, the absence of sculptural traditions is almost total—although the carving of useful objects from wood is universal—and the handful of tribes among whom such traditions survive seem often to owe them to some former relationship with tribes inside the art area.

For this remarkable dichotomy no clear-cut or generally agreed explanation offers itself. Racial factors will

hardly serve, since tribes representative of each of the major racial groups are found on both sides of the line (except that the Pygmies are all within and the Bushmen all outside—but neither race produces sculptors); about half the art-producing tribes are Bantu-speaking (and of the corresponding mixed origin), and so are a large majority of the art-less tribes. Nor has it anything to do with innate capacities, for there is no evidence whatever to show that East and South African Negroes are 'inferior' in skill, intellect or the incidence of genius to West Africans (or to Europeans); and in any case consideration of the pseudo-traditional carving done for the curio trade with Europeans shows East and West to be about equally adept and prolific. Geographical and climatic conditions seem, however, to play some part: the sculpture-producing area coincides more or less with the great rain forest together with the neighbouring savannah zones and, in the north, an extension into the sub-desert conditions of the western Sudan. The supply of timber can hardly have been a decisive factor, for no African tribe suffers from a crippling shortage of wood for more utilitarian purposes. Rather should we look to historical and cultural factors for the most probable explanations. The art-producing tribes of West and Central Africa are predominantly settled agriculturalists; the less sedentary peoples of the area, such as the nomadic Fulani in the north and the Pygmies in the south, produce no representational art. In eastern and southern Africa the pastoral economy is generally of much greater importance than agriculture, and such conditions are generally far less conducive to the development of sculpture, except possibly in the form of small and readily portable charms. Moreover, Africa east of the lakes, with its more open country, has been the scene, probably for three millennia or more, of large-scale migrations, wars and other displacements of population, and few tribes can have been left wholly in peace for more than a century or two at a time. To these vicissitudes we may perhaps attribute the comparative paucity of historical traditions in East as compared with West and Central Africa; and they would doubtless have had a similarly inhibitive effect on the development or continuity of sculptural traditions. Inter-tribal wars may well have been as prevalent in West as in East Africa (they flourished in Nigeria until the late nineteenth century); but whereas in the west defeated tribes normally continued to occupy their existing habitat, while their chiefs became tributary to the conquerors, in the east the tendency was rather for the defeated to give way before the victors and move on into territory which was either unoccupied or inhabited by less powerful adversaries. Even in West Africa, as we shall see, art throve none too well in those states—such as Benin, Dahomey and Ashanti—in which society was oriented towards war; most of their sculpture is pompous, mechanical, flamboyant and lacking in the evocative and dynamic qualities of the best African sculpture.

It may be convenient to refer here to the effects which the slave trade may have had upon West African art, since some writers have assumed them to have been considerable and for the worse. Let it first be said that slavery was an indigenous African institution of ancient standing, and that the Europeans came into it originally as middlemen, transporting slaves over long distances

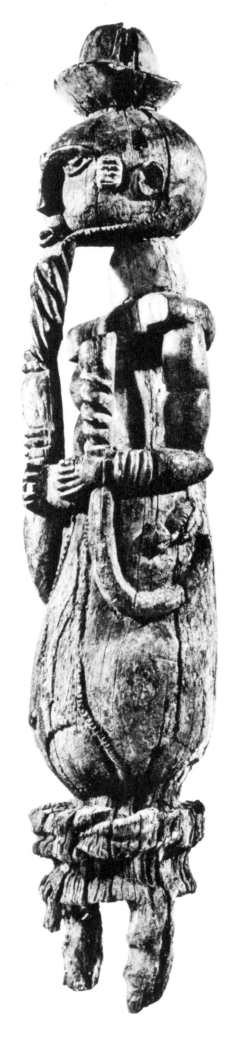

2
IBIBIO ANCESTOR FIGURE

The Oron, an Ibibio clan whose art style was almost unrelated to the main Ibibio tradition, carved many hundreds of ancestor figures (ekpu) such as this in the eighteenth and nineteenth centuries.

19

along the African coast from one tribe to another. But even when deportations to the American continent were in full flow, it may be doubted whether the effects upon art traditions were more than locally significant. Carvers are almost everywhere among the most respected members of the community, and are often chiefs in their own right; they would be likely in many cases to receive better treatment from the slave-raiders, while the lesser men were sold off to the European traders at the ports. But it is in any case highly improbable that at any one time a tribe would lose sufficient carvers from this cause to produce a serious deterioration in the tradition. On the contrary, the increased incidence of war hazards under the influence of the demand for slaves would be likely to increase the fervour of religious observances among vulnerable tribes, just as the approach of the punitive expedition in 1897 led to unprecedented resort to ritual human sacrifice at Benin; and this would be good rather than bad for art. Slaves were, nevertheless, among the saleable commodities which brought Europeans of many nationalities to the Coast of Guinea from the fifteenth century onwards; and this contact of industrial and pre-industrial cultures—rather than the slave trade as such—had its effects (such as the use of joinery and paint in the making of some Ijo and Ibibio figures, or the adoption of a sensuous naturalism and of some quasi-Christian subjects around the mouth of the Congo) upon the character and distribution of a number of the coastal styles.

The Technology of Carving and Modelling

In a volume which is conceived as an exposition of the morphology of African sculpture at its best, a fully detailed scientific account of its technological aspects would be out of place; but a brief summary of the chief methods used may well assist appreciation of the finished works.

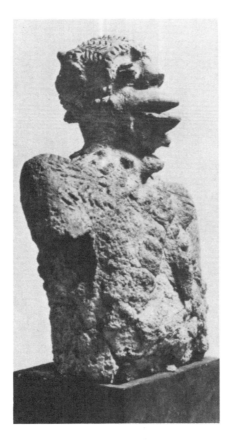

3

SAO FUNERARY FIGURE

The Sao culture probably flourished between the tenth and sixteenth centuries A.D. south and east of Lake Chad. Many heads and figures of this style have been unearthed in old cemeteries there.

Sculptural techniques in Africa, as elsewhere, may be divided into those of cutting down—including the carving of wood, ivory and stone—and those of building up—chief among which are the modelling of pottery and the casting of metals such as gold, copper, bronze and brass. The two principles may both be applied in the same tribe, for example in woodcarving and in brass-casting, but the results are often so dissimilar in style that, from internal evidence alone, one would hardly associate the one with the other as of common origin.

Carving in wood is the best-known and most widespread of the African visual arts, and provides the great majority of the works illustrated in this book. We may consider it under the headings of material, tools and processes. As to the first, the skilled Negro carver often has a more extensive knowledge of the trees, perhaps hundreds in number, to be found in his region, and of the special properties of their woods, than would be found anywhere in Europe, unless in some highly trained botanists; each tree has its own vernacular name and, if it is suitable for carving at all, its own recognized uses. In general, figures tend to be carved in the harder woods, masks in the softer. Two hazards against which the carver commonly guards in his choice of wood are white ants and the development of cracks; the most favoured woods are those, such as *iroko*, which are resistant to termite attacks (at least until the carved surface becomes desiccated from age and exposure) as well as to cracking. The African varieties of ebony are never used in traditional carving, though they are much used in work for Europeans, who prize ebony above all other woods.

The carver's tool *par excellence* in Negro Africa is the adze (p. 18), and with it he can do all that a European sculptor can do with mallet and chisel (and some other tools as well). It is common to find that the carver uses three adzes, differing from each other in form and weight, for successive stages of the work, and a small knife for the finishing of the surface; for hollow carvings, such as bowls and cups, he may use a curved iron knife or scoop. (Where, as among the Niger Delta Ijo, the adze is unknown, we may presume that it is long-established European influence which has supplanted it by the matchet—often of Solingen make—and other knives of European type.) Many Congo tribes, though few on the West Coast, embellish adzes with carved hafts, often with the blade issuing from the mouth of a human head; sometimes the blade itself is decorated with incised, wrought or inlaid designs. The more elaborate of these decorated tools are, however, thought to be ceremonial symbols of the carver's craft, not intended for actual use.

It is probable that the processes employed by African carvers vary as much between individuals, even in the same village, as do the styles of their finished works; surprisingly little work has been done at this level of inquiry, though it is a necessary foundation for the informed study of tribal aesthetics. It is probably a general practice among carvers to use freshly cut timber whenever possible; the wood of the *iroko*, for example, can be carved almost like a softwood within a few days of exposure to the air, but thereafter hardens up to a firmness (and a reddish colour) approaching or exceeding that of mahogany. This property no doubt enlarges the carver's freedom of action and so has subtle effects upon

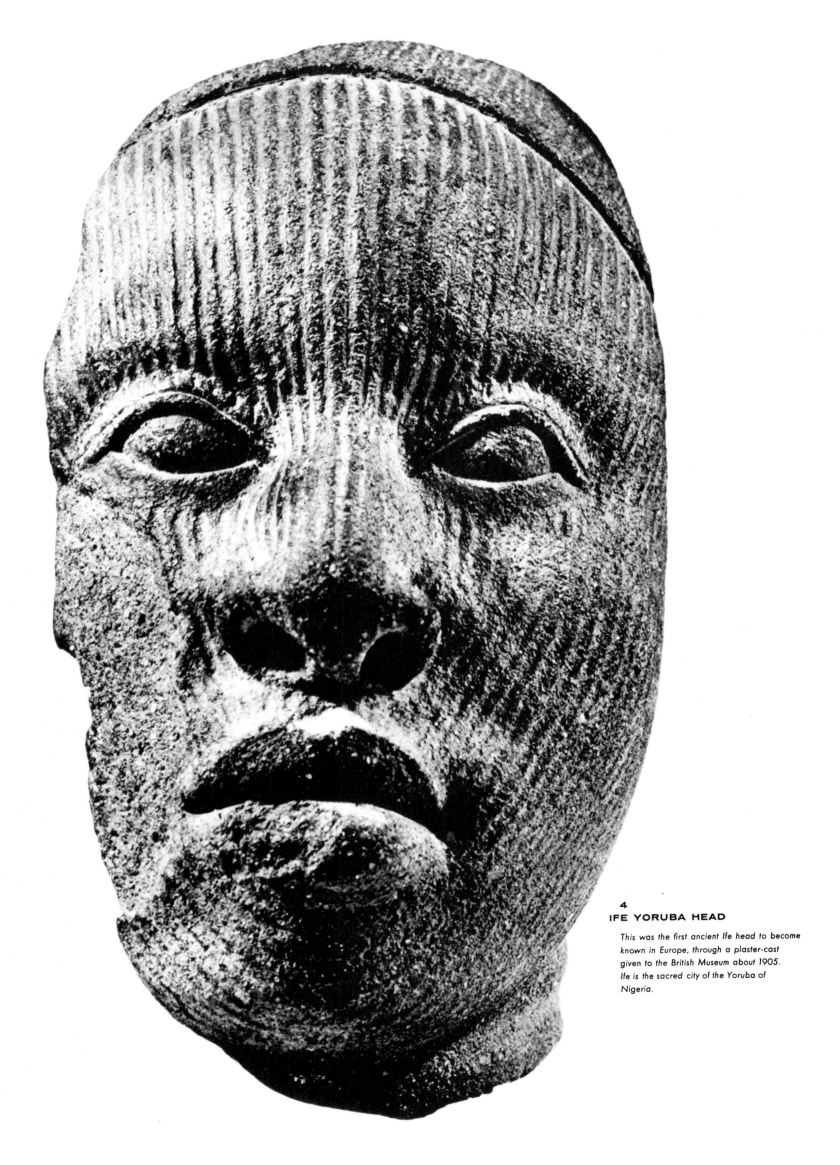

4
IFE YORUBA HEAD

This was the first ancient Ife head to become
known in Europe, through a plaster-cast
given to the British Museum about 1905.
Ife is the sacred city of the Yoruba of
Nigeria.

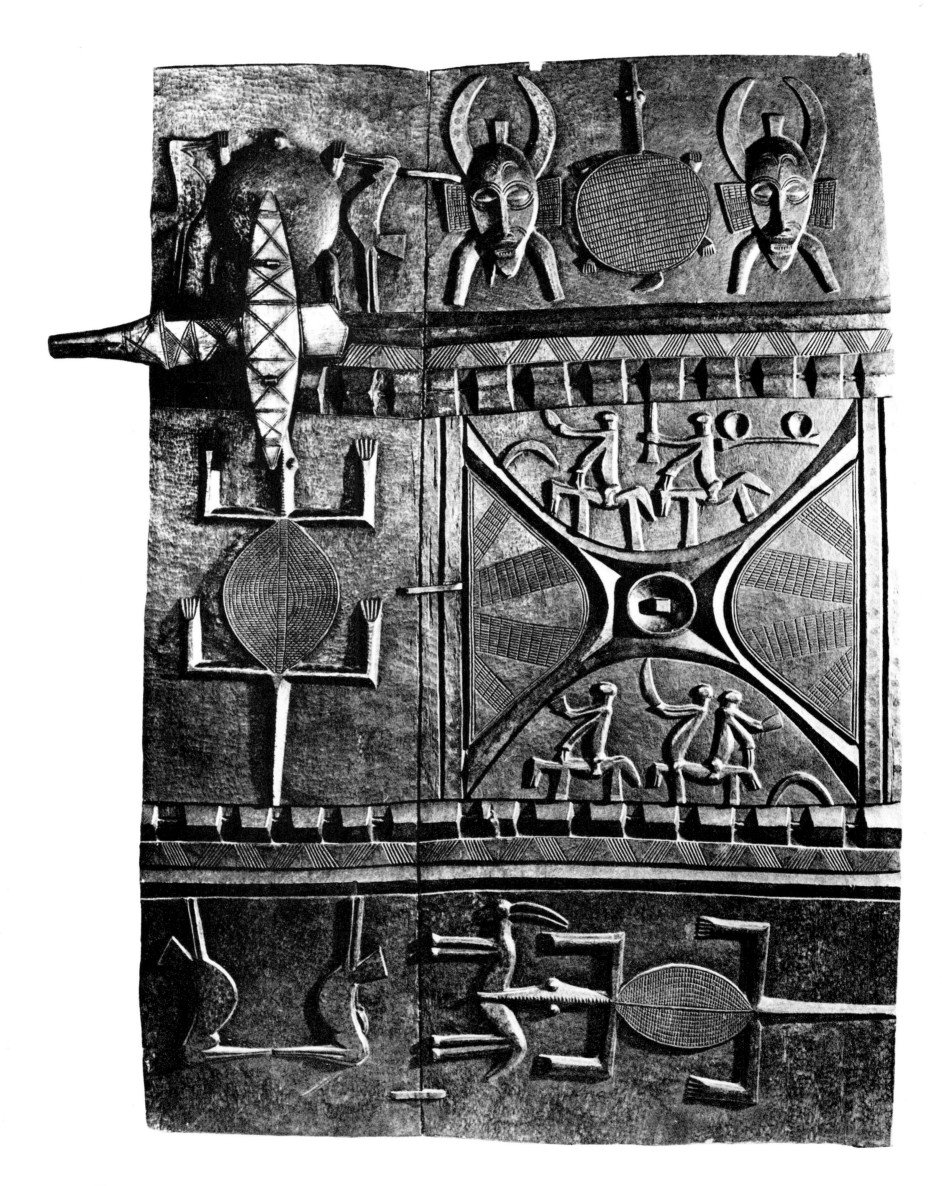

his style. The block from which he begins to carve may be a cylinder, if the girth of the tree is of the right size for the carving required, or it may be a segment or other shape cut from a larger trunk. The carver may, but does not always, mark the principal proportions by nicking the block with a knife or adze at what is to be the neck, and at some other points; or nowadays, among the Ijo and elsewhere, he may use a pencil. With bold adze strokes, he will then, usually, block out the head and the main portions of the body in such a way that the block begins to take on a vague and cubistic suggestion of humanity. He may now take an adze suitable for the main work of shaping the body and starting again at one end of the figure work over it with smaller, but still assured, strokes; the third adze may then come into play to complete the figure except for the surface finishing and the fine details such as the eyelids and the striations which represent the hair. But while the majority of carvers thus, probably, prefer to complete one stage of the work before beginning another, some others will rather carry the head to practical completion before proceeding to the torso and limbs; it is unlikely that this can ever be detected from a study of the finished work. It would seem that the composition as a whole is always present in the carver's mind before the work is started, and that only the smaller details—the decorative design on a loincloth or the scarification on a torso—may sometimes be left to be thought out at a later stage of the work.

Of carving in ivory and stone, little need be said here. Although some of the finest works are in ivory, the techniques employed in working it are not in principle very different from those of woodcarving; the material is less tractable, and the adze is probably little used, but the grain of ivory doubtless exerts an influence comparable with that of the grain in a hard wood. Field records of ivory-working processes are remarkably scanty. Stone-carving is of less importance and of very restricted distribution—the three principal centres being the Mendi-Kissi country, Esie (and to some extent Ife) in Yorubaland, and the Lower Congo region—and the favourite material, soapstone, is so easily worked as to impose little if any restraint upon the carver's freedom of action. It is true that the stonemasons of ancient Ife performed extraordinary *tours de force* in the fashioning of granite monoliths and quartzite shrine furniture; but these skills do not seem to have been much applied to representational art.

Additive or built-up sculpture again seems to impose less restrictive limits on the artist's invention than does subtractive sculpture, especially in wood. As so often, however, in cases where discipline is not enforced by the medium, there is a tendency for this freedom to degenerate into license in the hands of the ungifted.

Pottery sculpture, we must first note, is most often in the hands of the women, who are almost universally responsible in our area for the manufacture of pottery utensils. (One of the few instances of subtractive sculpture in pottery—the elaborately ornamented tobacco pipes of the Cameroons Grasslands, carved when the clay is 'leather-hard'—is in the hands of the men.) The essential skill in pottery art is that of so managing the construction on the one hand (thickness, consistency, temper, etc.) and the firing on the other that the work is evenly and sufficiently fired without any cracking; this includes the distribution of weight in such a way as to avoid collapse or distortion during the slow drying in the sun which precedes the firing. In this field the most considerable technical feats were performed in antiquity: at Ife, where life-size pottery figures, in elaborate dress, survived intact in the grove of Iwinrin until half a century ago (made in this case by men potters, as we can infer from the complete identity of their style with that of the famous bronze heads); and, more than a thousand years earlier, in the siderolithic culture of Nok, where nearly life-size figures (compare fig. 57) similar in many ways to those of Ife have been excavated (so far always in fragments) over a wide area in and to the north of the middle Benue valley. In recent times such large works do not seem to have been attempted in pottery, though life-size figures in unfired clay or mud are not uncommon, especially among the Ibo and the Bini.

Metal-casting is by far the most elaborate of African sculptural techniques, and the most difficult to master; but its essential principle is simple. The creative work is carried out in beeswax (or some substitute such as latex) —for the *cire perdue* method of casting metals was alone used in West Africa—and this model is then translated mechanically into bronze (or another ductile metal). In traditional work (as distinct from the revived craft of modern Benin) in this medium, no further 'art work' was carried out on the finished casting (though the metal rods which preserve the form of the vents and runners were of course removed), the care applied to the fashioning of the model and to its investment in fine clay rendering unnecessary any chasing or other finishing. Leon Underwood, himself a master of the process, has well examined its artistic implications in his *Bronzes of West Africa*; but it will be sufficient for us to note that while the prudent artist is strongly influenced by his knowledge of the properties of molten metal when modelling the clay core and its waxen envelope and in the disposition of runners, there is, nevertheless, scarcely any imaginable sculptural form which could not, with the requisite skill, be realized through this most versatile process.

On the Nature and Basis of African Art

It is not the purpose of these brief notes to attempt to define, describe or analyse the aesthetic qualities of Negro art. The progress made by our art critics in developing verbal techniques to match the non-verbal arts of their own culture holds out little hope for the success of such attempts, and indeed most of those who have written from an aesthetic point of view on African sculpture have succeeded only in interposing an opaque screen of largely irrelevant verbiage between it and the student. This volume is designed rather on the direct method of using the sculptures themselves, and not pale verbal shadows or distorted reflections of them, to propound the principles of African aesthetics; the best resources of photography have been employed to convey, where necessary in multiple reproductions, the

5

SENUFO DOOR

Southern Senufo clan shrines, isolated in sacred groves near villages, are often sealed by carved doors, on which ritual objects such as divinatory figures, dance masks and leg irons may be represented. Senufo culture is transitional between those of the Sudan and the Guinea Coast

diverse sculptural qualities of a very comprehensive sample of the finest African art.

The difficulties of describing or interpreting African art in verbal terms arise largely from the fact that it is in itself on the whole non-descriptive (unlike most European art): the things with which it is concerned are the things which are beyond speech, and the artist is expressing things which it would never occur to him to try to put into words. In short, the 'language' of African art is 'sculptural' in the fullest sense. European sculpture (including most modern sculpture) is, on the other hand, often only in part 'sculptural', being in part also literary or quasi-literary both in purpose and in treatment. European music, however, commonly takes strictly musical forms and cannot be adequately represented in words, and it is perhaps more with music than with any other of the European arts that African sculpture may be said to have an affinity in the direct way in which its forms are used to produce effects without the intervention of verbal concepts. It is poetic, in the sense in which poetry is distinguished from mere verse or prose by the conveyance, through form or pattern, of something over and above the specific content of the words used, in such a way that its effects are not wholly lost even on a hearer unfamiliar with the language in which it is spoken.

This directness of communication is doubtless helped by the fact that the African sculptor has almost invariably been less concerned to represent people and objects than (non-verbal) concepts about them. The human features in an African figure may be only just sufficient (see, for example, fig. 198) to identify its variations as being on a human theme. (The artist of the European tradition, on the other hand, is almost bound to make naturalistic representation of his subject the basis of his creation, which is artistic or poetic only by virtue of its transcension of mere representation.) The tendency of the Negro artist is to generalize, to proceed (as in scientific induction) from the particular to the general: for example, if he is carving a figure to stand for a recently dead chief on his family's ancestral altar, he will emphasize not the features of the deceased by which he was distinguished from other men (however well the artist may know them), but rather the traditional stylistic features by which he may be classified with the other tribal ancestors (see, for example, figs. 118–121). African art may thus be considered in a strict sense 'classical', unlike the romantic art of nineteenth-century Europe, in which general ideas were so commonly reduced to the particular by the use of highly naturalistic and individualized figures.

It is probable that the most fundamental quality of African sculpture is dynamism; but in trying to apply this concept in art we have passed beyond the field of scientific evidence into one where, for the present, we must rely largely on conjecture and speculation. We know from the plentiful evidence collected by missionaries and anthropologists that the life of many if not most African tribes is pervaded by this concept of dynamism (normally defined as a theory which explains the phenomena of the universe by immanent energy). It has been most explicitly described by Father Placide Tempels in his *Philosophie bantoue* (1947) on the basis of his long researches among the Baluba, and although much

further investigation is required before his conclusions can be either confirmed in detail or considered generally applicable in Negro Africa, they are to a large extent supported by independent studies such as those included in two recent symposia, *African Ideas of God* (London, 1950) and *African Worlds* (London, 1954). According to Tempels, African thought is conditioned by their ontology, that is, their theory of the nature of being: for them being is a process and not a mere state, and the nature of things is thought of in terms of force or energy rather than matter; the forces of the spirit, human, animal, vegetable and mineral worlds are all constantly influencing each other, and by a proper knowledge and use of them a man may influence his own life and that of others. Of course, the average African is no more conscious than the average European of having 'a philosophy'; but it has become clear that what were once regarded as foolish and naïve superstitions, developed *ad hoc* to plug gaps in the primitives' understanding of natural phenomena, are in fact part of a coherent and logically ordered system which, though alien to that of the industrial civilizations, has some affinity, for example, with the world of Democritus and even of modern sub-atomic physics. This interpretation of African belief about the nature of things accords well with what we have long known of tribal peoples in other continents, especially the concept of 'soul stuff' in South-East Asia and *mana* in Polynesia. All these peoples seem to share a belief in the desirability of increase in the broadest sense as a principal end of life, together with a corresponding fear of loss of force.

If the foregoing hypotheses are valid, it would be surprising if African sculpture were not profoundly influenced by the theory of force not only in its purposes but in its forms. It may be objected that movement is far more commonly shown or suggested in European art than in the somewhat rigid forms of African sculpture. Yet there is surely nothing more static than arrested movement: in a *Discobolus* or a *Laocoön* we search in vain for dynamism, which is in any case more readily suggested in the restraint of force than in its exercise.

As to the purposes of African sculptures, it is the doctrine of force which unites in a single system the three concepts (each having its appropriate art forms) of the worship of gods and spirits, the cult of the ancestors, and the direct harnessing of energy through charms and 'fetishes'—concepts which are too commonly treated in writings on African art as discrete entities. Even such apparently secular works as the carved doors of chiefs' houses in the Ivory Coast (fig. 133) and Nigeria, or the carved boxes of the Bushongo (figs. 267–268, 271), may owe something to a vague and vestigial sense that the owner's force tends to be enhanced by their presence.

The influence of belief on form is not only a difficult and at present speculative field of study but perhaps also one of the greatest potential value for a deeper understanding of Negro art. We may conclude these introductory notes with a hypothesis which is intended as a contribution to such studies. It is based on the frequent occurrence in African carvings of curves which recognizably approximate to those known to mathematicians as exponential or logarithmic: these are spirals which intersect all their radiants at the same angle, but the non-mathematician will recognize them more easily as

the curves described by the growth of the tusks and horns of many mammals, such as the elephant, the boar, the antelope and the ram. These excrescences are used by tribal peoples in all parts of the world as symbols of fertility (in pursuit of which so many of their ceremonies are conceived) because they so patently embody a principle of growth or increase. They are often used (figs. 297, 299, 300), or more or less faithfully represented (figs. 148, 265, 298), in African sculpture; but we are less concerned here with such direct representations than with the assimilation of the exponential curve by African carvers (notably the Ibo and Ibibio) as an important element in sculptural rhythm (for instance in figs. 44, 181, 218, 302)—not of course from any respect for or knowledge of mathematics but rather from an intuitive appreciation both of its inherent beauty and of its affinity with the ideas of increase and of vital force. Moreover, mathematical analysis of African sculptures would probably show that the relation between many exaggerations of human features (see especially figs. 68, 69, 103) and those features themselves can be expressed in terms of exponential co-ordinates, so that although the exponential curve is not directly in evidence it has nevertheless supplied the principle of growth which has produced the sculptural form; the same principle, no less unconsciously applied in most cases, can often be traced in the exaggerations of caricaturists in our own civilization. Though mathematics and its concomitant philosophical concepts play no part in the making of African sculpture, they may yet be valuable aids in the abstraction from it for the better understanding of Europeans of the mysterious elements of African dynamism.

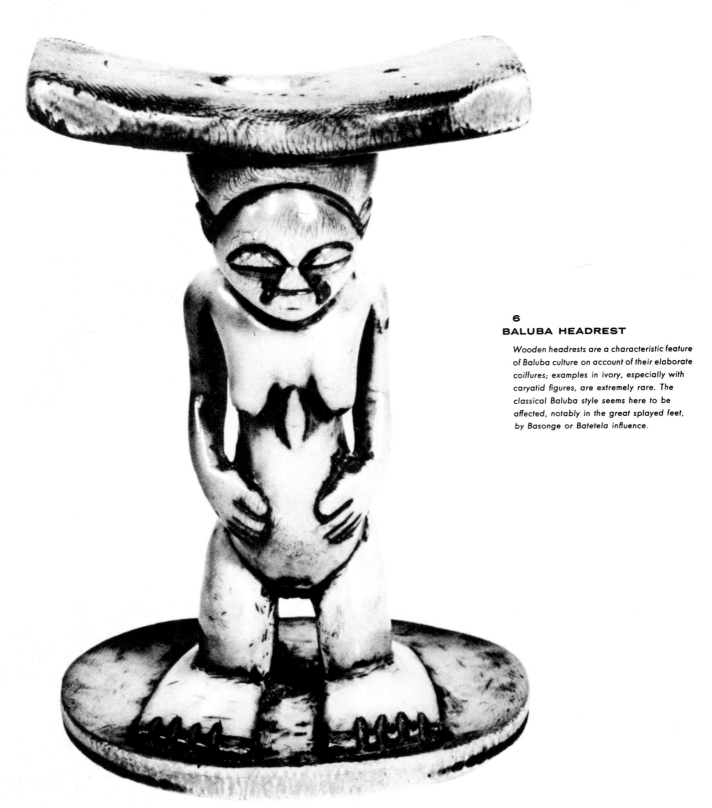

6
BALUBA HEADREST

Wooden headrests are a characteristic feature of Baluba culture on account of their elaborate coiffures; examples in ivory, especially with caryatid figures, are extremely rare. The classical Baluba style seems here to be affected, notably in the great splayed feet, by Basonge or Batetela influence.

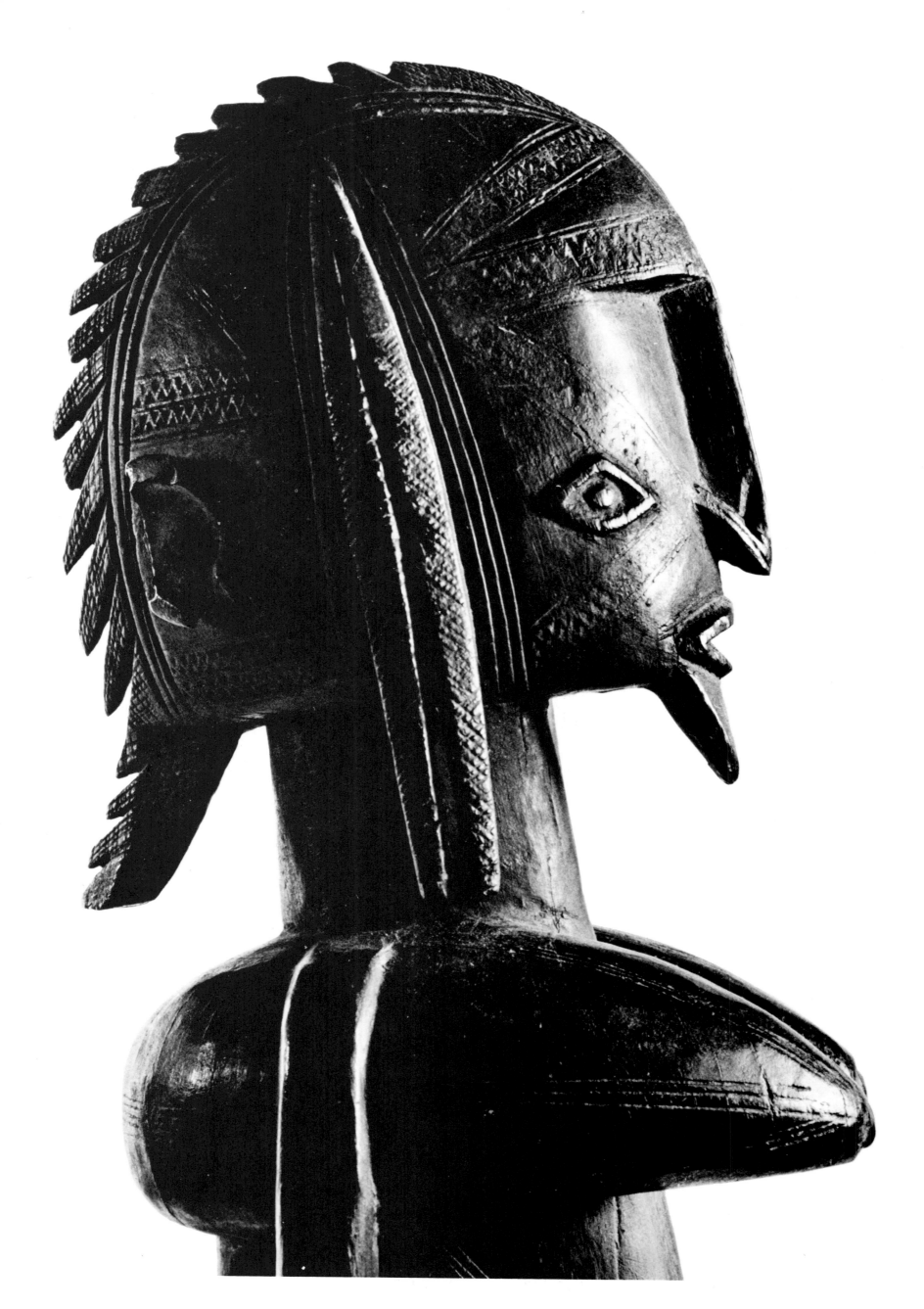

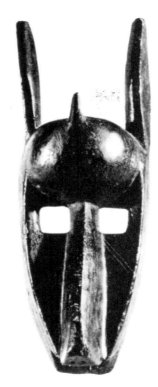

8
BAMBARA DANCE MASK
This portrays either the lion or the hyena spirit of Kwore, a society believed to control the sky and rain.

The

Western

SUDAN

To the geographer, and to the Arab who named it, 'The Sudan' connotes that whole vast belt of sub-desert and savannah country which stretches across Africa at its widest part, from the coast of Senegal to the Red Sea, including the northernmost areas of the Gold Coast (Ghana), Nigeria and certain other coastal territories. To the Englishman, and to the majority of semi-informed people in the world at large, it means that easternmost quarter of the belt which has been governed, chiefly by Great Britain, for the past half-century as the Anglo-Egyptian Sudan and has now received its independence as 'The Sudan'. To the Frenchman, again, it means a large tract at the other end of the belt which forms a central region of French West Africa and is commonly referred to as the western or French Sudan. And if the North Africans think of it, according to the meaning of the name, as 'the country of the Blacks', it is probable that the Guinea Coast Negroes think of it rather as the country of the Whites, of the 'Tyrians' (*Turawa*)—or Phoenicians—as some of them still call lighter-skinned peoples such as the Europeans, the Tuareg and the Fulani. In this section we are concerned only with that part of the Sudan in which important sculpture is found, namely the western portion, in and to the west of the Niger Bend.

By comparison with the Sahara, the Sudan is an agricultural country, and it is mainly by tilling the soil that its Negro populations live, though less easily than in the luxuriant vegetation of the Guinea Coast. They live also in part by the hunt, using the bow and arrow, the throwing club and knife, the spear and the dane gun, and practise burning of the bush, that most wasteful method of beating in which all but the stouter trees are consumed every dry season. The image of the antelope (see figs. 37–41) and other game leaping from the edge of the burning *kurmi* (or wooded patch watered by a stream) into the open parkland where the hunters wait is a familiar one among the Sudanese peoples. Again, many of the inhabitants depend in part on cattle for their food, but these are generally kept not by the Negroes themselves but by the nomadic Fulani, who are found throughout the savannah from Senegal to the Cameroons. In the conditions of the Sudan, therefore, the means of life depend upon the fertility of three domains—the crops and the domesticated and wild animals. It may well be that in such conditions human fertility will be found to be relatively less important than on the Guinea Coast or in the Congo as a determinant of behaviour, religion and art. But increase in general remains, as everywhere in Negro Africa, the dominating concept.

The western Sudan is better known in history than any other part of Negro Africa because of the copious and notably reliable writings of the Arab and Arabic-speaking Negro chroniclers; these are not, however, of great avail to the student of Sudan art, since the light which they shed on pagan (non-Muslim) cultures is largely indirect. For the chroniclers wrote almost entirely of kingdoms and cultures in which art of the kind which we are considering could hardly have arisen or survived. The western Sudan was, in the Middle Ages, a land of great empires, Muslim and pagan, of wide-spread power resting on the solidly human foundation of armies of cavalry; and it was, on the other hand, one of the intellectual centres of the world, with its Koranic university at Timbuktu—which flourished before the beginnings of Oxford and Cambridge and was one of the chief depositories of Graeco-Arab learning during that crucial period when the Arabs became the heirs, as they were to be in part the ancestors, of European civilization. These are not the conditions, material or philosophical, in which what we know as tribal or 'primitive' sculpture can exist. Islam, of which iconoclasm is an essential tenet, is overtly inimical to representational art; and states which are primarily militaristic tend either to be wholly insensitive to art or to produce—as in the Guinea Coast empires of Ashanti, Dahomey and Benin—an art which, with rare exceptions, is servile, mechanical, and sadly lacking in moral and aesthetic sincerity.

It is improbable, then, that the Sudanese empires practised any but the geometric art of Islamic cultures (which may, of course, reach a very high artistic level), or that the tribal arts with which we are to deal owed

anything directly to them. It is none the less necessary to take note of these facts of history if we are to understand the differences and similarities among Sudanese art styles.

We may compare the pagan tribes with certain curious geological formations which are to be seen here and there in the Sudan—miniature cliff-sided plateaus, a hundred feet or more in height, which are the last vestiges of an older land surface to escape erosion, its hard points as it were. So are the pagan cultures, with their arts, hard points surviving, often on the tops of craggy hills, as islands of diversity amid the unifying flood of Islam. Yet their cultural independence is not wholly uncompromising: often they accept or imitate some elements of the material culture of their Muslim neighbours, including, in the case of some pagan chiefs,

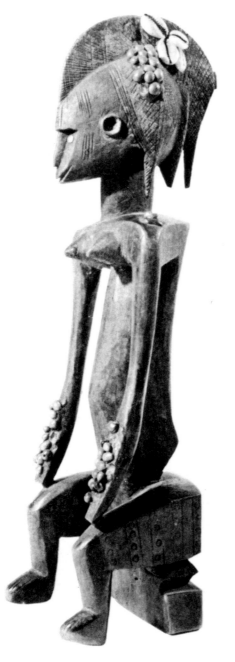

9

MALINKE FERTILITY FIGURE

A young girl carried this while she danced, invoking its help to obtain a husband and children. Although nominally Muslim, some Malinke seem to have produced religious sculpture—masks, headdresses and statues, related to Bambara work— until recently.

their formal dress; and, in a more subtle way, their sculpture and its associated ritual seem to be modified (and often also concealed) in a way that might render them less objectionable to orthodox Mohammedans (see, for example, figs. 20, 28, 43). It is difficult to say what may have been the motives behind this tempering of the outward forms of paganism—whether it was intended to render easier necessary commercial contacts with Muslims, or to avoid provoking holy wars, or was simply partial imitation, more or less conscious, of the abstraction favoured by Islam, or indeed whether it is attributable to Muslim influence at all rather than to coincidence or to a common environment. Such a phenomenon is, however, found elsewhere along the borderlands of Islam, notably in the Malay Archipelago where the crouching human figures carved from wood or ivory which form the handles of *kris* or ceremonial daggers were stylized, sometimes to the point of unrecognizable abstraction, or disguised as birdlike forms, in order, so it is said, that they might survive the arrival of Islam—while in Bali, which was never converted to Islam, the handles remained more recognizably human in form. Similarly, among the Nupe of Northern Nigeria, who were conquered in about 1830 by the Muslim Fulani under Mallam Dendo, one may occasionally see (as in certain large houses at Mokwa) houseposts ostensibly of geometrical design in which derivation from the human figure is still discernible. Islam commonly wields great prestige beyond its frontiers through respect for its material power and moral and doctrinal certitude; it is probably true to say that it tends to convert communities, whereas Christianity converts individuals. It is suggested here that historical influences such as these may have had a greater part in determining the abstract tendencies in the art styles of the Sudanese pagans than is appreciated by those writers who are content to explain them solely in terms of the fashionable jargon of psychology.

It is true that some of the Sudan styles—those of the Dogon and the Bambara, and to a less extent of the Mossi (and the northern Senufo)—show morphological tendencies towards asceticism and restraint and a severity of line and form (see, for example, figs. 15, 28, 31, 51); and it may be that psychological correlations are justified in some cases, as with the Dogon masks used in the dances which are said to be intended to expiate the original sin of the tribal ancestors (see, for example, fig. 18). But in general it is improbable that psychological factors have played a major part in the determination of sculptural forms; and most of the attempts so far made to apply psychological methods in detail to the study of African sculpture, or indeed other aspects of culture, have been superficial, fallacious (because based on techniques developed in terms of European culture) and sometimes, it must be said, decidedly disingenuous. Easy generalizations are assisted —while serious scientific study is hindered—by our continued lack of knowledge on which to base firm interpretations of the forms of African sculpture; and to find laws where none exist is not science but its negation.

Anyone who supposes that the art of the Sudan is necessarily introvert will doubtless be surprised by Bobo sculpture (see figs. 48, 49) which, in appearance at least, is often as extrovert, in a very different idiom, as that of

the Cameroons. And on the other hand hundreds or thousands of miles from the Sudan one may often find sculptural traditions rivalling the Dogon in the severity of their abstractions (see, for example, figs. 175, 217, 224–232, 302, 305, 313); this sometimes leads those addicted to circular arguments to hold that the tribes concerned must therefore be displaced outliers of Sudanese culture. In truth all forms of determinism are unsafe guides for the student of African art.

Such caution should be our watchword even when we use what are by far our most copious and valuable sources on the Sudanese arts and cultures—the works of the late Marcel Griaule and his followers on many aspects of the life of the Dogon and, to a less extent, of the Bambara and other neighbouring tribes of the Niger Bend region. If the great corpus of ethnographical data on the Dogon collected and published by this school during the past twenty-five years does not appear wholly convincing, this is probably due to an inherent hazard of such intensive and prolonged research within a single community. No one can properly offer serious and definite criticism of their work without first himself testing their data in the field; but to many anthropologists who are familiar with other African fields their results seem to exhibit a kind of deterministic perfection —in terms of the European practice of logic—which is hard or impossible to parallel anywhere else in Africa: in particular, the paramountcy of ritual symbolism in daily life is represented as being carried to an extreme if not incredible degree. It is often hard to resist the feeling that ideal rather than actual behaviour is being described. The hazard which has been hinted at is the danger of 'saturation' of a group by anthropological investigation —an effect noted long ago in some North American Indian tribes, though rare in Africa. This danger is increased if the investigators employ as their main 'research tool' a well defined 'theoretical framework', to which perhaps their school is passionately devoted. Highly competent investigators are likely to select the most intelligent informants in the community, and at the point of saturation these may, perhaps quite suddenly and probably quite unconsciously, absorb the framework and begin, unknown to the investigators, to interpret their own culture in terms of it.

It is not suggested that so dire a calamity has befallen the Dogon expeditions to any serious extent (and Professor Griaule was unusually aware of methodological problems). But it may not be amiss to mention this danger—to which the French school of ethnology is no more subject than many others—as a general *caveat* against the too ready acceptance of rigidly deterministic interpretations of material culture and specifically of art forms. Even among the Dogon, there must be considerable freedom for the carver to arrange his forms and decorations according to his liking so long as he does not transgress the ritual limits. We must in any case reiterate that an immense volume of valuable data of a kind most unlikely to be distorted by methodological error has been gathered by the French ethnologists, and that the masks of the Dogon, in particular, are better documented, in Griaule's great work, than the works of any other African tribe. We must hope that his French and other successors will carry forward and consolidate his multifarious researches in this most interesting area.

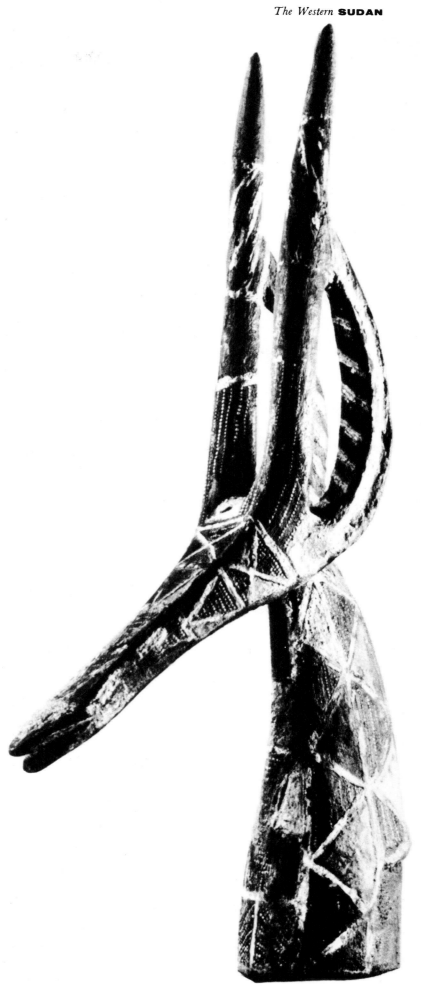

10
KURUMBA DANCE HEADDRESS

Such wooden antelope heads are lashed to caps and worn in ritual dances in the Aribinda region to end the period of mourning for a dead man by driving his soul from the village, and also in farming dances. They are remarkably uniform in their sculptural treatment.

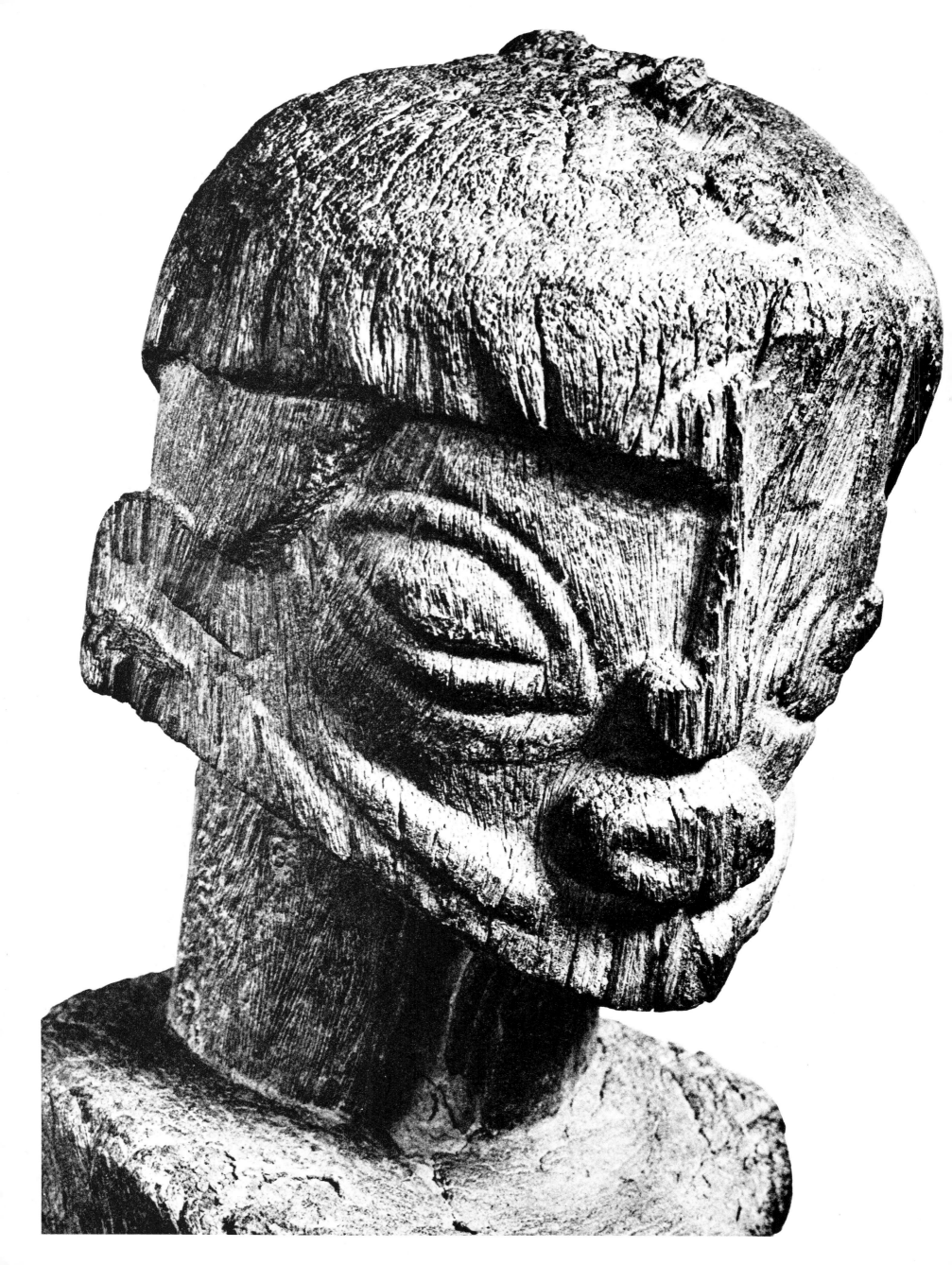

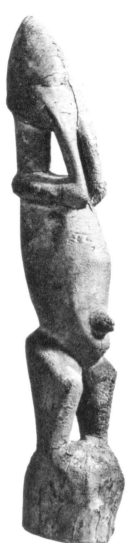

**12
CULT FIGURE**

Quantities of these old figures are found in cliff-side
sanctuaries. Their usually encrusted condition
indicates use in rites of sacrifice.

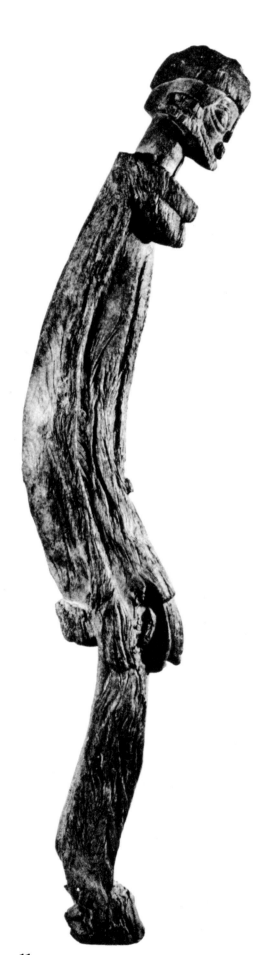

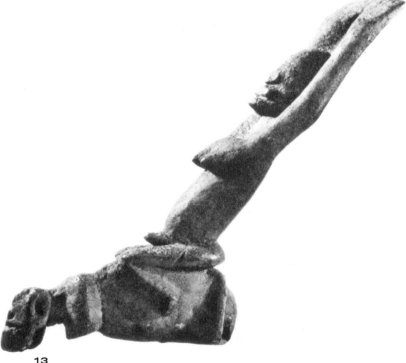

**13
CULT FIGURE**

The old figures often show upraised arms, a gesture
thought to connect earth and sky, perhaps by
beseeching rain. The posture appears again in
fig. 22.

**11
CULT FIGURE**

Some Dogon ascribe such old figures to the 'Tellem',
who supposedly preceded them on the Bandiagara
cliffs (where this piece was excavated), but the style
seems ancestral to their own more recent work.

DOGON

14
CULT FIGURE

Dogon style often, as here, exaggerated the breasts of male figures for aesthetic effect. Images were made both for the newly dead, as memorials and soul-receptacles to be kept by his family, and for the personal shrines of the living.

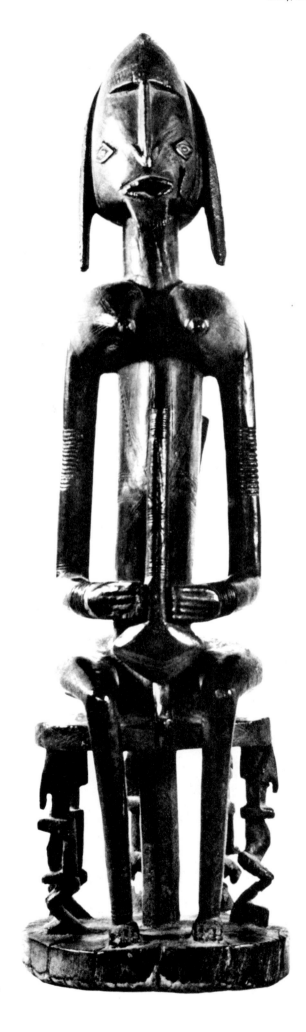
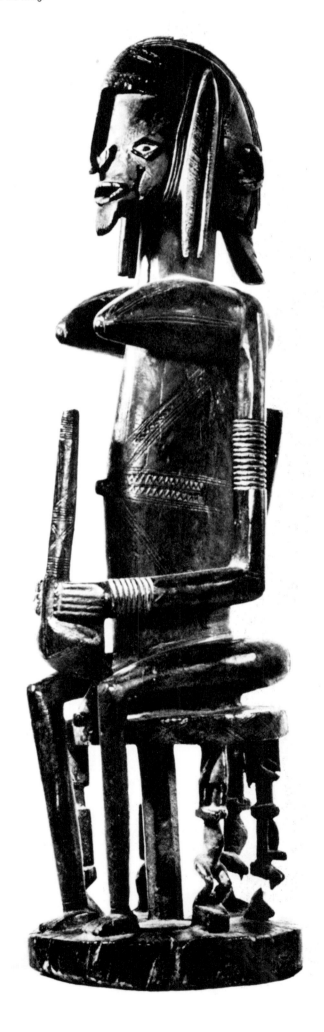

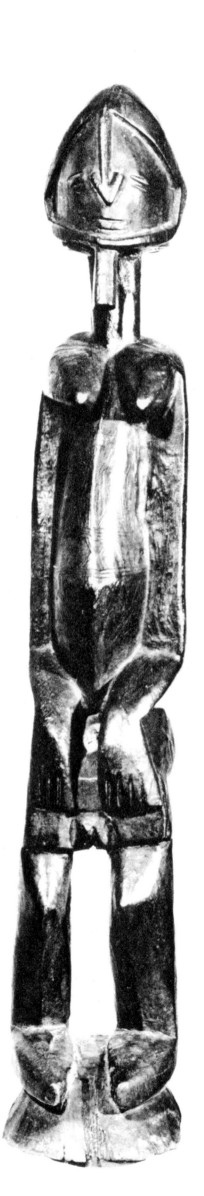
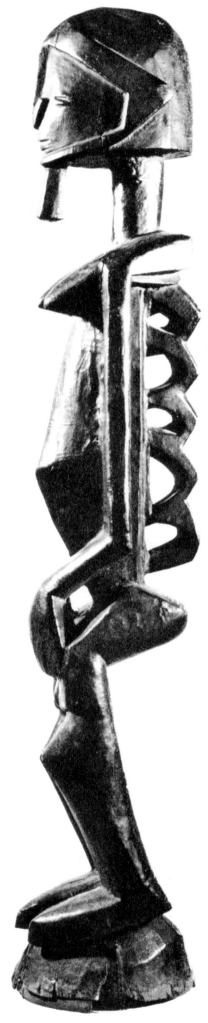
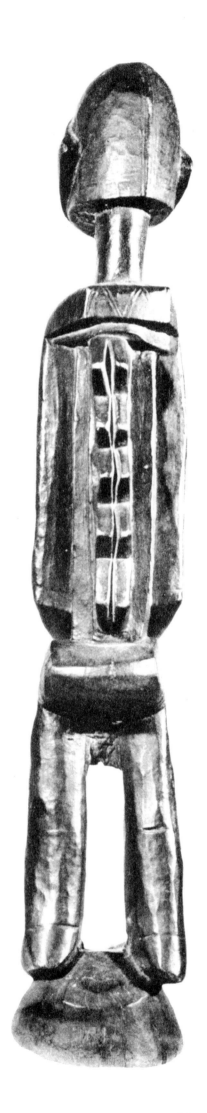

15
CULT FIGURE

The beard-like appendage represents a woman's lip plug; the dorsal ornament may be derived from the human vertebrae. This and the preceding figure are amongst the finest examples of more recent Dogon style.

DOGON

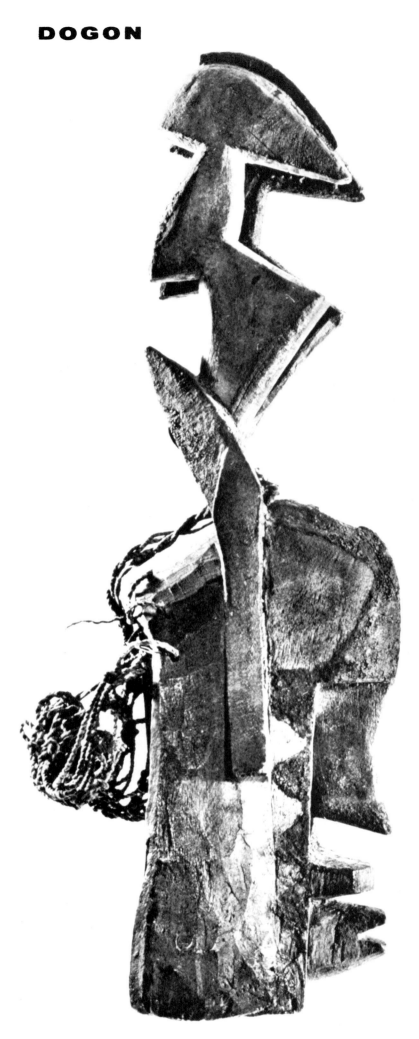

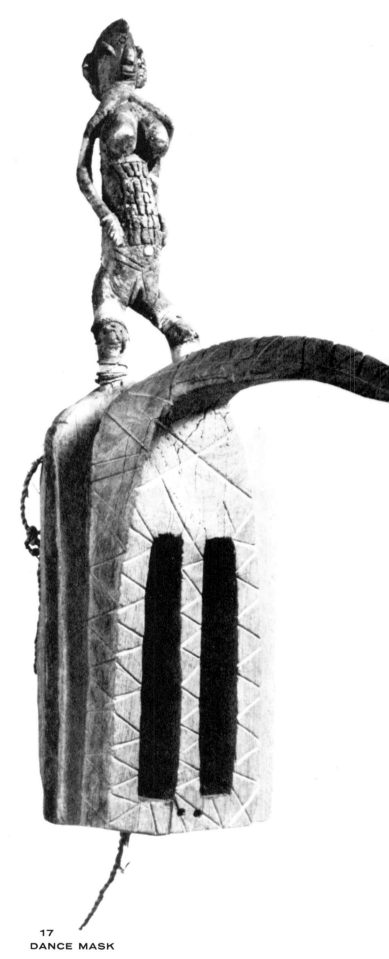

17
DANCE MASK

This hornbill mask culminates in a figure of a
standing woman. Each type of mask has its own
name and special song and dance. The masked rites
are largely expiatory and apotropaic.

16
DANCE MASK

The mask is surmounted by what appears to be a
pair of stylized birds. Dogon masks are used mainly
in rites which are intended to expel the souls of
the recently dead.

18
DANCE MASK

This is walu, a large antelope, one of the best-
known characters at funeral plays, and also connected
with agricultural rites. The influence of Dogon
architecture is evident in this and the preceding
mask.

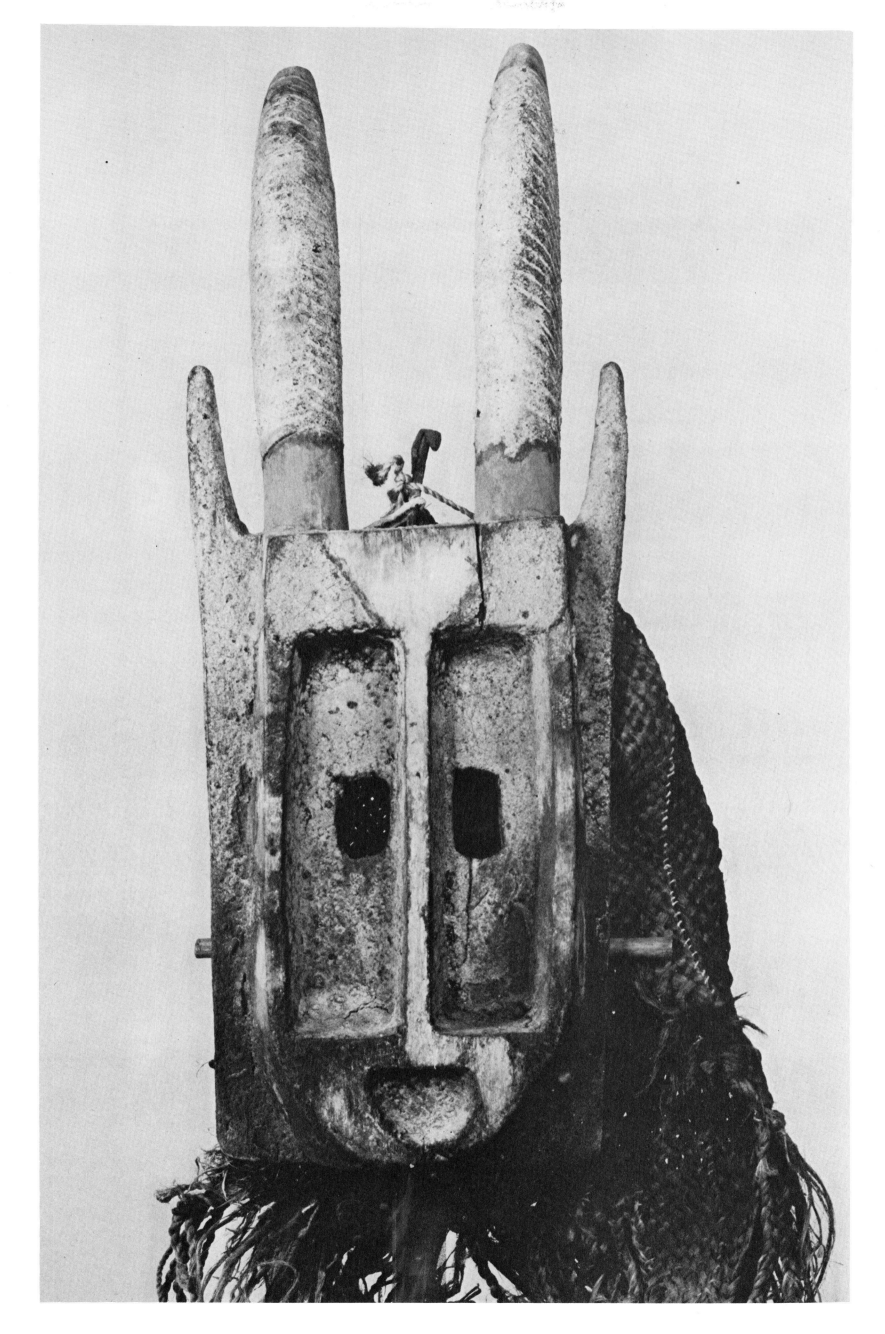

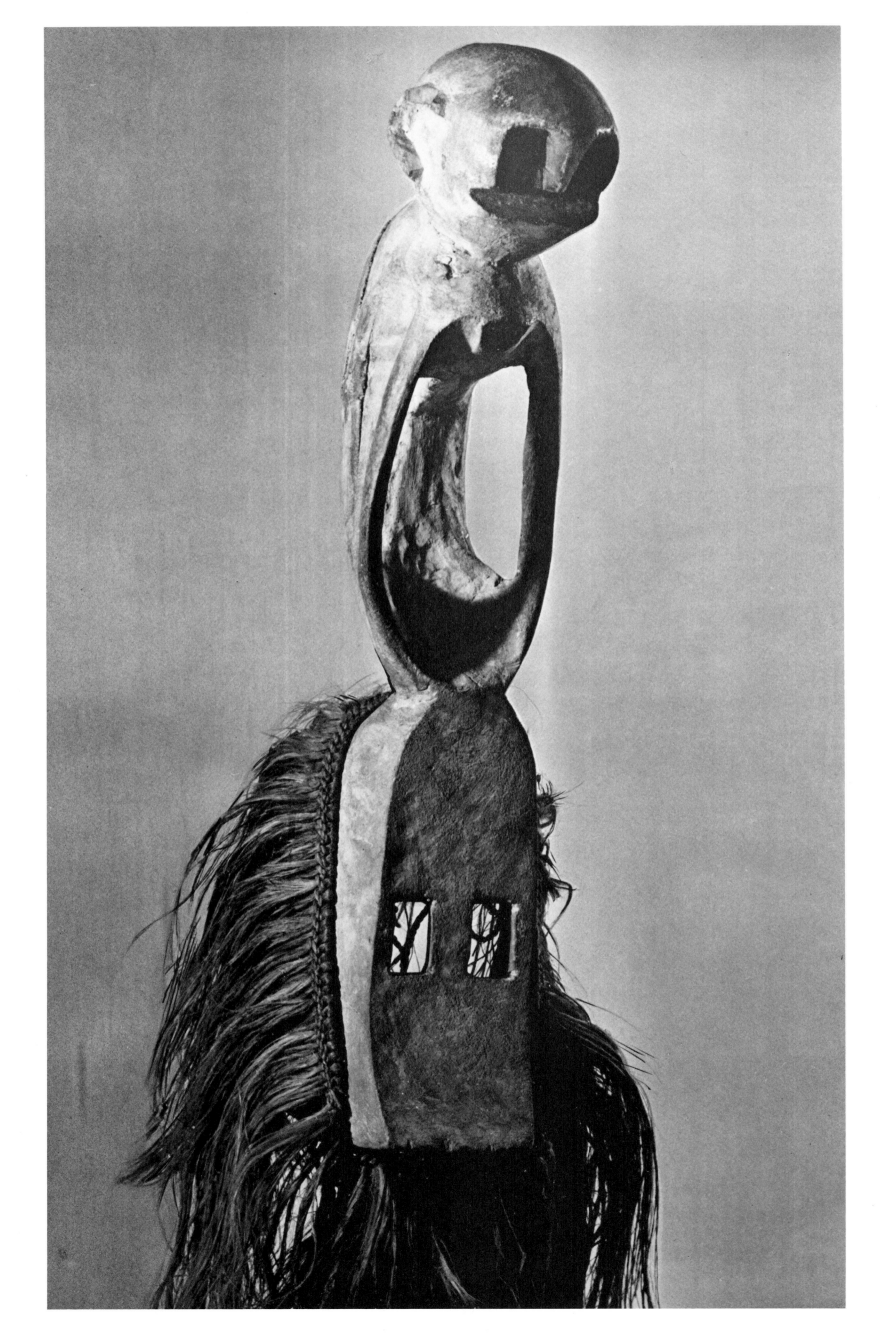

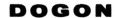

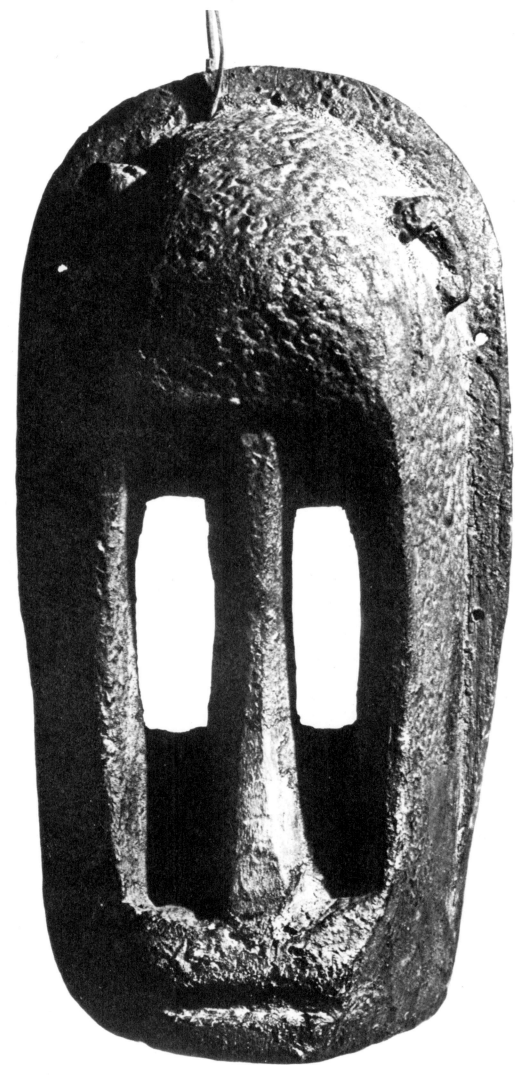

19
DANCE MASK

This is the white monkey, who plays a clownish part in the dances. The mask cult, though primarily ritual, also exercises an important measure of social control.

20
DANCE MASK

The iron ring in the crown of this baboon mask protected the dancer against the life force of the tree from which it was carved. The masks are sacrificially anointed before use.

DOGON

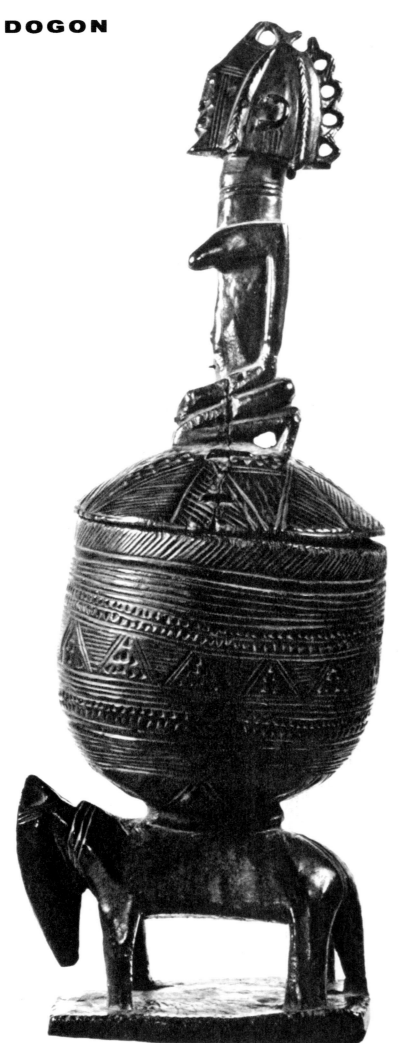

22
GRANARY DOOR

In the Western Sudan granaries are especially
charged with the mystical life force. Here the
tiered headgear may be insignia of the Hogon.

23
GRANARY DOOR

The human figures so often found on Dogon doors,
locks and other furniture of the priestly class are
ancestor images.

21
FOOD VESSEL

The Hogon, spiritual leaders of Dogon
communities, could eat only from such ritual
vessels as this.

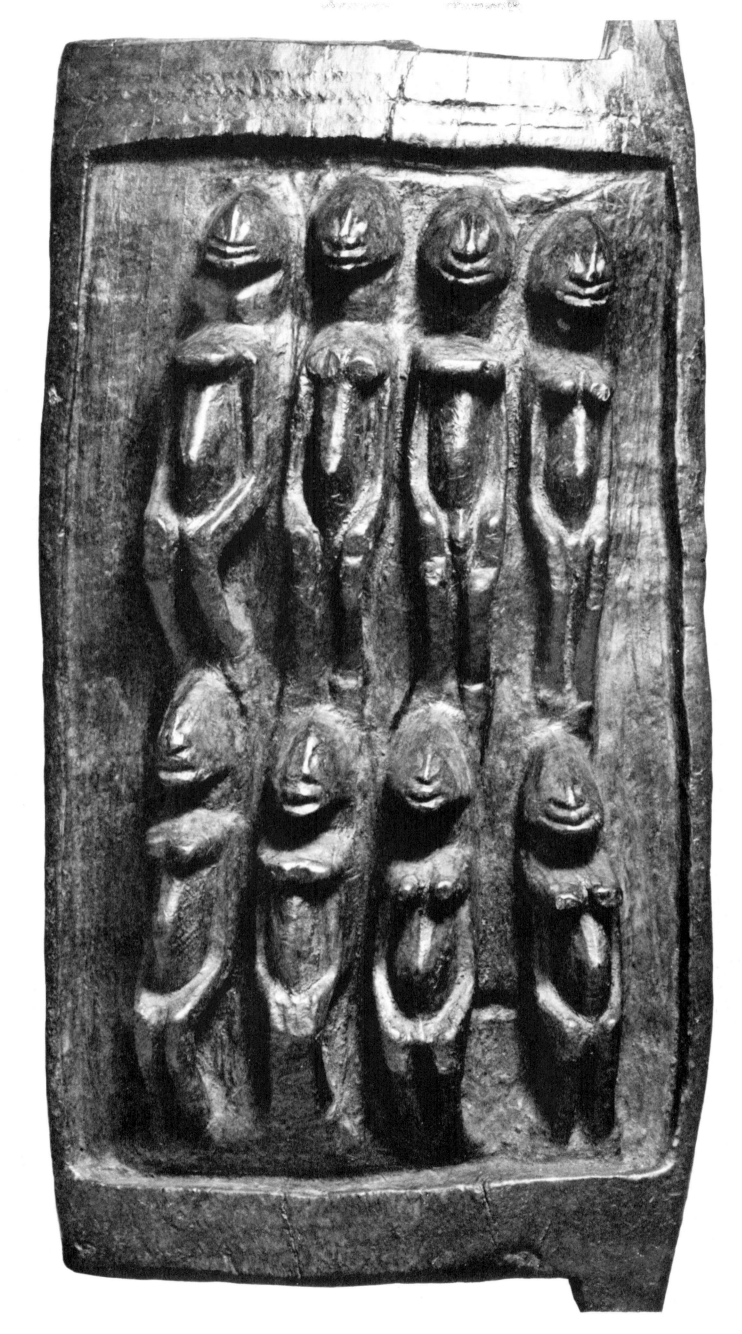

39

BAMBARA

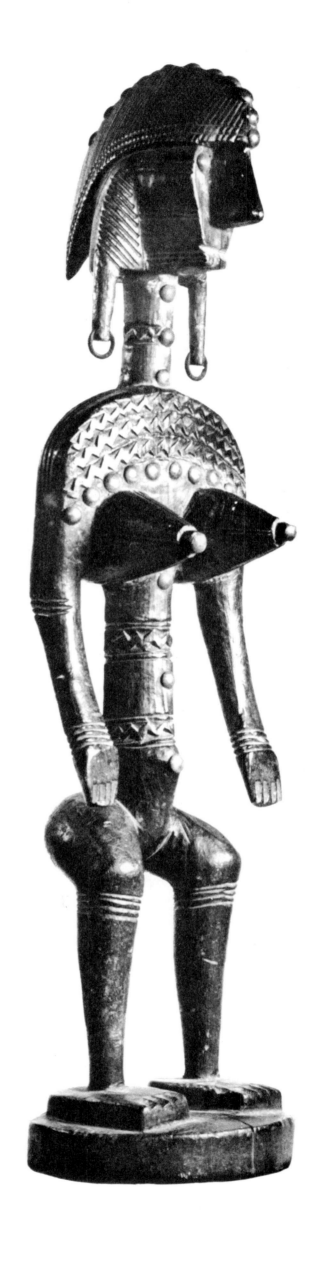

24
ANCESTOR FIGURE

Bambara figure sculpture is, if anything, even more 'abstract' than
that of the Dogon (among whom the elements of a composition tend
to be less dissociated). This figure is ascribed to the Bamako
district.

40

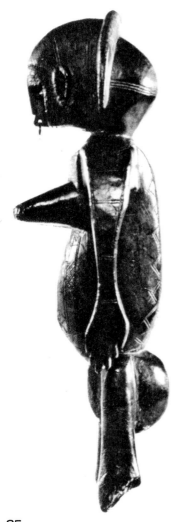

25
ANCESTOR FIGURE

This female figure, with legs broken off at
the knees, is unusually 'contrapuntal' in
character—severe cones and planes
balancing full-bodied spheroid forms.

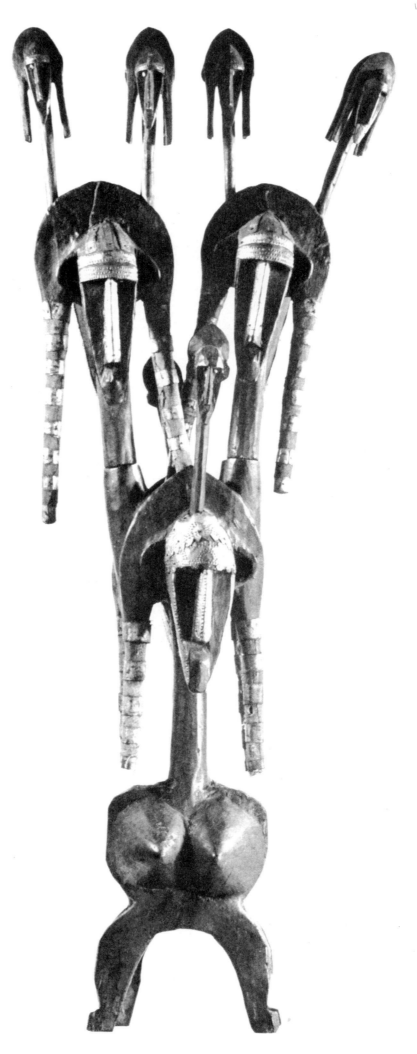

26
DANCE HEADDRESS

This remarkable creation was used in farming dances near
the town of San. The smaller heads recall the marionettes
which are a peculiarity of Bambara art.

BAMBARA

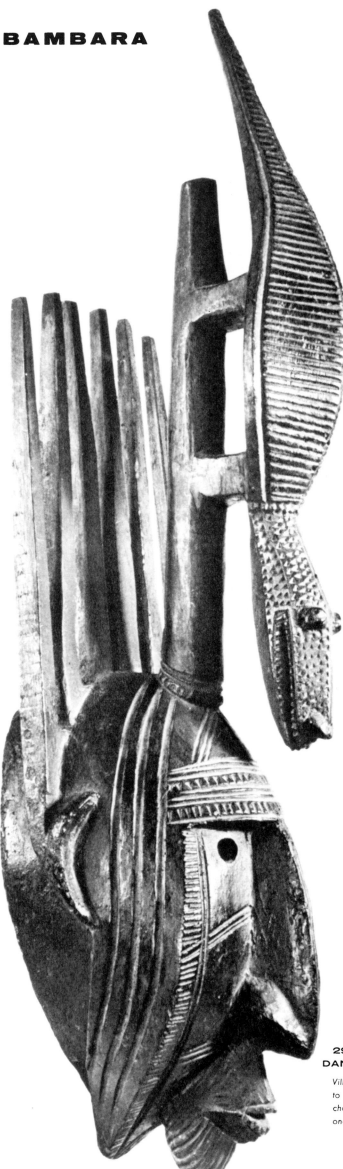

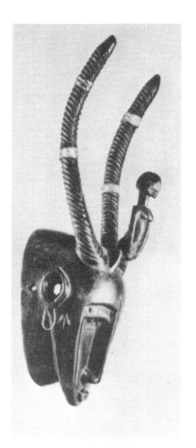

27
DANCE MASK

This human-antelope mask, surmounted by a kneeling female figure, was found near Kenedugu in eastern Bambaraland.

28
DANCE MASK

Works in this ascetic style are generally ascribed to the Marka, who may be regarded for purposes of art as a Bambara group.

29
DANCE MASK

Village children, before circumcision, belonged to the Ntomo society, and one of them was chosen to wear a many-horned mask such as this one surmounted by a crocodile.

42

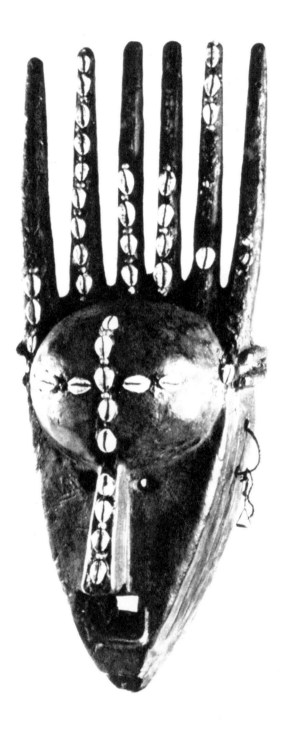

30
DANCE MASK

Ntomo masks of this simple (and possibly earlier) type
were commonly ornamented with cowrie shells,
sometimes all over.

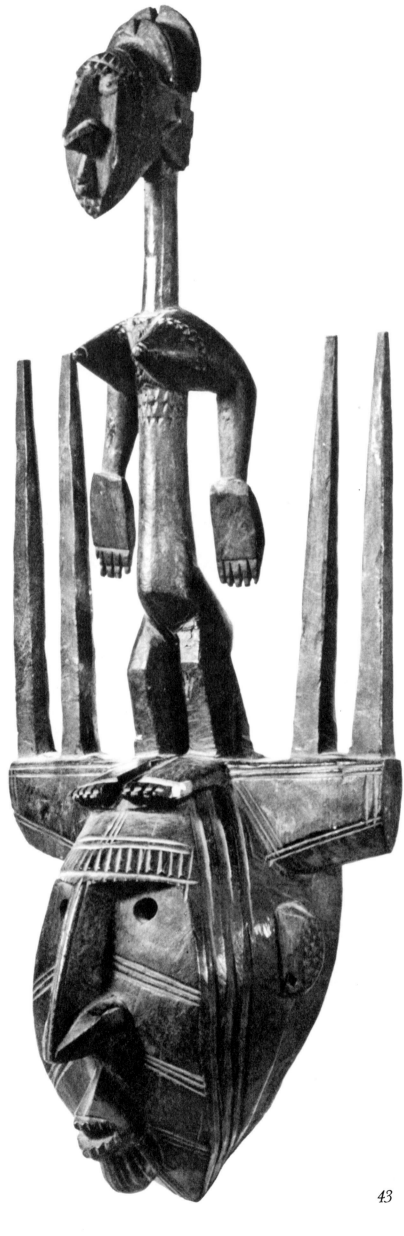

31
DANCE MASK

This Ntomo mask, like fig. 29, is in the Segu
sub-style. The female figure is of identical style with
certain separately carved statues.

32
DANCE HEADDRESS

A Bambara myth tells of a half-human being, Chi wara, who taught the tribe to cultivate grain. Antelope figures commemorating him and worn in plays following hoeing contests, are illustrated in great variety on this and the following pages.

33
DANCE HEADDRESS

This style conceives the antelope within an imaginary vertical cylinder. All these headdresses were attached to basketwork caps, worn in the mythological plays by the best farm workers of the young men's society.

34
DANCE HEADDRESS

In the Segu sub-style the roan antelope is represented with an elaborate openwork mane.

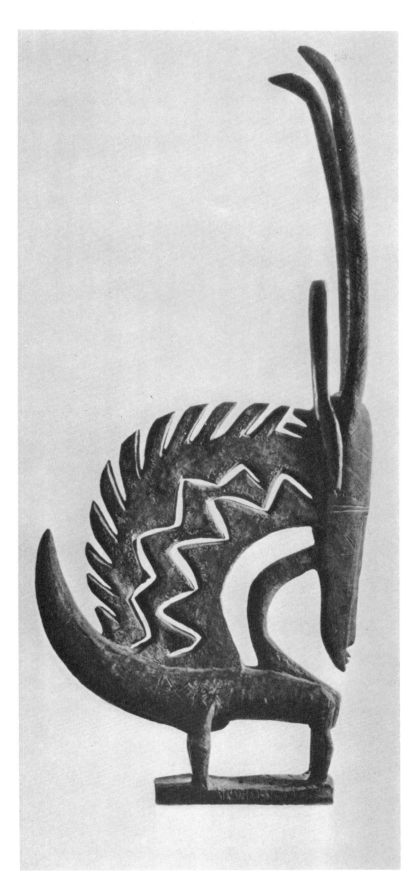

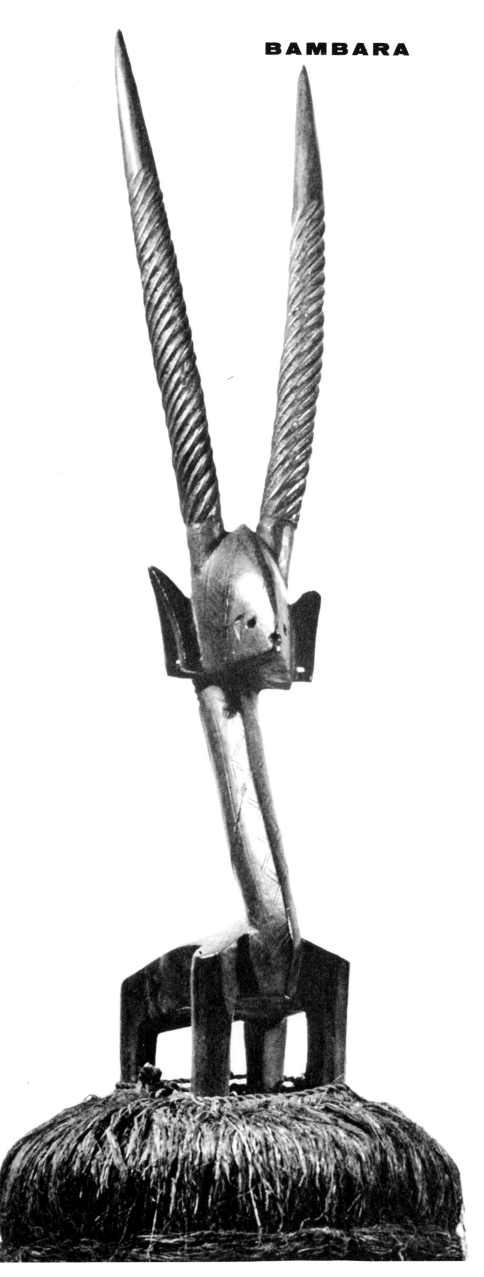

BAMBARA

35
DANCE HEADDRESS

Here again the composition consists of a radial design based
on fantastic exaggeration of the roan buck's mane. Even
more than most African masks, these are not seen at their
best except when in motion in the dance.

36
DANCE HEADDRESS

Chi wara dancers move in a crouching
posture, carrying staffs to help push
themselves upward in antelope-like bounds.

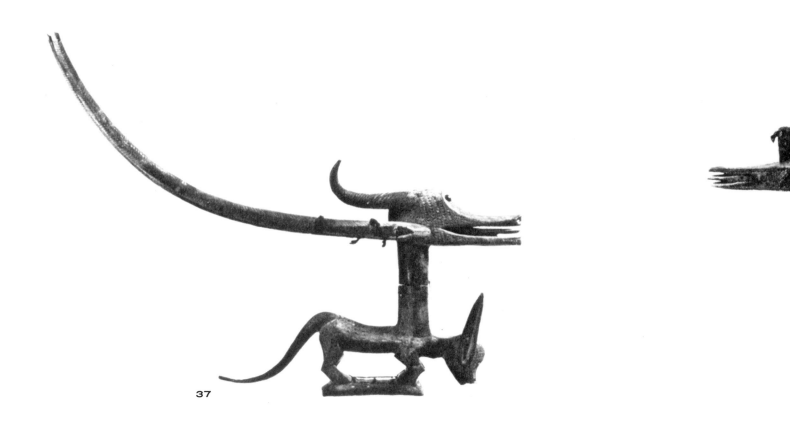

37

38

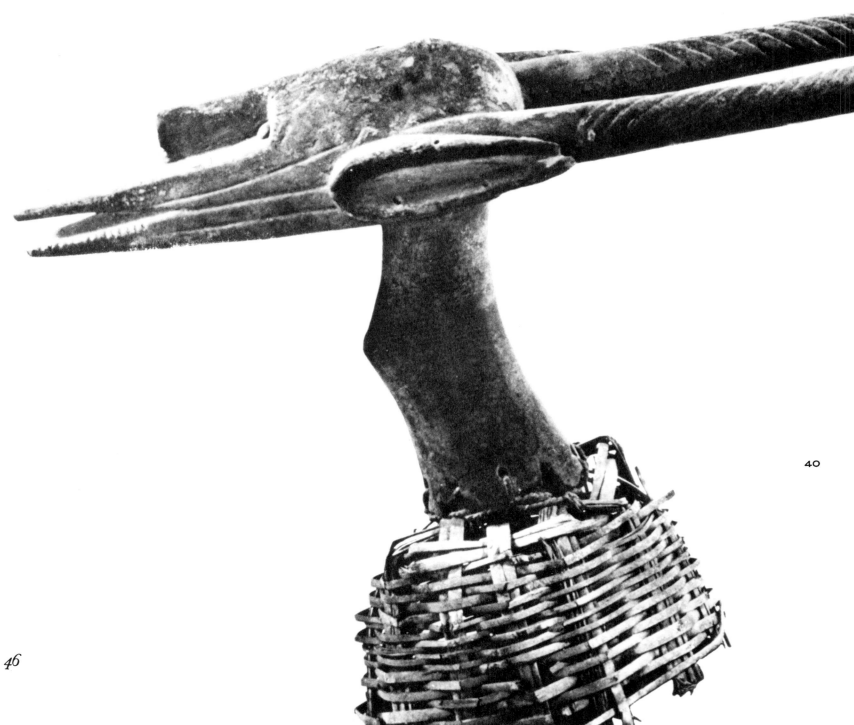

46

40

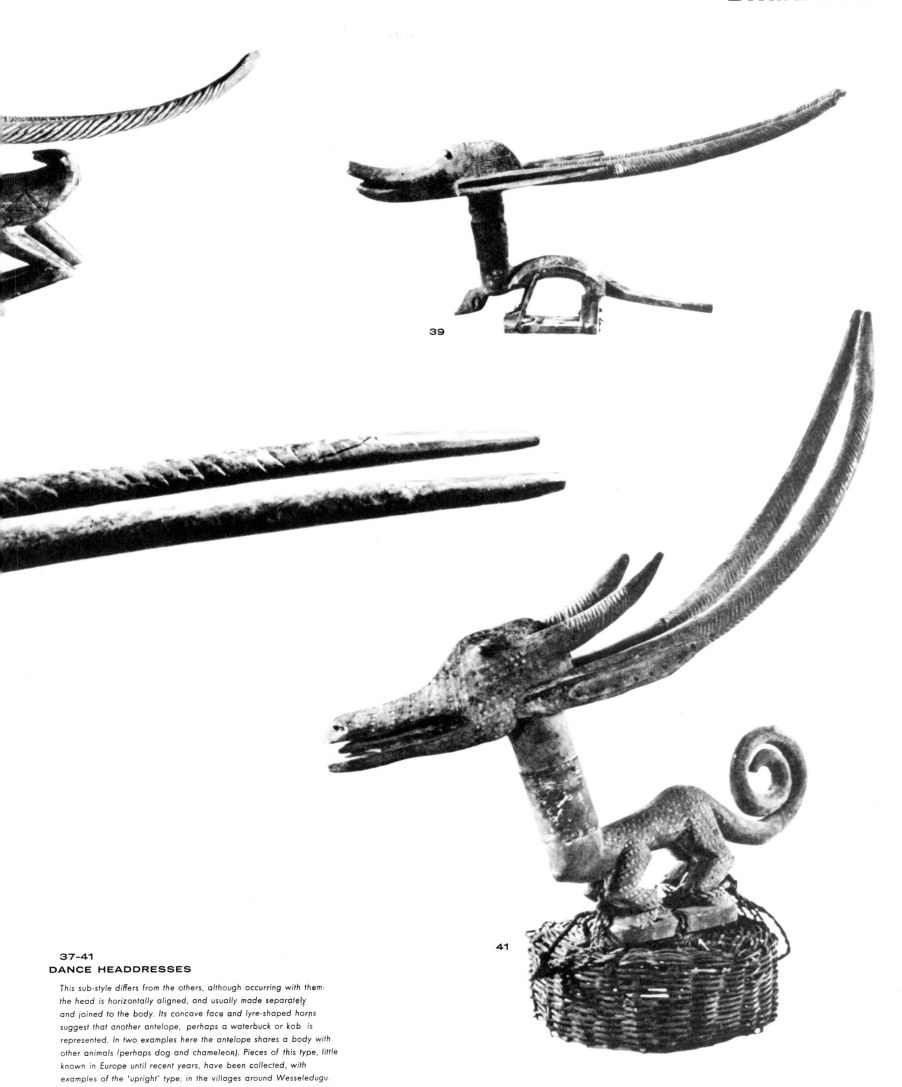

39

41

37-41
DANCE HEADDRESSES

*This sub-style differs from the others, although occurring with them:
the head is horizontally aligned, and usually made separately
and joined to the body. Its concave face and lyre-shaped horns
suggest that another antelope, perhaps a waterbuck or kob is
represented. In two examples here the antelope shares a body with
other animals (perhaps dog and chameleon). Pieces of this type, little
known in Europe until recent years, have been collected, with
examples of the 'upright' type, in the villages around Wesseledugu.*

BAMBARA

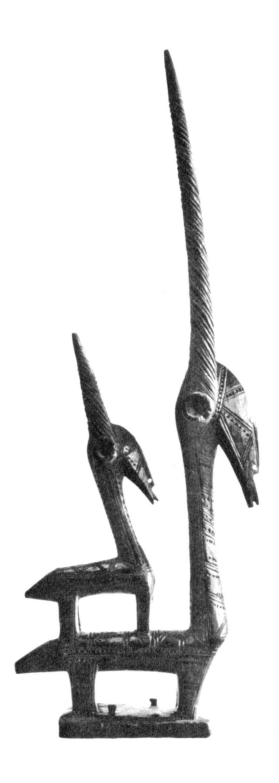

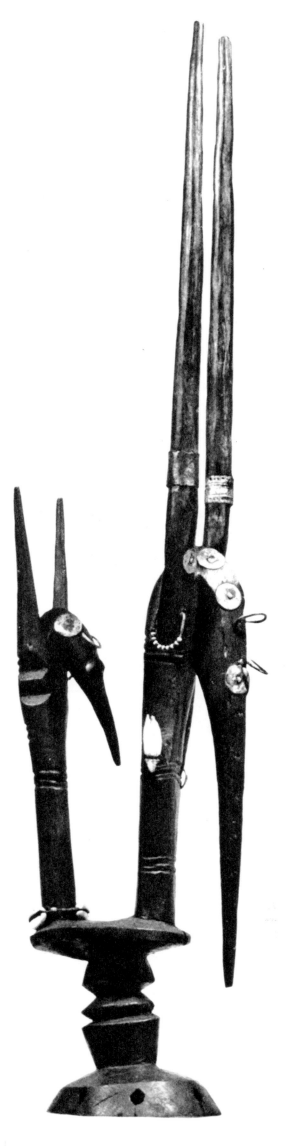

42
DANCE HEADDRESS

*Straight horns, and a fawn perched upon the hindquarters,
distinguish the female roan antelopes carved in the Segu sub-style.
In this area the Chi wara dance was usually performed with a
male and a female figure.*

43
DANCE HEADDRESS

*In this version, formalization of the antelopes has
been carried to extreme lengths, especially in the
pedestal which replaces the body.*

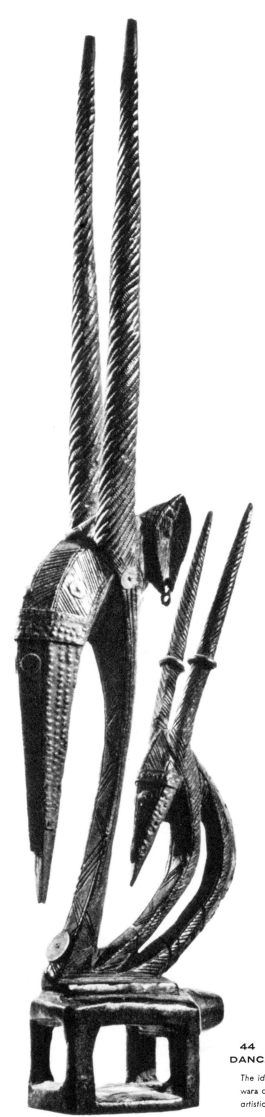

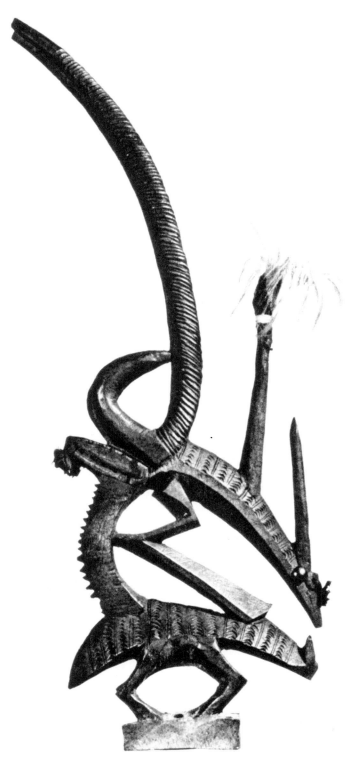

45
DANCE HEADDRESS

*In the Buguni sub-style of west-central Bambaraland
the antelope form (or forms) becomes a geometrical
design of fantastic and involved proliferation,
sometimes with other animal and human additions.*

44
DANCE HEADDRESS

*The idea of increase, which underlies all these Chi
wara carvings, is here perhaps translated into
artistic form with especial subtlety.*

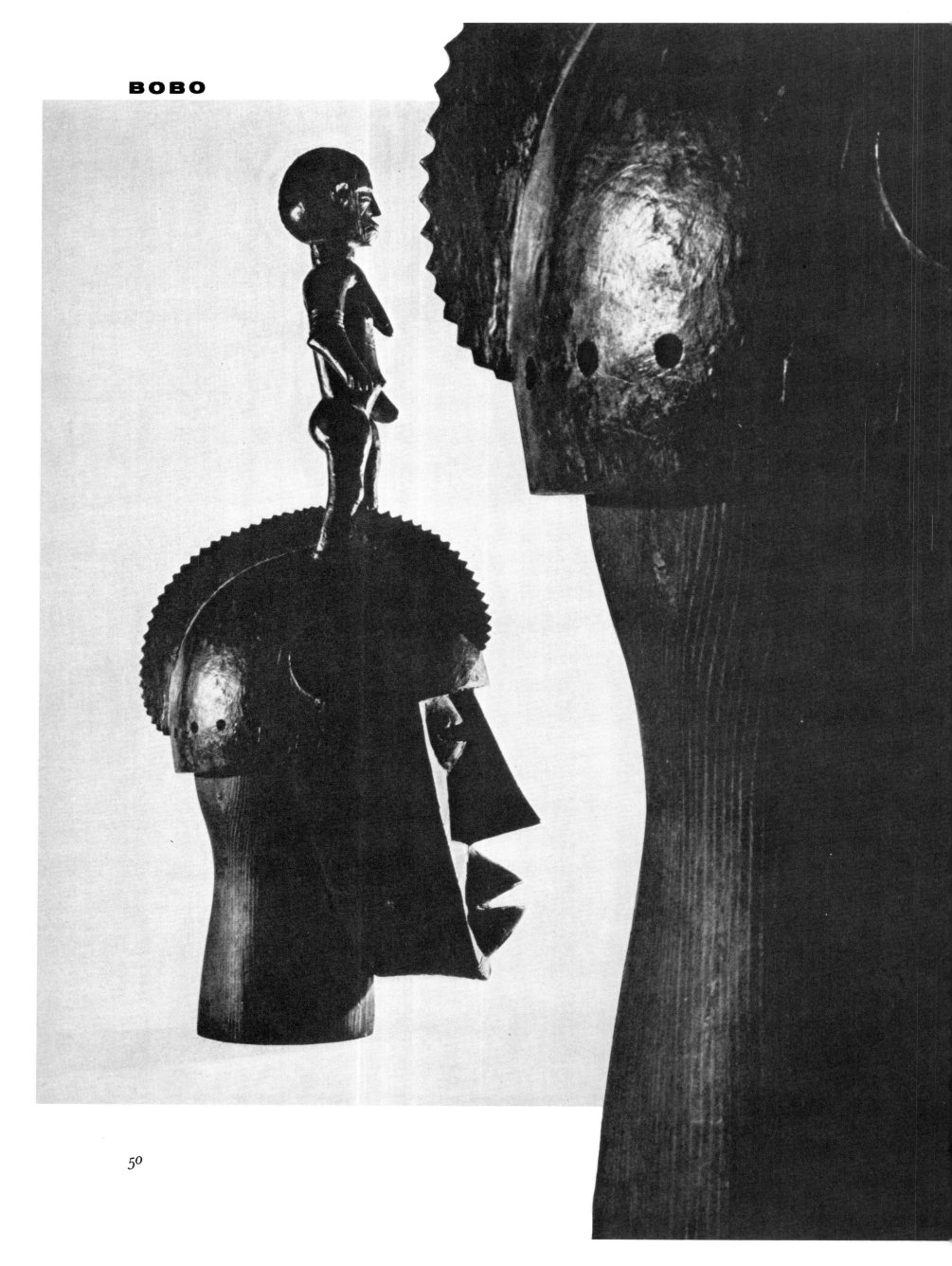

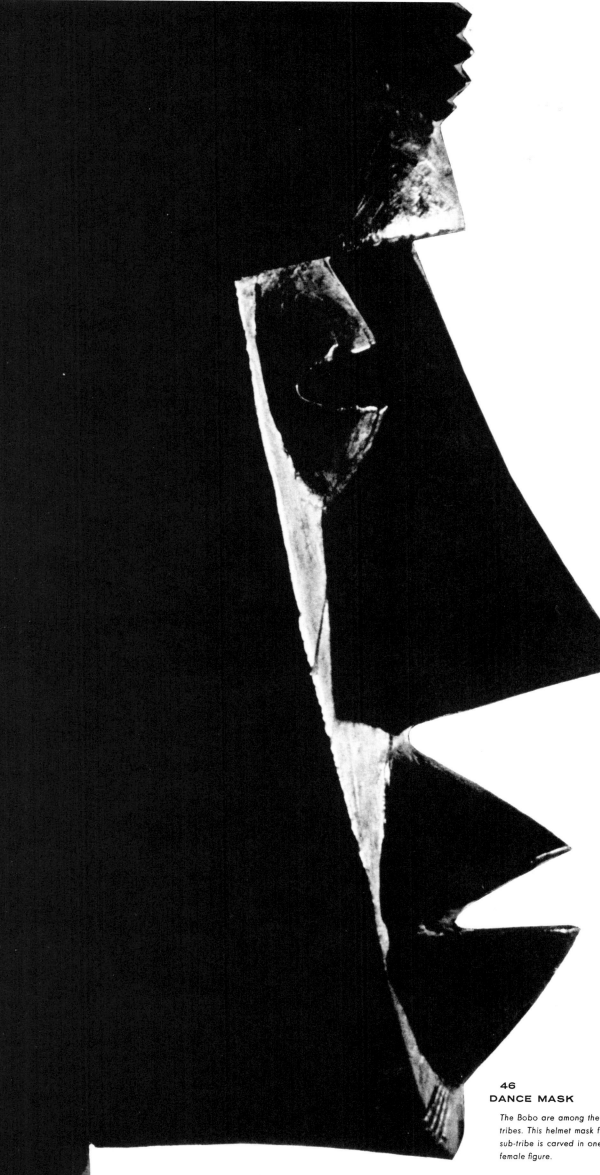

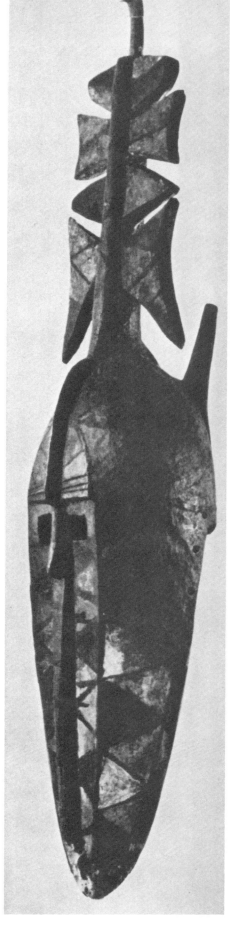

47
DANCE MASK

*This mask from Bobo-Diulasso exemplifies
Dogon and Mossi influence in Bobo art.
It was used in agricultural rites.*

46
DANCE MASK

*The Bobo are among the more primitive Sudanese
tribes. This helmet mask from the Bobo-Fing
sub-tribe is carved in one piece with the surmounting
female figure.*

51

BOBO

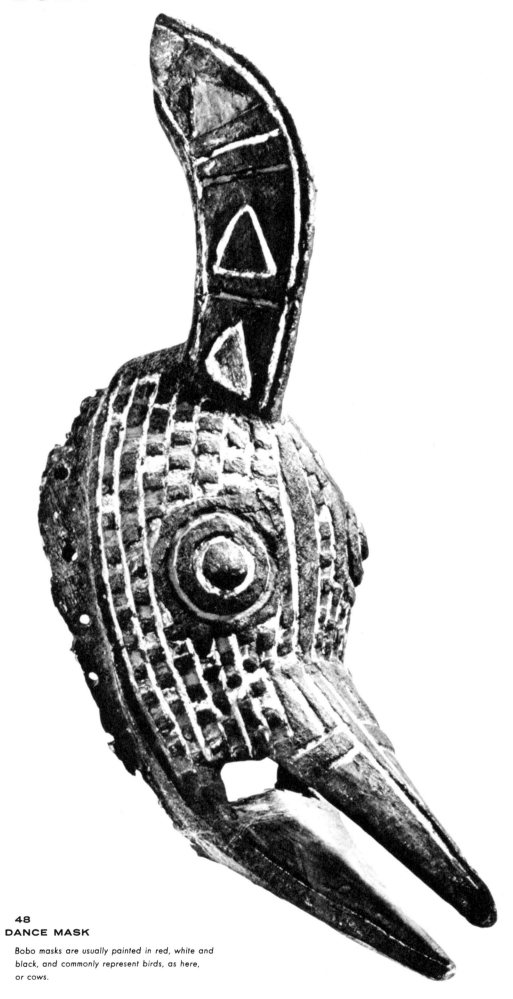

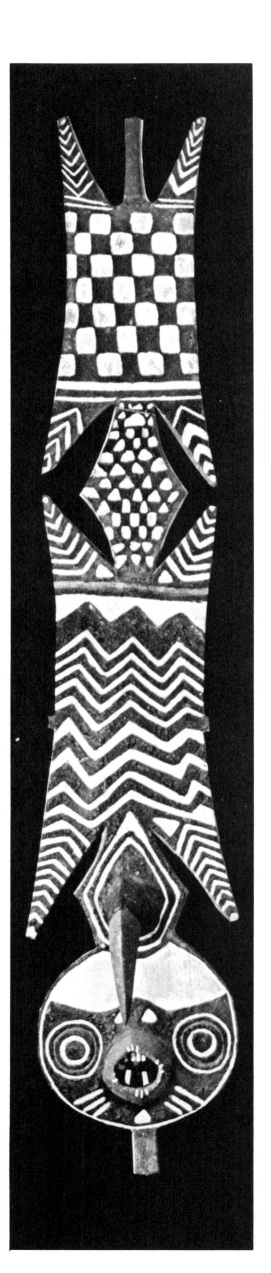

48
DANCE MASK

Bobo masks are usually painted in red, white and
black, and commonly represent birds, as here,
or cows.

49
DANCE MASK

These great masks (again suggesting Mossi-Dogon
influence) are worn in groups in farming rituals.
The geometrical designs are said to be heraldic.

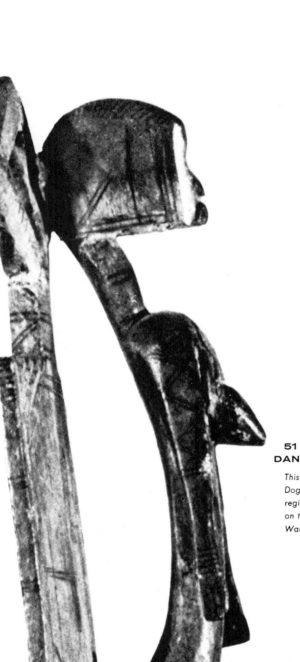

51
DANCE MASK

This type of mask is related to the tall masks of the
Dogon and Bobo; this one, collected in the Yatenga
region, is unusual in having a human figure carved
on the superstructure. These masks belong to the
Wango society.

50
DANCE HEADDRESS

Headdresses such as this, in the form of small
wooden caps from which rise human and animal
heads, though sometimes attributed to the Bobo, may
belong rather to the Mossi, or to the Gurunsi.

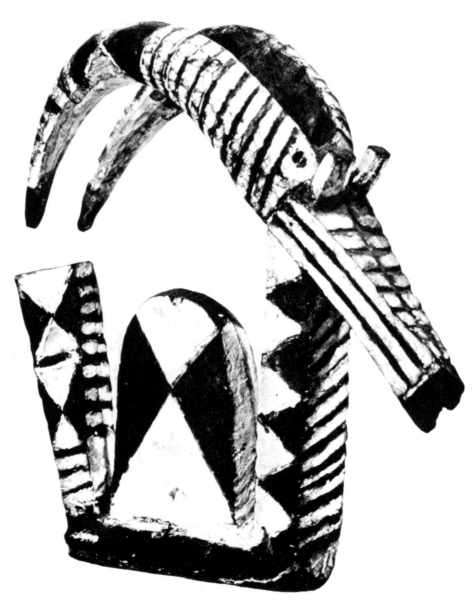

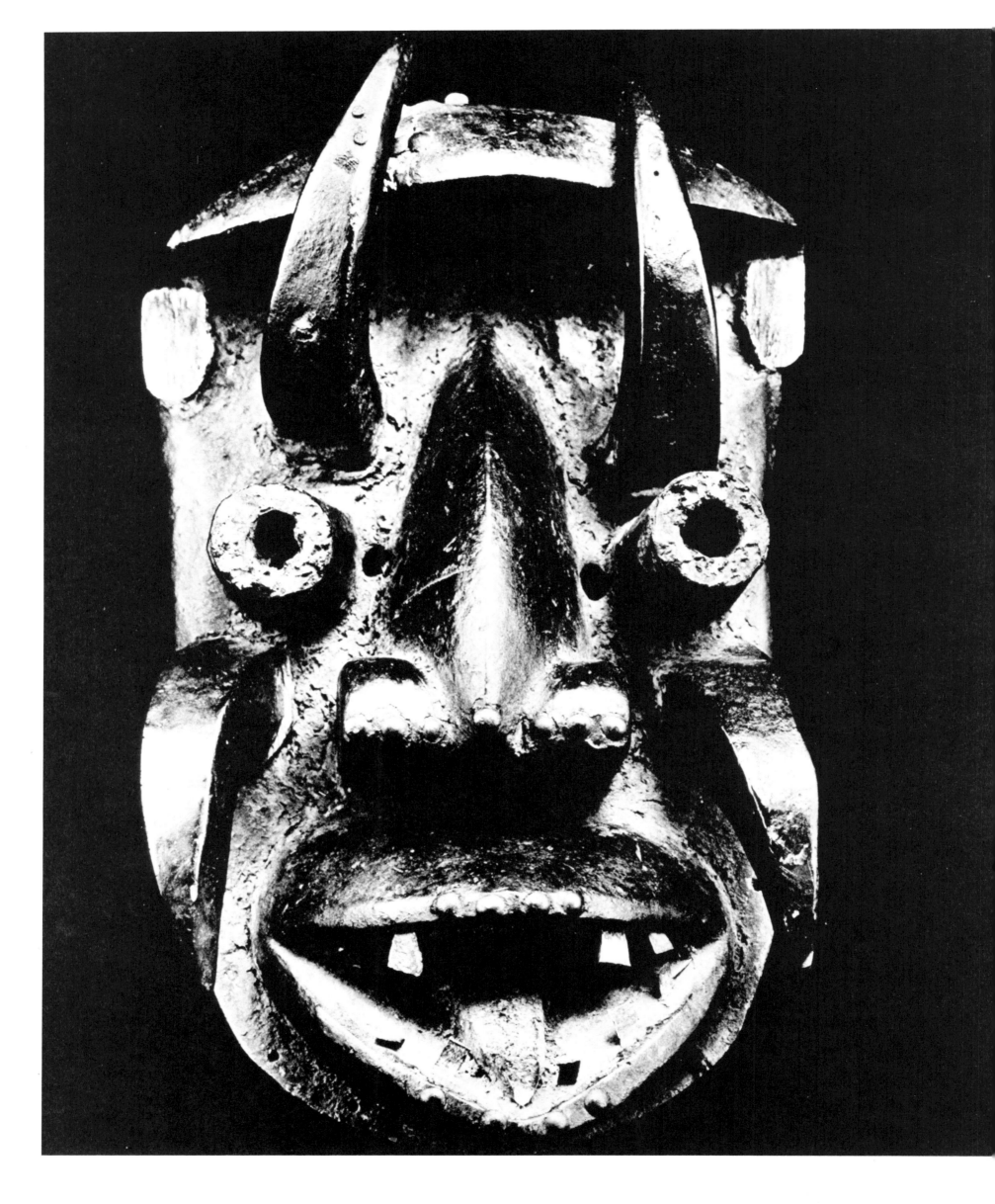

54

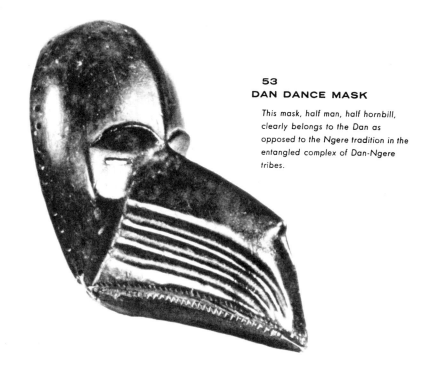

53
DAN DANCE MASK

This mask, half man, half hornbill, clearly belongs to the Dan as opposed to the Ngere tradition in the entangled complex of Dan-Ngere tribes.

The
GUINEA
Coast

The Guinea Coast is, for the purposes of this book, all that part of West Africa between the Sahara and the middle Cameroons which is not included in the Sudan, as above defined. It therefore includes the following territories, beginning from the westernmost point of Africa at Dakar: Senegal and the Gambia (which, however, produce little or no sculpture); Portuguese Guinea with the Bissagos Islands; all but the inmost areas of French Guinea; all of Sierra Leone and Liberia; all but the northernmost areas of the Ivory Coast, Ghana, Togoland (British and French) and Dahomey; the whole of Southern Nigeria with some adjacent areas of Northern Nigeria; the British Cameroons and that part of the French Cameroons within about 250 miles of the coast and bounded on the south by the Sanga or Sanaga River (chosen to divide the Guinea Coast from the Congo art region because it happens to pass through an area from which little or no sculpture is recorded and which seems to form a kind of stylistic watershed). This coastal belt corresponds roughly with the area of greatest rainfall, is generally low-lying and fertile, and with rare exceptions is inhabited by the true or Sudanese Negroes (as distinct—although the distinction is far from absolute—from the Bantu peoples who occupy the Congo region). Although this region includes quite considerable areas of downland or savannah, it exhibits a notable degree of geological and ecological unity, its fertility being perhaps in part due to the immemorial process of erosion by which the many rivers have carried the red soil from the inland regions to the coast.

Although an attempt is made here to define three main regions into which the art-producing area of Africa can be divided, it must always be remembered that these are only abstractions drawn up for our convenience and do not correspond with any essential or precisely marked differences in culture or art. There are no Rubicons over which we may cross and say 'Here we pass from the art of Guinea to the art of the Sudan'. It is probably true to say that more artistic variation exists within each of our three areas than could be found between what we may call their three type styles—which would in fact be meaningless abstractions if they could be arrived at at all, though their existence is constantly implied in the more airy writings on African art. In some ways it would no doubt be preferable not to attempt to group the tribes under separate regional headings, but simply to place them in one continuous geographical series. But the tripartite division has certain advantages in making the material more manageable and facilitating the grouping of tribes with their more important neighbours, provided that it is clearly understood and remembered that

52
NGERE DANCE MASK

This mask, carved with six horns or tusks (of which two are lost) probably represents a warthog. The tubular projections are probably cheekbones or warts, rather than eyes.

convenience rather than theory has been the determining factor.

Of all our three great regions, the Guinea Coast is undoubtedly the most varied in art. This may be partly because it includes more tribes and a greater population (more than thirty million in Nigeria alone) than our other regions, and partly because they are distributed along a long and slender coastal belt rather than in a compact mass, like the few art-producing tribes of the Sudan or the very numerous tribes of the French, Belgian and Portuguese Congo. The extremes of naturalism and abstraction are to be found within the area, often within a few miles of each other (compare fig. 80 with fig. 81, and fig. 175 or 187 with fig. 191). So are the extremes of emphasis on sculptural form at the expense of surface (figs. 75, 177, 195) and on surface enhancement—by way of fine carving, purposeful patination, paint, or decorative relief—at the expense of form (figs. 70, 76, 123, 180), as well as those styles, not necessarily superior, in which form and surface are nicely balanced (figs. 68, 122, 192).

We have referred to the Sudan as a region in which

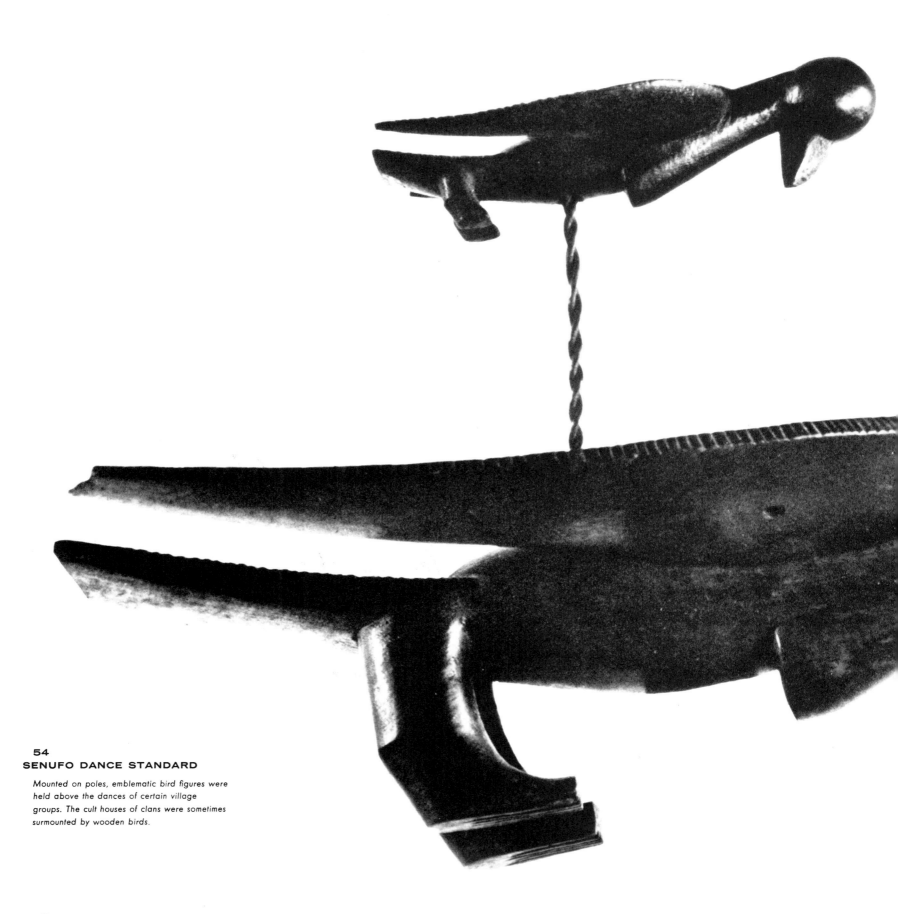

54
SENUFO DANCE STANDARD

Mounted on poles, emblematic bird figures were held above the dances of certain village groups. The cult houses of clans were sometimes surmounted by wooden birds.

recorded history has no more than indirect relevance to the study of tribal art; art history therefore finds little scope there, at least at the present time. On the Guinea Coast, however, and especially in Southern Nigeria and in neighbouring areas such as Dahomey and southern Ghana, we find not only that considerable written records exist of European dealings with the coastal tribes over the past five centuries (though these records but rarely concern themselves with the arts), but that some of the most important of the art-producing tribes themselves have historical traditions, orally transmitted

indeed, but often convincing enough after collation of variant versions. And it is probable that far more of such unwritten history remains to be collected and evaluated as competent scholars turn their hands to the work and governments come to an understanding of their responsibilities. At present we certainly do not have enough knowledge to attempt to construct a comprehensive history—and still less an art history—of the Guinea Coast. In most areas we have only an occasional suggestive hint of an interesting historical problem which may or may not some day yield its solution to research. Writers on African art have mostly been content with unrestricted speculation on these matters instead of seeking to build up a systematic method of collecting and interpreting historical and archaeological evidence. Only in the Nigerian region is enough material becoming available for the formation of hopeful hypotheses on a fairly large scale, and even there the speculative element is still dangerously large, and must be recognized as such.

Such caution may seem surprising to some, seeing that many European museums are prepared to date their Benin antiquities unequivocally as 'sixteenth century' or 'late classical period (1591–1675)'. Such false certitude —which has for half a century been the main stumbling block in the way of the development of a genuine African art history—must be swept boldly aside if we are to erect, from what we know of Benin history and art, a sound framework to which we can relate the phenomena of the other cultures of Guinea. The great complex of error in which Benin studies have been for so long enmeshed is a signal warning of the dangers of an excess of authority and prestige in the world of scholarship. If the work in this field of that doyen of German ethnologists, the late Professor F. von Luschan, could be regarded simply as a descriptive and illustrated catalogue of known Benin antiquities, then he would have deserved our gratitude for a meritorious, if by its nature somewhat pedestrian, compilation which needed to be made if the vast mass of material was to be organized and interpreted in a systematic way. But in fact he went far beyond this, and, ignoring some of the elementary rules of scientific method, propounded an interpretation of the data which, though in essence deductive and based largely on his own unsupported conjectures, was represented as definitive and put forward with the full weight of his authority. The intuitive character of his reconstruction was not in itself reprehensible, for there was need of an inspired guesser at the time, though von Luschan was not qualified for the part. But in his work description and interpretation were so inextricably fused and the speculative element so well disguised that there is some excuse for the extent to which other scholars, less closely familiar with the great collections of Benin art, have been misled.

Von Luschan's view of Benin chronology—as well as the unqualified respect paid to him by other German scholars—is perhaps most easily seen in the long article by his disciple, Professor Bernhard Struck, on 'Die Chronologie der Benin-Altertümer' in *Zeitschrift für Ethnologie*, Vol. 55 (1923), where specific dates are allotted on the master's authority to each type and variety of antiquity. It is possible from the internal evidence alone, and still more readily from evidence which can still be collected at Benin, to demonstrate that

55
BAULE DANCE MASK

In this was performed, accompanied only by rattles, the goli dance to avert misfortune. The dancers, concealed by shredded flounces, lashed with rods at themselves and their audience.

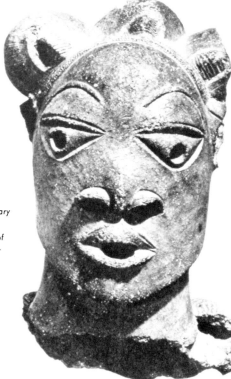

56
ASHANTI WEIGHT

This piece for weighing gold dust may perhaps allude to the folk proverb, 'Hunger is felt by a slave and hunger is felt by a king.' Professional story-tellers sometimes illustrated their narratives with such weights.

57
NOK HEAD FROM A FIGURE

The Nok or Ancient Benue Valley culture of Nigeria was contemporary with the introduction of iron, probably rather before the birth of Christ. Terracotta heads and other fragments of great variety are excavated deep in the tin mines.

most of these conjectural datings are without foundation. One major source of error lay in the fact that von Luschan treated everything found (or thought to have been found) at Benin as forming part of the Bini stylistic succession. He thus on the one hand sadly confused his picture of that succession and on the other blinded himself to the all-important links with neighbouring cultures; for, as was to be expected at the heart of a once great empire, a large number of the objects found there had been imported from vassal or friendly peoples or made there by foreigners (see, for example, figs. 158, 164, 173). Once these are distinguished, the Benin succession becomes much clearer and a number of minor mysteries are resolved. Further space cannot be given here to refutation of these entrenched errors, but it must be made clear that progress in Benin studies can be looked for only if a fresh start is made from verifiable unprejudiced collation of the material relics of old Benin and particularly from new field research among the Bini and other Edo-speaking peoples. Fortunately, work is already in train along both these lines, and the growing interest of Nigerians in their history is likely to ensure that it will be pursued with vigour, continuity and adequate resources.

If the art history of Guinea is, as we have implied, still at an embryonic stage, it is nevertheless possible to pass in review certain facts and reasonable hypotheses which may give the reader an impression of its eventual shape. First we may note that man has lived in West Africa, if not from the earliest human times, at least—what is not quite the same thing—from the earliest stages of human culture, that is, in the lower stone age; and a normal succession of stone-using cultures seems to have occurred, so far as we may judge from the far from copious archaeological evidence. It is not until the close of the stone age, in the siderolithic phase when iron had been newly introduced from the east or north but had not yet ousted stone tools and weapons, that we find the first evidence of sculpture. This appears in the Nok Culture (fig. 57), which seems to have flourished over a wide area in the middle Benue valley during the centuries just preceding the Christian era. It is difficult indeed to believe that this extraordinary terracotta statuary—demanding a very high level of technical skill, and rivalling modern Yoruba art in its imaginative sculptural diversity within a unitary tradition—can be the beginning of West African art; it is an accident of the geological process which has sealed it for us in association with the tin which is modern Nigeria's chief mineral asset. Although well preserved fossil trees have also been found in association with it (and have been dated to the period 900 B.C.–A.D. 200 by the carbon-14 method), we cannot say whether woodcarving was already practised, although we may think it highly probable. The use of copper and brass was almost certainly still unknown in West Africa, although the Nok people seem to have known how to cast tin in open moulds.

Unless the Nok Culture lasted much longer than we are at present entitled to assume, there follows a hiatus of a thousand years or more, leaving us with an open field for speculation on the genetic relationship, if any, between Nok and the humanistic art of Ife (figs. 67, 150–157), which remains the greatest problem in the art history of Negro Africa. A connection, direct or collateral,

is by no means to be ruled out: although the human heads of Nok and Ife present a considerable contrast— the first outstanding for imaginatively stylized and 'conceptual' treatment, the second with one or two important exceptions for an idealized naturalism otherwise found only in ancient and Renaissance Europe—, yet in the execution of bodies difference is much less well marked. Indeed, if the collections of terracotta fragments in the museums at Jos and at Ife were by some mischance to be mixed together, it would be extremely difficult to separate them all again by differences of style; but this kind of convergence—where in each case the bodies are somewhat simplified for what were probably artistic reasons—is certainly not decisive evidence of connection. There is some evidence from material culture to support the view that the Nok terracottas were the work of ancestors of some of the present inhabitants of the pagan belt of middle Nigeria where the relics are found—peoples whose primitive way of life does not seem at all like a degeneration from a 'higher', more intellectualized level of culture such as might have led to the humanism of Ife art. In this case, we could still regard Nok and Ife as collaterally deriving from a third ancient culture, and are encouraged to do so by the fact that, though only 300 miles apart, they are the only two places in Negro Africa where the considerable feat was performed of building and firing life-size statues in pottery.

The doubts which are expressed from time to time, and sometimes by responsible writers on art such as Leon Underwood, about the indigenous origin of the Ife style of sculpture are based upon the belief that so close an approximation to the style resulting from classical Greek mensurational techniques could not arise in West Africa except as the product of a philosophy of art developed over some centuries and following similar stages to that of ancient Greece—and that no such development could in fact have occurred within the context of the African way of life. We may note here that this view incorporates some of the errors of the two old-fashioned anthropological heresies of extreme diffusionism and extreme evolutionism—on the one hand, the doctrine that a trait (and especially one so advanced as naturalism in art) is never invented more than once, and on the other, the doctrine that like environments are necessary to produce like results. It is indeed possible that the *raisons d'être* of naturalism in Athens and in Ife were opposite: in Greece naturalism was a function of humanistic rationalism, of the downfall or at least the emasculation of the old high gods, of the reduction of religion to an intellectual exercise; in ancient Yorubaland, religion itself may have dictated the greatest possible naturalism of artistic treatment, as it seems to do even today at the Yoruba town of Owo, less than 100 miles from Ife. Here several observers have noted that the second and more elaborate burial of a chief is performed with a life-size, articulated and clothed wooden effigy of him, the essential being that the head and other exposed parts should be as life-like as possible. On the other hand, it can be argued, though it can hardly be established, that at the material time—perhaps about A.D. 1000–1200 —there had indeed developed in the ruling circles of some of the great Yoruba city-states, as in the city-states of Greece about the sixth century B.C., an atmosphere of

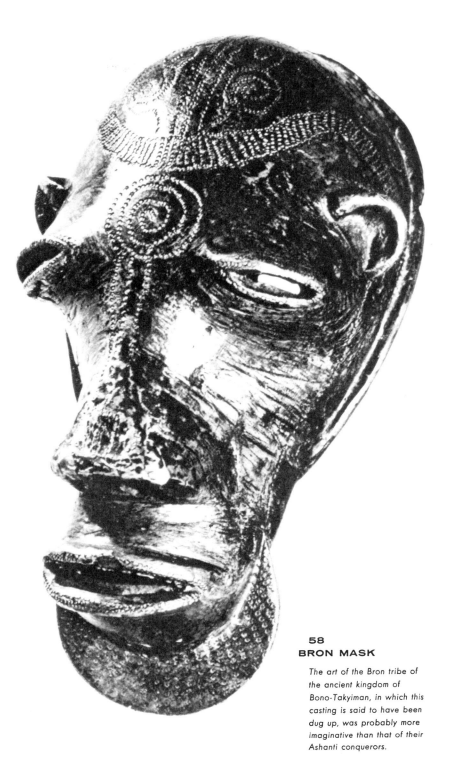

58
BRON MASK

The art of the Bron tribe of the ancient kingdom of Bono-Takyiman, in which this casting is said to have been dug up, was probably more imaginative than that of their Ashanti conquerors.

59
AGNI PENDANT

For certain rites tribal rulers and nobles adorned themselves heavily with symbolic pendants. Although usually considered Baule work, such castings often recall the pottery and woodcarving styles of the related Agni.

sophistication of thought and even perhaps of that cynical materialism which is found among priestly castes who have intellectually risen above the beliefs on the maintenance of which among the people in general their own livelihood and prestige depend.

Legends collected in recent times make it seem not unlikely, for example, that even in such early times Shango and the other great Yoruba gods, who must have begun as nature gods generalized in conception, some of them ambisexual or perhaps neutrisexual, were being anthropomorphized and provided with earthly life histories just as the Olympians were in Homeric Greece. Ifa, the principle of order and predictability, and Eshu, the uncertainty principle in Yoruba cosmology, seem to have been personalized, and Eshu's exploits are strikingly reminiscent of those of that other divine trickster, Hermes, in the Homeric Hymn. In legend, gods came to be regarded as deified heroes, a reversal of their actual development. Examples could be multiplied from the mythology of Ife and Oyo of curious similarities to the world of pre-Classical Greece, and although they are not substantial enough to amount to proof, they at least suggest a hypothesis of the existence in Yorubaland in early times of some of the intellectual or philosophical conditions pre-requisite for the development of naturalistic representation.

In the foregoing paragraphs two alternative and apparently opposed hypotheses have been noted concerning the origin of naturalism at Ife; a third may be added, namely that the first two are in fact reconcilable. Our purpose has not been, the reader will readily understand, to arrive at the truth—the time for that is not yet—but rather to make clear the latitude of interpretation which is open to us and to discourage the premature petrifaction of dogma.

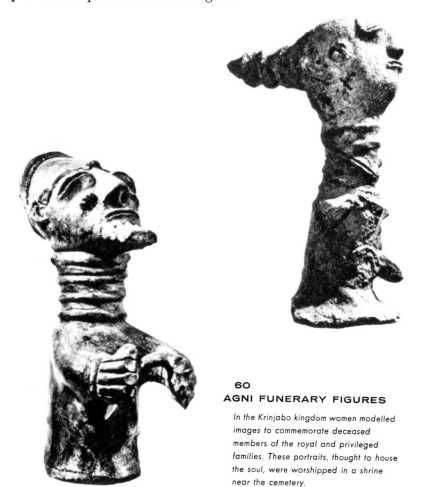

**60
AGNI FUNERARY FIGURES**

In the Krinjabo kingdom women modelled images to commemorate deceased members of the royal and privileged families. These portraits, thought to house the soul, were worshipped in a shrine near the cemetery.

We do not yet know enough about the ancient culture of Ife to be able to say whether the extant remains were all produced within a single generation or whether they were the work of two or three centuries—though the latter seems more likely. Since we cannot, on any internal or other evidence, arrange them in a chronological succession, we must confess that, for all that we can at present see, the whole *œuvre* of Ife belongs to a single point in time—and that of uncertain position. This is to say that of the Ife culture in itself no diachronic study seems as yet to be possible; and it may be that much archaeological drudgery, alike in the red laterite and decaying quartz of Ife and on the study table, must be gone through before this point can be stretched into a line.

It is otherwise when Ife art is considered in its relation to certain other of the relics of West African antiquity. From internal evidence we can by comparative studies seek to place them as points on a line in a relative time scale; still more conjecturally, we can use external evidence, chiefly in the form of oral tradition, to introduce an element of absolute chronology into this scale. Ife art is so strange a phenomenon in the West African context that its influence, or the absence of it, can be readily enough discerned in the surrounding areas of the east-central Guinea Coast.

It is in cast metalwork primarily (and to a less extent in the related terracotta sculpture) that we must seek the connections between Ife and other traditions. It is true that Ife was at the same time the most important centre of stone-working in western Africa. But it does not seem that the great monoliths of Oranmiyan and Ogun, centres of pilgrimage though they were, and the extraordinary quartz shrine furniture were imitated elsewhere; and with the more distant centres of stone-working in Sierra Leone (figs. 72, 73) and the Congo no comparison suggests itself. Near the little town of Esie, some fifty miles north-east of Ife, is a group of some 800 stone figures of undetermined date and tribal origin, but of all these one only, and that probably intrusive, bears any resemblance at all to Ife work.

We may here review briefly the incidence of brass-casting in the Guinea Coast, noting first that while all West African *cire perdue* casting may have had a single origin it is equally reasonable to postulate two or more points of departure: it may have been diffused from the North African coast as well as from the Upper Nile Valley. Even if it was brought solely from the east, it seems unlikely that only one tribe were the bearers; and we certainly have no grounds for interpreting the history of West African metal-casting in general as a progressive differentiation from the pristine naturalism of Ife. At the western and eastern ends of what we may call the 'lost-wax belt' are found brass industries which, at least in their non-figurative work, are remarkably similar and occasionally even indistinguishable in appearance. These belong, in the west, to the Dan-Ngere group of tribes of Liberia, French Guinea and the Ivory Coast and, in the east, to the Grassland tribes of the Cameroons. Their common characteristic is decorative motifs built up from threads of wax about one-sixteenth of an inch in thickness. Nearer the centre of the zone, among the Baule-Ashanti peoples to the west (figs. 137, 138) and the Ibo, Jukun, Tiv and other tribes of eastern Nigeria to the

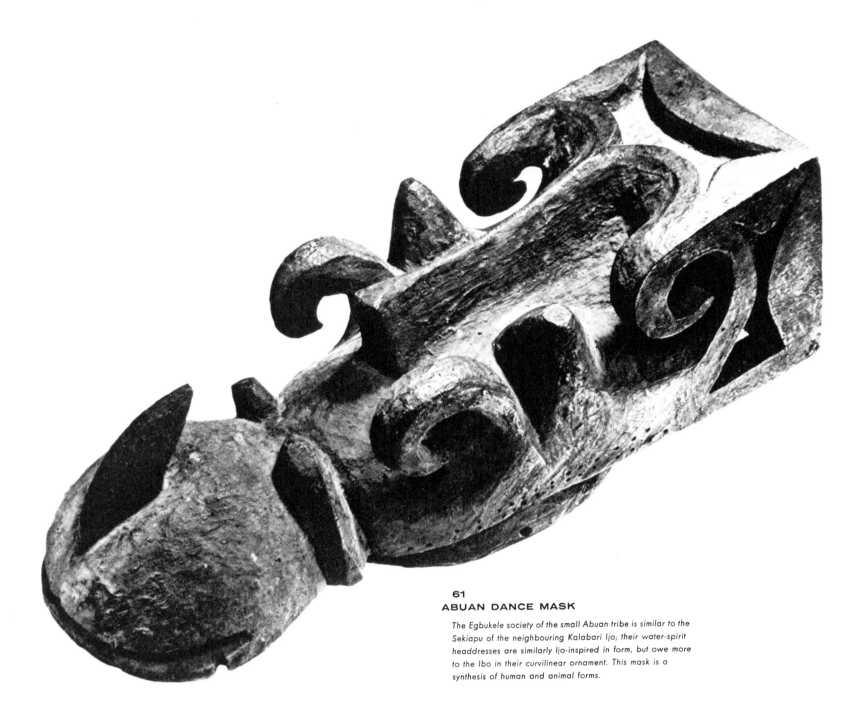

61
ABUAN DANCE MASK

*The Egbukele society of the small Abuan tribe is similar to the
Sekiapu of the neighbouring Kalabari Ijo; their water-spirit
headdresses are similarly Ijo-inspired in form, but owe more
to the Ibo in their curvilinear ornament. This mask is a
synthesis of human and animal forms.*

east, a narrower gauge—about a thirty-second of an
inch—is or was favoured; and at the centre, in Yoru-
baland and Benin, motifs of this kind are hardly present
at all, either in ancient or modern work. It is this central
group, practically confined to western Nigeria, with
which we are here chiefly concerned, since the several
styles seem to form a complex related whether by direct
or collateral descent to Ife. It is surrounded, moreover,
by metal industries which seem clearly to belong to other
families: on the east by the Ibo and other work, largely
decorative in character, which is best exemplified in the
hoard excavated between Igbo and Isuofia villages not
far from the Niger; on the north, by Igbira, Igala and
Gwari work, with links chiefly leading towards the
Benue Valley cultures, and by that of the Muslim Nupe,
whose penchant is for fine *repoussé* techniques; and on the
west, by the attenuated, almost skeletalized brass figures,
probably of no very long pedigree, of the Fon-speaking
people of Dahomey, and by the smaller goldweight
figures (see figs. 137, 138) and the cast ceremonial vessels
of the Ashanti beyond.

The brass-casting styles which we must now examine
in their historical relation to the art of Ife are then the
following: a small but highly important group of bronzes
(in two or more styles) reposing in the Nupe villages of
Tada and Jebba Gungu on the banks of the Middle

Niger; the copious output of the great imperial city of
Benin, not far from the creeks of the Niger Delta, and
certain other related or associated styles; and the brass-
work still, or till recently, in use, and here and there still
made, among the modern Yoruba, whose cultural
heritage may be thought to stem in part at least from Ife.

The first group includes what is perhaps the most
important and extraordinary of all West African metal
sculptures—the seated figure of Tada, to which small
and inaccessible village it is unfortunately confined
because of its function in maintaining the community's
fertility and wellbeing. This male figure of about two-
thirds life size is at once recognizable (though the features
are obscured and the hands and feet lost through
centuries of ceremonial scrubbing with sand and water)
as a piece in the authentic classical style of Ife. What sets
it apart, in an aesthetic sense, not only from all the other
antiquities of Ife but from African sculpture in general,
with only rare and partial exceptions, is its remarkable
freedom and relaxation of posture, its emancipation,
worthy of a Myron, from the rigid symmetry which
frames the African concept of sculpture. It may be that
the rigidity and the symmetry were prerequisites of the
sculptural achievements of the Africans (as of most tribal
sculptors); but the sculptor of this piece achieved a
different sort of greatness, and this shows us, as nothing

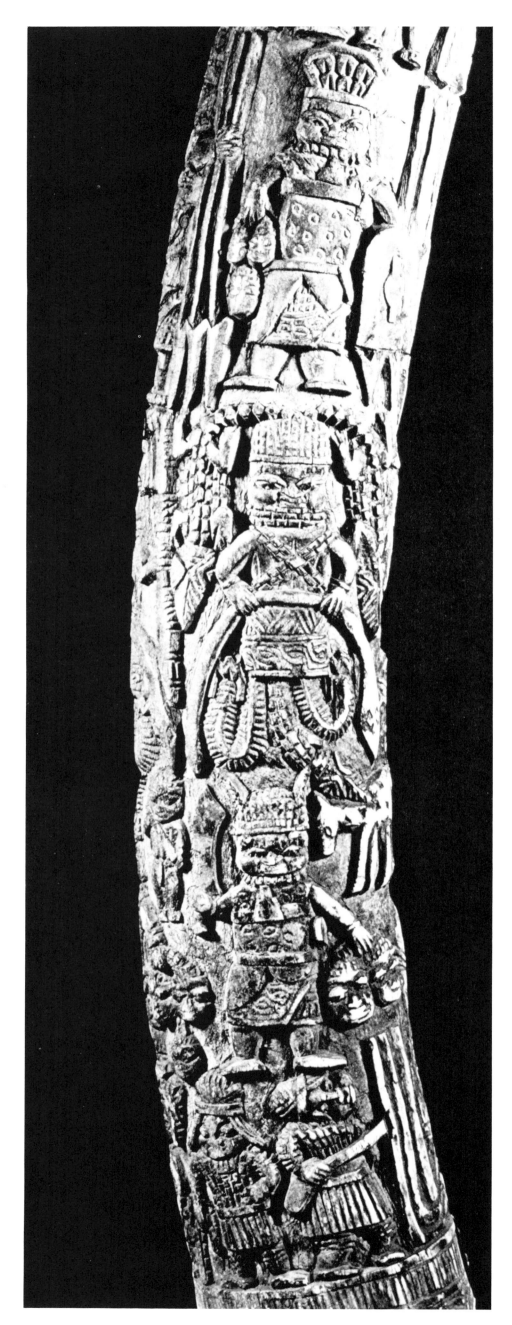

yet found at Ife itself shows, how great was the revolution of thought that must have taken place there among the artists and their chiefly patrons before such realism and humanism could become acceptable. The large standing male figure and several lesser figures at Tada and the large standing male and female figures at Jebba have no such special aesthetic interest, being conformable to African aesthetic convention, although quite unequalled for size (in the case of the three largest) among African bronzes. They are, however, deeply interesting from the point of view of art history because they do not readily attach themselves to the Ife tradition, but seem rather to belong to an as yet unidentified group showing greater affinity to Benin than to Ife. It is at least possible that they represent the style of the large town of Idah on the Niger, capital of the Igala tribe, which seems to have been a rival of Benin long before the war of 1515–16. Such indeed is the traditional evidence, which tells us that the great Nupe kingdom was founded in the middle fifteenth century by the culture hero Tsoede or Edegi, a king (Ata) of Idah who was driven from his throne and fled up the Niger, abandoning these bronze treasures at towns on the way.

It is at Benin that we can best discern the aftermath of the Ife school of sculpture; but to do so we must first consider Benin in its own right. The Bini are the smallest by far of the Edo-speaking group of tribes who occupy most of the eastern part of western Nigeria, between the Yoruba and the Niger River; the others, such as the Urhobo, the Kukuruku and the Ishan, have left but little mark on history, apart from providing contingents at times for the Benin armies. It is far from clear how the Bini came to dispose such disproportionate power, stretching at times beyond the Dahomey border to the west and the Niger to the east, unless it was because at some early time, whether by historical accident or through the conscious design of some person or group, their whole culture became war-oriented with a degree of authoritarian centralization which does not seem to

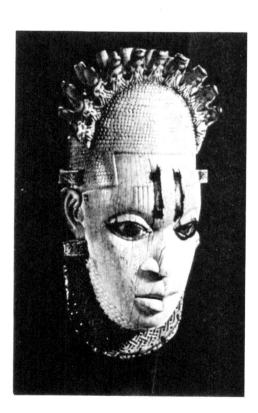

62
BENIN CARVED TUSK
(detail)

Elephant tusks carved with mythological and historical relief designs were installed upon the altars of the king's ancestors, sometimes mounted on bronze heads. Most of these tusks are probably of the nineteenth century.

63
BENIN PECTORAL
MASK

This is one of five or six ivory masks, apparently carved in the sixteenth-century style, which were found in a chest in King Ovonramwe's bedroom in 1897.

have been at all characteristic of the Edo-speakers in general. The nearest parallels—and with a like effect on the aesthetic life of the tribe—are found at a much later time in the Dahomey and Ashanti kingdoms to the west. As is usual in such military societies there was great emphasis on the commemoration of the events of the past, and it is fortunate for our purpose that we have a greater volume of historical and quasi-historical information about Benin than about any other African people, much of it recorded by the exertions of Chief Jacob Egharevba. As is the case nearly everywhere in Negro Africa (and more generally in tribal societies elsewhere), the history is not that of the whole people but of the ruling class, stratum or oligarchy, who may or may not be of the same stock; at Benin, Yoruba influence may in fact as in legend have played a decisive role. Moreover, the history has undoubtedly been subject through the ages to more or less subtle reinterpretation and distortion in the interests of the rulers for the time being. The oral tradition naturally evinces no interest in aesthetic aspects of the tribal arts, and this objectivity enhances the value of the indirect light which it throws on them from time to time.

It would seem that the art history of Benin can be best interpreted in terms of a counterpoint or interaction between two styles, a tribal style and a court style or, to borrow from the not wholly irrelevant terminology of Roman history, a 'plebeian' and a 'patrician' style. Reconstruction of the history of the tribal or plebeian style must of necessity be to a large extent conjectural, chiefly because it was practised in the perishable materials such as wood, and also because its works would not have benefited to anything like the same extent from the socio-political factors and mechanisms which tended to give permanence to the art of the king's court. From a comparison of the woodcarving styles of the Urhobo, Kukuruku and other Edo tribes with the wooden pieces collected among the Bini by the 1897 expedition, we can form a reasonably convincing picture

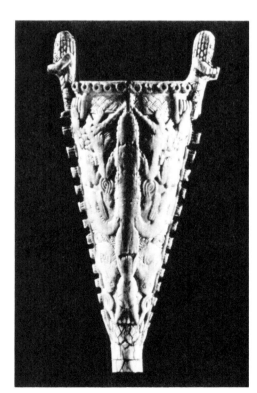

64
BENIN DOUBLE GONG

These gongs, perhaps of the sixteenth century, are elaborate imitations of metal forms. They are said to have been struck at court to signify the Oba's approval. About five of them were found in the Oba's palace in 1897.

65
BENIN DOUBLE GONG (reverse)

The central figure here is an Oba with mudfish instead of legs and may refer to the sea god Olokun or to Oba Ohen who introduced his cult.

of the true and ancient Benin style as a somewhat humble and rustic tradition, using *iroko* wood almost exclusively and showing a marked predilection for low-relief decorative carving closely filling all available surfaces with human, symbolic and geometrical subjects. The well-known 'altars of the hand' (often miscalled 'execution blocks' in the literature) are perhaps the most pleasing examples of the style, and show a clear relation to chip-carved work among the little-known Kukuruku. But few if any works in the style show that interest in and feeling for sculptural form which have attracted the attention of the Western world of art to the carvings of other African tribes. That such qualities were never very prominent among the Bini tribal carvers is suggested by the vicissitudes of the court style, to consider which we now proceed.

The court style, manifesting itself in bronze and ivory work, is strictly so called, for the bronze-casters were from the earliest times forbidden on pain of death to work for anyone but the Oba; and their works were in consequence almost confined within the mud walls of the great palace compound, apart from a few pieces which the Obas had on exceptional occasions presented as marks of favour to certain of their senior chiefs and vassals and some of which are still in the possession of their descendants. As to the origin of the court style, Bini tradition presents us with a consistent and reasonably convincing account (which also conforms well with conclusions drawn from the internal evidence) of its importation. It is not impossible that bronze-casting was known at Benin before that, but if so it was probably crude, unimportant and small in scale. In any case, the tradition states that until the late thirteenth century the necessary memorial head of a deceased Oba could not be made at Benin but had to be obtained from the Oni of Ife, the Oba's spiritual overlord, to whom also (according to one story) the dead king's head was sent for burial. We do not know for certain whether any of these Ife heads are among those found at Benin in 1897, but from internal evidence it seems very unlikely. About 1280 Oba Oguola asked the Oni to send a master founder to teach bronze-casting to Bini apprentices so that the memorial heads could be made there; the man sent is known to the Bini as Igue-igha, and is still worshipped as the first Ine, or chief of the brass-casters, in a shrine in the Street of Brass-Casters near the palace. There is nothing surprising in this introduction of a Yoruba craftsman to Benin, since the dynasty itself was, or claimed to be, of Yoruba origin, having been founded by Eweka, son of the legendary Oranmiyan, son of Odudua, who was present at the creation of the world at Igbo Idio in the centre of Ife. (That Benin did not wholly accept the Ife cosmogony is clear from the fact that Bini tradition records an earlier dynasty, the Ogiso, as reigning for some centuries before Oranmiyan's visit.)

Of the many bronze heads in the extant corpus of Benin work, one type is by common consent the earliest: namely, the very thin heads of generally naturalistic form but with some stylization of certain features such as the ear and the nostrils (for one of somewhat unusual form, see fig. 165). Some informants at Benin have declared that these are the heads brought from Ife before Oguola's time, but these reports may be discounted

because more or less subtle stylistic differences are not among the details that an ancient oral tradition is likely to preserve. It is far more likely, from a close study of their iconography, that they are from the first two centuries of Bini casting, which terminate with the period of first European contact in the late fifteenth century. What is very clear is, on the one hand, that the realistic subtlety of their modelling can derive only from the Ife tradition, and, on the other, that stylization of a somewhat superficial kind is already well advanced as compared with the more idealized heads of Ife, and at the cost of an appreciable loss of sensitivity, for example in the lifeless ears. The same tendency is evident a little later in the famous bronze heads of Queen Mothers (fig. 160)—a rank and style said to have been instituted for his mother Idia by the great Oba Esigie in the early sixteenth century—but these also have a remarkable formal abstract quality, as of a drop of liquid, almost as if they had been influenced by Brancusi. (To this period also may belong the finest ivories, namely the masks and the ivory gongs—figs. 63–65—and these would seem to be closely related in style to the early bronze heads, and so indirectly to the Ife works.)

Thus far, we see that the Ife conception, though very noticeably modified at Benin during the early period of perhaps two centuries, retained much of its essential character, was still recognizably based on naturalism, was representational rather than conceptual. Moreover, the head itself as a form completely overshadows the ornament with which it is invested: the hair, in concentric tiers, reminiscent of the coiffure of many ancient Egyptian wooden figures, is represented in the male heads fitting closely against the skull; the collar of fine beadwork fits so closely to the neck (figs. 160, 165) as almost to appear a condition of the skin. The delicacy of the conception and the modelling match the almost eggshell-thin casting; and it is reasonably certain that these heads, like those of Ife (which are considerably thicker) were not made to support tusks. A certain variety of features and expressions (possibly but not certainly evidence of portraiture) still survives.

In the late sixteenth century the gradually changing artistic tradition seems to have undergone a major reorientation, and a comparative study of the extant remains suggests that it was somewhat sudden, since there are no obviously transitional works. It is hard not to see in the change a reflection on the aesthetic plane of a shift in political emphasis. Perhaps the most striking development was a great increase in the number and variety of the bronze castings: besides heads recognizably deriving from those of the early period, massive figures of hornblowers and other functionaries (figs. 163, 168) now appear, and above all the great series of several hundred rectangular wall plaques (figs. 161, 162) which were to adorn the mud pillars and pilasters of the palace courts for the next century and a half, until they were torn down by a later Oba and stacked in an outhouse to wait another 150 years for the British expedition. A striking quality of all these middle-period works—and one all too familiar to the curators of the large Benin collections—is their great weight; the heads are commonly four times heavier than the earlier heads of comparable size. This may be reasonably connected with the importation about this time by the Portuguese

and others of copious supplies of European bronze, copper having until then been one of the most precious of commodities, mined and brought by caravan from the Sahara. The opportunity may well have prompted the desire to give greater weight to the sculptures; but it is also possible that the primary motives for the change were of a more general and political character. With the change in weight there appears also a marked change in shape and treatment: an unvarying uniformity of facial type prevails, a notably prognathous type still often to be seen at Benin, and recalling in feeling the portrait heads of those Roman emperors who found it convenient to emphasize in their public effigies the brute strength of their characters rather than a kingly wisdom. And the faces are, indeed, greatly reduced in importance in relation to the regalia of large coral beads and still larger carnelian beads which frame in a close rectangle the conventional eyes, nose and lips—for the beaded collar is now so greatly increased in diameter and size as to conceal the whole of the chin. These heads are no longer works of art sufficient in themselves, but seem rather to be applied art, architectural features, comparable in their massive broad-based form to the base of a pillar; and in a sense this may be what they were, for this is the point in Benin art history when it seems most likely that the practice of resting the bases of large carved tusks on bronze heads was introduced. Yet if originality and imagination have now given place to a stereotyped uniformity as the inspiration from Ife—never perhaps fully understood by the Bini—finally waned, there remain an admirable technical mastery and the regard of the true craftsman for proportion and an inner coherence of design. Given their presumed function of supporting large tusks, these heads are not unpleasing, although their qualities are essentially negative.

How, then, may we interpret the art of the middle period in terms of socio-political history? The greatness of Benin was by now well past its apogee—the great days of Ewuare and Esigie in the fifteenth and early sixteenth centuries—and the state and royal power could not escape the complacent relapse into a static regime no longer vigorous but developing only on the plane of form, ceremonial and the aggrandizement of a hierarchic bureaucracy. The imperial system increasingly maintained itself not only by armed might but by propaganda, by the erection and continuous inflation of a *mystique* in which the temporal came more and more to overshadow the spiritual functions of the divine kingship. And clearly art—the court style—came under philistine direction, as in other totalitarian states. A contributory and perhaps a main cause of these developments must have been the arrival and establishment of the Portuguese with their superior equipment of finery, weapons and wealth and their status as emissaries of a great king beyond the seas; they provided both means and incentive, and the Obas must have felt the need to maintain their pomp and status at a high level *vis-à-vis* the foreigners in order to retain the allegiance of their subjects and vassals. The prestige of the Portuguese was increasingly turned to the glory of the Oba by the representation of them in the art of the middle period (for a later example, see the foot of fig. 62).

In the great middle period, so extraordinarily prolific of imposing if seldom masterly bronzes, Benin art stood at a kind of climacteric. The Ife aesthetic had run down for lack of appreciation and nourishment; its aftermath and the philistine influence of a partly alien materialism were in an equilibrium which made possible the production of works whose most admirable quality was restraint. Only by hindsight do we discern in this period the seeds of decay; for indeed the seeds of what might have been a future greatness of a new kind were present as well. In a word, here was a situation pregnant with new aesthetic possibilities: if there had been at Benin in the early eighteenth century artists—and patrons—of genius, able to draw inspiration from the dynamism and spirituality of the traditional religious sculpture of West Africa, the artistic results during the next century and a half might even have justified the uncritical estimation which is put upon works bearing the name of Benin today.

In the event, artistic discipline gave way and a flamboyant decadence set in. If we again consider the heads of Obas, as a constant subject in Benin art—manufacture of the rectangular plaques having been by now discontinued—we find three notable differences emerging at once: first, the standard of craftsmanship sadly declines, with seriously disfiguring casting faults common and seldom made good; secondly, there is now a premium on mere size and on an unpleasant inflation of the facial features and of the unnaturally long and thick neck; and, most important in an artistic sense, attention is no longer paid to the maintenance of a due proportion, whether between the elements of the sculptural form itself (cylindrical collar, face, and hemispherical cap) or between the form and its surface decoration (beads, tribal marks and, a little later, incised eyelashes). Emphasis shifts more and more to the enhancement of incidental ornament as the faces become more and more stereotyped (which is very different from saying creatively stylized). First there appears a broad flange at the base of the collar, and upon it dwarfed representations in the round of leopards, bound and decapitated human bodies, and other symbols of a temporal power minatory and perhaps unsure of itself. The increasing elaboration of ornament may have reflected a similar efflorescence in court life and ceremonial, but in earlier times such ornament would have been skilfully assimilated into the composition. Its final development was reserved, it seems, for the nineteenth century: recent research at Benin has established with reasonable certainty that it was Osemwenede, Oba from 1816 to 1848, who added to the royal headgear the upstanding comb-like appendages of coral beadwork and the wired carnelian beads which curve round from above the ears in wide arcs, almost meeting in front of the wearer's eyes. These ornaments are represented in many male heads (fig. 167) and other works of the last eighty years before the Expedition which represent the final decadence of the Benin court style.

The deterioration of sculptural form in the male heads of the late period is equally evident in the female heads from the altars of the Obas' mothers in the palace—perhaps, indeed, more evident, because of the comparative absence in their case of superfluous ornament, rendering more obvious the failure of proportion. And a comparison of bronze figures of the middle and late periods is equally illuminating.

It will be understood that the foregoing reconstruction

of Benin art history is in part conjectural and it is in fact in conflict at many points with the succession and chronology propounded by von Luschan and Struck, which, by the default of others, have held the field for many years in spite of their *a priori* character and their disregard of many significant details. Much confusion has been caused by von Luschan's unquestioning admission to the Benin canon of several types of works which have proved to be of extraneous origin. Among these is the vigorous provincial style of Udo, twenty-five miles west of Benin (fig. 158), but this is at least recognizably related to the Benin tradition itself, which cannot be said of some of the other styles found at Benin, including such magnificently imaginative works as the huntsman with an antelope (fig. 173) in the British Museum. It is clear that there were attracted to Benin through the centuries many works, and perhaps artists also, from vassal and neighbouring tribes in Yorubaland and to the east on both sides of the Niger. When all these works are rigorously excluded from our survey, we see far more clearly the true lines of Bini art history, and— by comparison with some of them—how it fell short of the highest aesthetic possibilities. The best Yoruba brass-casting, which is associated especially with the Ogboni Society, stands in strong contrast with Bini work. It is not impossible, though it is not perhaps altogether likely, that this style with its protruding eyes and marked avoidance of naturalism was derived originally through progressive stylization from the classical style of Ife; certainly the concept of vital force seems to reach a high level of expression in many of these Ogboni brasses.

Before we leave the history of bronze-casting in the central Guinea Coast we must revert briefly to the afore-mentioned anomalous pieces, found at Benin, at Jebba and Tada, in the Ijo and Andoni creeks of the Niger Delta, at Isuofia and many other places along the lower and middle Niger and the Benue, which are alien both to the Yoruba complex, ancient and modern, and to the Benin complex (although nearer in spirit to the former). Their affinities lead us eastward, to Tiv and Jukun work along the Benue, to the Grasslands of the Cameroons, even perhaps to the ancient empire of the

Sao, which flourished near Lake Chad during the apogee of Benin. There has been no systematic study of these diverse brass-casting industries and, although they form no coherent whole, it is difficult not to form the impression of some as yet unidentified third force, exerting its influence upon them like an invisible planet. Its identification is perhaps an even more important task for research than the problems of Benin and Yoruba history which are already the subjects of intensive field study in Nigeria. Perhaps the search will lead us to Idah, where the Ata still wears upon his breast the great brass mask *Ejube auilo*, in the early style of Benin, and which may well have been the place of origin in the fourteenth or fifteenth century of the bronze figures taken to Jebba and Tada by Tsoede. We may be led, too, to the abandoned site of Kwororofa, once the capital of a great empire in the Benue Valley. Such discoveries, if and when they are made, should help to throw light on those earliest periods of West African proto-history when the culture-bearing peoples were moving in from the east, mingling perhaps with the descendants of the palaeolithic people who had lived there for half a million years.

Since it is not the purpose of these essays to be encyclopaedic, no effort has been made to give a comprehensive account of the manifold arts of the coast of Guinea; rather we have singled out one series of problems for an attempted study in depth, because the central Guinea Coast gives most favourable scope for examination of the possibilities and limitations of such historical study. It would have been feasible, no doubt, to consider the art of Guinea from the point of view of the influence of secret and semi-secret societies on West African woodcarvings (see, for example, figs. 61, 69, 70, 74–95, 149, 175–177, 190, 191), for this again is a phenomenon especially characteristic of the area. But, given that we have before us admirable photographs spanning the whole range of styles and bringing out very strikingly their dynamic qualities, we have perhaps learnt more about their nature by reviewing the decline and failure of the far from typical Benin art than if we had sought to study them more directly.

66
BAULE DANCE MASK

This abstract interpretation of a bovine or possibly antelope head is said to be used in the goli dance (see fig. 55).

67
IFE YORUBA MEMORIAL FIGURE

This casting, dug up in 1938 with seventeen brass heads, probably represents an early Oni (divine king) of Ife; with regalia similar (except for the crown) to those used by modern Onis at their coronation. A complete figure was found in 1957.

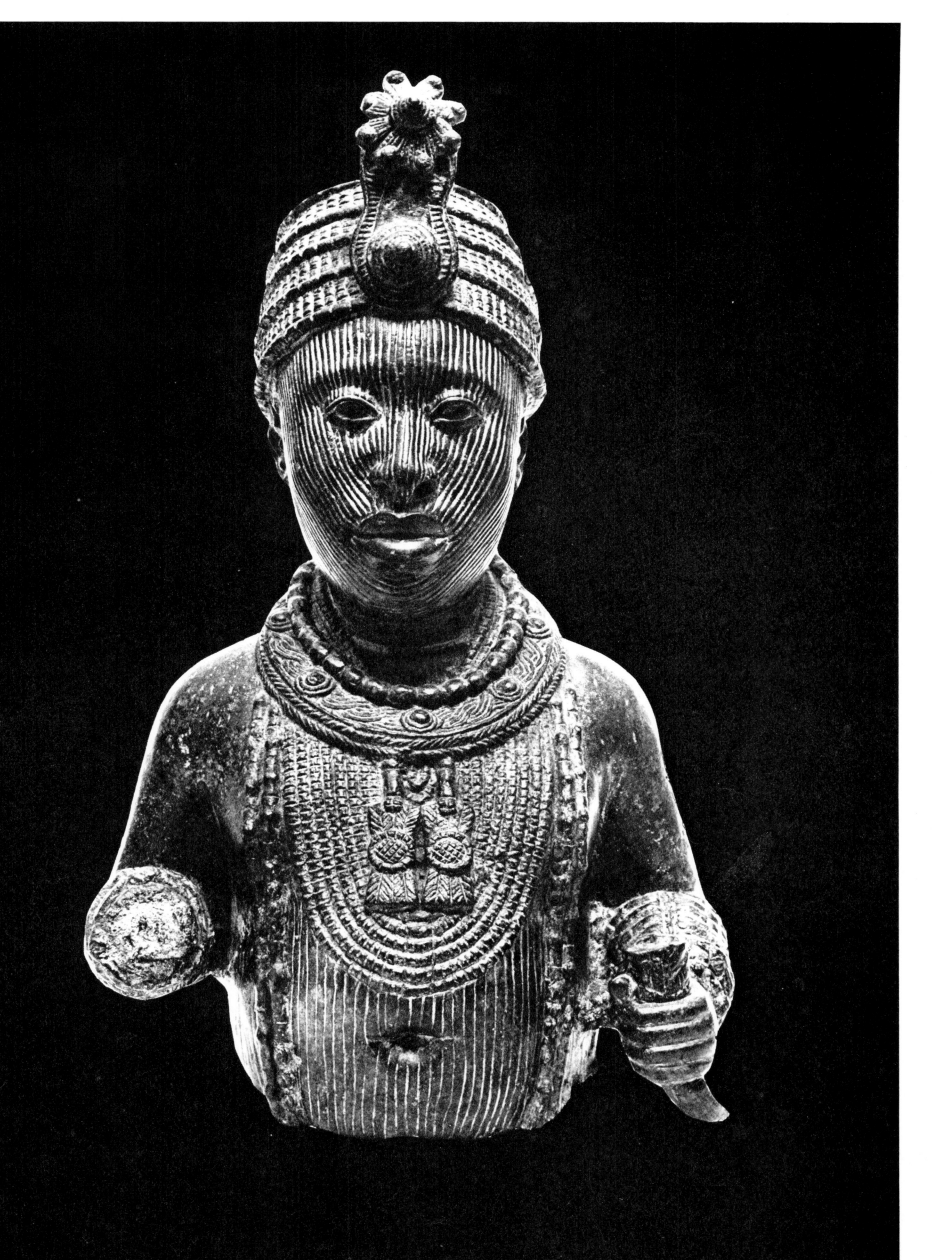

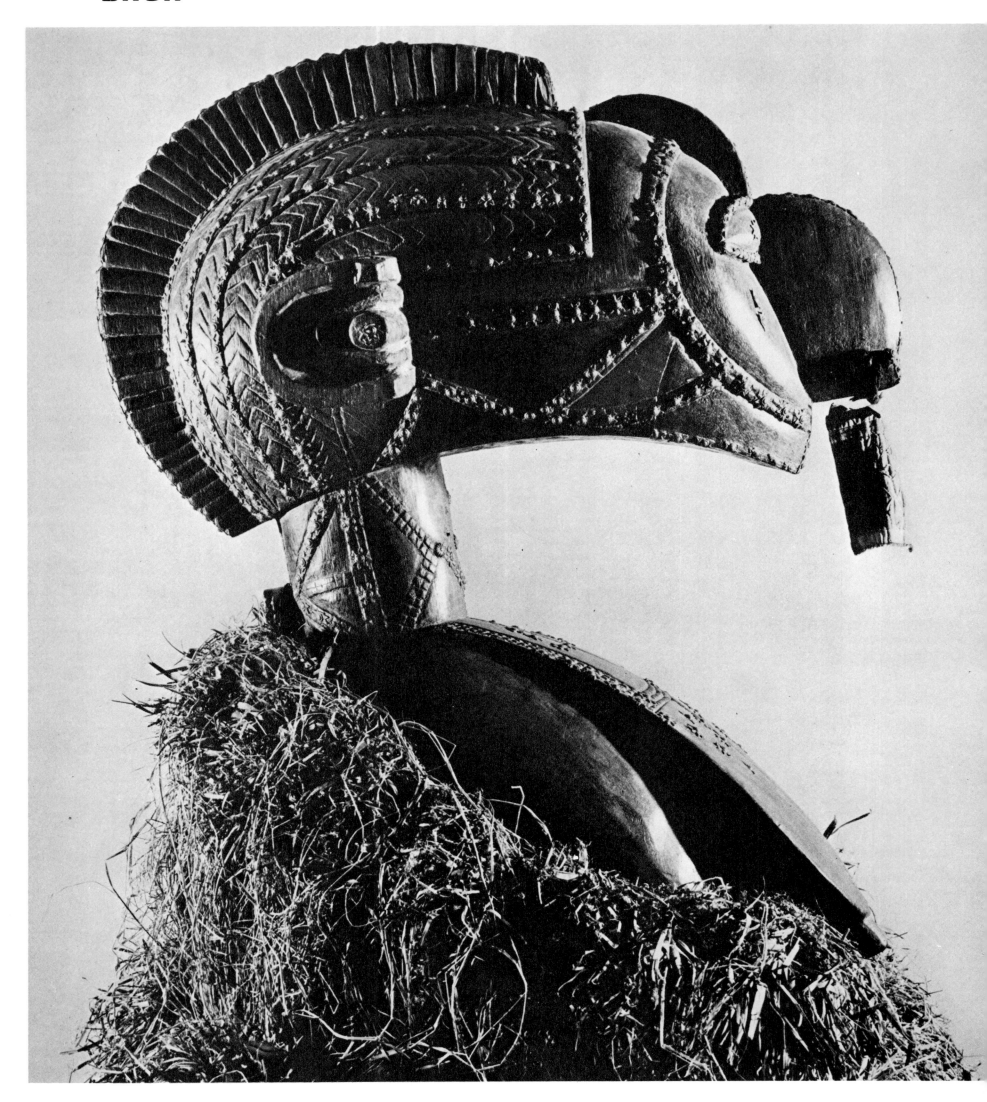

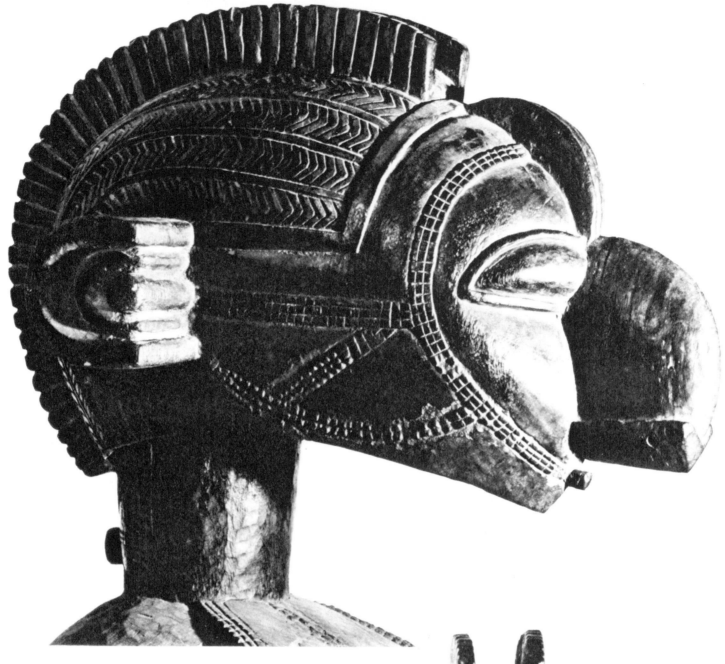

69
DANCE MASK

Nimba, the embodiment of fertility and the cult spirit of the Simo society, is celebrated in these enormous masks, whose salient curves so imaginatively express the concept of increase.

68
DANCE MASK

Before the rice harvest this ponderous fibre-clad figure emerged to dance with the village. The hollow bust fitted over the head and shoulders of a dancer, who saw through a hole between the breasts.

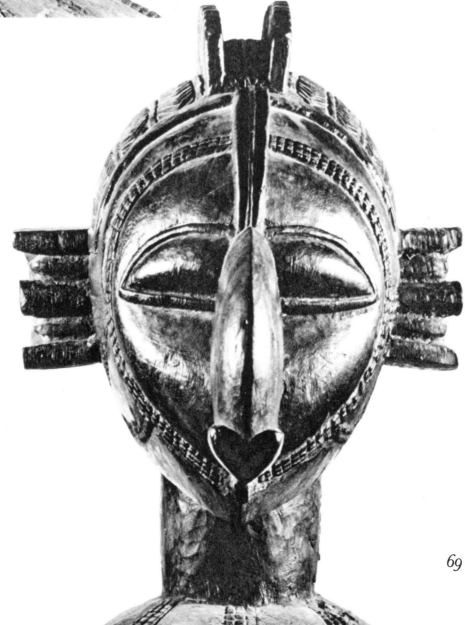

MENDI-KISSI

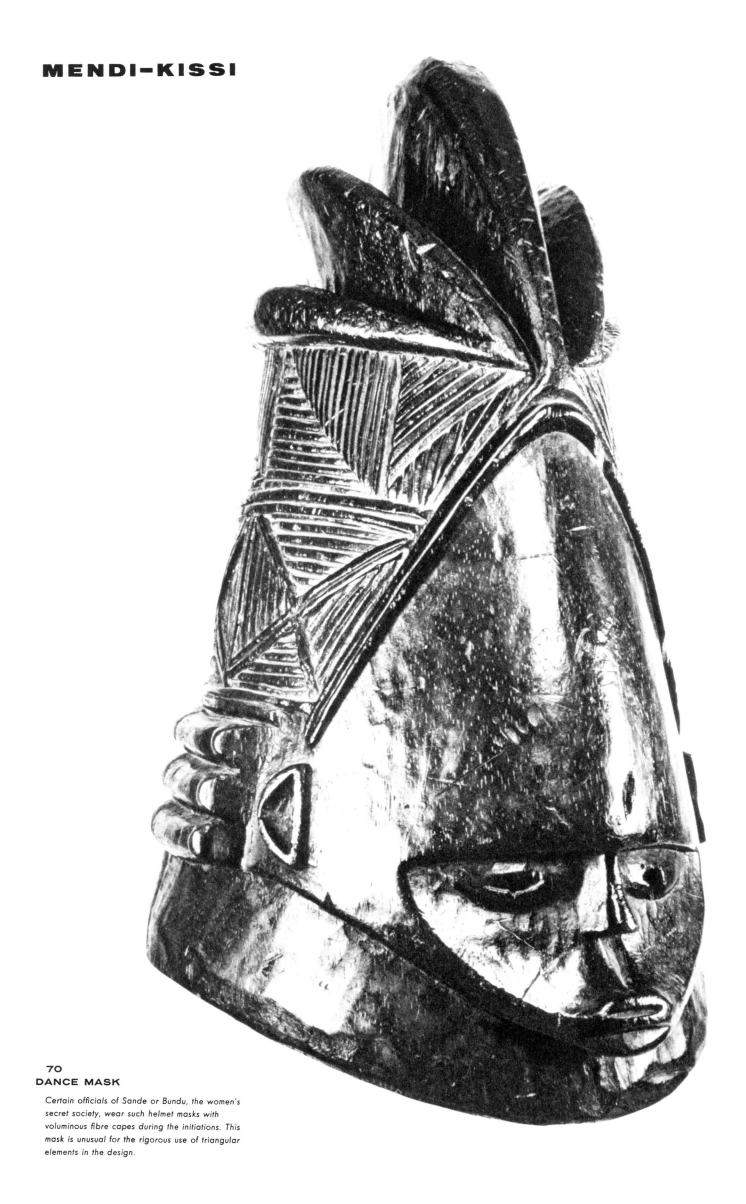

70
DANCE MASK

Certain officials of Sande or Bundu, the women's
secret society, wear such helmet masks with
voluminous fibre capes during the initiations. This
mask is unusual for the rigorous use of triangular
elements in the design.

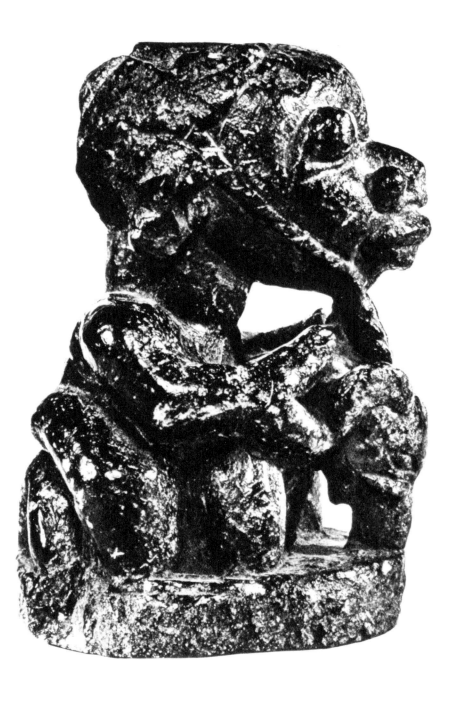

72-73
ANCIENT FIGURES

Soapstone figures such as these have been found in most parts of Sierra Leone and in the Kissi country of French Guinea. Though adopted on discovery by the Mendi and other tribes as 'rice gods' to bring crop fertility, they may be the ancestor figures of an older population. In fig. 72 a man rides an elephant.

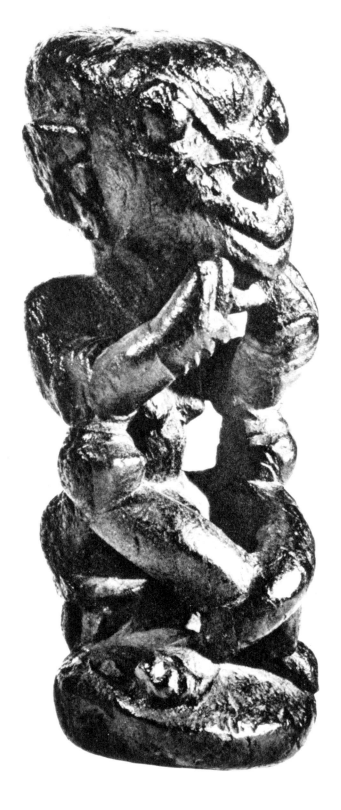

71
PALETTE

A similar piece is said to have been used to prepare 'grease paint' for cosmetic purposes. Female heads on Mendi carvings often indicate their use in women's societies, such as the Sande (see fig. 70) or the Yassi, a curing group.

DAN—NGERE

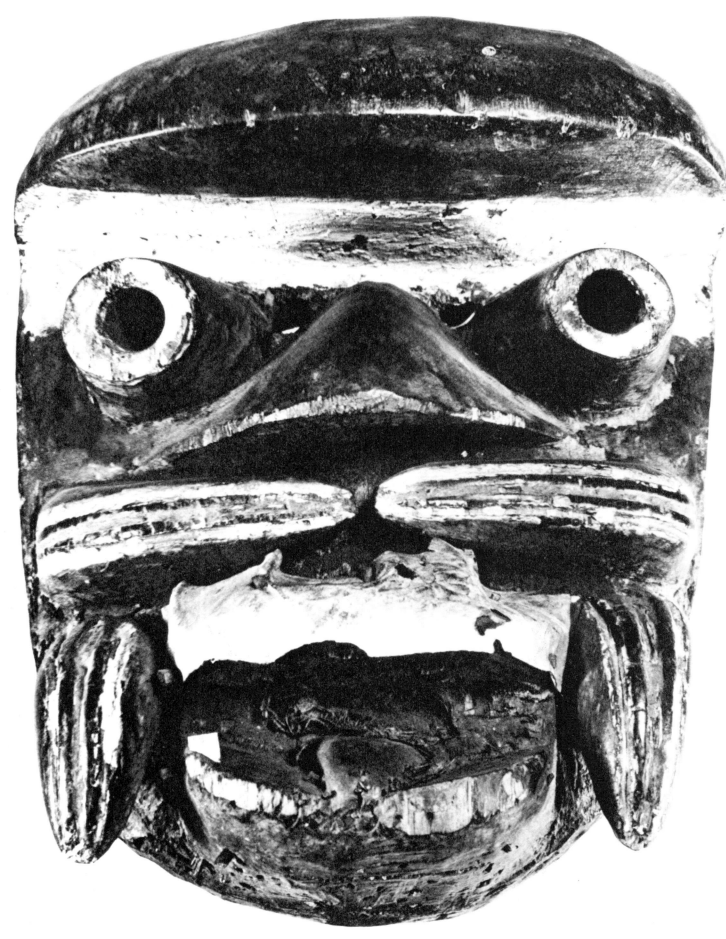

74
DANCE MASK

This warthog mask, like fig. 75, is typical of
the exaggerated features and grotesque
expressionism of the Ngere tradition, in contrast
to the Dan tradition (figs. 76–81). There are few
if any Ngere figures.

75
DANCE MASK

The Ngere follow a rather 'cubist' aesthetic,
involving fragmentation of the subject into
dissociated features which are converted into
geometrical forms such as cones, cylinders and
sections of spheres, and may also be
reduplicated.

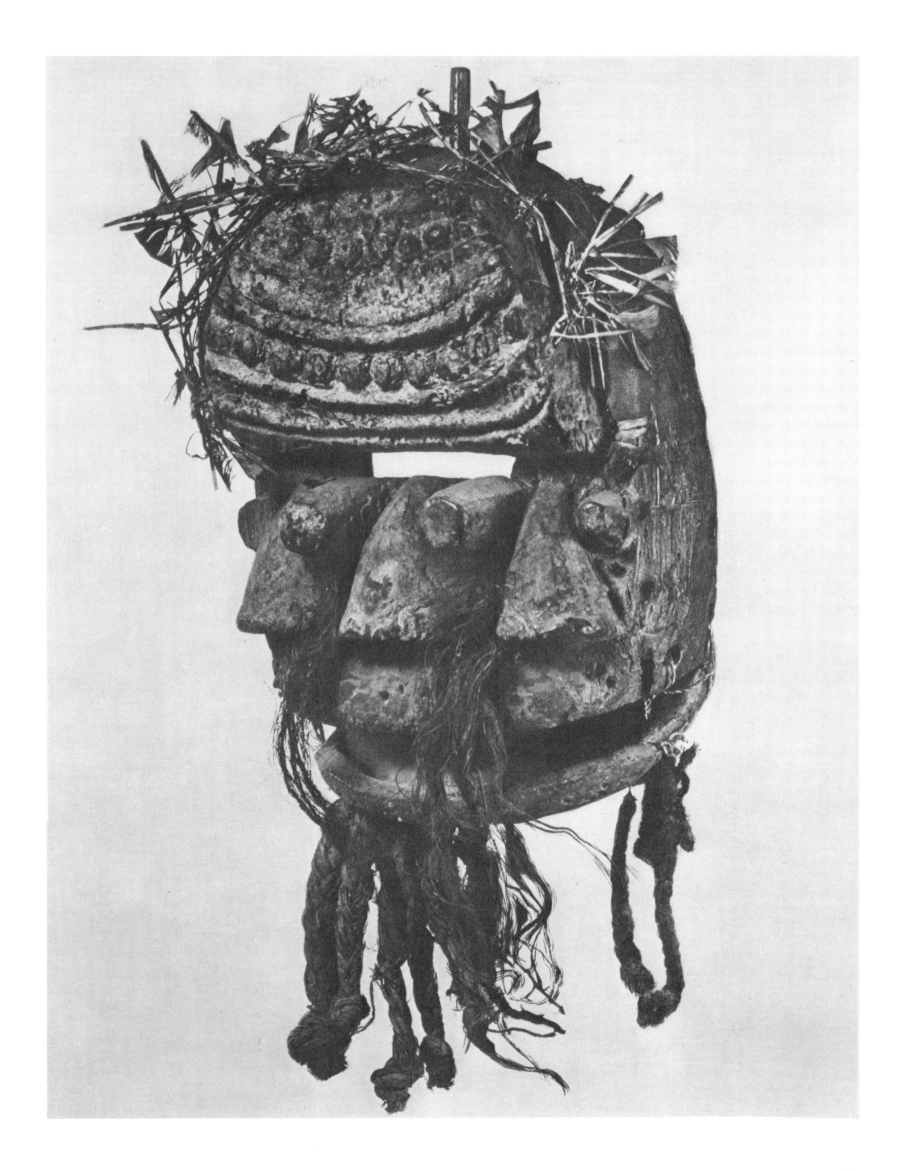

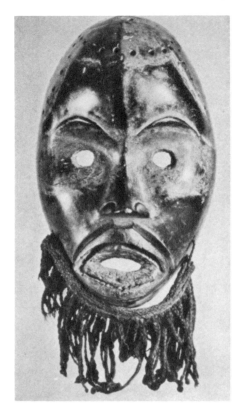

76
DANCE MASK

This bearded and finely patinated mask is typical of the Dan tribes— a linguistic and artistic entity extending under various names from the Ivory Coast into Liberia and French Guinea, and practising this restrained and naturalistic style. Their neighbours, the Ngere tribes, apply an opposite aesthetic to similar subjects and purposes.

77
DANCE MASK

Among western Dan and Ngere tribes the secret political society, Poro, was probably superimposed upon an older mask-using ancestor cult. The mask institutions of most eastern groups seem to have been beyond the influence of the Poro. This is from the western Dan.

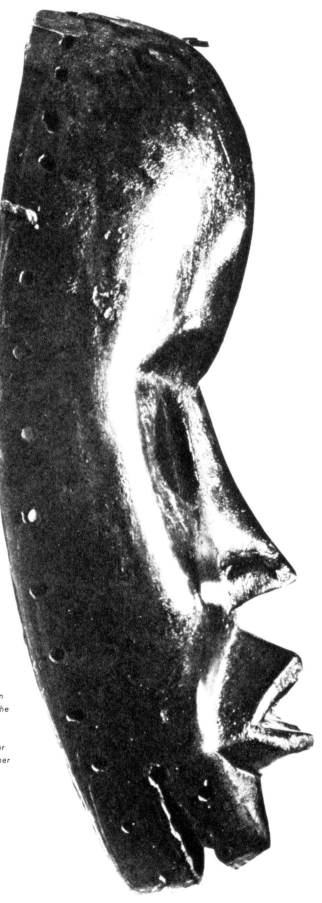

78
DANCE MASK

Despite a marked homogeneity, regional and sub-tribal styles can sometimes be discerned among the Dan tribes. But especially among western groups Dan and Ngere style elements often seem to occur in the same place and much further research is needed.

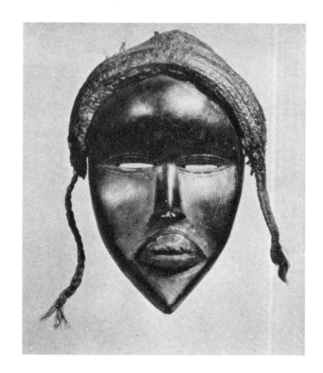

79
DANCE MASK

The masked dancers wear heavy and voluminous clothing, which restricts lively movements; some of them dance on tall stilts. Some masks are said to be portraits of their owners or others, but this should not perhaps be taken too literally.

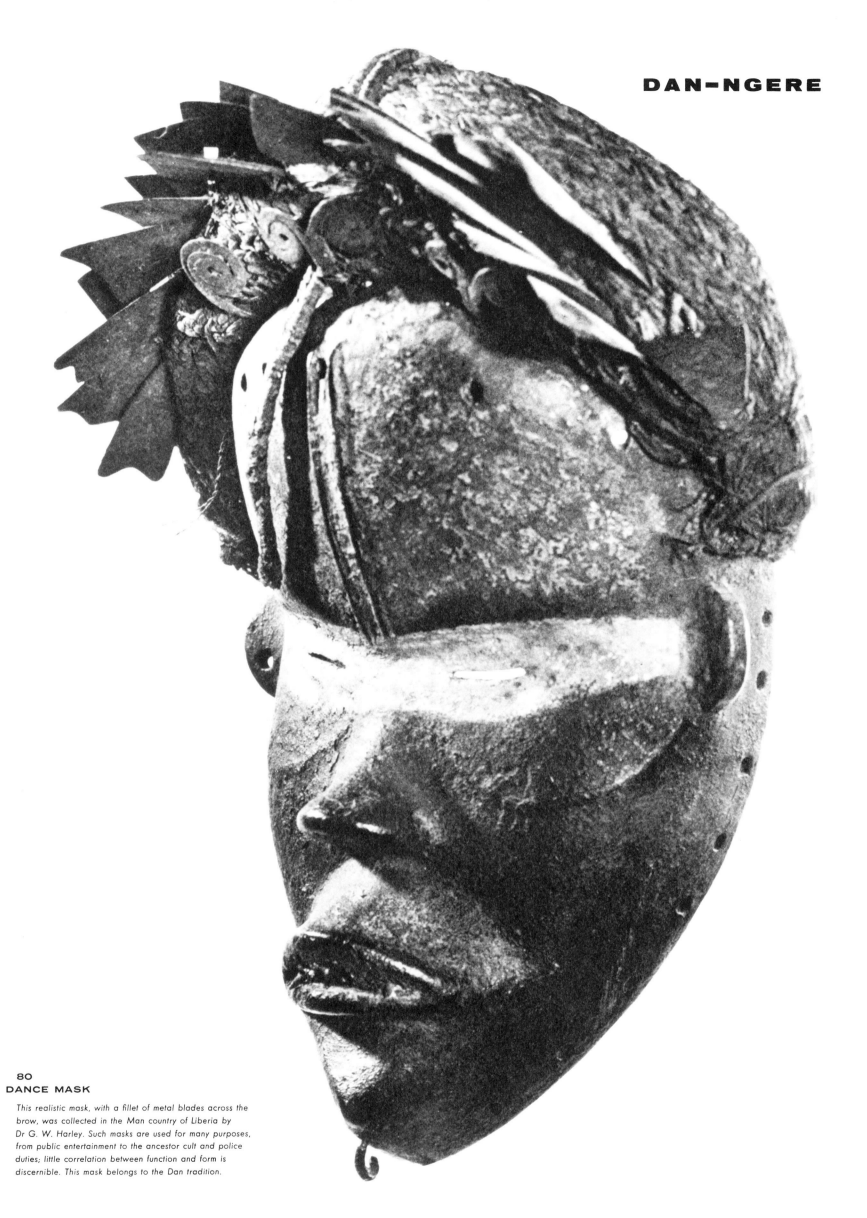

80
DANCE MASK

This realistic mask, with a fillet of metal blades across the
brow, was collected in the Man country of Liberia by
Dr G. W. Harley. Such masks are used for many purposes,
from public entertainment to the ancestor cult and police
duties; little correlation between function and form is
discernible. This mask belongs to the Dan tradition.

DAN-NGERE

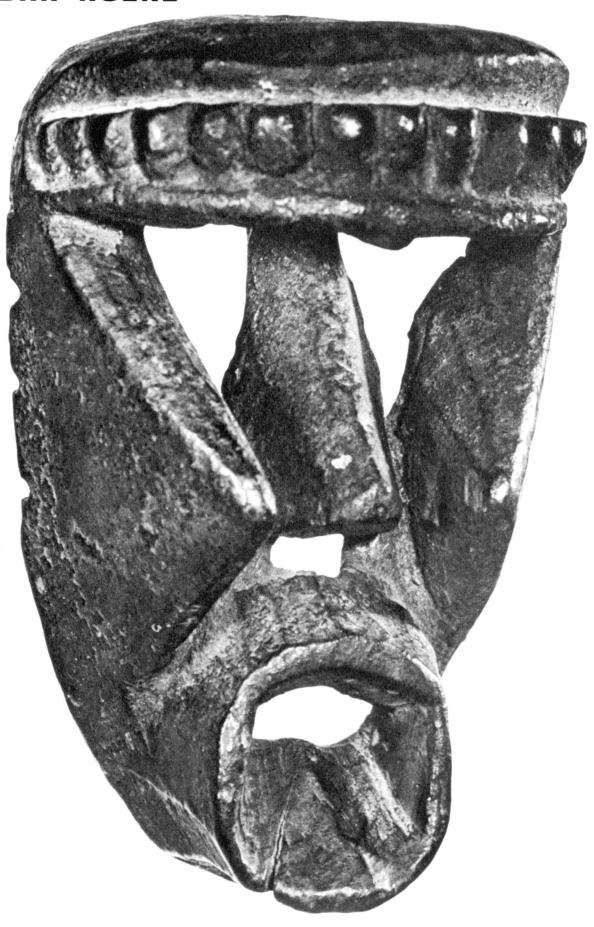

81
DANCE MASK

This strikingly abstract conception of the human (or possibly simian) face is found among both western and eastern Dan groups, this example being from the Liberian side; but the dissociation and triangulation of features suggests Ngere influence.

82
DANCE MASK

*Masks with asymmetrically distorted features, as in this
Liberian example, are found exceptionally in various
African (and also American, Asiatic and European)
societies, usually with reference to diseases or other
pathological conditions such as facial paralysis.*

DAN-NGERE

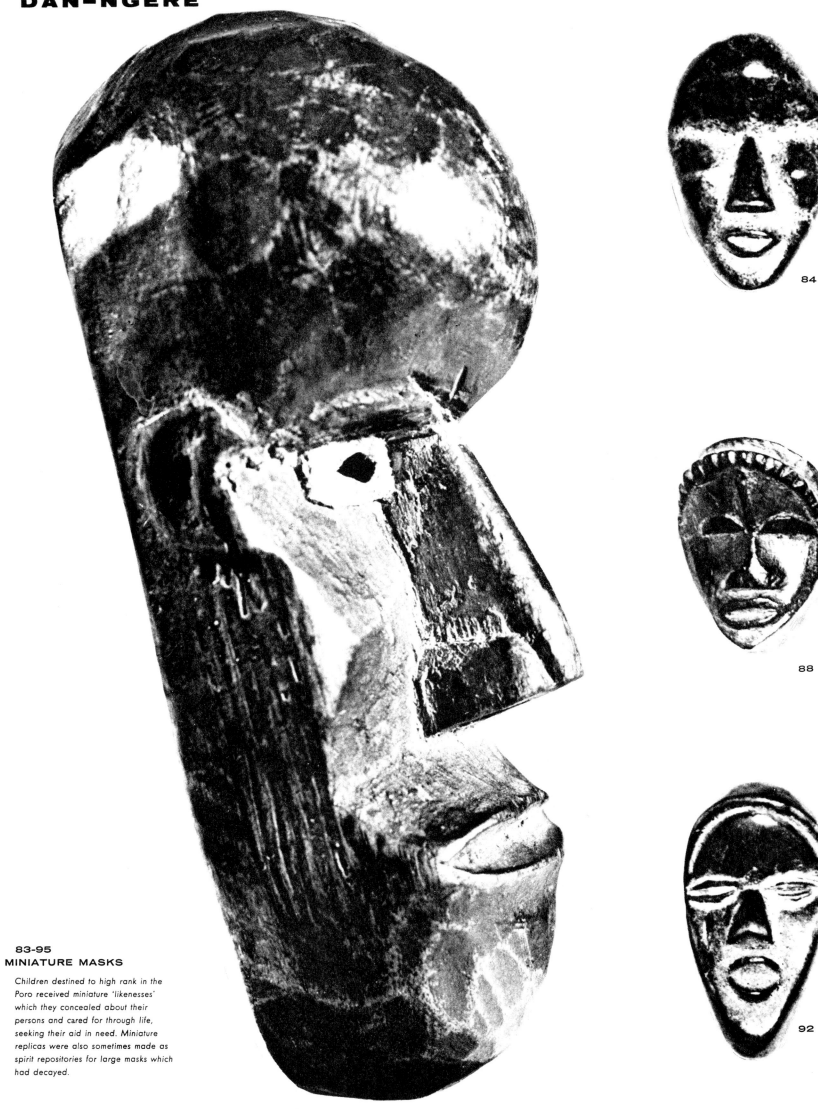

83-95
MINIATURE MASKS

Children destined to high rank in the
Poro received miniature 'likenesses'
which they concealed about their
persons and cared for through life,
seeking their aid in need. Miniature
replicas were also sometimes made as
spirit repositories for large masks which
had decayed.

84

88

92

85

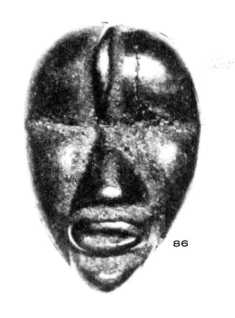

86

87

89

90

91

93

94

95

SENUFO

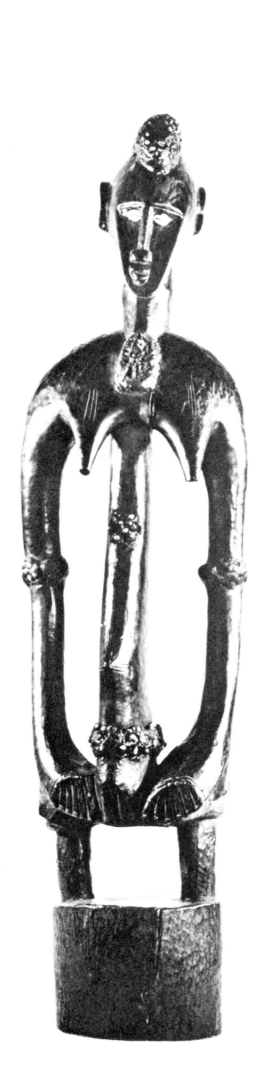
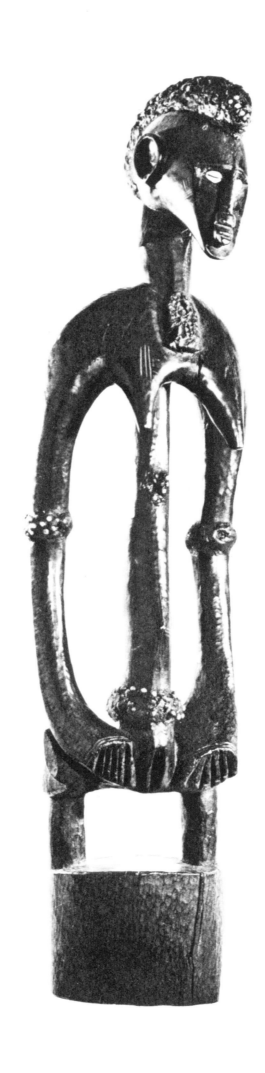
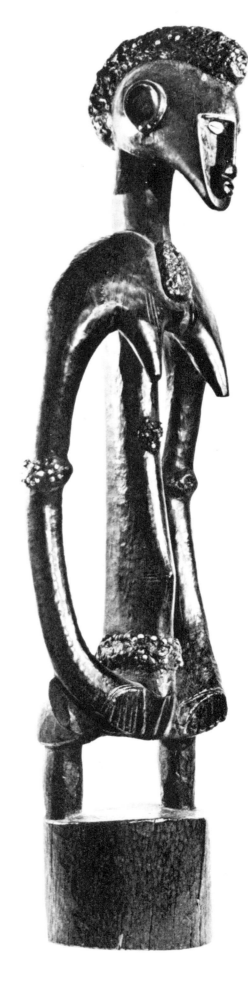

96
RITUAL FIGURE

This female figure, like the following two pieces, is from the Pomporo sub-tribe of the Folona district. Such pieces, with their heavy bases (only part of which is seen in these photographs), are said to be used in the

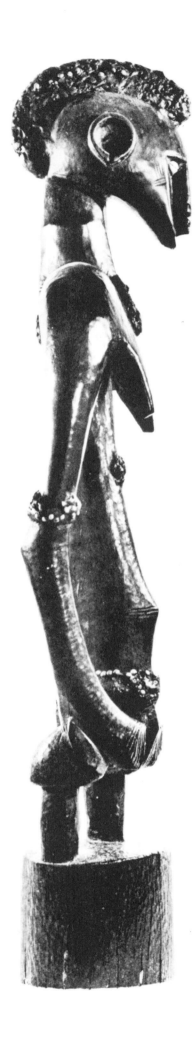
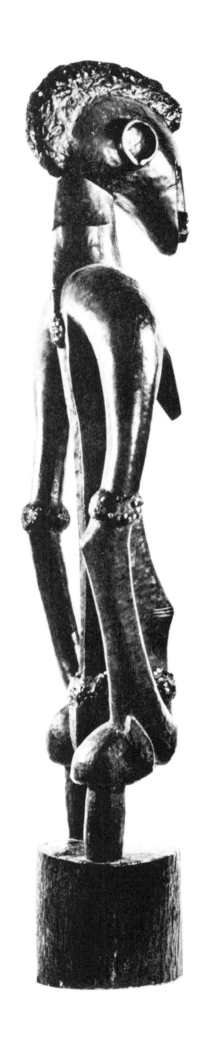
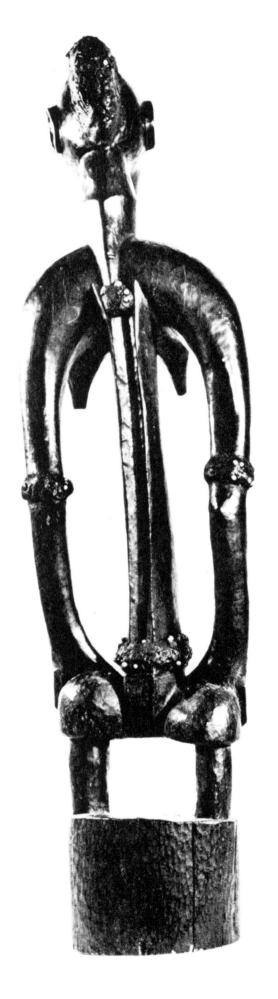

dances of the village initiation society, called Lo, to
mark the rhythm; they are lifted by the arms and the
bases struck against the ground with a thumping sound.
This one is decorated with cowries and red abrus seeds.

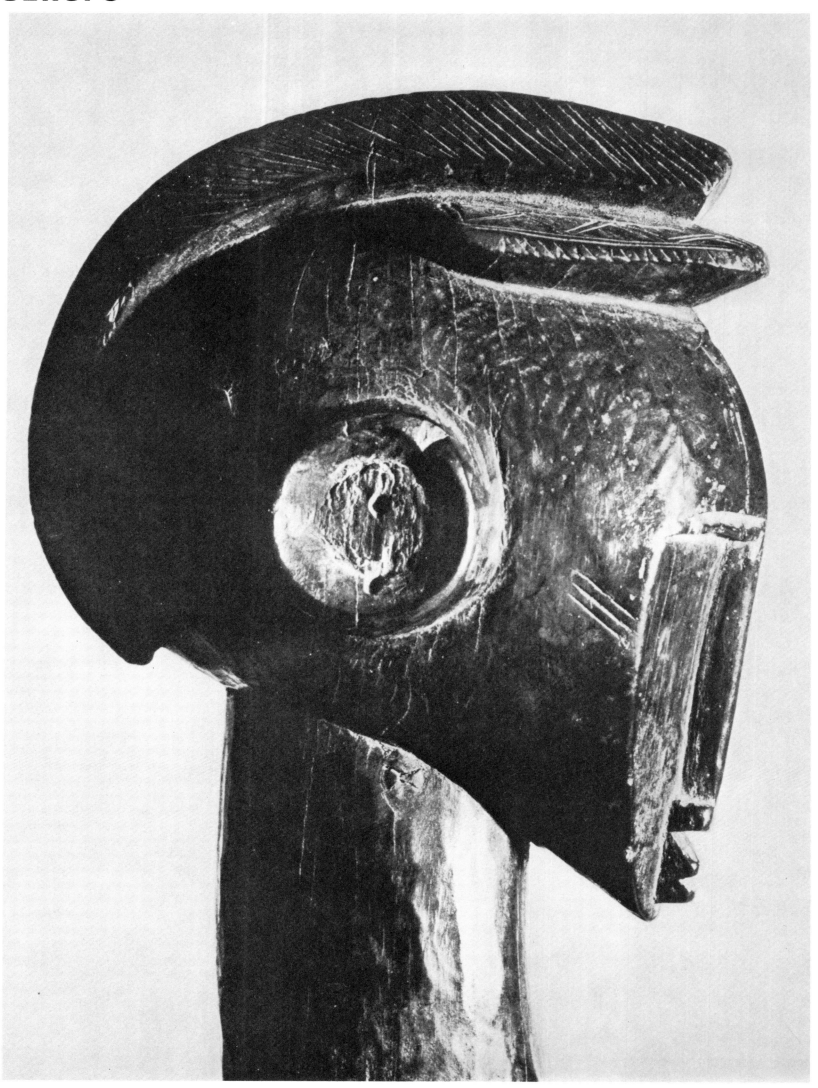

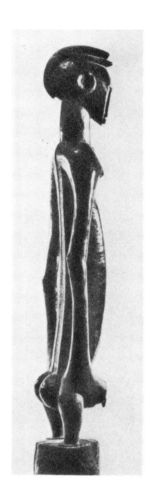

97-98
RITUAL FIGURE

This male figure is a rare exception, most of the rhythm-marking figures represent women. These northern Senufo figures show much affinity with Dogon and Bambara style.

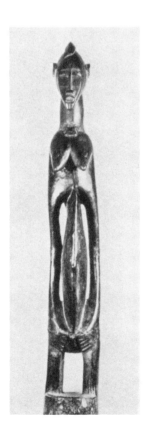

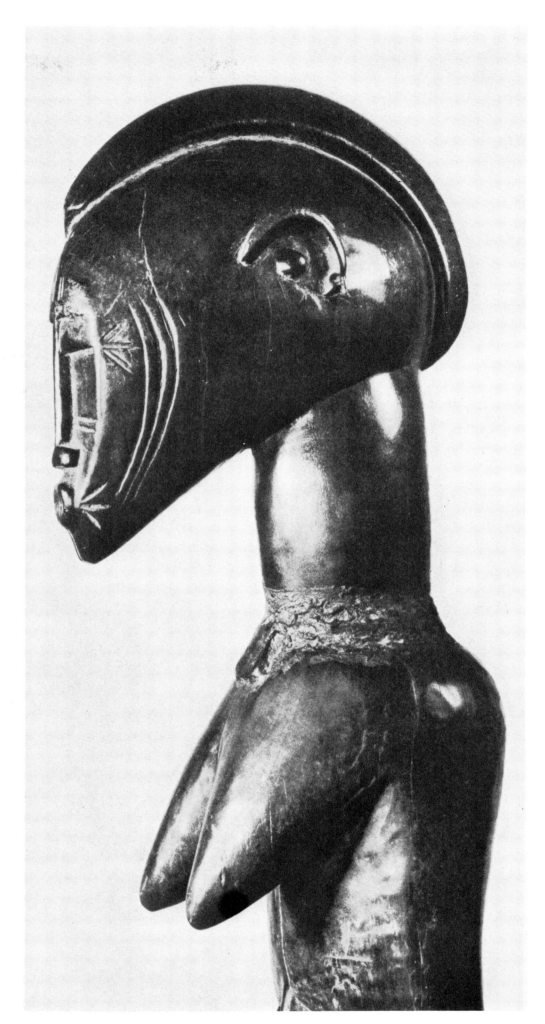

99-100
RITUAL FIGURE

This female figure, from near Sikasso in the Folona district, is in typical northern style, with its severe and attenuated forms, but shares the essentials of Senufo style with, for example, the double face mask (fig. 111).

SENUFO

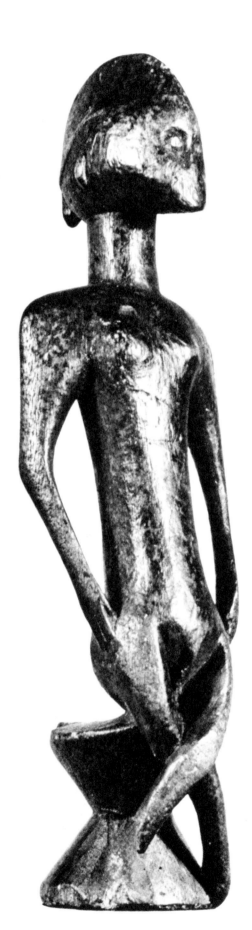

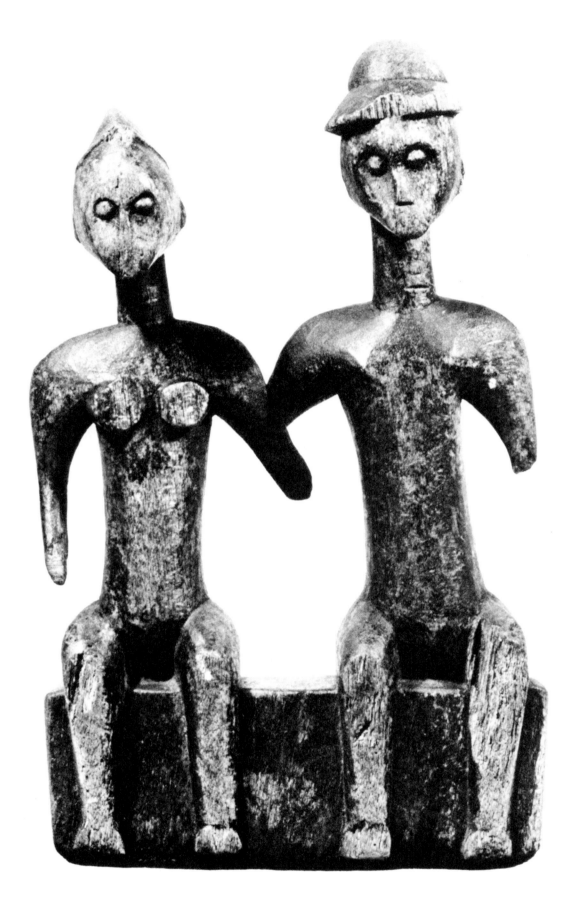

101
FERTILITY DOLL

This small figure of a woman perched on a stool was found in the Sikasso region, where it was in use as a small girl's doll or charm.

102
SEATED FIGURES

These old and mutilated female and male figures, carved on their seat from a single block of wood, were collected in the

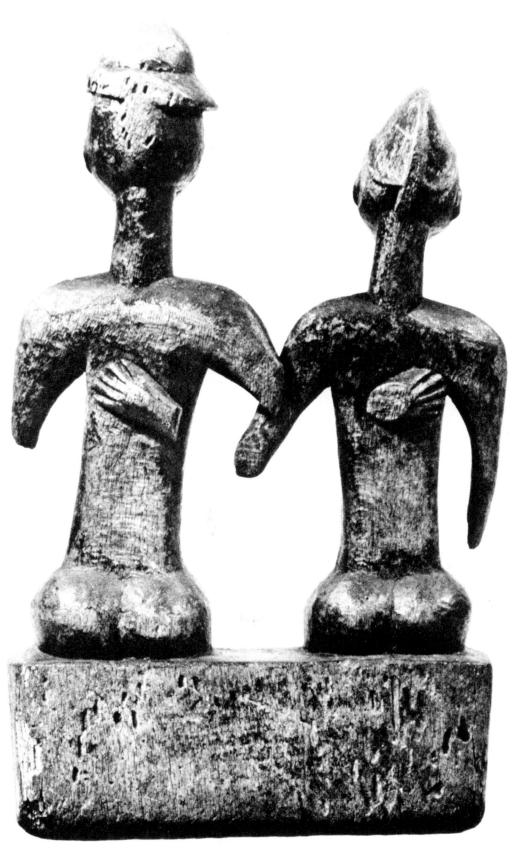

*Kenedugu region near Sikasso by M. Lem,
who considered them to have been made in the
Korhogo district some distance to the south,
and to have been intended for twin children.
Similar groups occur in much larger sizes.*

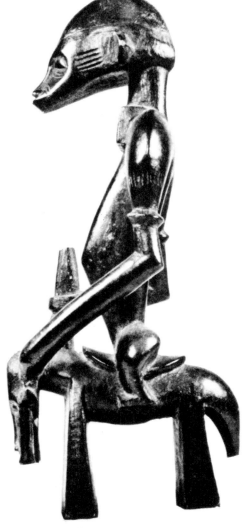

**103
EQUESTRIAN FIGURE**

*The rider holds a gun in his right hand and
the horse's legs are represented as two
solid blocks. This may be from the Korhogo
district, where horses are connected with rain
magic.*

SENUFO

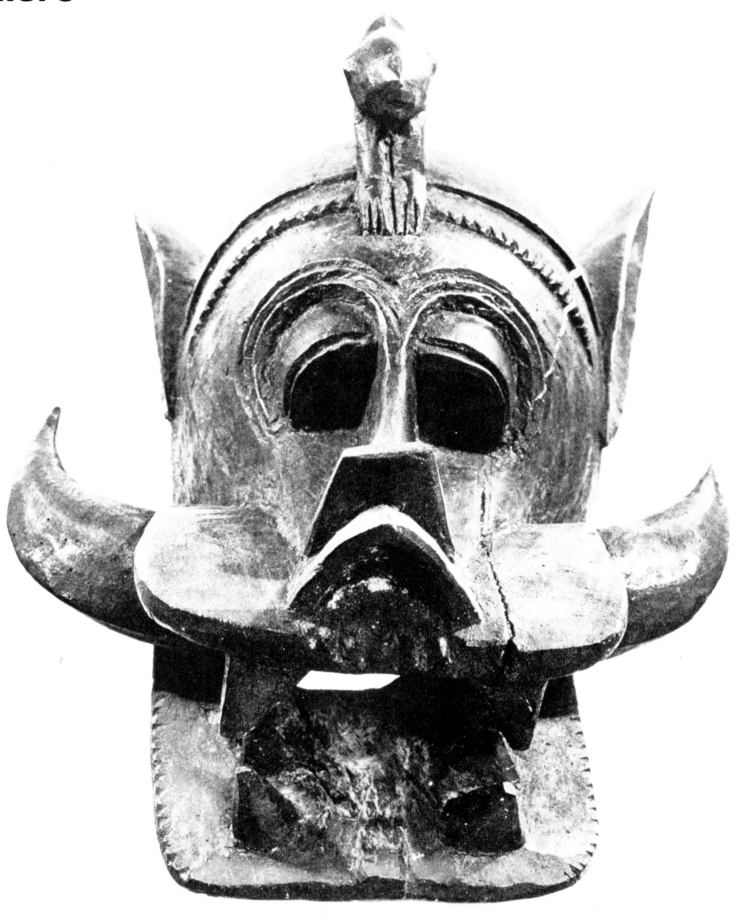

104
DANCE MASK

*This helmet mask, part boar, part man, and
surmounted by a chameleon, was collected by
M. Lem at Faïdonga, near Korhogo in western
Senufoland; he attributes it to the Lo society, but some
such masks belong to the Korubla anti-sorcery society.*

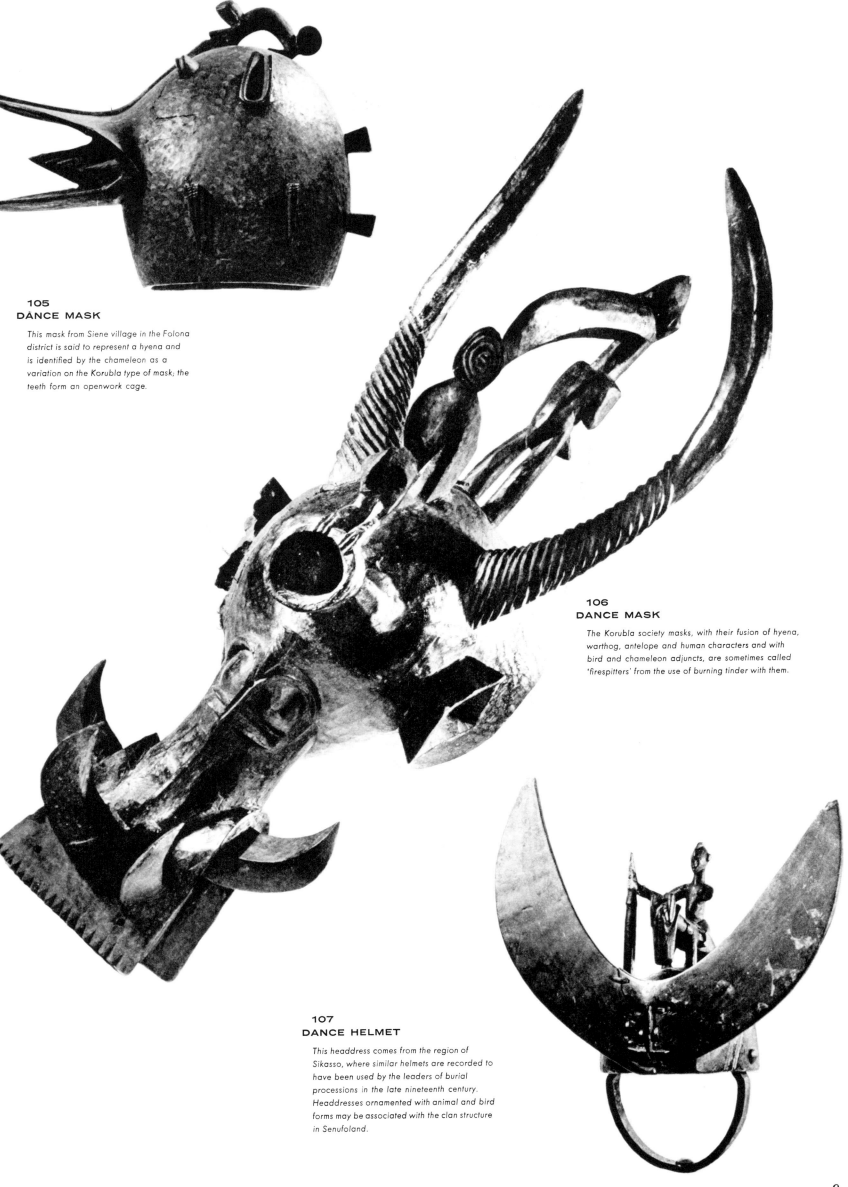

105
DANCE MASK

This mask from Siene village in the Folona district is said to represent a hyena and is identified by the chameleon as a variation on the Korubla type of mask; the teeth form an openwork cage.

106
DANCE MASK

The Korubla society masks, with their fusion of hyena, warthog, antelope and human characters and with bird and chameleon adjuncts, are sometimes called 'firespitters' from the use of burning tinder with them.

107
DANCE HELMET

This headdress comes from the region of Sikasso, where similar helmets are recorded to have been used by the leaders of burial processions in the late nineteenth century. Headdresses ornamented with animal and bird forms may be associated with the clan structure in Senufoland.

SENUFO

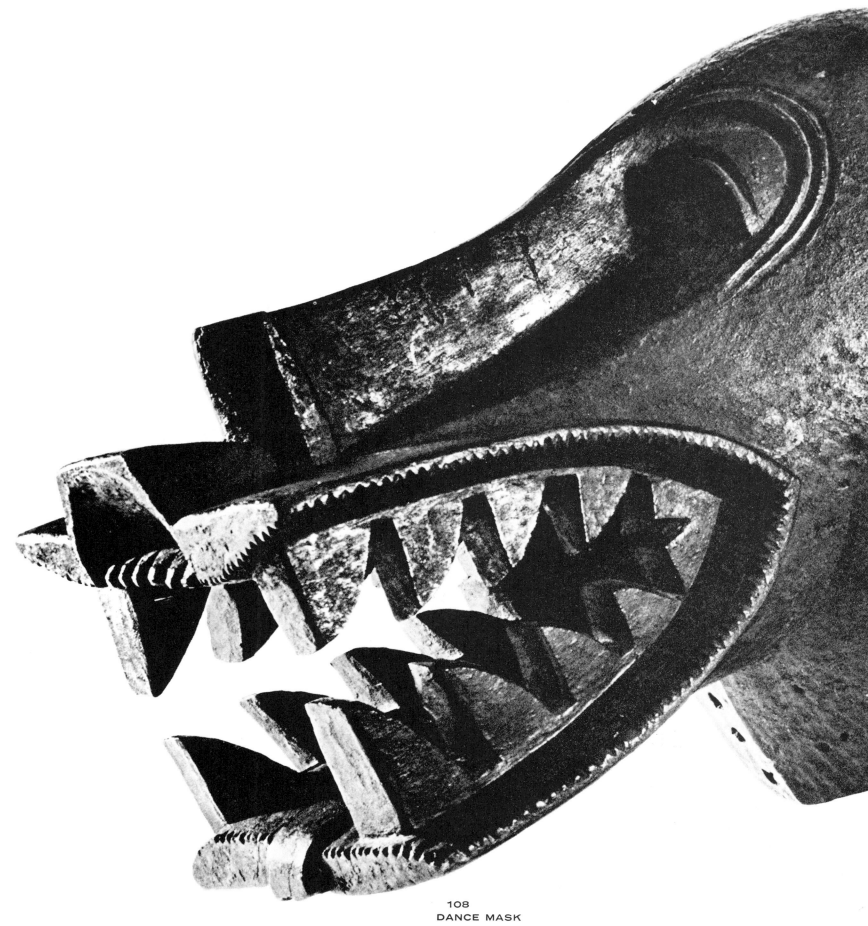

108
DANCE MASK

*This is one of the finest and simplest of the Korubla hyena
masks. Tinder is said to be burnt in the mouth or in a cup on
the crown, though signs of burning are seldom if ever evident.*

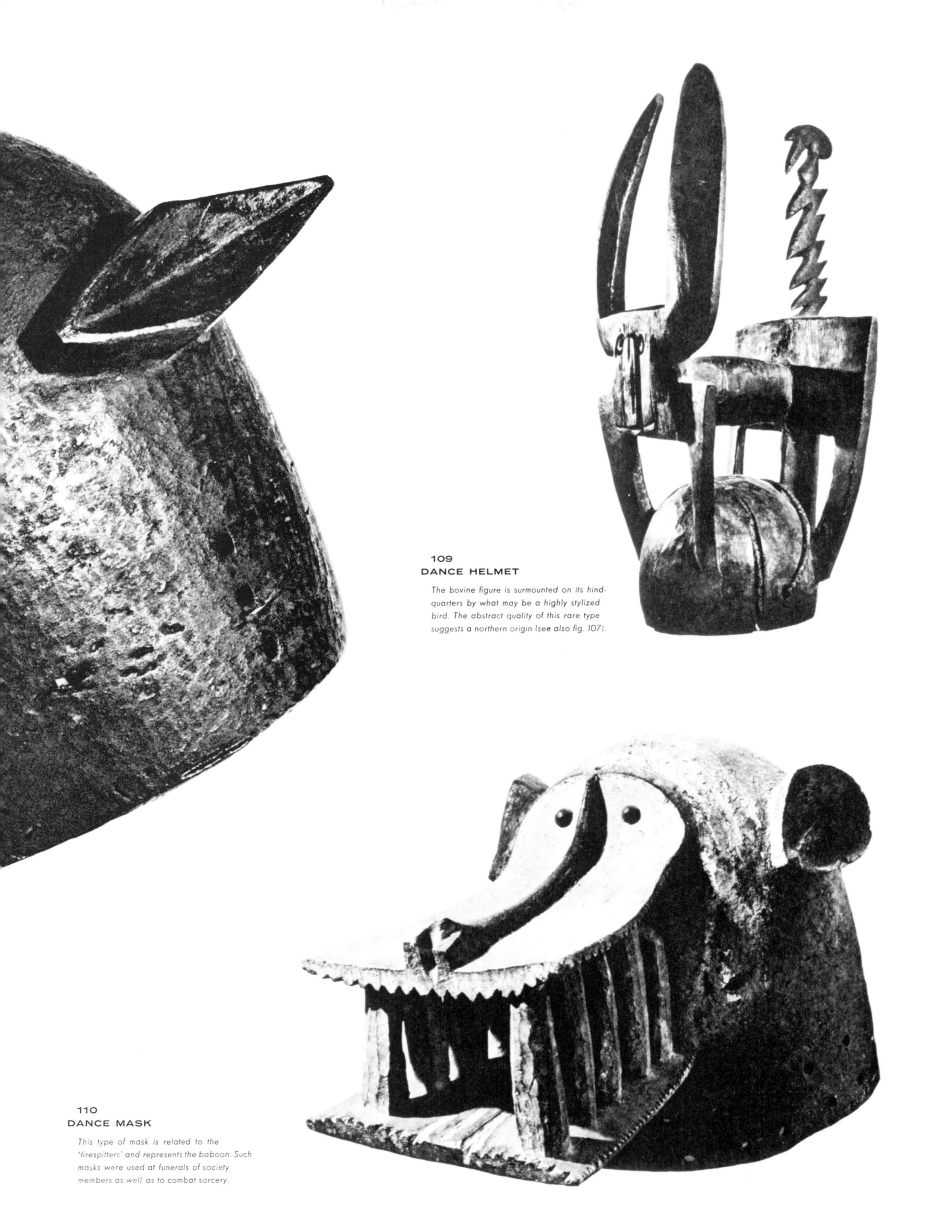

109
DANCE HELMET

*The bovine figure is surmounted on its hind-
quarters by what may be a highly stylized
bird. The abstract quality of this rare type
suggests a northern origin (see also fig. 107).*

110
DANCE MASK

*This type of mask is related to the
'firespitters' and represents the baboon. Such
masks were used at funerals of society
members as well as to combat sorcery.*

SENUFO

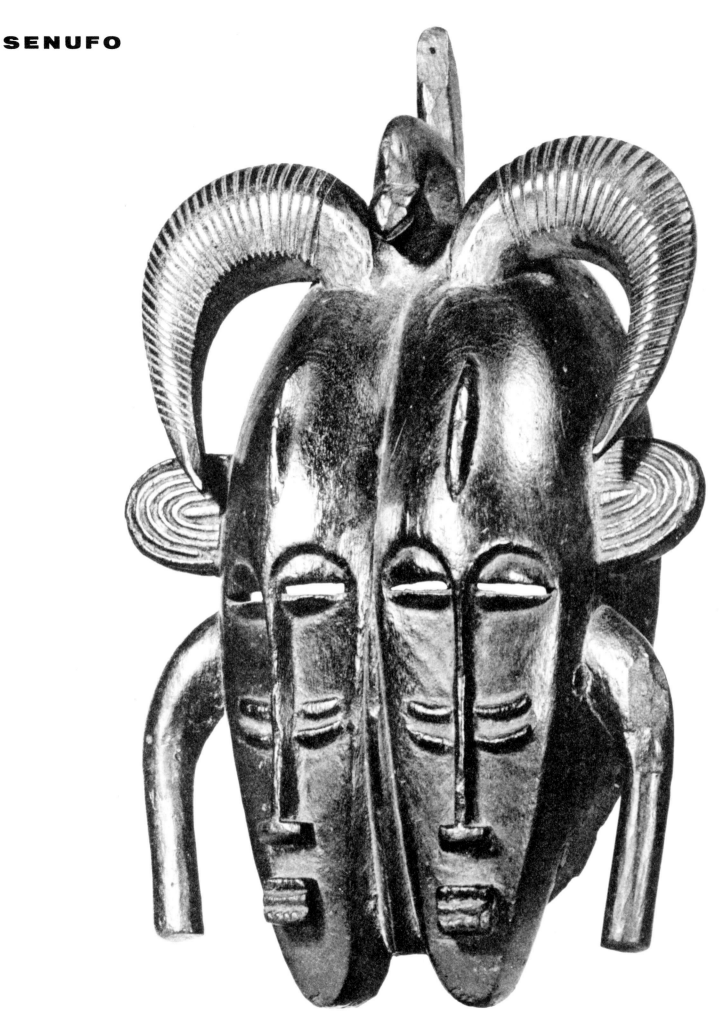

111
DANCE MASK

These frontal face masks are the best known
of the Senufo works, though fine specimens
are rare, particularly those with two faces.
They are usually horned, and the pendent
pieces at the sides have been thought to
represent rudimentary legs.

112
DANCE MASK

These masks seem to belong to the south-
western Senufo. Nowadays crude copies of
them are turned out in large numbers for the
curio trade by Senufo and others. The
type is sometimes carved in relief on Senufo
doors.

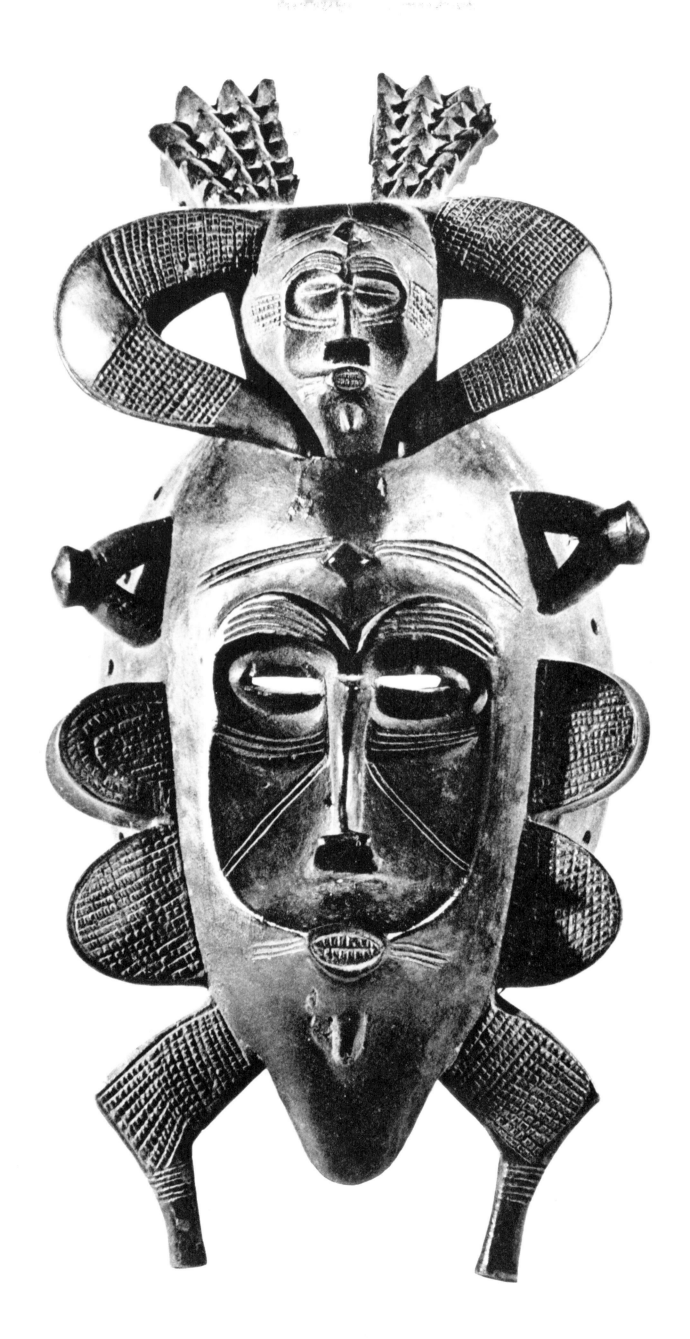

GURO

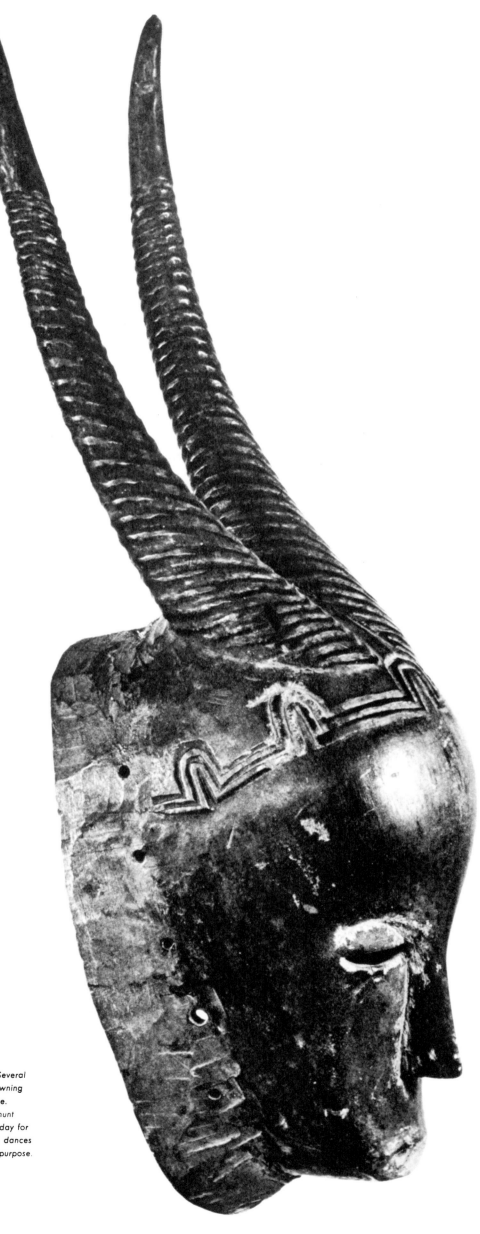

113
DANCE MASK

Guro art comprises chiefly masks and heddle pulleys. Several
mask societies occur, often in the same village, each owning
various animal masks, some with human features as here.
The tutelary spirit of Guro society emerges at night to hunt
sorcerers and attend burials; Gori masks come out by day for
funerals; the Zamle dancers perform bird and antelope dances
for the populace. Increase seems to be the underlying purpose.

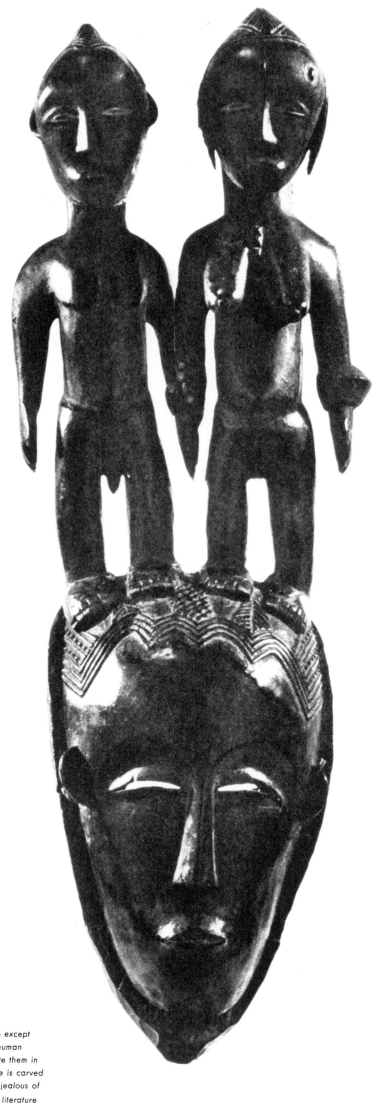

114
DANCE MASK

Wooden figures are almost unknown among the Guro except occasionally when carved, in couples, on the top of human masks of one sub-style; no attempt is made to integrate them in one composition with the mask, even though the whole is carved from a single block of wood. This people seems very jealous of its religious art, as many mask types mentioned in the literature are not found in collections. The angular hairline is a Guro characteristic.

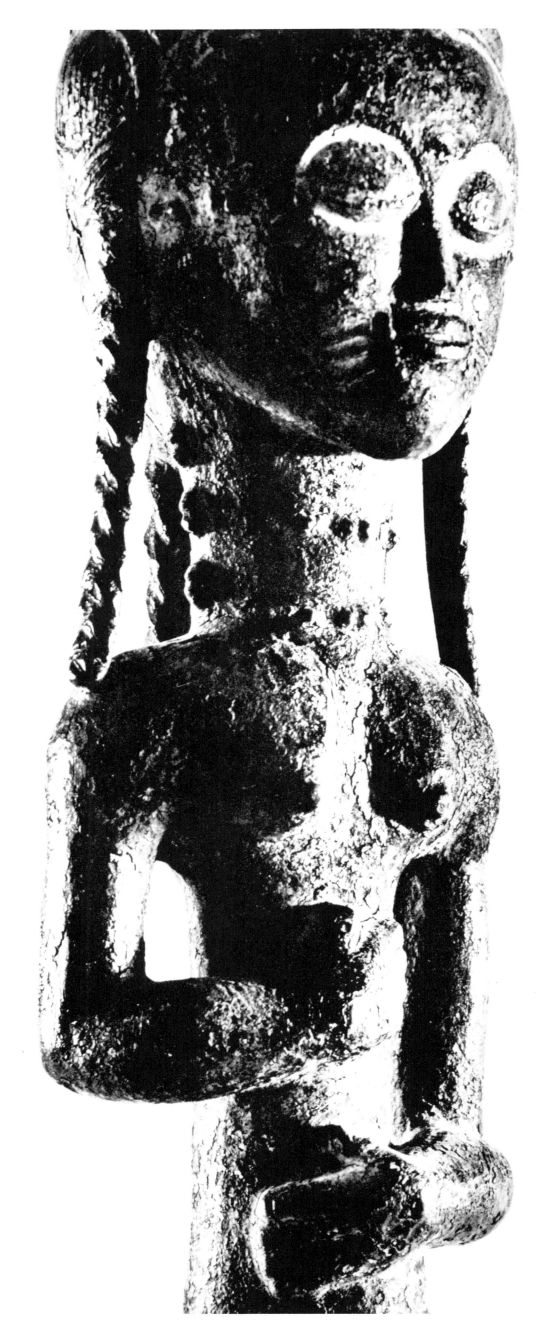

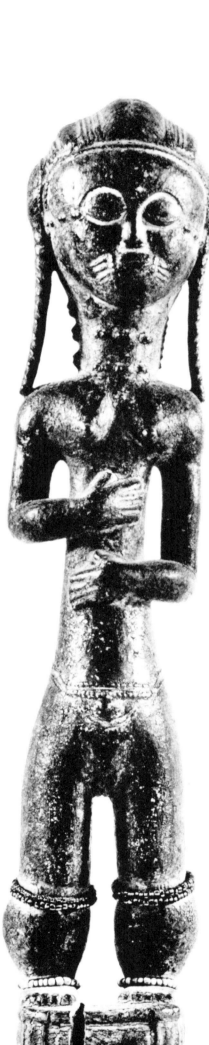
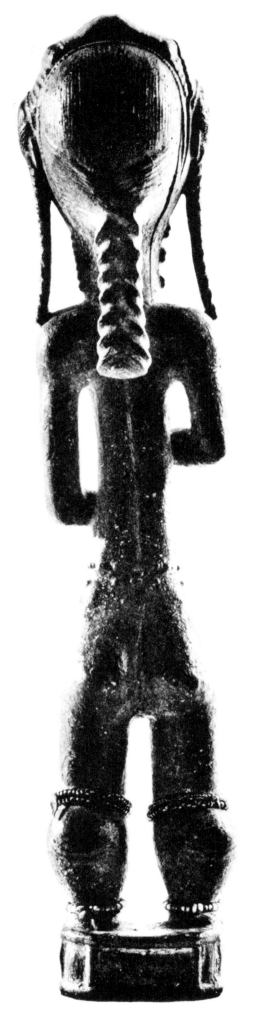

115-117
FEMALE FIGURE

The Baule show more interest than the Guro in spheroidal and other forms suggestive of solid geometry rather than in sinuous line carried through the composition: on these forms is superimposed their characteristic relief scarification, especially above the bridge of the nose.

BAULE

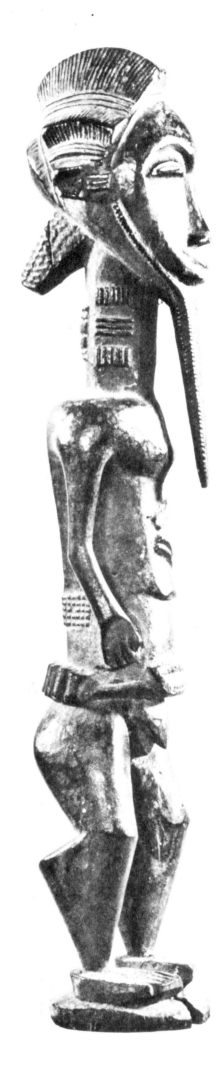

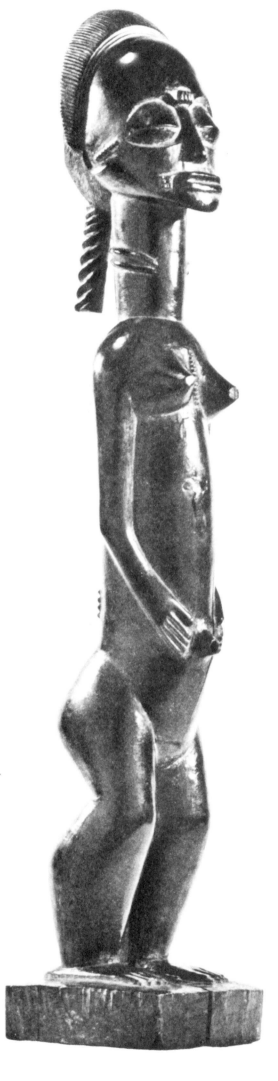

119
FEMALE FIGURE

*Baule style is among the most
sophisticated in Africa and
indeed often verges on
aestheticism. Arms are commonly
carved in relief.*

118
MALE FIGURE

*Baule figures may be carved for the ancestor cult, as secular
'portraits' of living or dead persons, as repositories of
impersonal force, or for art's sake. But the purpose can be
determined only from external evidence.*

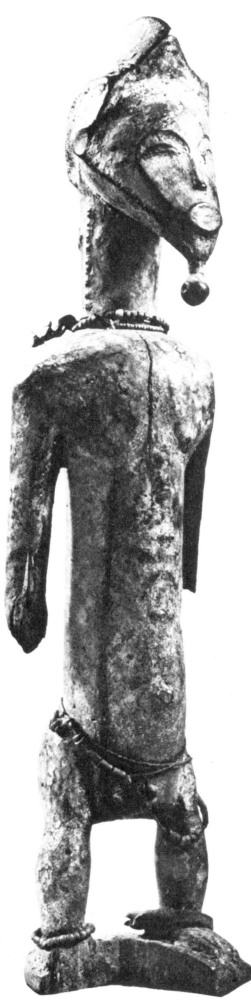

120
MALE FIGURE

This is an unusually vigorous piece and appears older than most examples. The beard ending in a knob is frequently found in Baule masks and figures, but the elongation of the lower face is unusual.

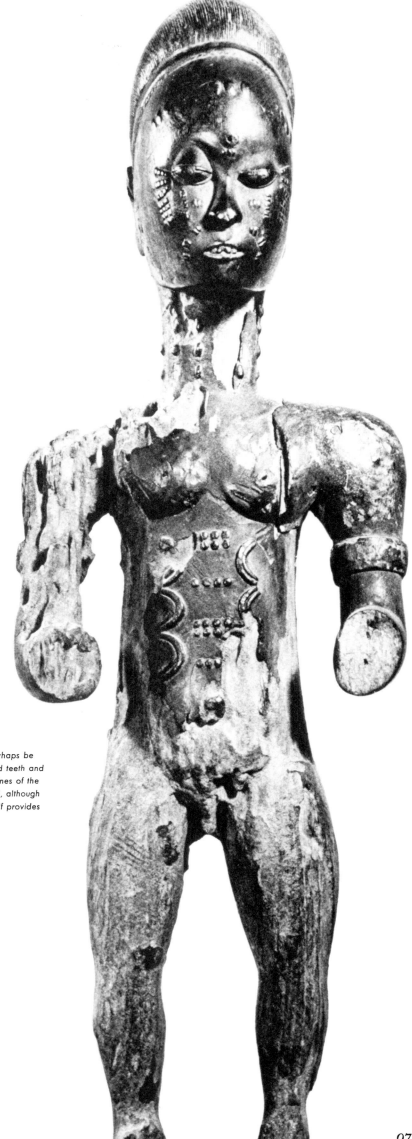

121
MALE FIGURE

Guro influence may perhaps be discerned in the shaped teeth and the sensuous, flowing lines of the head. This appears old, although termite damage by itself provides little criterion.

BAULE

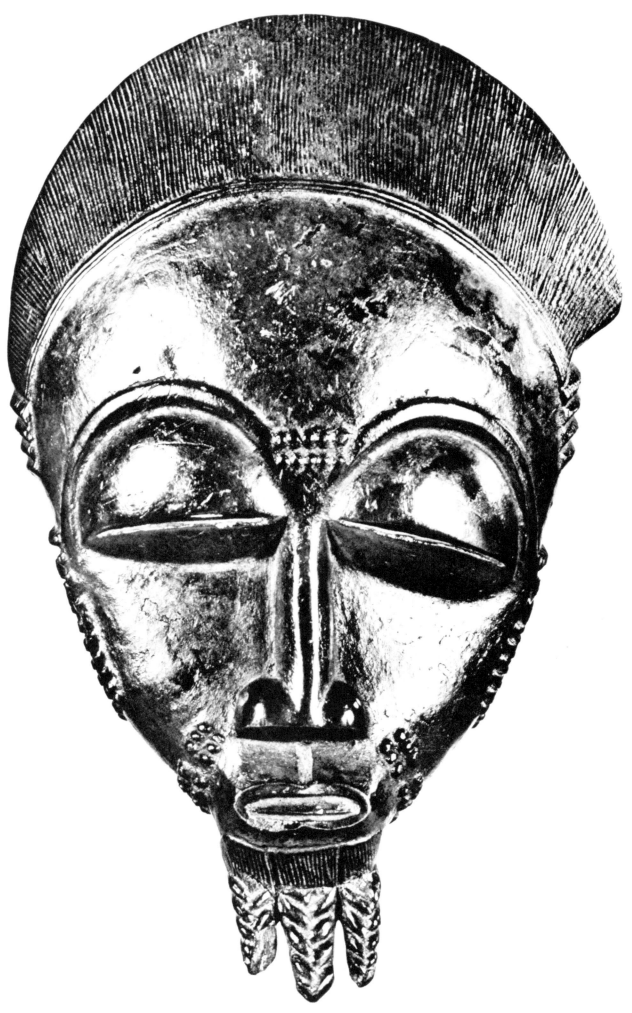

122
DANCE MASK

*Schematic nose, tribal marks and slightly
asymmetric coiffure are typical of the classical
Baule style, of which this is one of the purest
examples.*

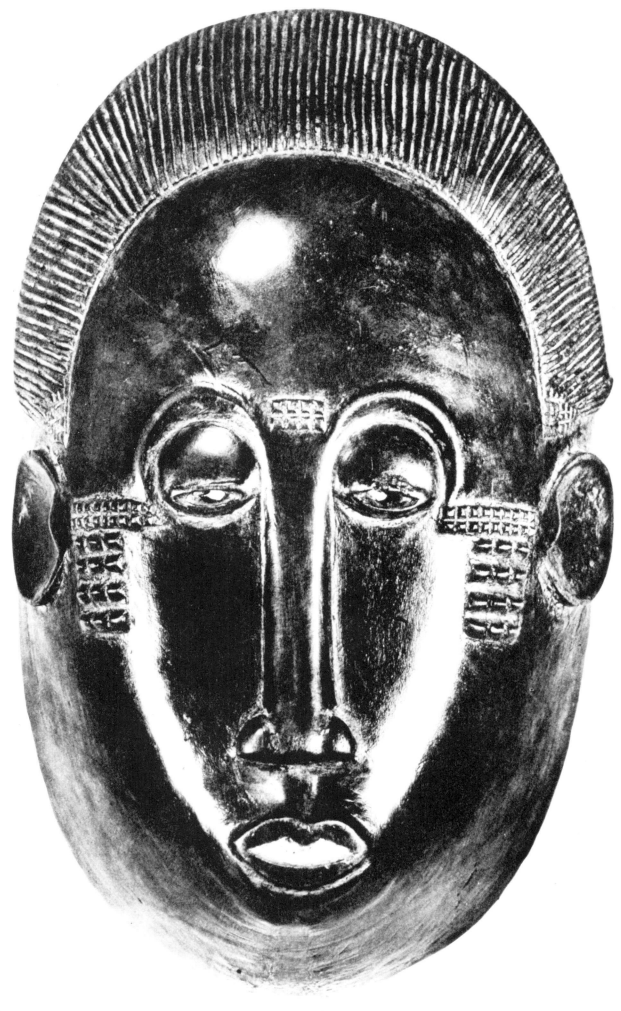

123
DANCE MASK

*Masks of these types are said to represent
male and female divinities. The transverse
crescentic coiffure is supposed to symbolize
the horns of a ram. This mask is not made
for wear.*

BAULE

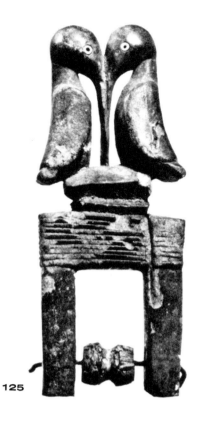

125

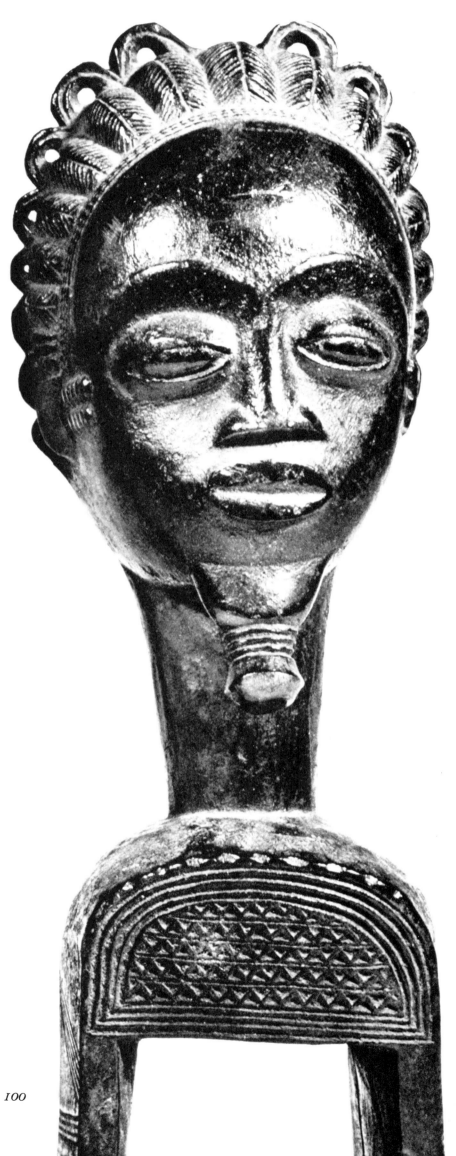

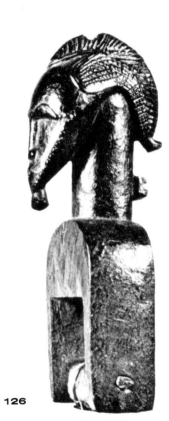

126

124

124-129
LOOM HEDDLE PULLEYS

From these pulleys are suspended the frames (heddles) used to separate alternate warps in a horizontal narrow band loom, as used by men throughout the Guinea Coast. A

100

127

128

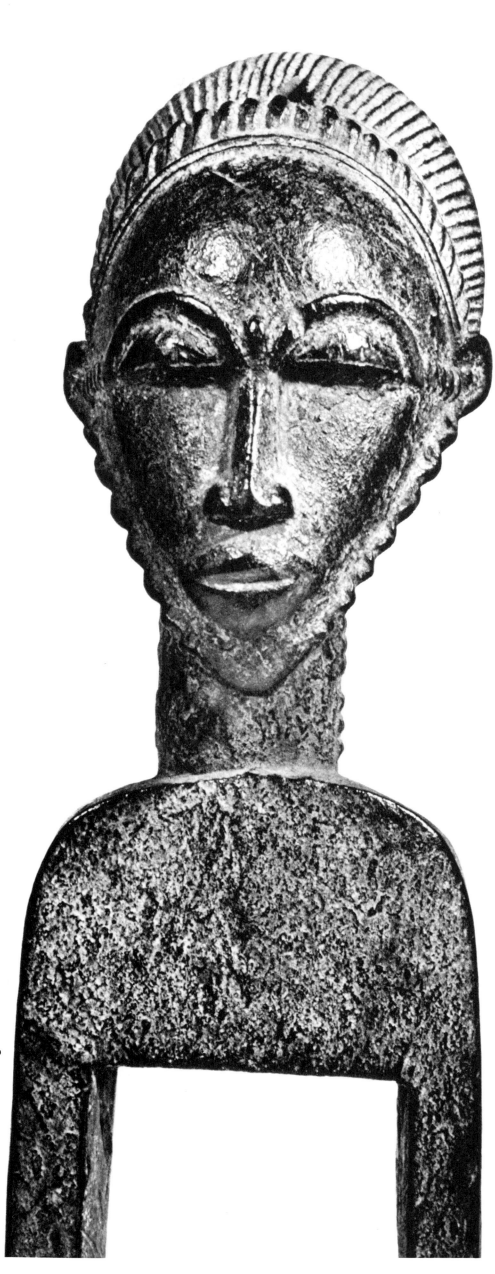

129

number of tribes carve ornamental pulleys,
but those of the Baule and Guro are the
most numerous and beautiful. Fig. 125 may
be of Senufo origin. Fig. 128 is derived from
a common bovine mask. No ritual purpose
is ascribed to these pulleys.

BAULE

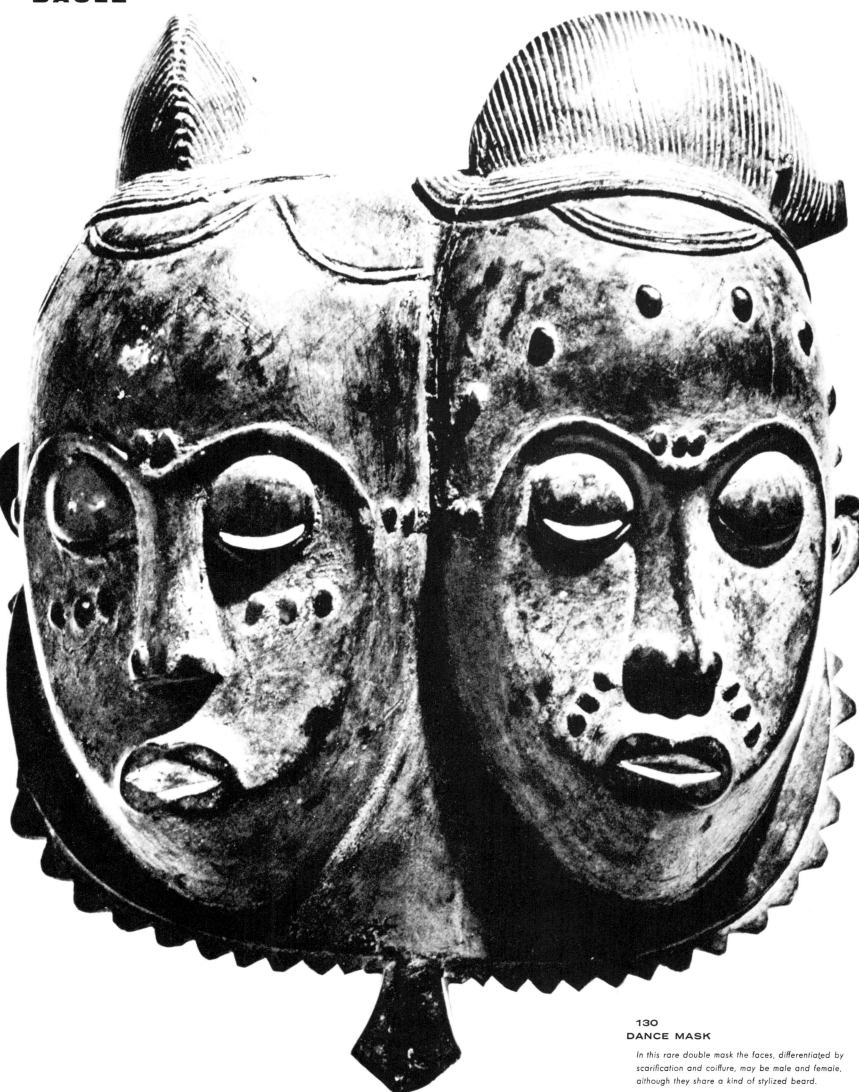

**130
DANCE MASK**

*In this rare double mask the faces, differentiated by
scarification and coiffure, may be male and female,
although they share a kind of stylized beard.*

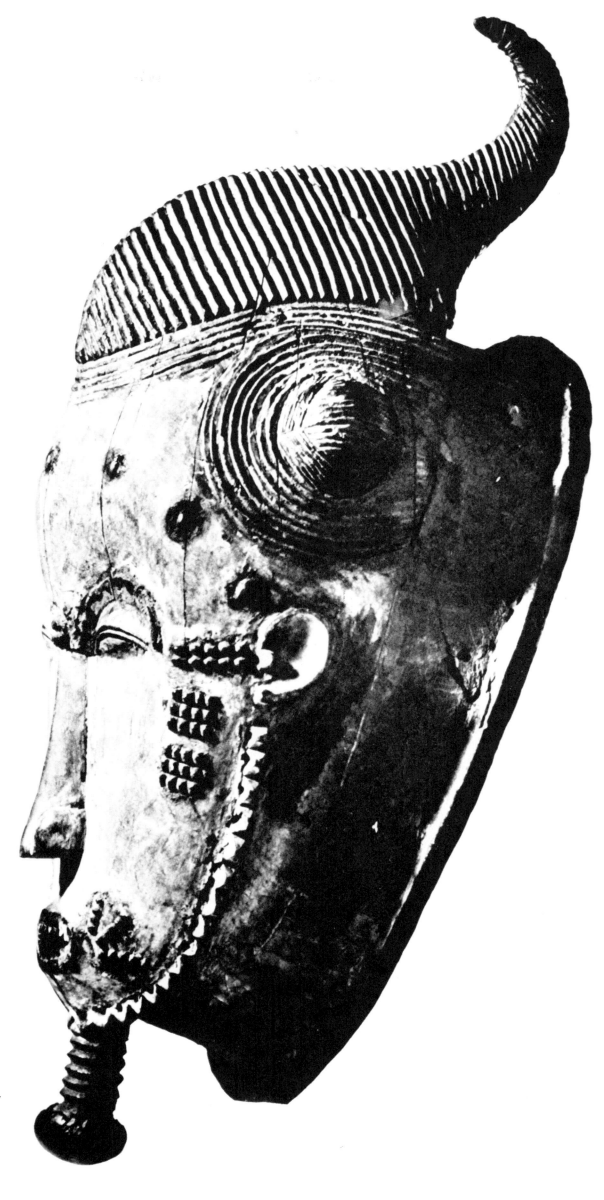

131
DANCE MASK

The recurving lock of hair, angular hairline
and painted face are Senufo traits, although
the essentials of Baule style are also present.
The eyes are not pierced.

BAULE

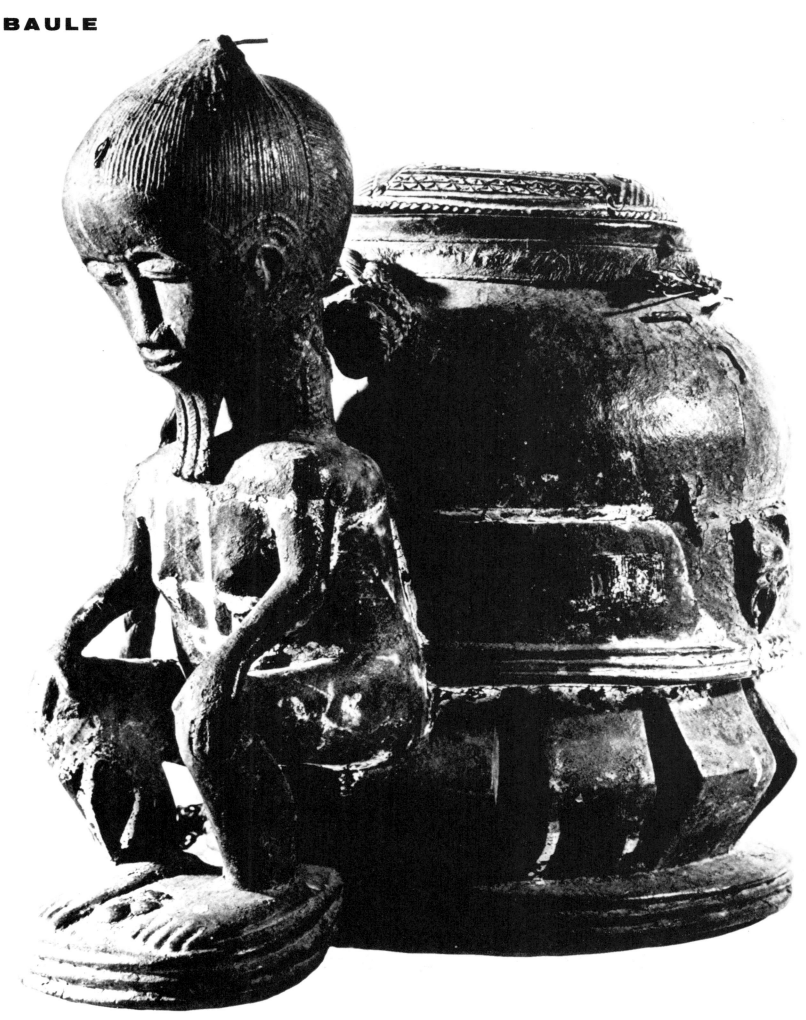

132
MOUSE ORACLE

Divination is based on interpretation of patterns produced when mice disturb sticks arranged within the vessel. This example from the Atutu sub-tribe is unusual in being carved with a human figure in the round.

133
DOOR

Bas-reliefs, sometimes coloured, adorn the doors and clay walls of many houses, secular as well as religious. The diverse representational designs include animals, fish, tutelary spirits and genre scenes.

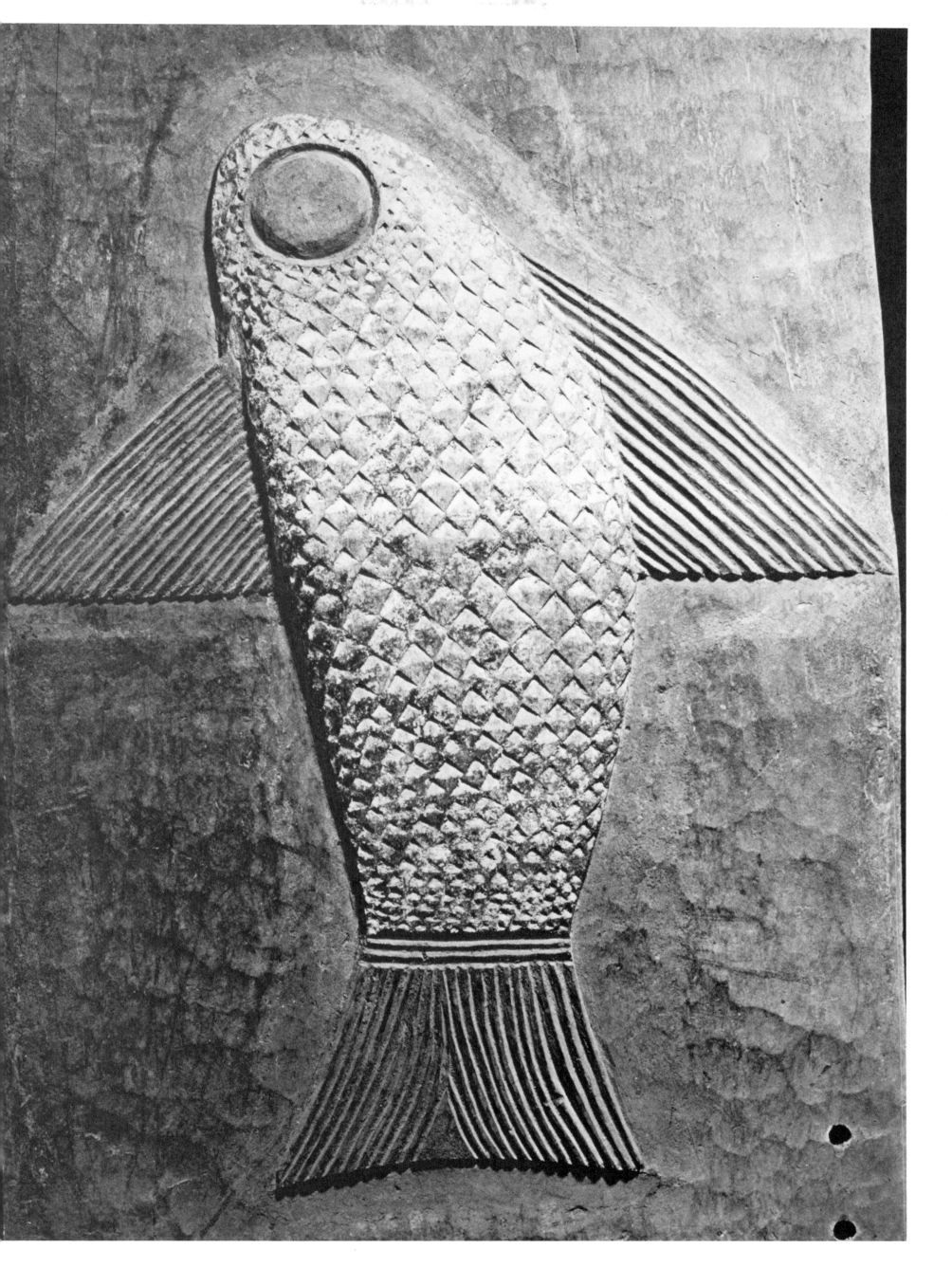

ASHANTI

134
GIRL'S DOLL

*Almost the only form of representational wood carving
among the Ashanti is the akua 'ba or girl's doll. This old
piece is unusual in its suggestion of movement and in
showing a mother holding a child.*

135
GIRL'S DOLL

*Girls carried such images thrust into the back of their
waistcloths, partly to ensure that their offspring would be
well formed. An Ashanti ideal of beauty is expressed by
the discoid head and long neck.*

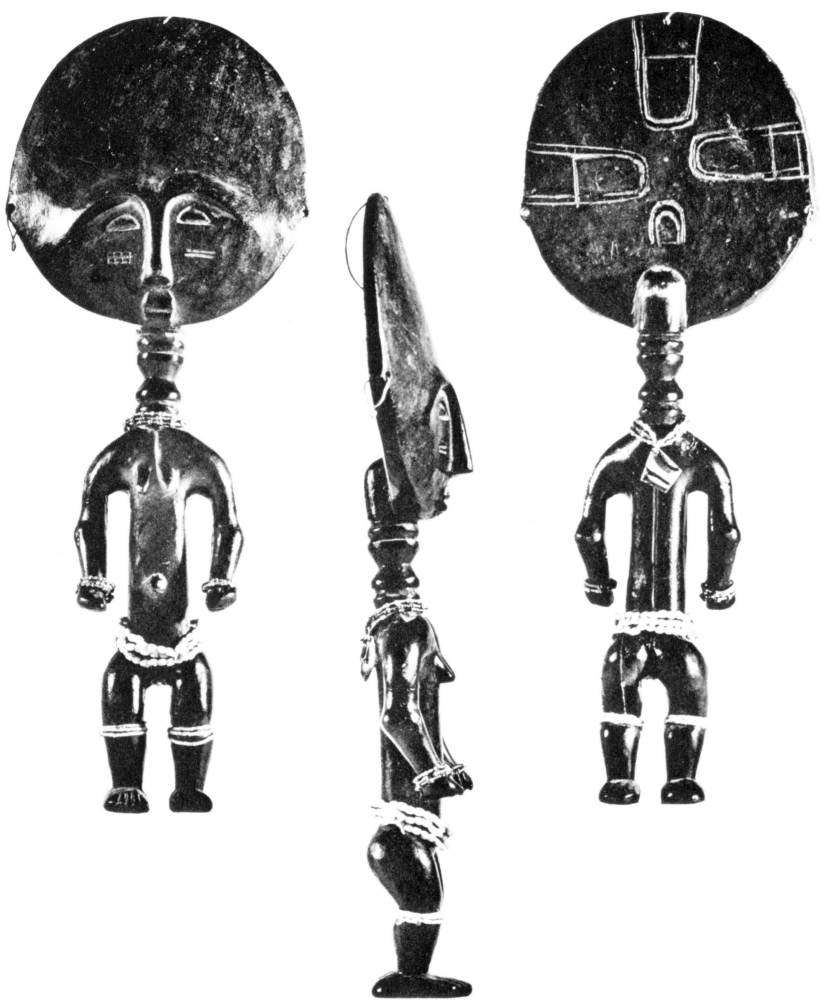

136
GIRL'S DOLL

Full representation of body and limbs is thought recent.
Fig. 135 being more characteristic. The disc-headed
conception occurs often in Ashanti pottery. Varied symbolic
designs are carved at the backs of the heads.

ASHANTI

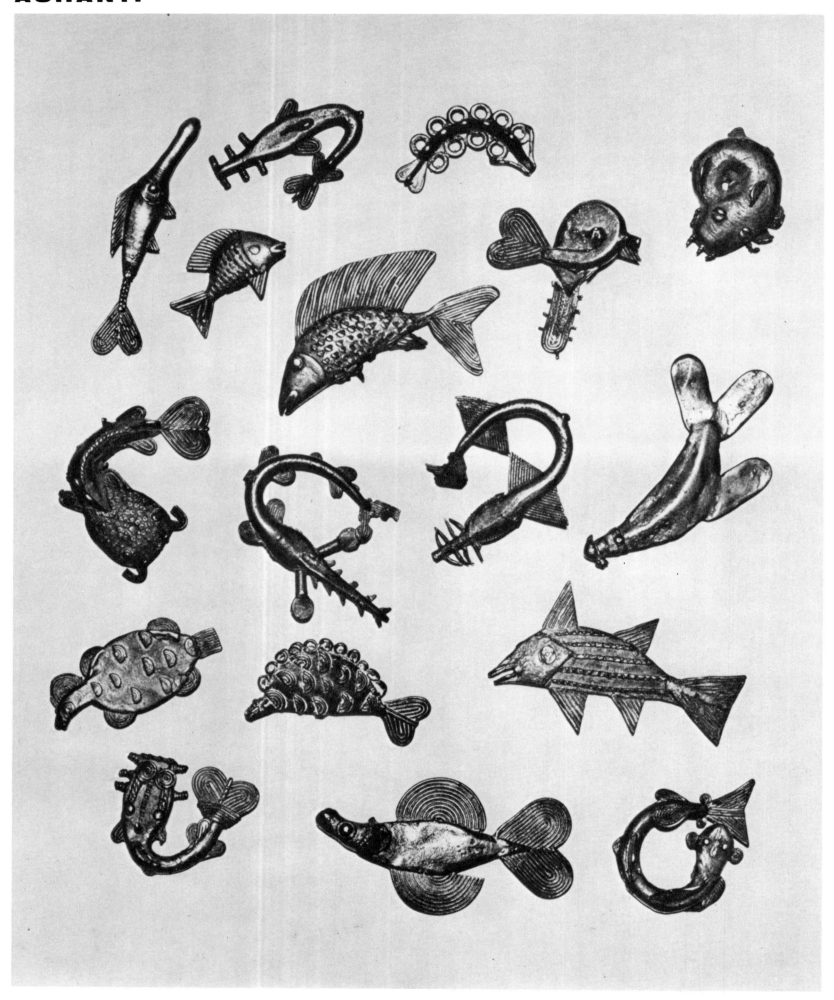

137-138
WEIGHTS FOR GOLD DUST

Before colonial times, the Ashanti medium of exchange was
gold dust. Payments were determined by an intricate system
of weights, gold being balanced on the scales by an object
of inferior metal, usually brass. These counterbalances, cast

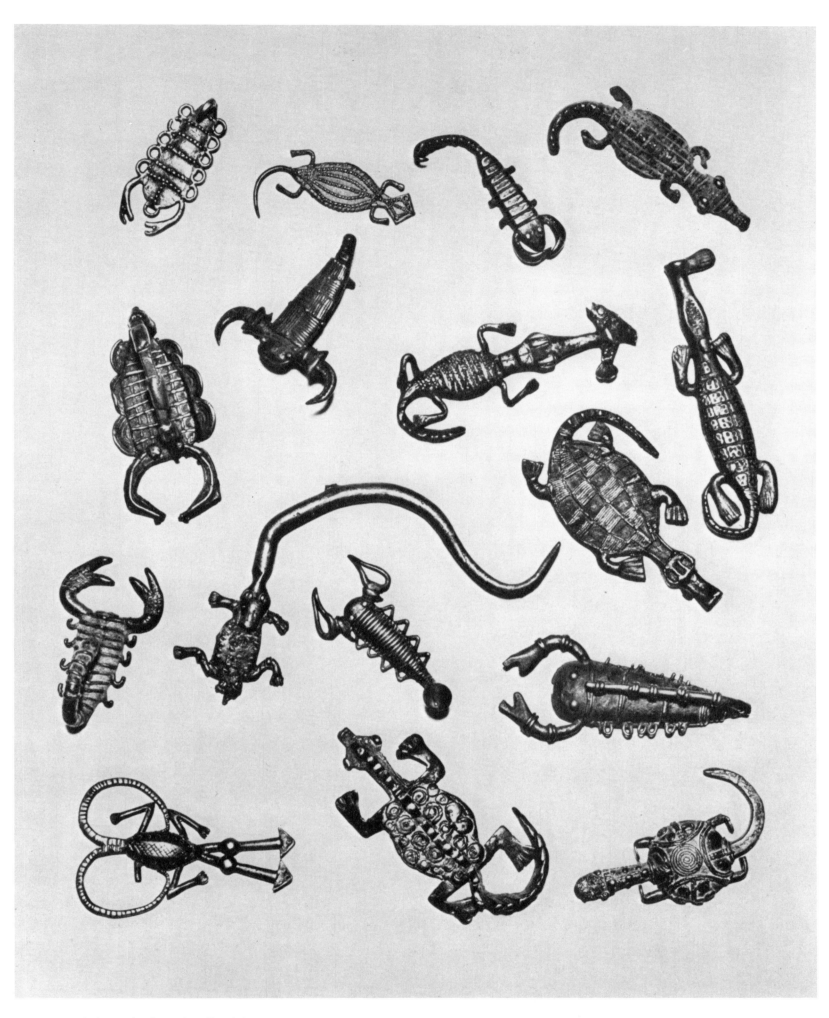

by the lost-wax method, were of endless variety, although
their weights were fixed by royal decree.
Subjects included geometric forms, supposed to be the
earliest, artifacts, vegetables, insects, birds, animals and men,
alone or in innumerable combinations; some illustrated
proverbs or embodied cosmological symbols.

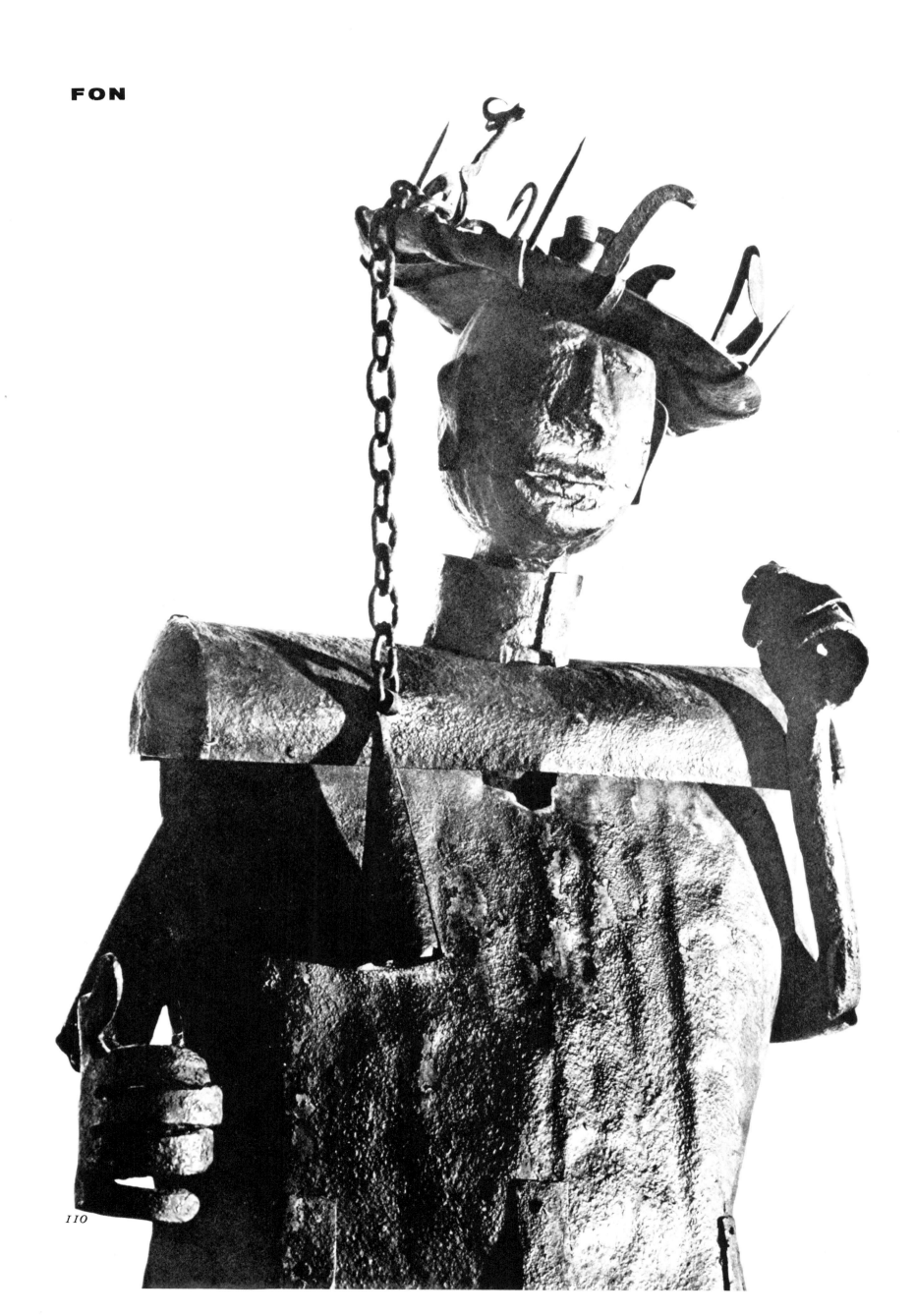

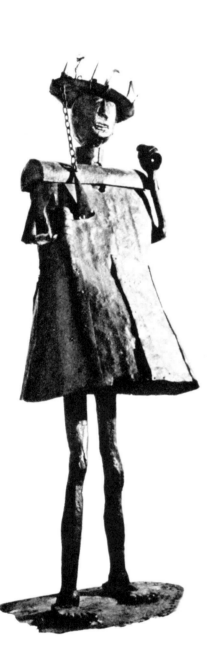

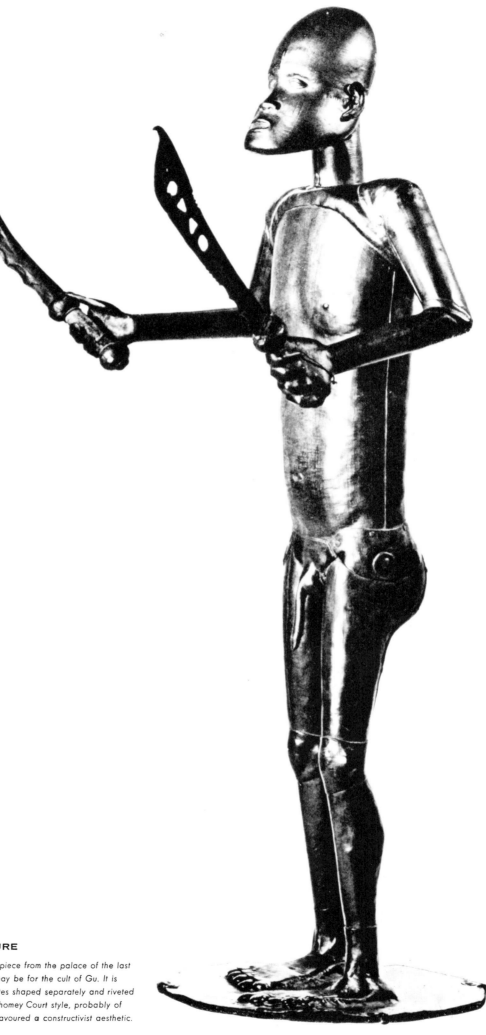

139
SHRINE FIGURE

*This, the largest piece of wrought iron
sculpture known from Africa, is said
to have been made for the cult
of Gu (the Yoruba Ogun), god of
iron and war.*

140
SHRINE FIGURE

*Like the last, this piece from the palace of the last
king, Behanzin, may be for the cult of Gu. It is
composed of plates shaped separately and riveted
together. The Dahomey Court style, probably of
synthetic origin, favoured a constructivist aesthetic.*

YORUBA

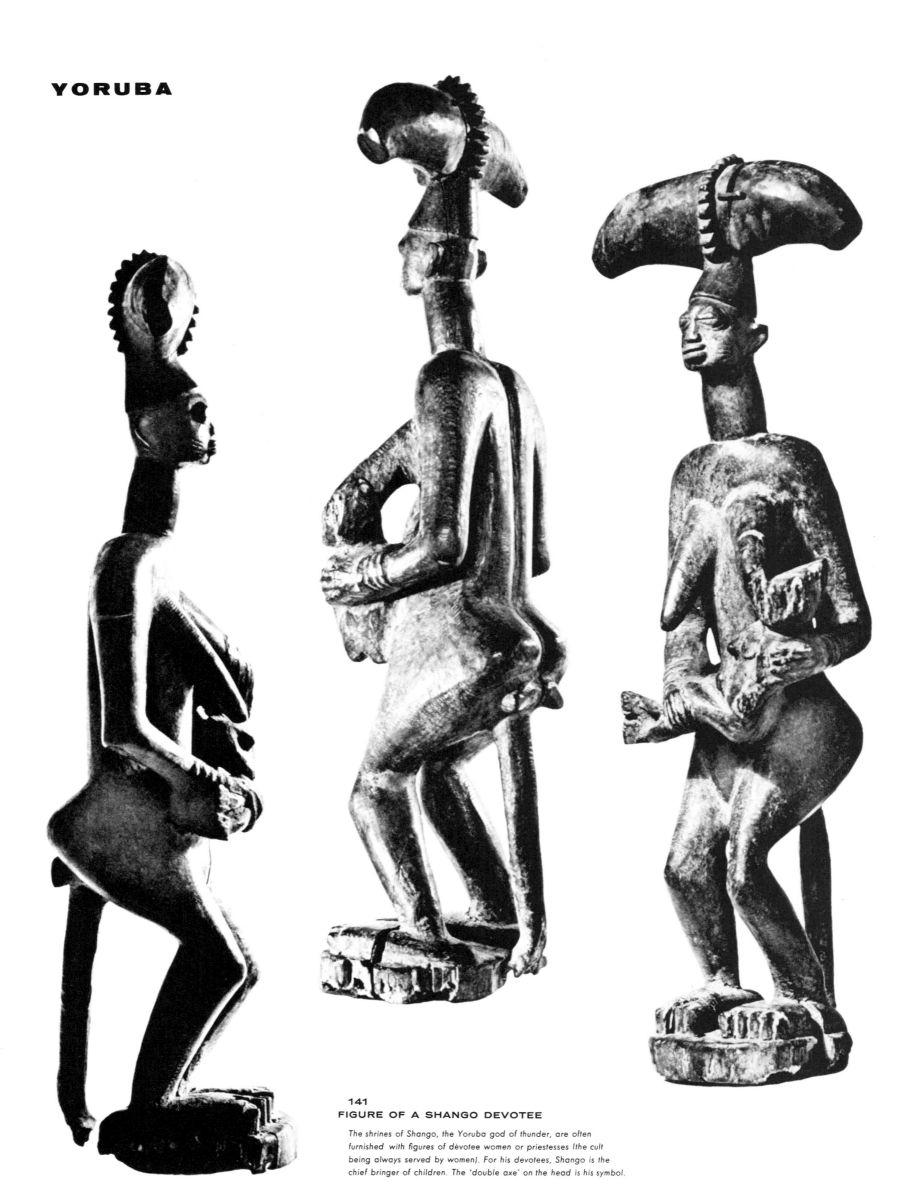

141
FIGURE OF A SHANGO DEVOTEE

*The shrines of Shango, the Yoruba god of thunder, are often
furnished with figures of dèvotee women or priestesses (the cult
being always served by women). For his devotees, Shango is the
chief bringer of children. The 'double axe' on the head is his symbol.*

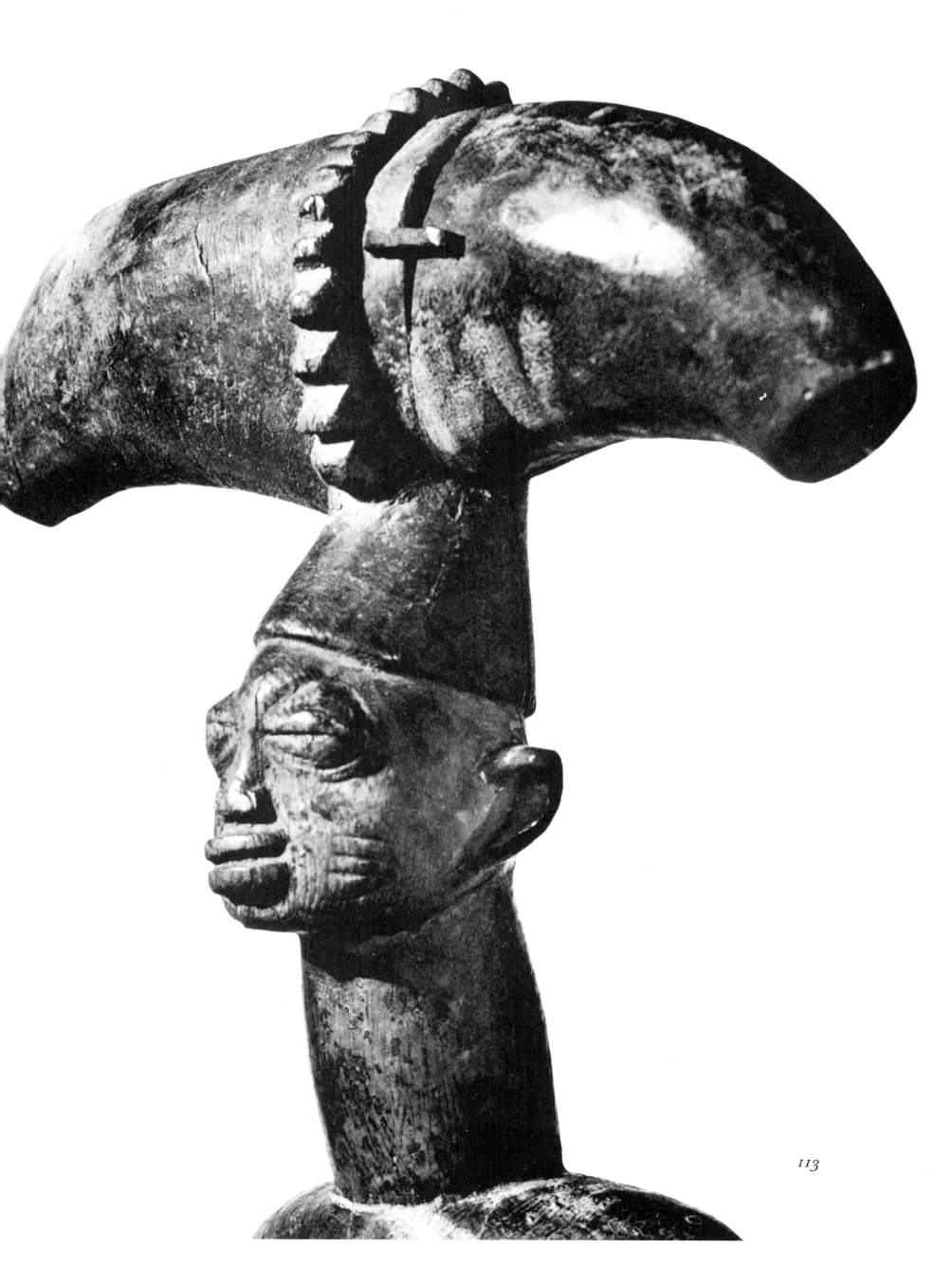

YORUBA

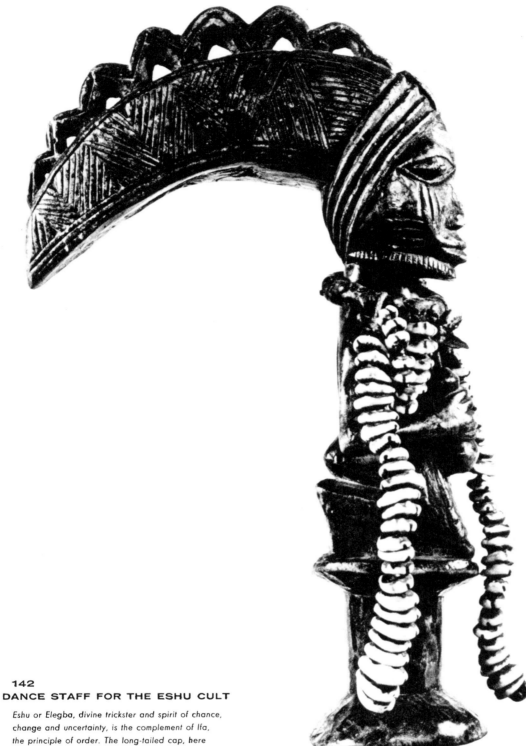

142
DANCE STAFF FOR THE ESHU CULT

Eshu or Elegba, divine trickster and spirit of chance,
change and uncertainty, is the complement of Ifa,
the principle of order. The long-tailed cap, here
exaggerated, is his symbol.

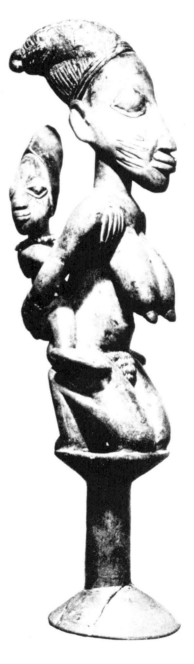

143
DANCE STAFF FOR THE
SHANGO CULT

The Shango symbol is implied in the forked
hairdress. These staffs are carried by
devotees possessed by the god at his
festival.

144
DANCE MASK FOR THE EPA FESTIVAL

Epa is an increase cult of north-eastern Yorubaland,
in which youths perform short twisting dances and
high jumps while wearing these unwieldy masks,
which may weigh up to 80 pounds. This mask,
called Jagunjagun, the warrior, was carved in one
piece by the famous sculptor (and senior priest
of Ifa) Bamgboye of Odo-Owa about 1925.

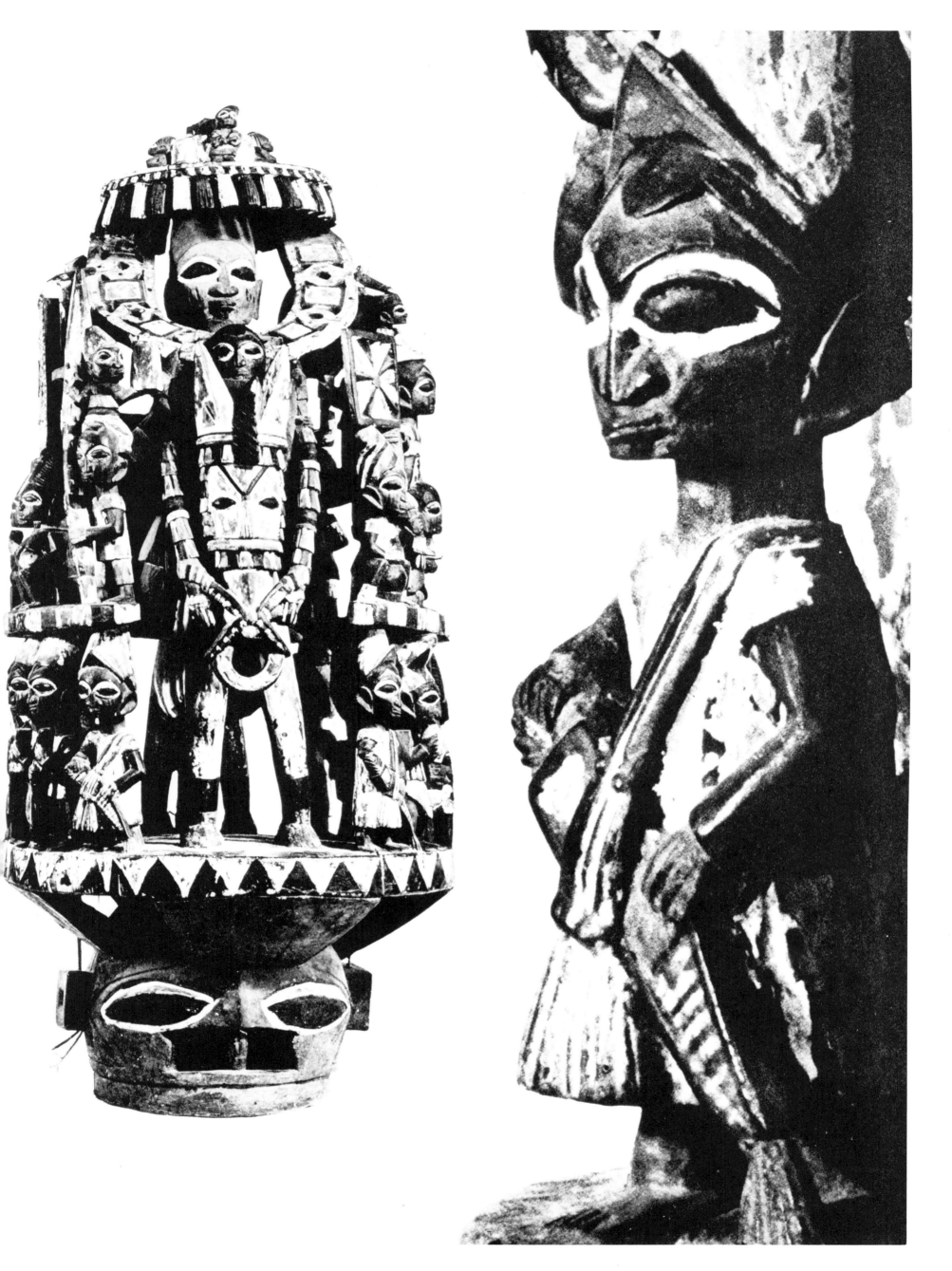

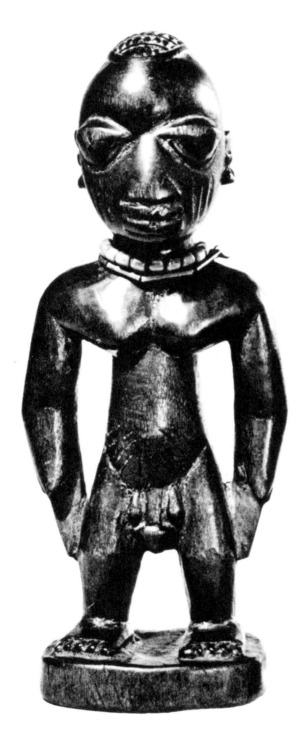
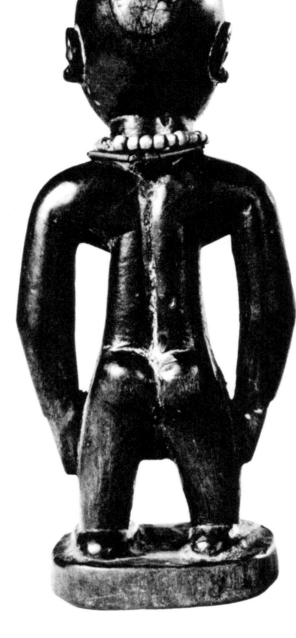
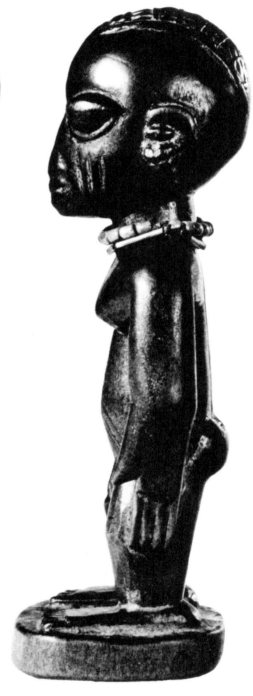

145
TWIN FIGURE

In the Yoruba cult of twins (ibeji), a figure or figures are carved whenever one or both of a pair die, in order to avert further visitations on the family. The images are carefully tended and 'fed' by the family, sometimes for a century or more.

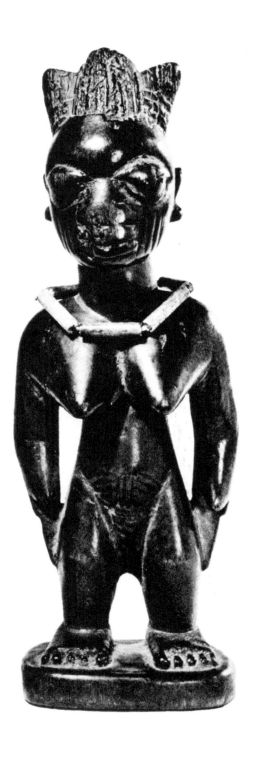

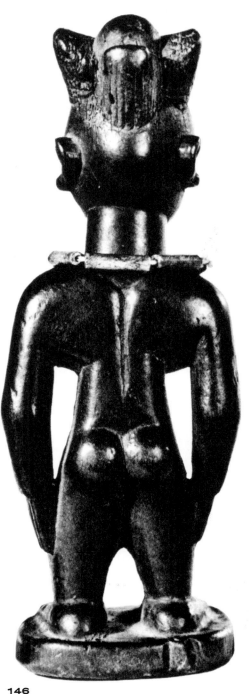

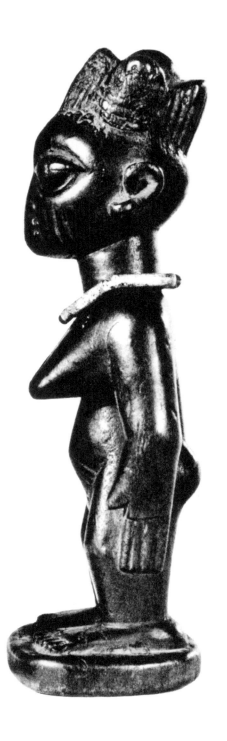

146
TWIN FIGURE

Since the ibeji cult is found almost everywhere in Yorubaland, these figures provide a valuable means of comparing local carving styles. These two, male and female, though not a pair, appear to be by the same carver or at least from the same village.

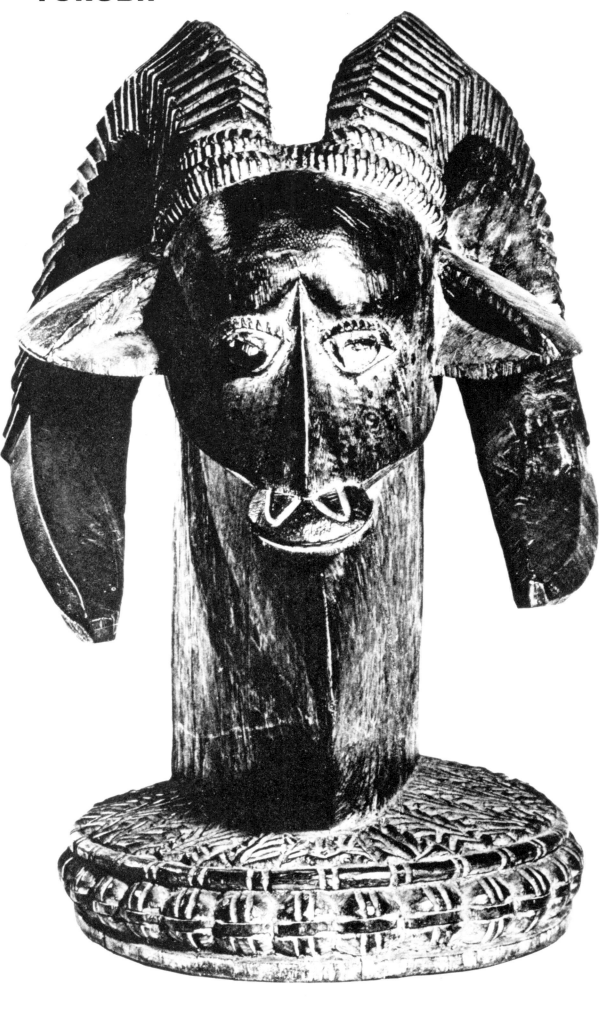

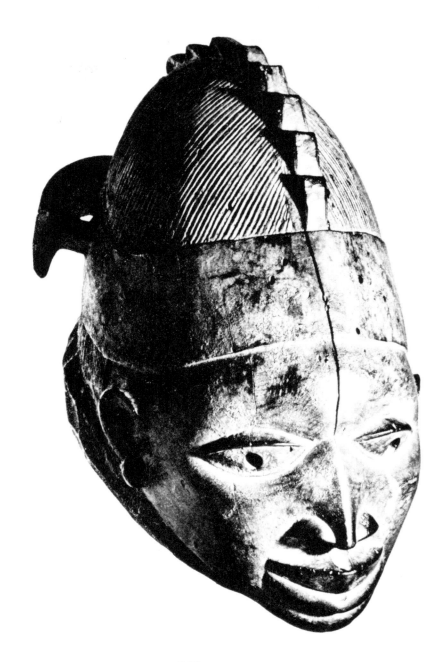

149
DANCE MASK FOR THE GELEDE CULT

The Gelede is a men's increase society which puts on plays at a yearly festival and at members' funerals in most towns of western Yorubaland. The mask spirits are said to be female, but the characters, in identical pairs, are mostly male. The dancers, clad in bright strips of cloth, and wearing the masks flat on their heads, use fluttering movements like birds, in a series of divertissements. This example was carved at Otta, 20 miles north of Lagos, about 1870.

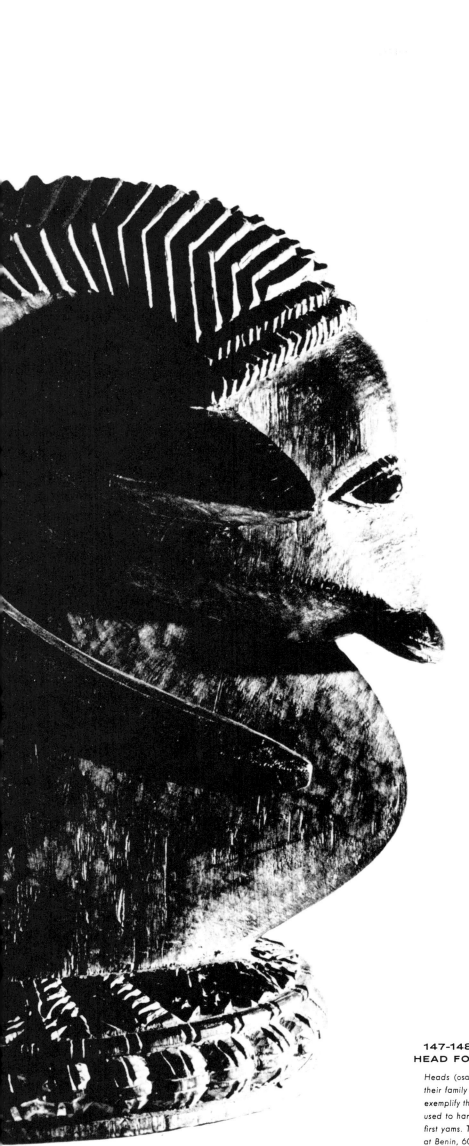

147-148
HEAD FOR THE YAM CULT

Heads (osamasinmwi) of rams or ram-horned men are kept on their family altars by chiefs of Owo in eastern Yorubaland, and exemplify the inseparability of ancestral and increase cults, being used to harness the power of the ancestors at the cutting of the first yams. They seem to be related to wooden ancestor heads at Benin, 60 miles to the south. This one was carved about 1909.

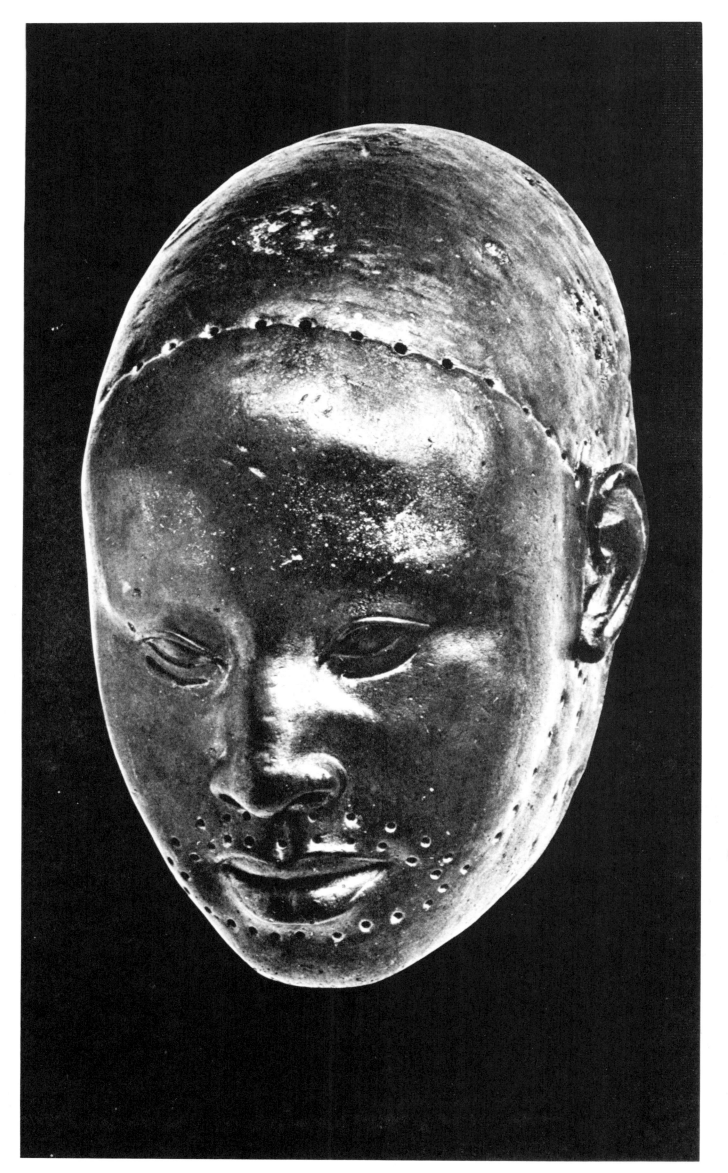

150-151
MASK AND HEAD

The mask is made to fit over the wearer's head and has slits below the eyes; it has always been in the possession of the Onis of Ife and is supposed to represent the third Oni, Obalufon II (only three generations from the creation of the world). The head is one of eighteen dug up at Wunmonije just outside the present walls of the Afin or palace in 1938. The small holes may be for the attachment of a ritual veil of beadwork.

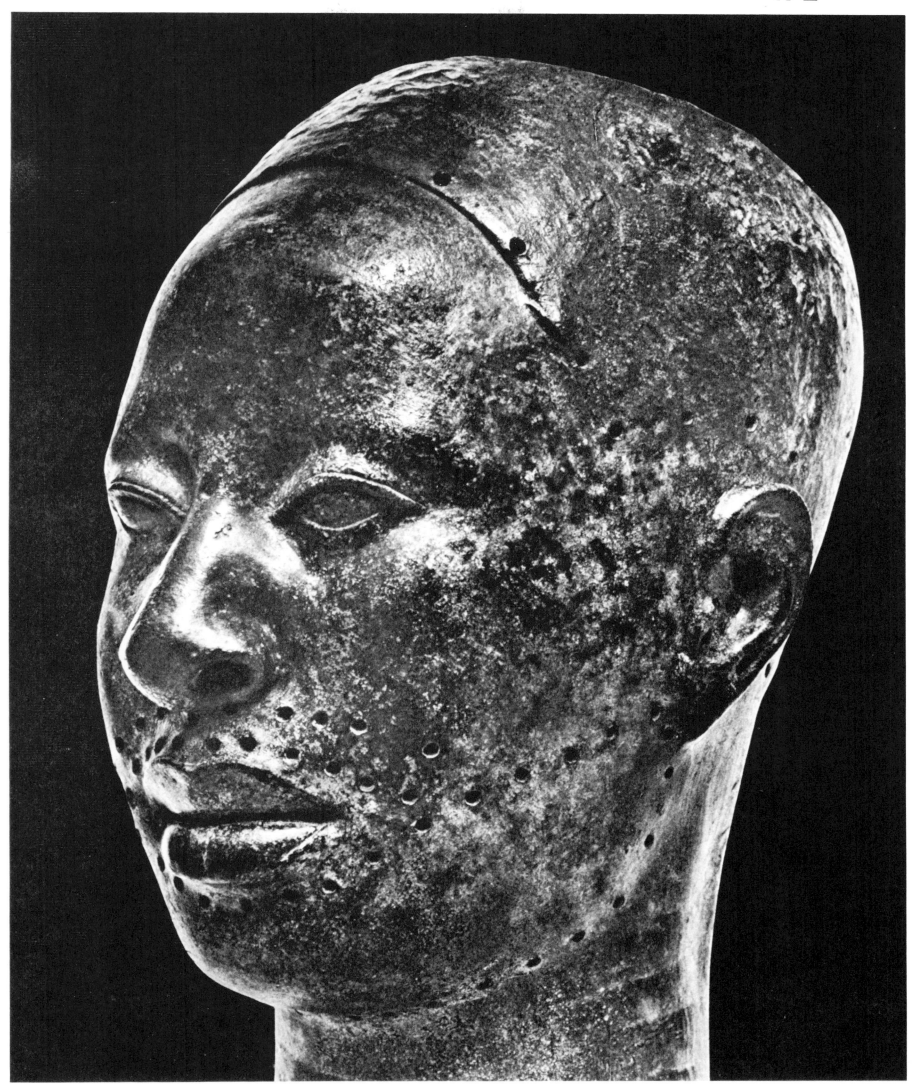

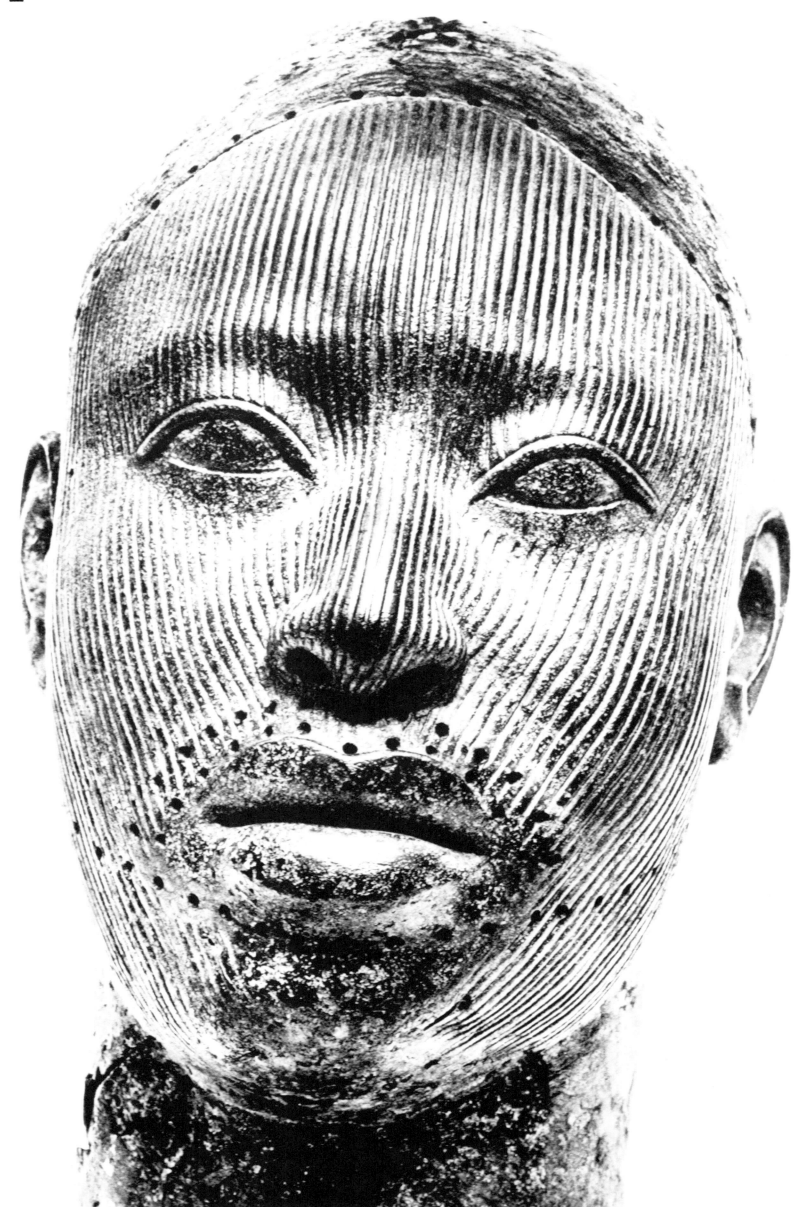

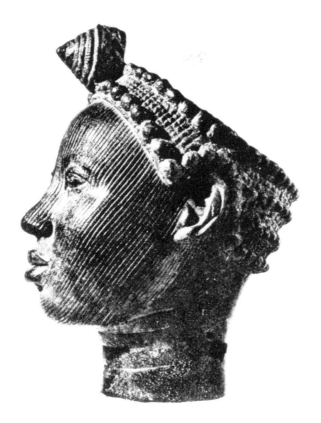

154
MEMORIAL HEAD

Although of feminine appearance, this and other heads of this smaller type are always crowned, and probably represent Onis. A plume similar to that of fig. 155 is broken off.

155
MEMORIAL HEAD

This resembles quite closely the first Ife bronze to become known, a head discovered by Frobenius in 1910 (which seems to have been replaced by a modern copy). Bands of red paint are present on the crown.

152
MEMORIAL HEAD

Although the Ife heads look to us like portraits, this is far from certain. The striations may represent facial scarification, or surface enhancement for aesthetic effect, or a way of suggesting long strings of small beads such as many Yoruba divine kings still wear, hanging from their crowns. This is one of several heads showing Hamitic features.

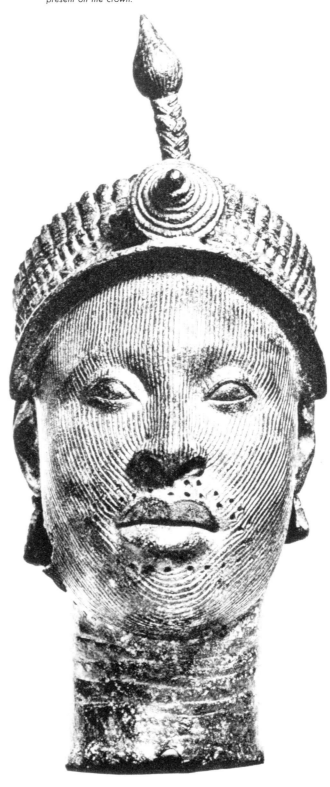

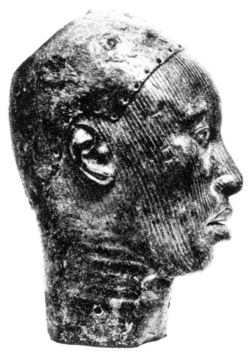

153
MEMORIAL HEAD

The features of this head are almost Mongoloid. The holes on the neck suggest that these heads were attached to wooden bodies or stands. The Yoruba of Owo still make life-like effigies of notables for their second burial.

IFE

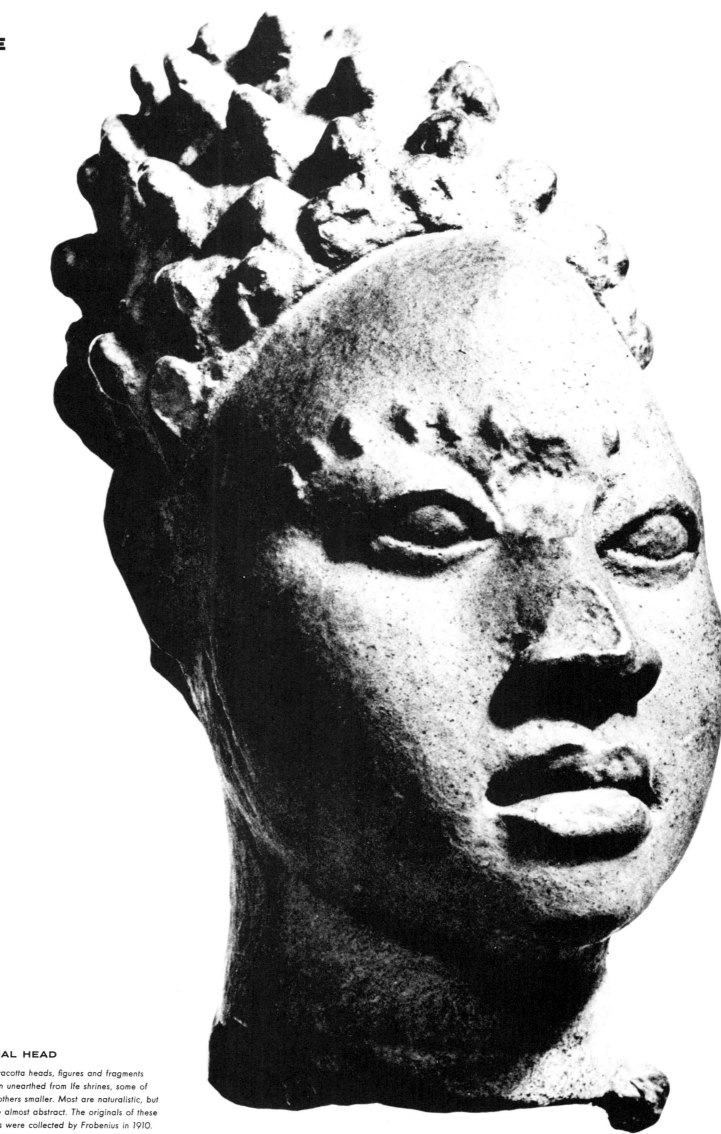

156
MEMORIAL HEAD

Many terracotta heads, figures and fragments
have been unearthed from Ife shrines, some of
life size, others smaller. Most are naturalistic, but
a few are almost abstract. The originals of these
two heads were collected by Frobenius in 1910.

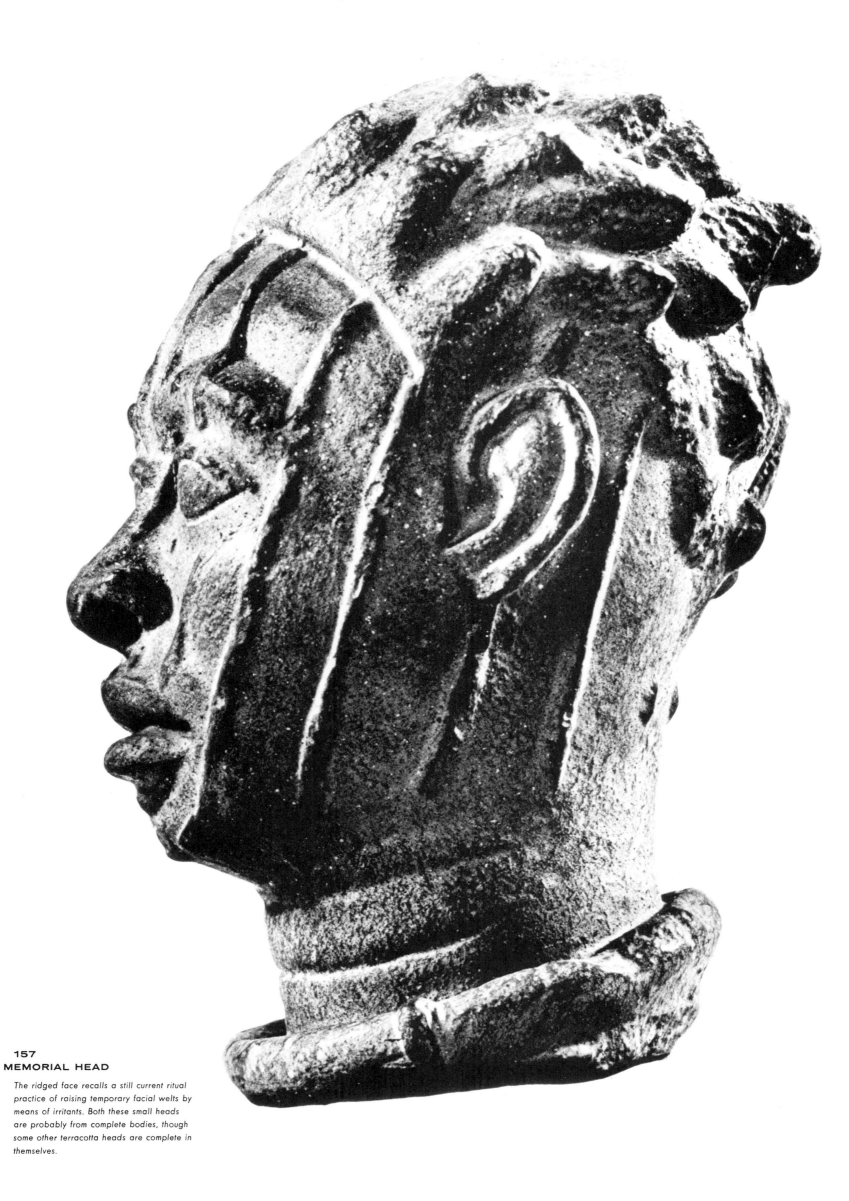

157
MEMORIAL HEAD

The ridged face recalls a still current ritual
practice of raising temporary facial welts by
means of irritants. Both these small heads
are probably from complete bodies, though
some other terracotta heads are complete in
themselves.

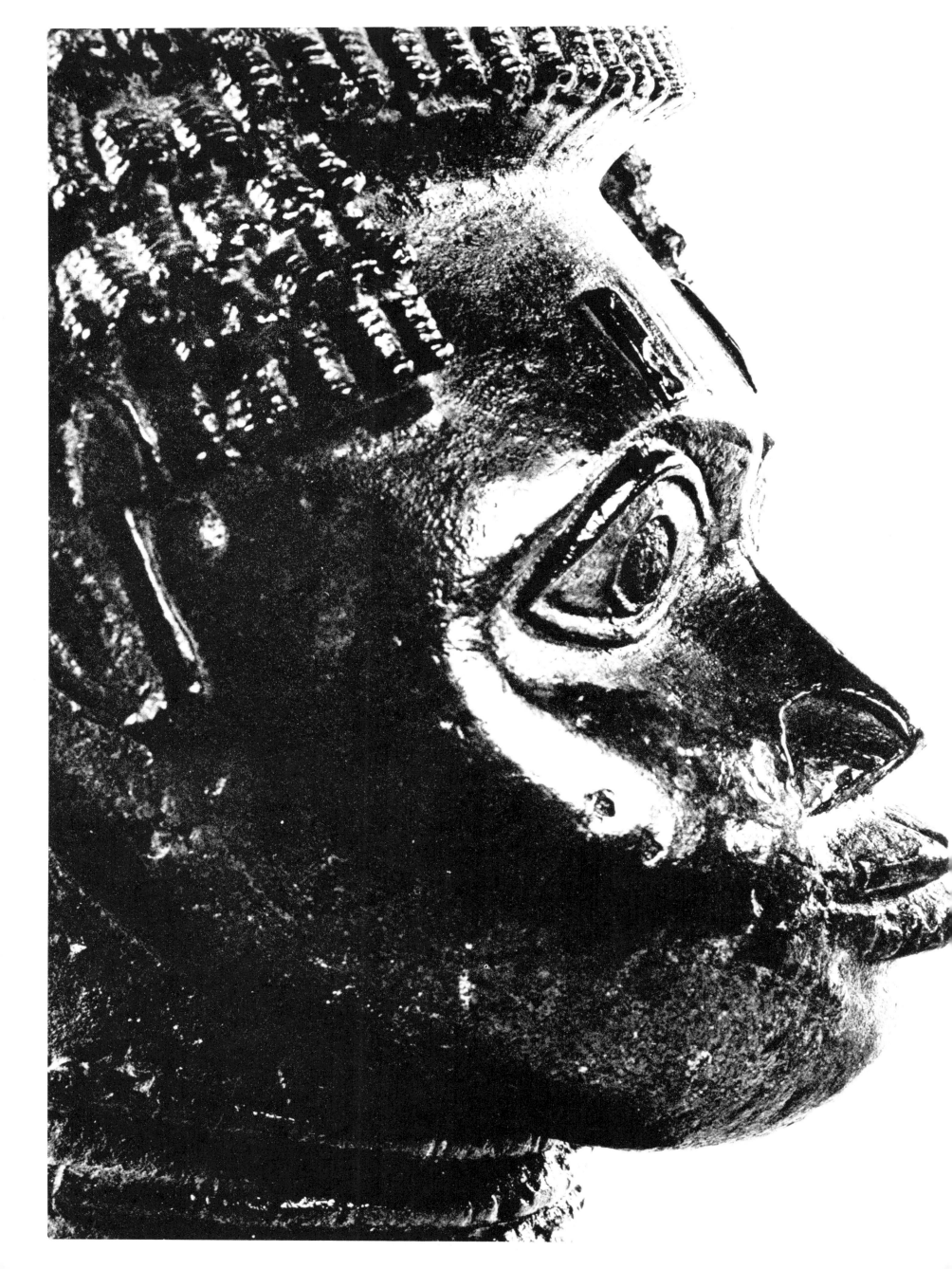

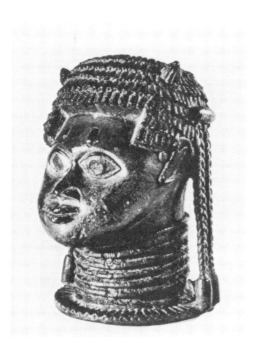

158-159
MEMORIAL HEAD

The rulers of Benin and other Bini towns installed bronze heads
upon altars consecrated to the spirits of their deceased
parents and ancestors. This head, perhaps of the eighteenth
century, illustrates the provincial style of Udo, a town 25 miles
west of Benin, and formerly its great rival; this style of
casting is always identifiable by a rectangular opening
at the back.

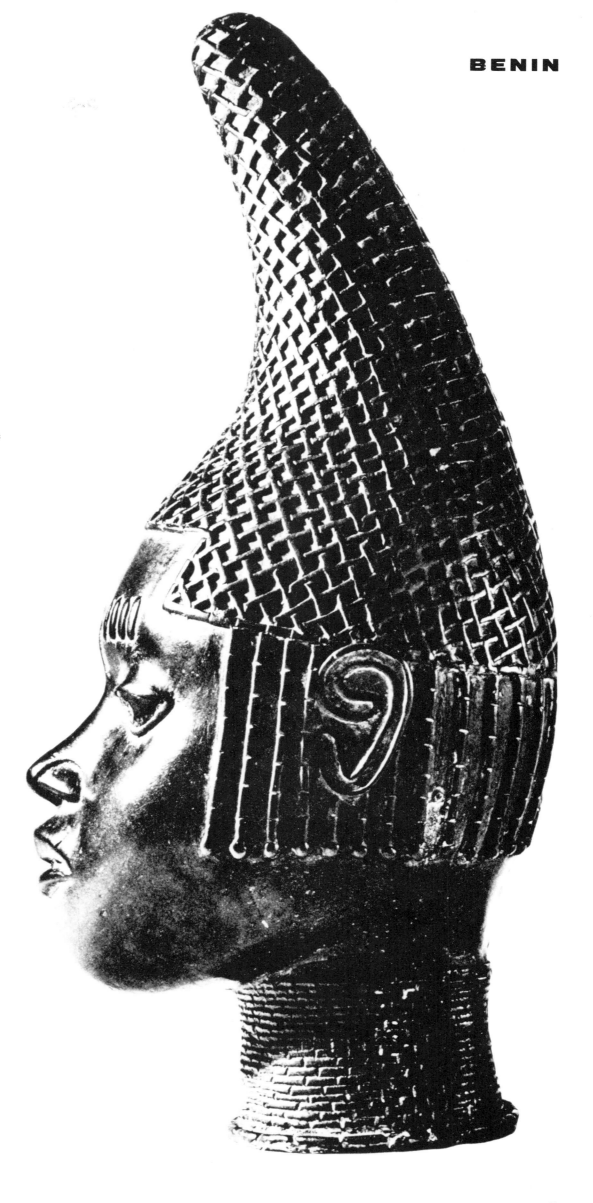

160
MEMORIAL HEAD

The Altar of the King's Mothers in the royal palace was
furnished with heads which are said to represent the Queen
Mothers. This casting, attributed to the middle sixteenth
century, is almost identical with another, which suggests that
an idealization rather than a faithful portrait was intended.
The collar and cap are of coral beads.

BENIN

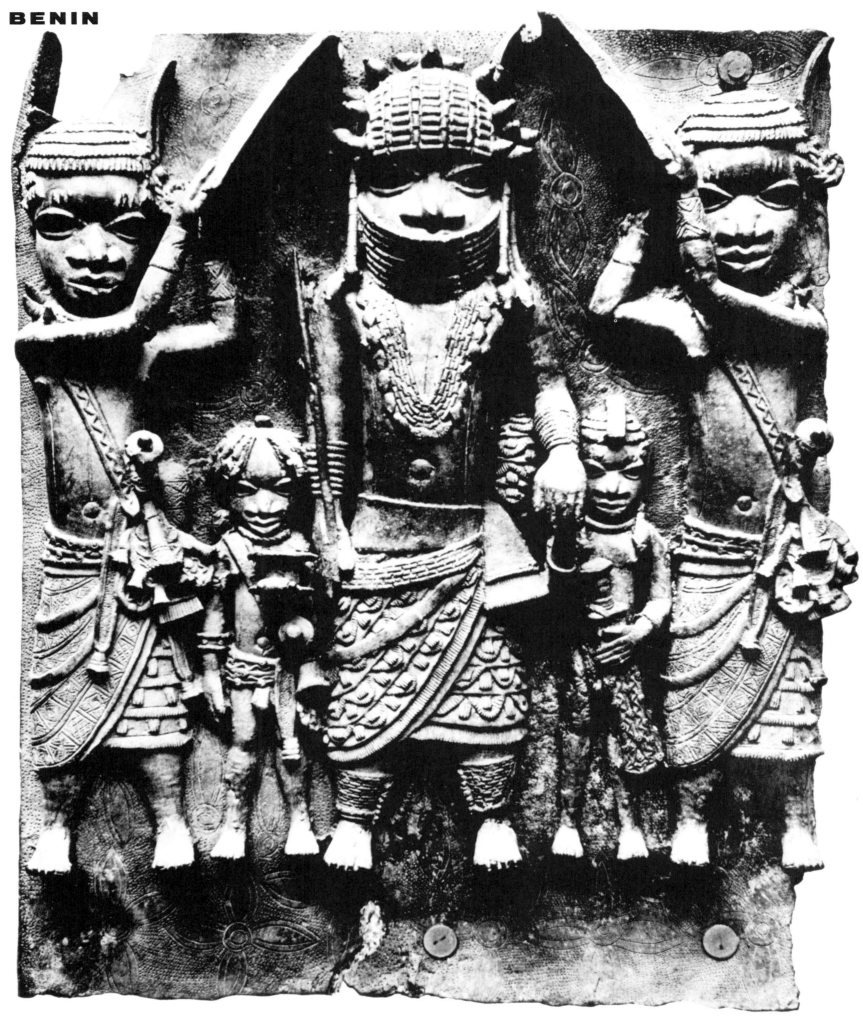

161
COMMEMORATIVE PLAQUE

The red mud pillars of the royal palace were ornamented in the
seventeenth century with hundreds of these rectangular reliefs
(suggestive of metopes). An Oba is here shown escorted by
shield-bearers and by adult servants in reduced perspective.
The style is typical of the middle period.

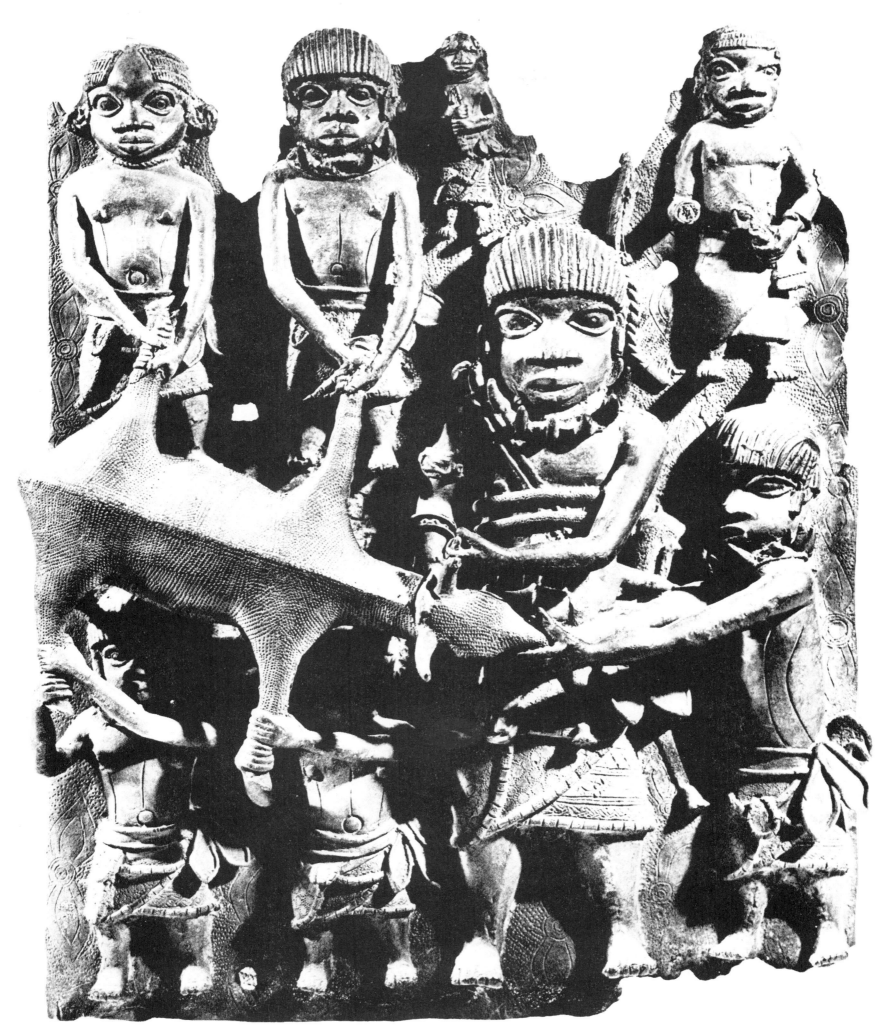

162
COMMEMORATIVE PLAQUE

The sacrifice of a bull, perhaps at the funeral of an Oba, is here
represented on one of the most elaborate and skilfully made
plaques. Though stacked in a palace store since the eighteenth
century, they were still being used as historical mnemonics
on occasion in 1897.

BENIN

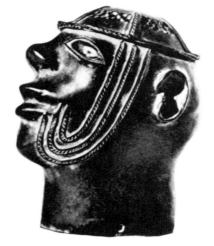

164

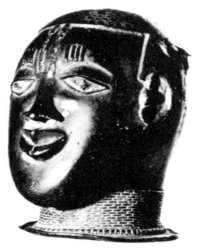

165

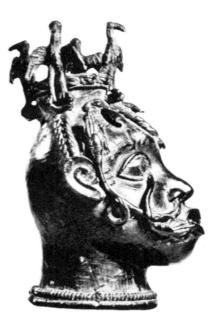

166

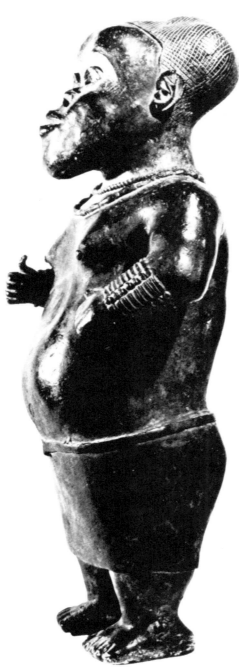

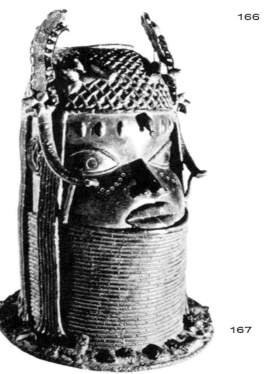

167

163
FIGURE OF A COURT DWARF

In the middle period of Benin art many accessory figures were cast for the Altars of the King's Fathers, perhaps to add importance to the ancestor cult. These included hornblowers, Portuguese soldiers and figures wearing Maltese crosses. This figure of an achondroplasic dwarf is highly exceptional in its realistic bodily features and posture, but is probably from this period.

164-167
MEMORIAL AND RITUAL HEADS

Fig. 165 seems to belong to the earliest period at Benin from which examples survive (probably the fifteenth century), but is not typical, apparently representing a pathological condition such as acromegaly. Fig. 166, probably of the middle period, does not seem to belong to the ancestor cult, but to that of a nature spirit. The late period was marked by the introduction of winged headdress ornaments—fig. 167—said to have occurred after 1816. The thinly cast head—fig 164—illustrates an undetermined regional style, possibly of Yoruba origin, examples of which, though found at Benin, must be excluded from the Benin canon.

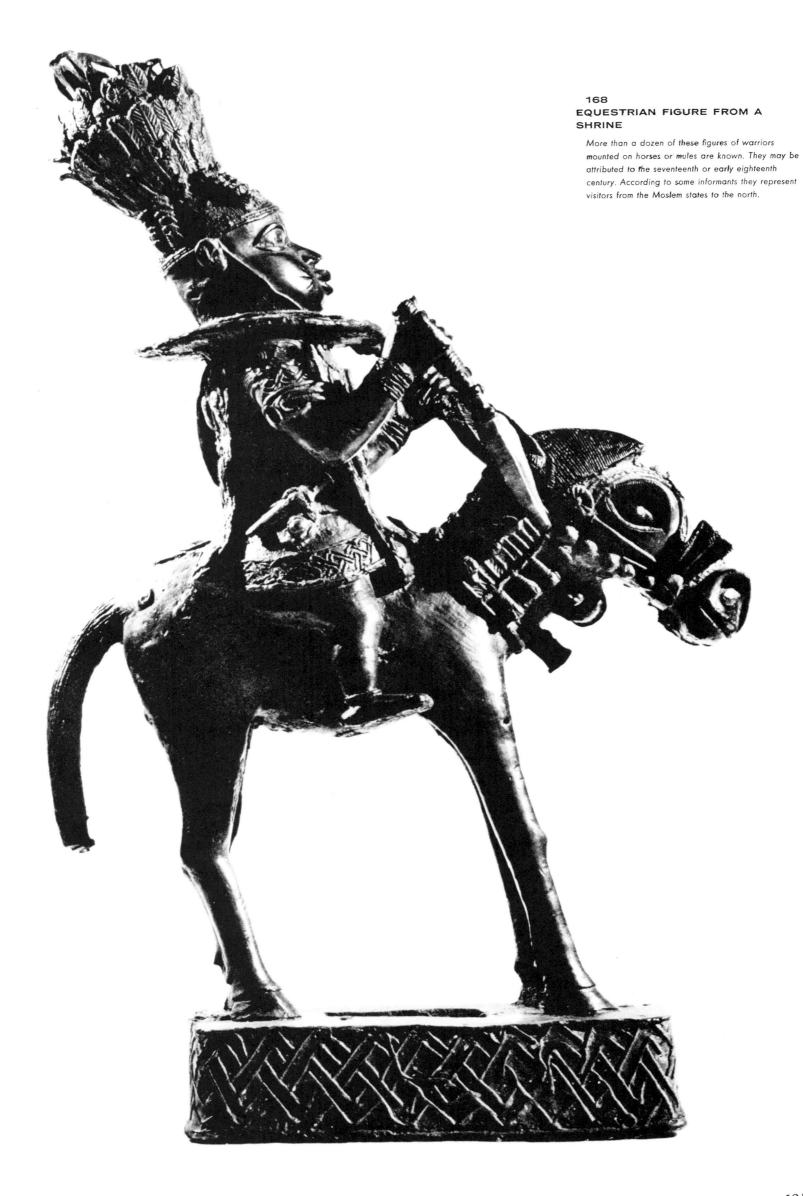

168

EQUESTRIAN FIGURE FROM A SHRINE

More than a dozen of these figures of warriors mounted on horses or mules are known. They may be attributed to the seventeenth or early eighteenth century. According to some informants they represent visitors from the Moslem states to the north.

BENIN

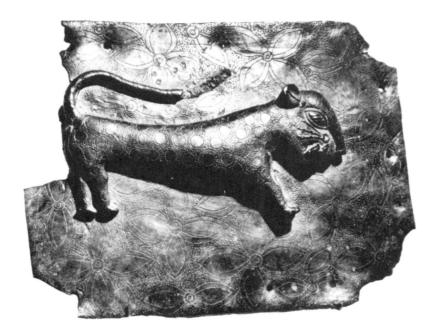

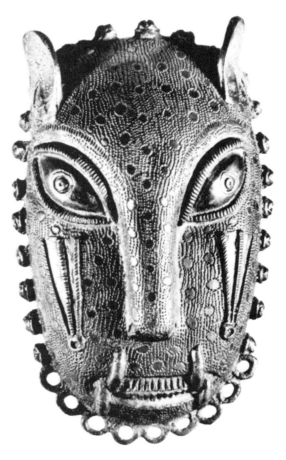

**169
PLAQUE**

*Leopards, the symbols of kingly power, were depicted in
various scenes in the royal palace. The king kept live
leopards, captured for him by special hunters.*

**170
BELT MASK**

*These masks, in leopard or human
form, were worn on the left hip
covering a fold of the skirt in the
court dress.*

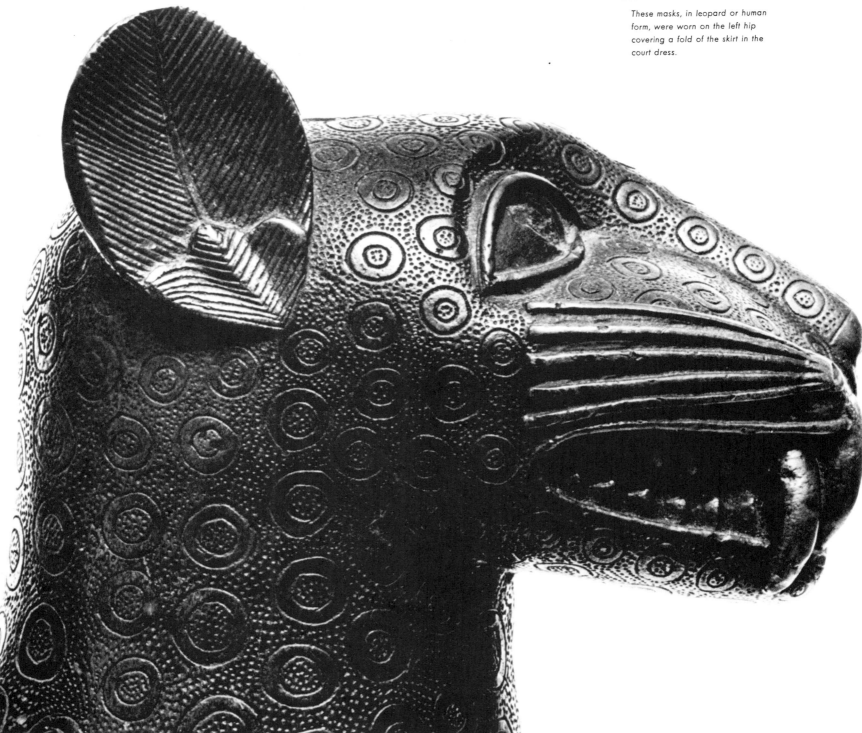

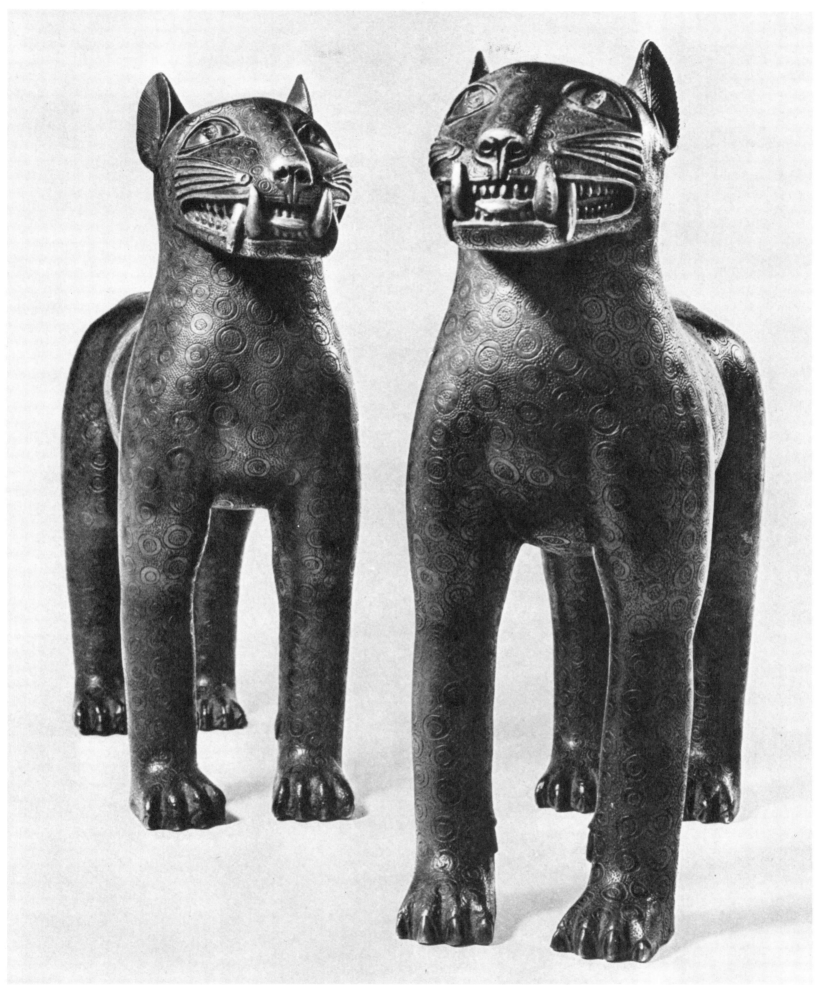

171-172
LEOPARD FIGURES

Like the images of hornblowers and horsemen upon the altars, these leopards were possibly prestige symbols. They are among the most technically perfect of Benin castings and are probably of the middle period. Another pair of similar size were made from fitted sections of ivory.

BENIN

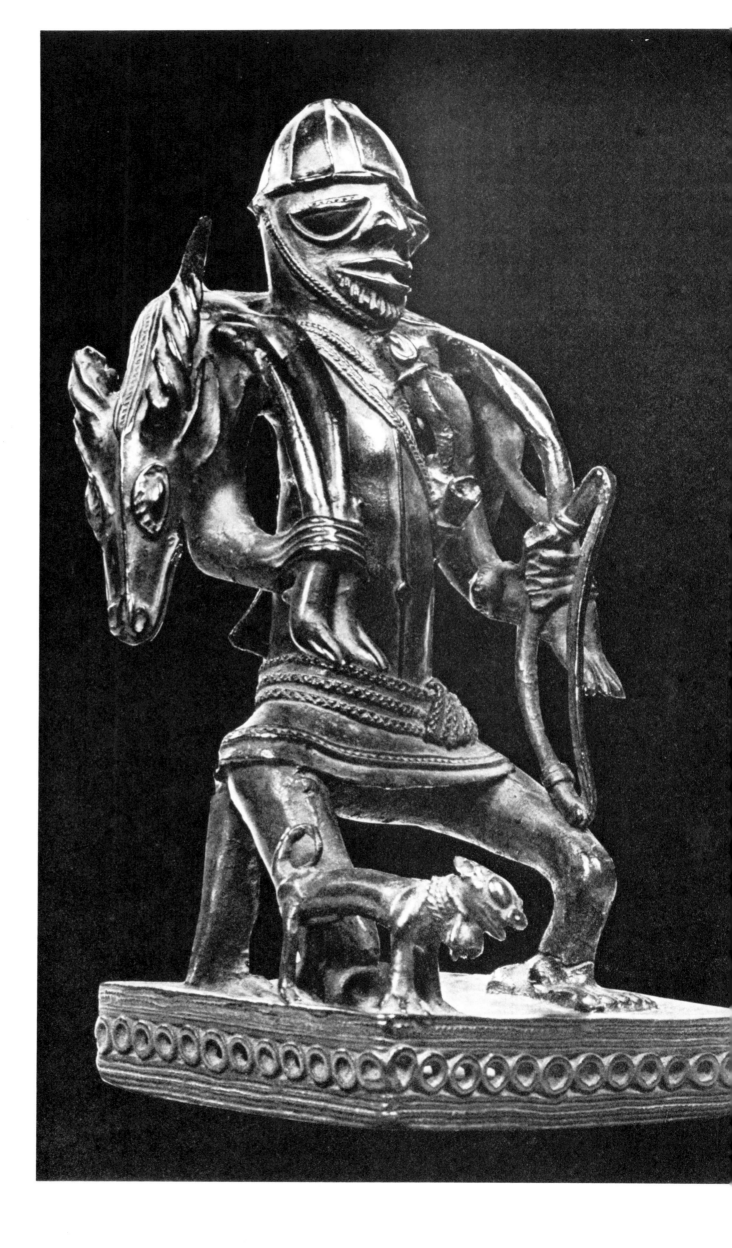

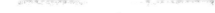

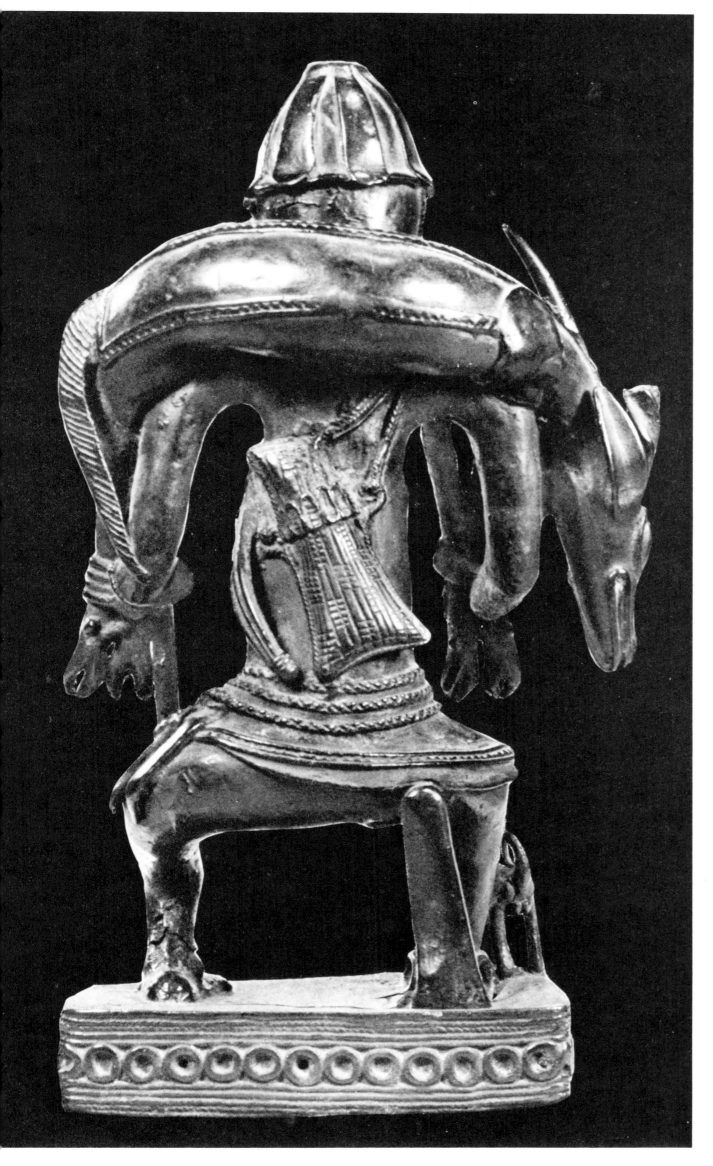

173-174
FIGURE OF A HUNTSMAN

This casting, found at Benin, of a
huntsman returned from the
chase with his dog and carrying
a dead waterbuck, is an
outstanding example (another is
fig. 164) of a style, probably
belonging to the Niger valley,
whose imaginative quality
and free composition are in
strong contrast with the more
pedestrian tradition of Benin
work. By a bold artistic stroke
the artist has omitted the lower
part of the right leg, between
thigh and foot.

IJO

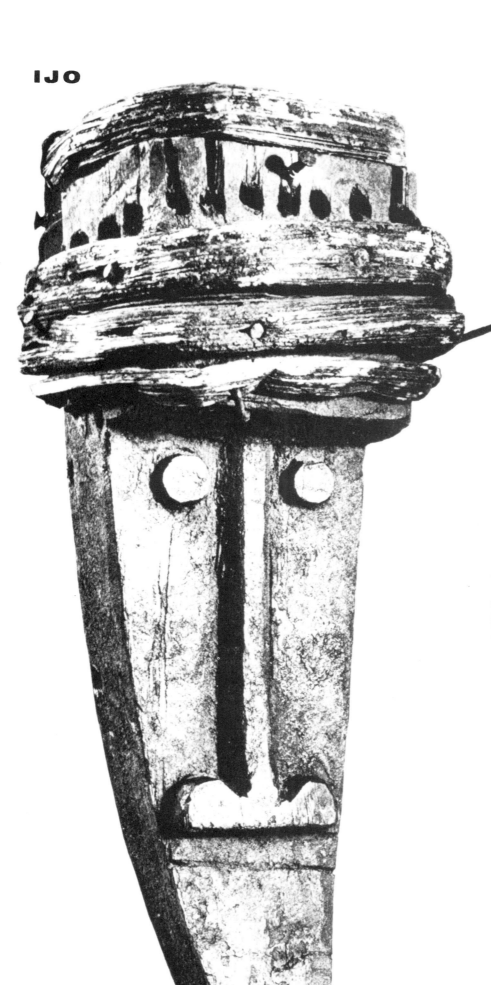

175
WATER SPIRIT MASK

The Sekiapu, chief secret society of the Kalabari clan, performs a long cycle of plays to propitiate the water spirits (owu). This mask, named Igbo, illustrates extreme economy of artistic means.

176
WATER SPIRIT MASK

This mask is called Igu. The performers, concealed by cloths, wear the masks like caps, with the faces directed skyward. These plays are still performed.

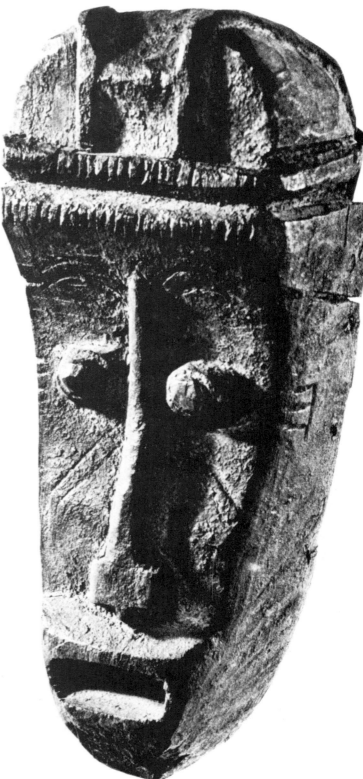

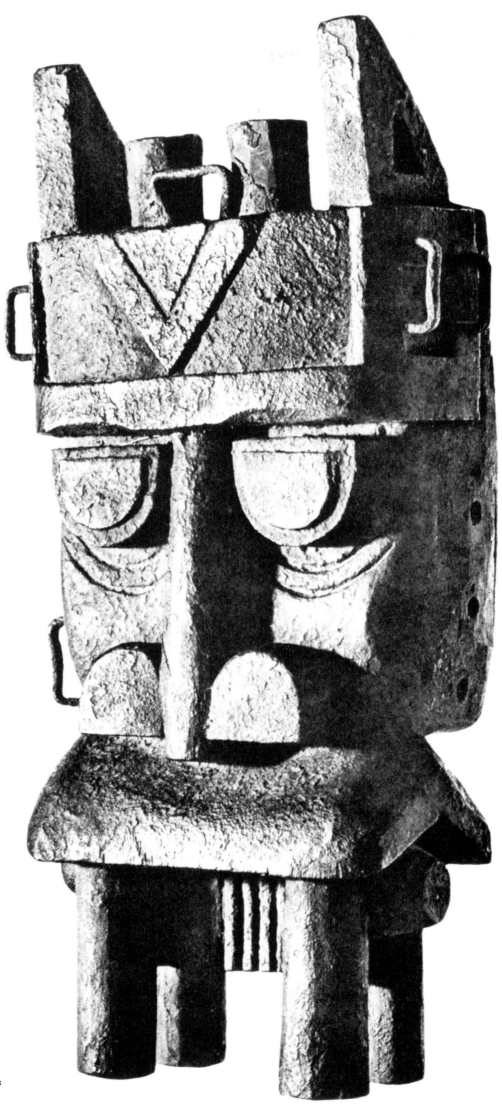

177
WATER SPIRIT MASK

In this cubistic mask, called Otobo, human and
hippopotamus features are combined; the great
canines are transformed into cylinders. Certain plays
were performed in the water. Kalabari carvings
display an unusual uniformity of style, from village to
village and cult to cult, whereas the western Ijo clans
have a more variable style. This is a cap mask.

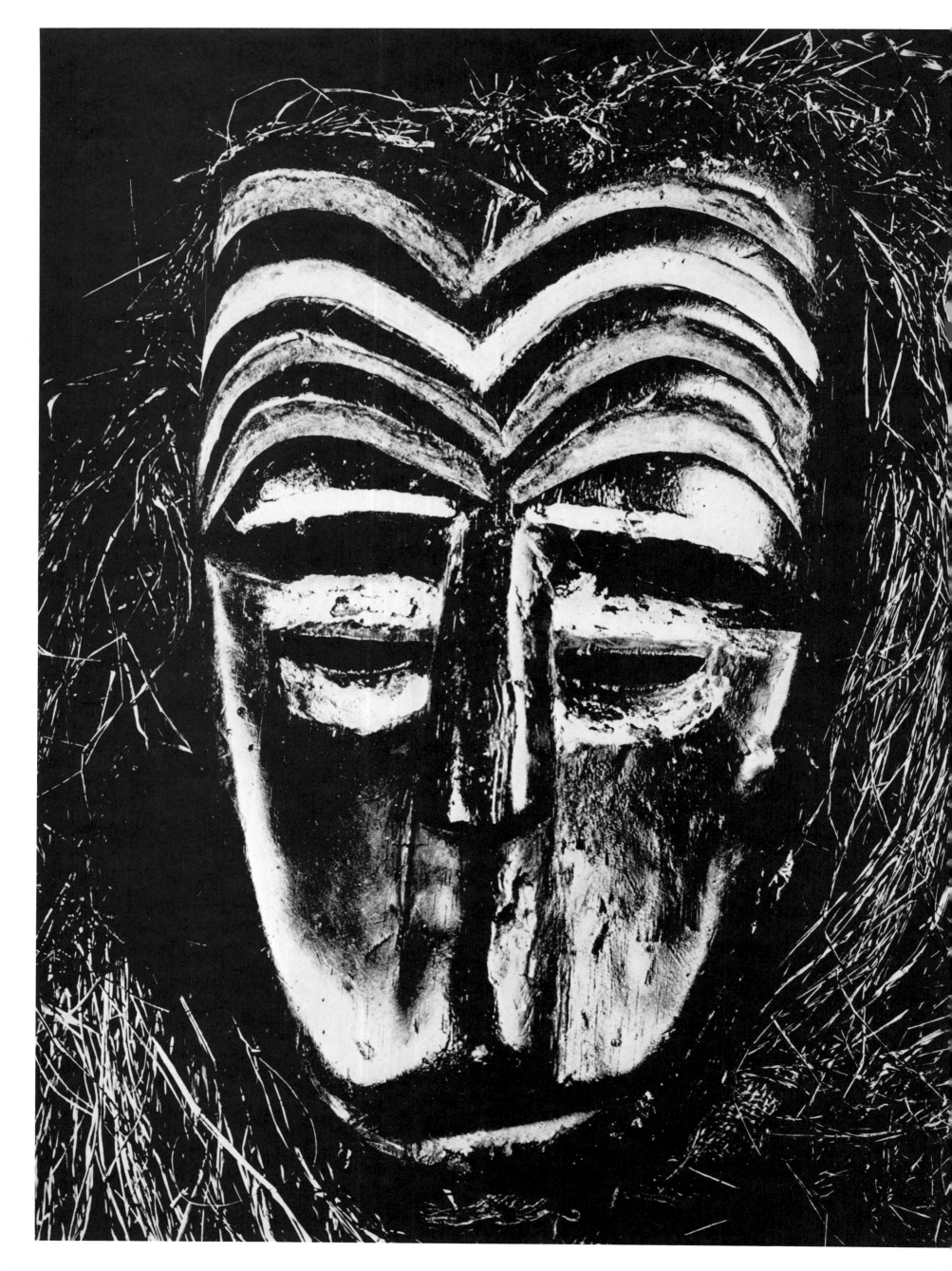

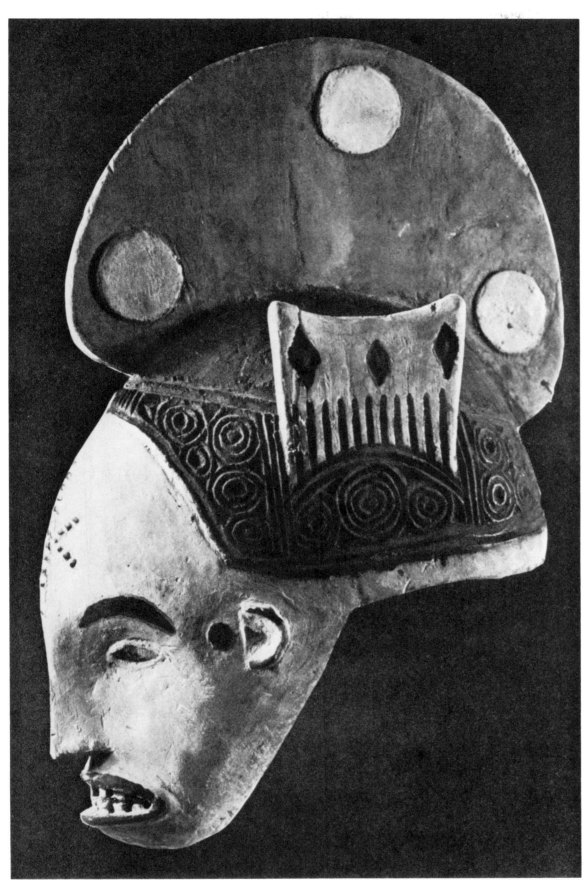

179
DANCE MASK FOR THE ANCESTOR CULT

The Mmwo secret society controlled northern Ibo villages in the name
of ancestral spirits, and performed, in masks representing the spirits
of women, and wearing tight, vari-coloured string garments, at
festivals and funerals.

178
**DANCE MASK FOR THE
YAM CULT**

The Ibo of Ozuitem used this mask in the
Ekpe play, performed by a secular club.
Ibo styles of sculpture differ markedly
from each other, even in a single area.

180
DANCE MASK FOR THE YAM CULT

Initiated youths of certain eastern Ibo groups danced
energetically in masks such as this from Amaseri
village. The crest represents a knife used in
ceremonially cutting the first yams. The projections
are said to represent teeth.

IBIBIO

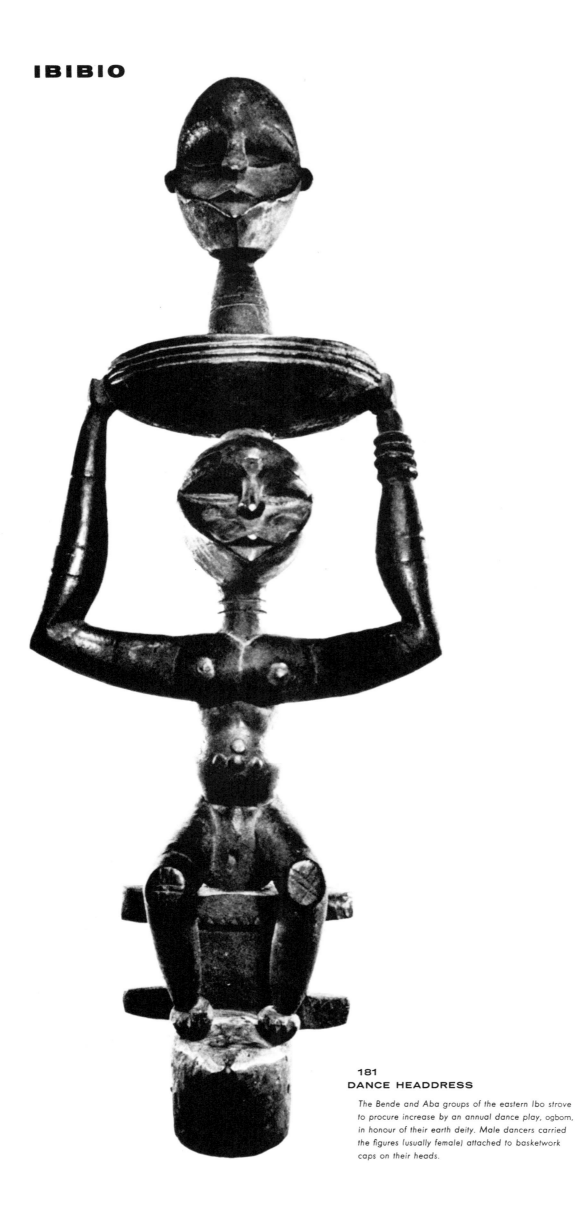

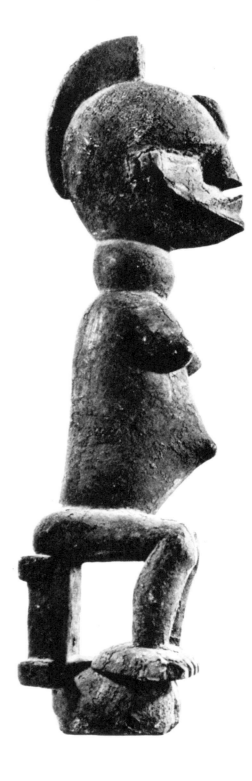

182
DANCE HEADDRESS

This piece was found among Ibo who asserted that both the ogbom dance and its sculptures were imported from their Ibibio neighbours; and stylistically they are Ibibio rather than Ibo. Several examples show this armless conception.

181
DANCE HEADDRESS

The Bende and Aba groups of the eastern Ibo strove to procure increase by an annual dance play, ogbom, in honour of their earth deity. Male dancers carried the figures (usually female) attached to basketwork caps on their heads.

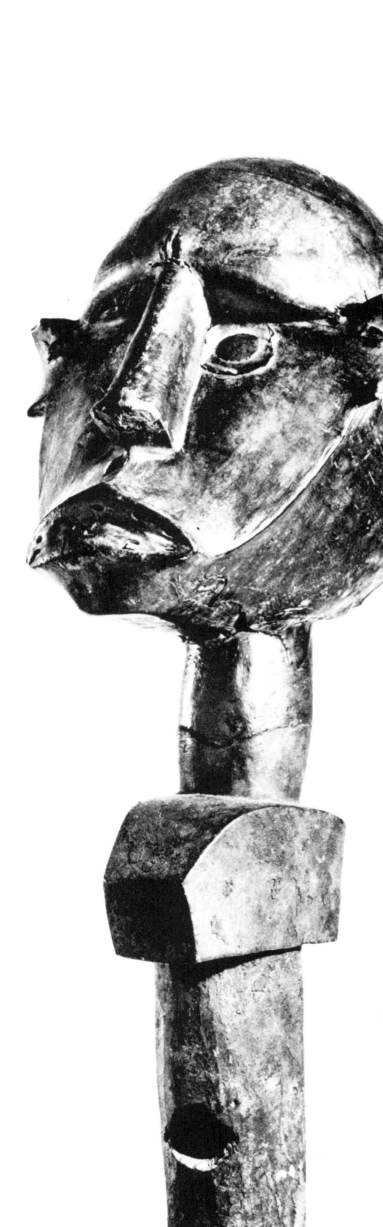

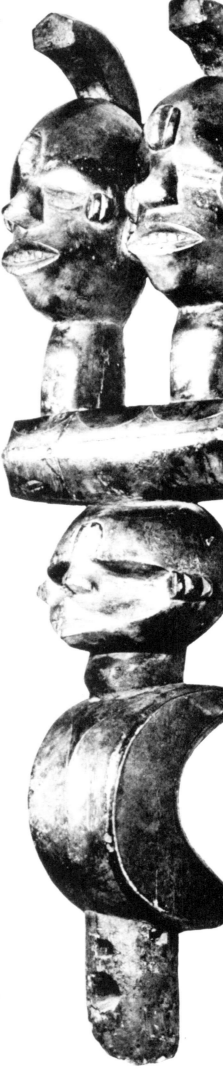

183-184
DANCE HEADDRESSES

The hide-covered head (fig. 183) is an example of influence from the Cross River Ekoi on their Ibibio and Ibo neighbours. Ogbom carvings notably illustrate the use of the exponential curve as an increase symbol.

IBIBIO

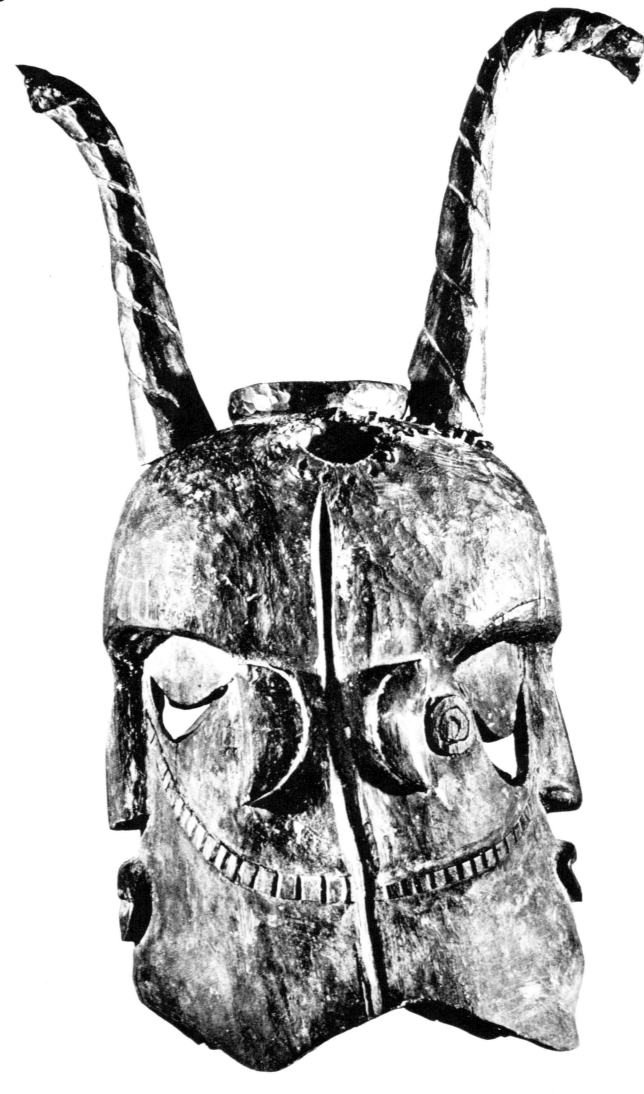

185
JANIFORM DANCE MASK

This two-faced helmet mask was carved among the Ibo of Ozuitem around 1900 for the ikem play. The dancer wore a smoking smudge pot between his four horns (two of which remain) and threatened onlookers with a whip. Ekoi style has perhaps influenced the ikem masks.

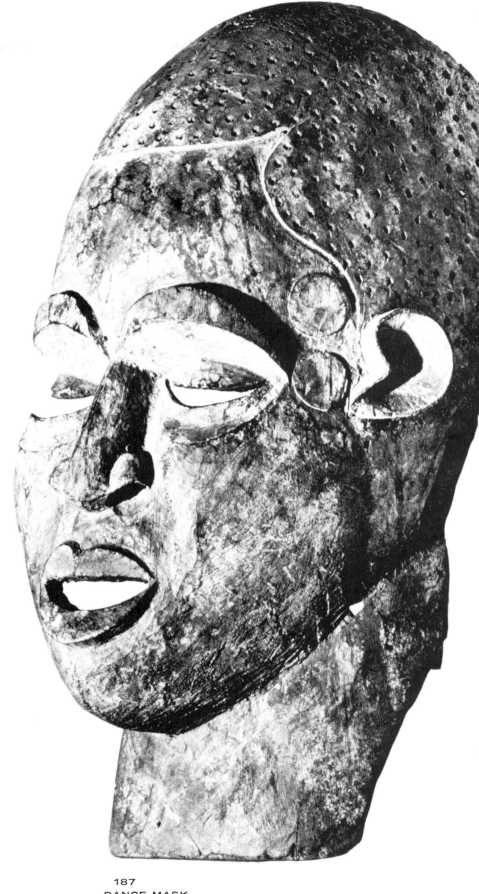

187
DANCE MASK

This is the surviving face from a great three-faced mask (formerly covered in skin in the Ekoi manner) which was used in the ikem play at Ozuitem, and is said to be Ibibio work.

186
DANCE MASK

This mask, purchased by an Ozuitem Ibo from an Ibibio at the end of the last century, was worn in plays of the Ekpa club, dedicated to feasting and mutual aid.

OGONI

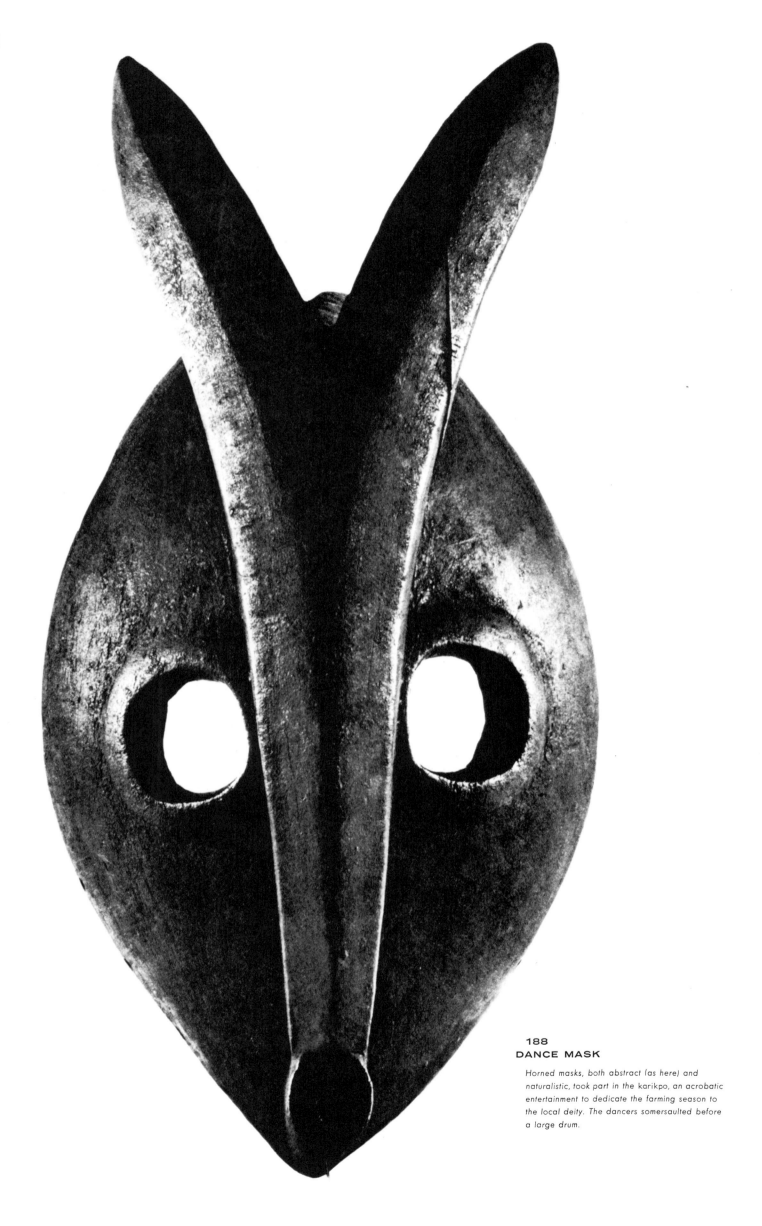

188
DANCE MASK

Horned masks, both abstract (as here) and naturalistic, took part in the karikpo, an acrobatic entertainment to dedicate the farming season to the local deity. The dancers somersaulted before a large drum.

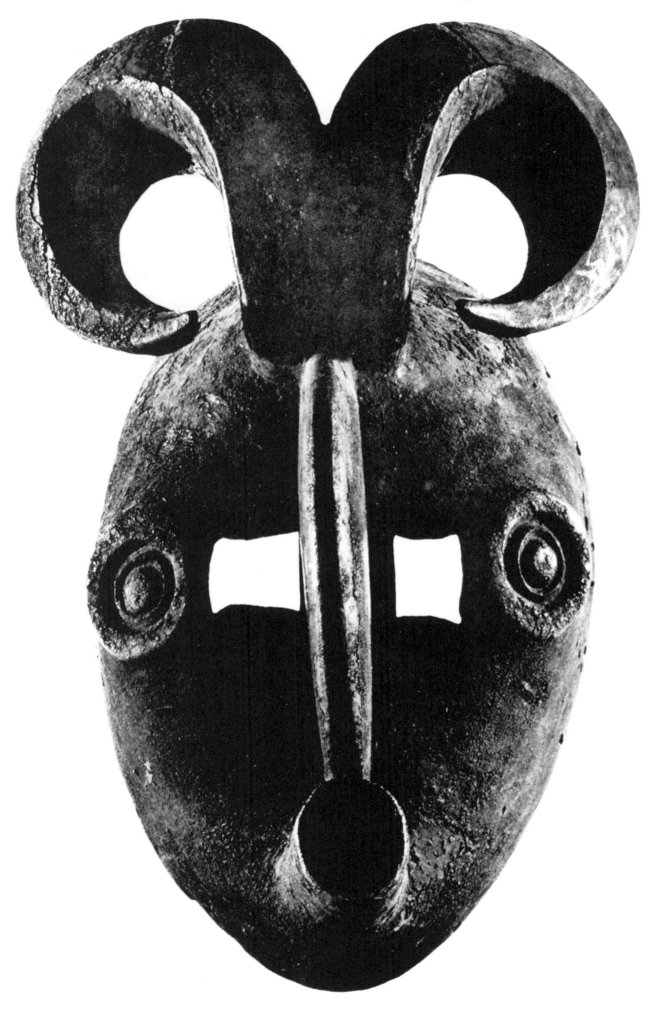

189
DANCE MASK

Karikpo masks were usually painted white, brown and black for performance, but were stored in sooty conditions in house roofs. The Ogoni are closely related to the Ibibio in culture and art.

EKOI

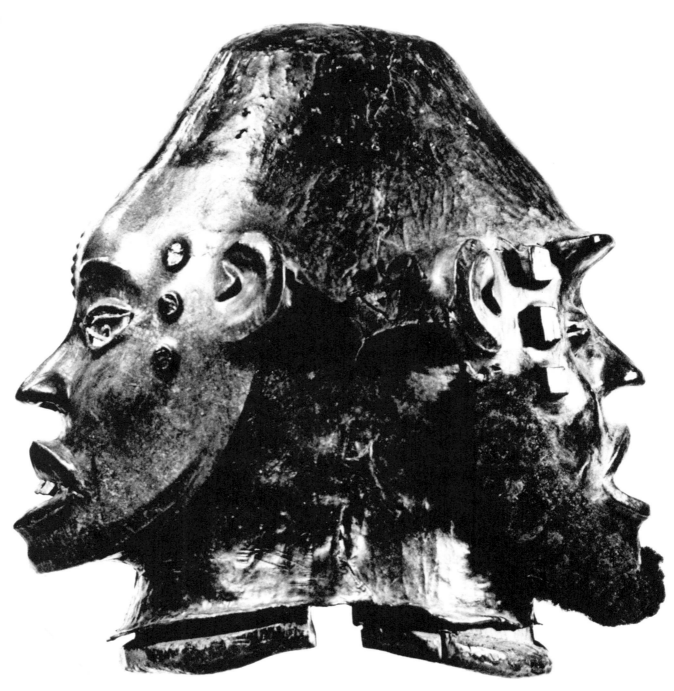

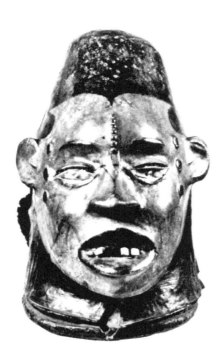

190
JANIFORM DANCE MASK

The Ekpo (Ancestor-spirit) secret society formerly exercised governmental functions among the Ekoi (or Ejagham), who live partly in Nigeria, partly in the British Cameroons. The essential naturalism of their style is enhanced by the animal skin stretched over the masks, which include both single and double helmet and headdress forms.

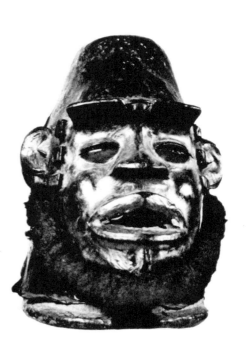

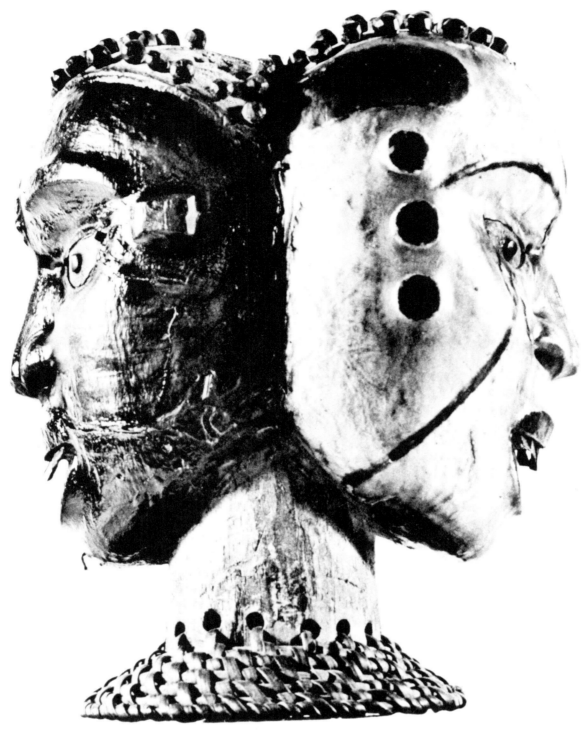

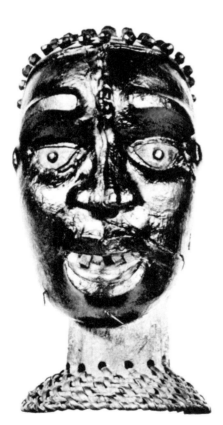

191
JANIFORM DANCE HEADDRESS

*These masks are used at society festivals and funerals of
members. The best examples show excellent anatomical
observation: for example, in these two masks the brow ridges
of the male (black) faces are more strongly marked than in
the female faces. Human hair may be used (fig. 190) or
represented by pegs (fig. 191).*

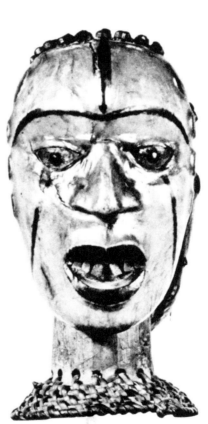

AFO

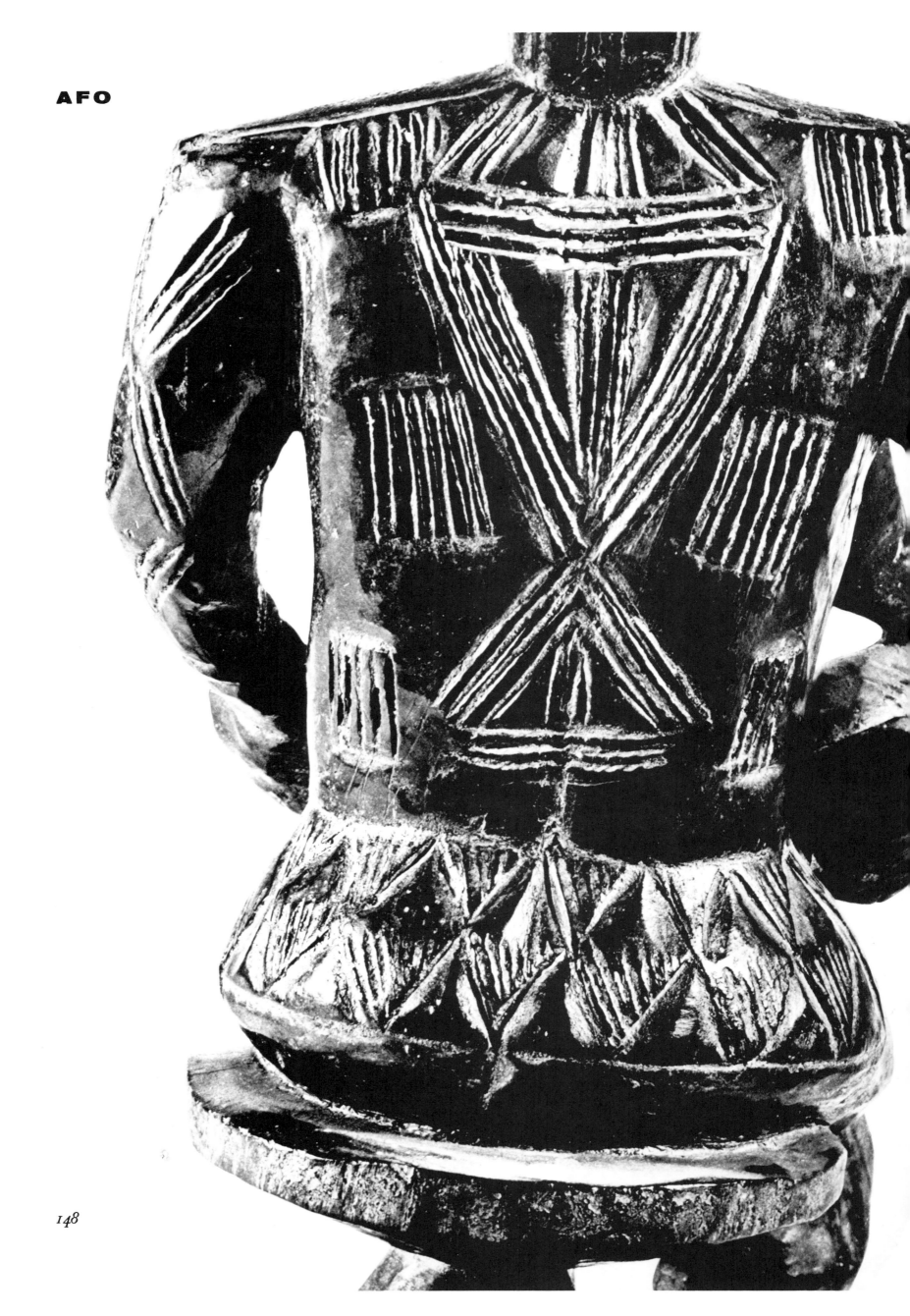

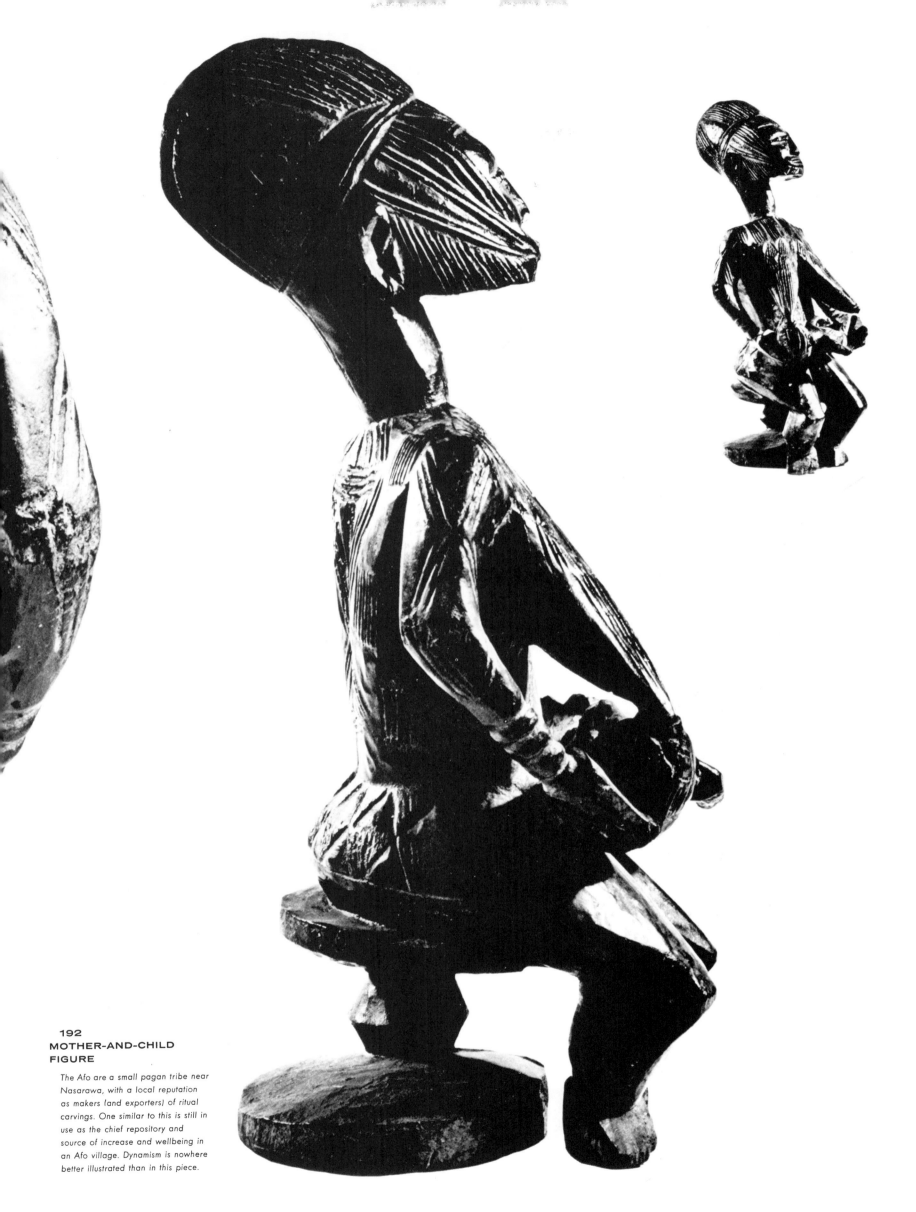

192
MOTHER-AND-CHILD
FIGURE

The Afo are a small pagan tribe near
Nasarawa, with a local reputation
as makers (and exporters) of ritual
carvings. One similar to this is still in
use as the chief repository and
source of increase and wellbeing in
an Afo village. Dynamism is nowhere
better illustrated than in this piece.

CAMEROONS

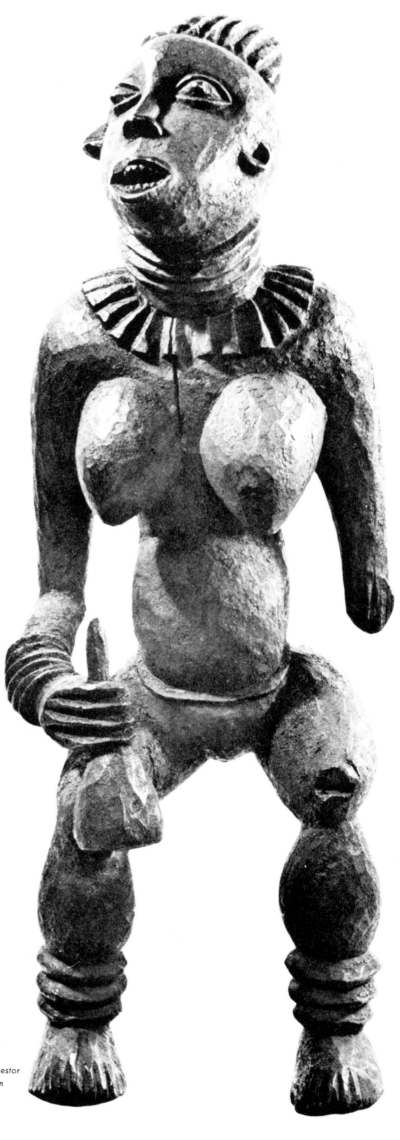

193
KING'S STOOL

In the Grassland chiefdoms the forms of throne and stool are closely related to rank; deceased kings are sometimes represented by their thrones at grand rites. In this example, a woman is shown in the attitude of respect before the king (whose upper lip is broken away).

194
ANCESTOR FIGURE

Among the Bamileke each king owns an effigy of himself and of his first son's mother, and these are preserved as ancestor figures. This work from Bangwa chiefdom exhibits a spiral movement unusual in African art.

150

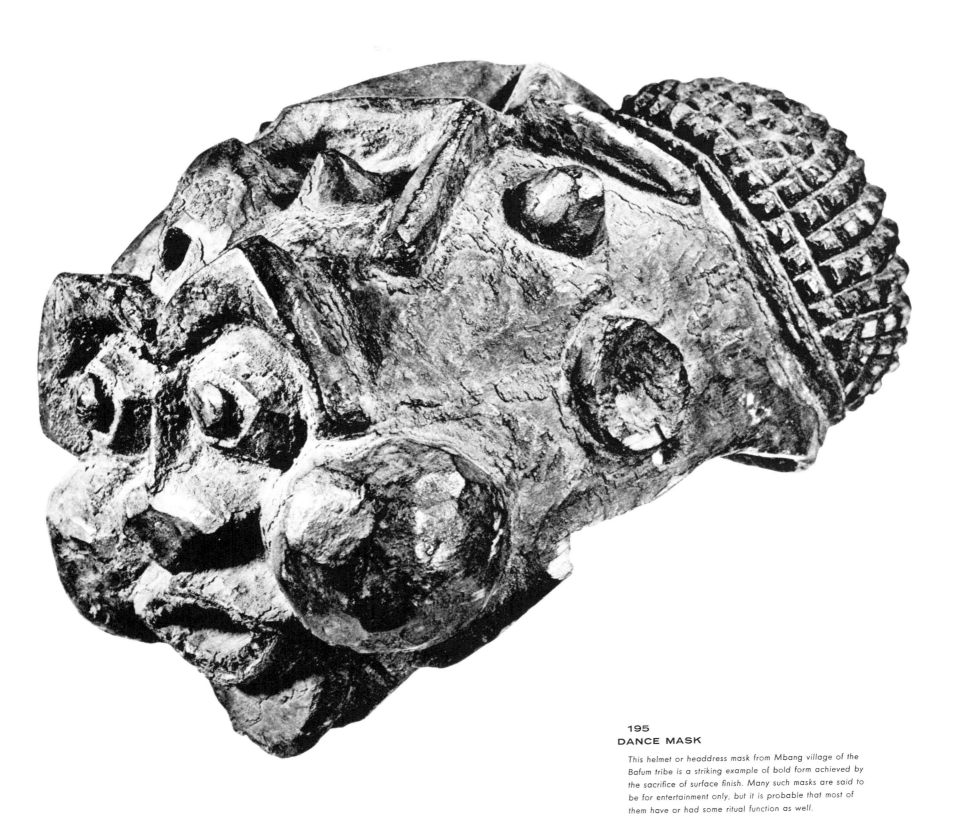

195
DANCE MASK

This helmet or headdress mask from Mbang village of the Bafum tribe is a striking example of bold form achieved by the sacrifice of surface finish. Many such masks are said to be for entertainment only, but it is probable that most of them have or had some ritual function as well.

CAMEROONS

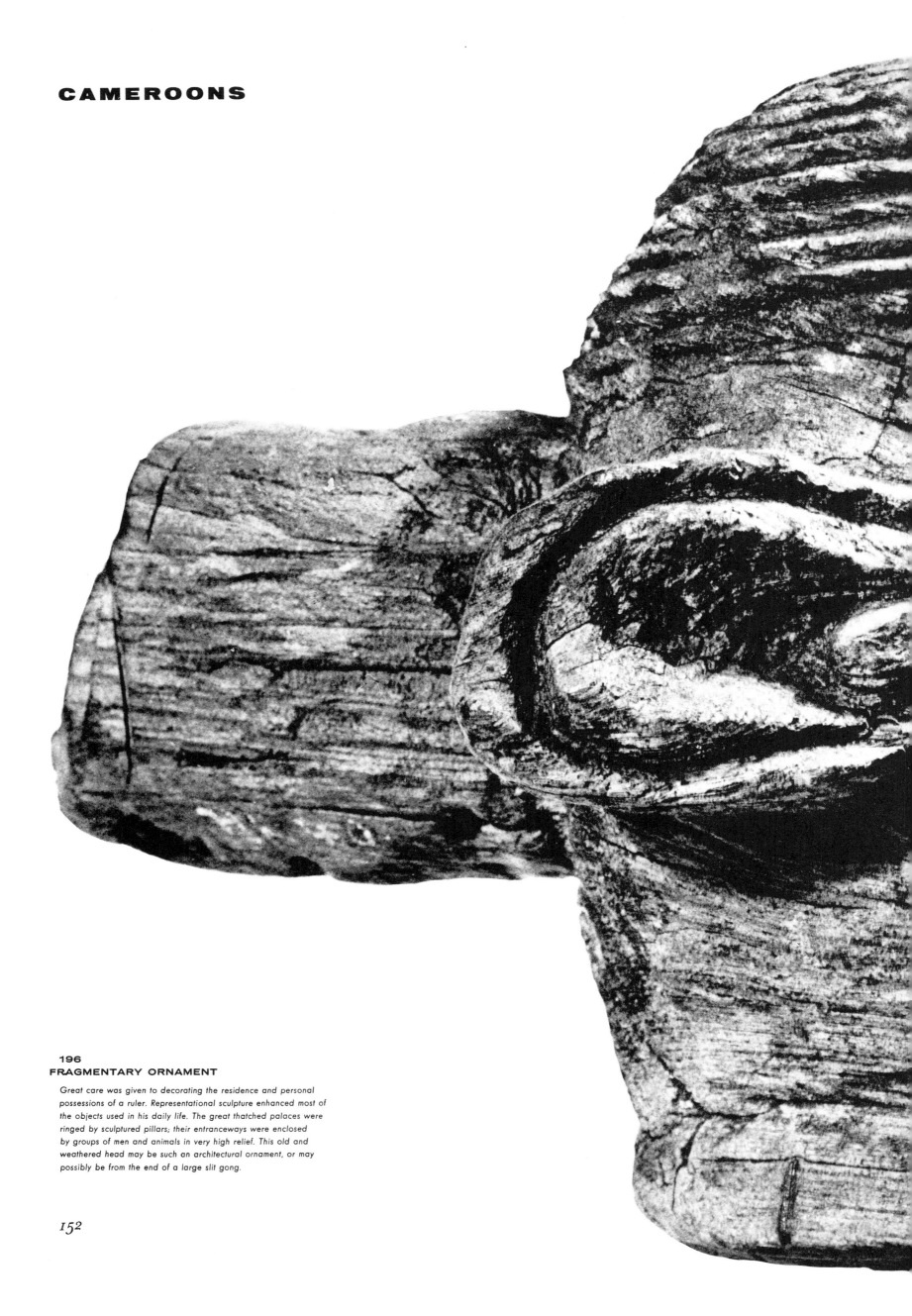

196
FRAGMENTARY ORNAMENT

Great care was given to decorating the residence and personal possessions of a ruler. Representational sculpture enhanced most of the objects used in his daily life. The great thatched palaces were ringed by sculptured pillars; their entranceways were enclosed by groups of men and animals in very high relief. This old and weathered head may be such an architectural ornament, or may possibly be from the end of a large slit gong.

152

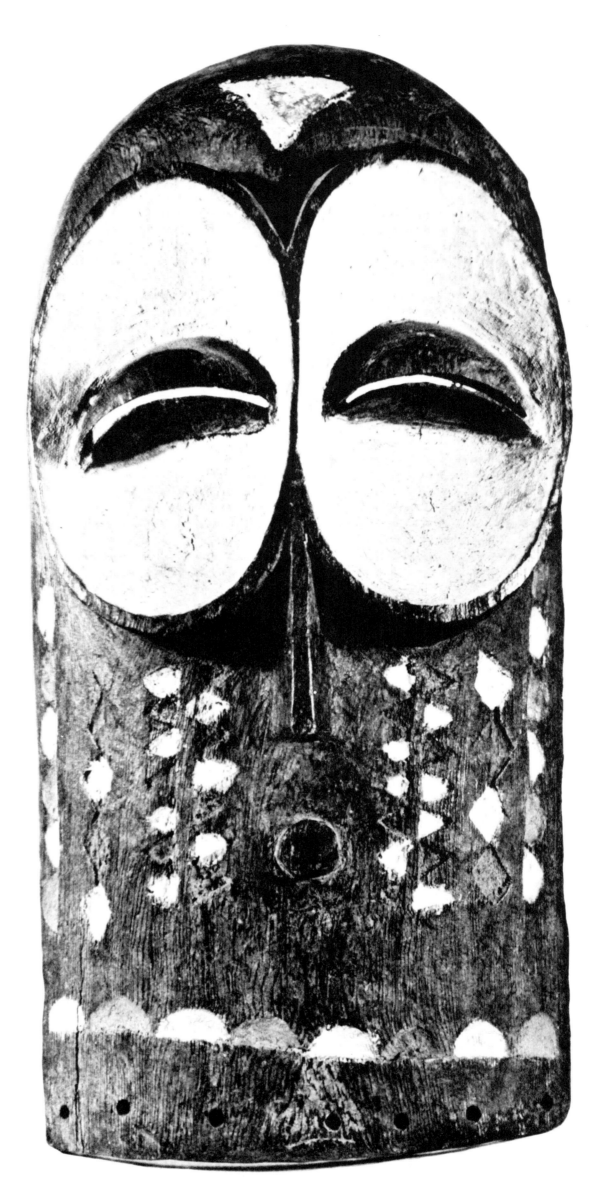

197
WABEMBE DANCE MASK

This type of mask, attributed to the Wabembe and Banyabungu near the northern end of Lake Tanganyika, suggests certain masks of the Azande far to the north.

198
BATEKE DANCE MASK

This mask from near Mosenjo represents one of the most highly abstract treatments of the human face in Africa.

The

CONGO

The third great region in our tripartite division of that well defined portion of Africa which produces sculpture consists very largely of the great basin of the River Congo: besides the Belgian Congo itself, it comprises (for the purposes of this book) the French Cameroons east and south of the Sanga or Sanaga River; the French territories of Gaboon, Moyen Congo and Ubangi-Shari, with the southernmost portion of the eastern Sudan; Spanish Guinea or Rio Muni, the Portuguese enclave of Cabinda and the northern portion of the great colony of Angola, bounded on the south by the Kalahari Desert; and those parts of Northern Rhodesia, contiguous to the Belgian Congo, in which sculpture occurs under Bajokwe-Lunda and Baluba influence; and we may consider the Makonde complex, spanning the Tanganyika-Mozambique border on the East African coast, as a cultural outlier of the Congo area, although separated from it by some hundreds of miles, which are inhabited by art-less tribes.

Of our three regions the Congo is by far the wettest and most heavily forested. Its nucleus, the northern and greater portion of the Belgian colony, is almost wholly covered by rain forest and has virtually no dry season at all; it is also much the poorest in art, although fine work is not wholly absent. The less central areas, however, are predominantly parkland and downland with considerable patches of woodland at intervals; but the climate is much wetter than in the savannah of the Guinea Coast. The Congo is a land of rivers *par excellence*: in most parts it is hard to travel twenty miles, especially between east and west, without having to cross a substantial river; and in many areas (as notably west of the Kasai) they run roughly parallel at much smaller intervals. These geographical factors must clearly have exerted much influence on the diffusion and development of cultures and arts in the Congo.

The Congo peoples, with the exception of some Sudanic-speakers in French Equatorial Africa and along the northern borders of Belgian territory and some of the Pygmies who are found in many parts of the French and Belgian Congo, speak Bantu languages. Anthropologists have increasingly found that linguistic unity is no proof of racial unity; neither anthropometry nor blood-group studies have been able to establish any clear racial division between the Bantu-speakers and the Sudanic-speakers anywhere along the 'Bantu line'. It is likely that the racial is far more mixed than the linguistic composition of the Congo—a view which is borne out by the fact that many of the very numerous Pygmy groups so far identified have long ago lost their distinctive language and culture and acquired by miscegenation a stature hardly less than that of their Bantu neighbours.

To the east of the Congo region across the great lakes and to the south across the Kalahari and the Zambezi dwell innumerable tribes, mostly Bantu, reaching to the oceans, but none of them—the Makonde almost alone excepted—give a sculptural form to their aesthetic expression, although this is not to say that their aesthetic life is necessarily less developed, since many of these tribes have fostered musical and other artistic traditions of a very high order. A high proportion of the Congo tribes, on the other hand, do produce sculptors, and although the rain forest has yielded far less carving than the more open parts, and that (with some outstanding exceptions) of less than the usual vigour and excellence of design, this may well be because of the much greater difficulty of studying and collecting art in the almost impenetrable bush and perhaps also of a greater prevalence of secrecy in the ritual aspects of life.

We have discussed in an earlier essay some possible explanations of this singular dichotomy between the art-producing peoples and those beyond the lakes and the Zambezi. Our purpose here is to point out that when it has been said that the Congo peoples find their chief artistic expression in sculpture, it is difficult indeed to formulate further generalizations about their art which

are not equally applicable to African art as a whole. Naturalism (see figs. 238, 245, 320) and abstraction (see figs. 198, 304, 311) are both to be found, just as in the Guinea Coast; there is the same variation between angular, sharply faceted forms as among the Basonge (for example, fig. 299) and the gently swelling and curving masses of their neighbours the Baluba (for example, fig. 292), or between the Bakota (fig. 229) and the Fang (fig. 215). We can, in short, readily describe the peculiarities of particular tribal styles or sub-styles, but they are so well differentiated that attempts to find a common denominator in any large group of them bring us at once on to the plane of Africa rather than of the Congo. The generalizations which have been ventured aplenty in many books on African art about allegedly fundamental differences of aesthetic between the arts of the Sudan, the Guinea Coast and the Congo, or of the forest and the savannah, are found invalid when reduced to the particular.

For the Congo, or rather the Belgian Congo, the student of African style finds himself in much better case than for the Sudan or Guinea, for neither of which is any single and comprehensive corpus available of the works of art themselves or of documentation about them. A most admirable framework for Congo studies has been set up by the late Professor Frans Olbrechts, who was Director of the Musée Royal du Congo Belge at Tervuren, in his *Plastiek van Kongo,* and an English or French translation of this masterly work, revised in the light of the refinements which he had been able to make in our knowledge since 1940, is greatly needed. In it, he identified and skilfully analysed nearly all the major styles of the Belgian Congo and many of their sub-styles; and this book, with its illustrations, combines with the vast resources of Tervuren to make the Belgian Congo the best field at present for the training of students in the comparative aesthetics of style—although aesthetics have not been a main interest of the Belgian school. Yet the advancement of the frontiers of science and learning always produces more new problems than answers to old ones; and there is almost unlimited scope for further exploration of the lines of study begun by Olbrechts (largely on the basis of internal evidence rather than of field study), as well as for the starting of new lines of research. Indeed there is scope for a substantial volume to be devoted to each of the important tribal styles of the Congo.

Olbrechts's method is based on generalization at the level of the tribal or sub-tribal style, on the basis of very detailed study of particular works. But the same data can equally be used to fix styles of a lower order than the sub-tribal, including those of the village and, above all, of the individual carver; for differences are found to be just as striking at these levels as at those of broader classification. The two approaches, so far from being incompatible, are complementary and imply each other, although it is certainly desirable that priority should be given, as it has in fact been given, to isolating the major styles. To confine ourselves to the larger groupings at the expense of the local and individual styles would be to exaggerate unduly the difference between European and African art in this matter of the degree of conformity to the tradition. It is sometimes possible, as Olbrechts has shown, to isolate the *œuvre* of a single sculptor such as

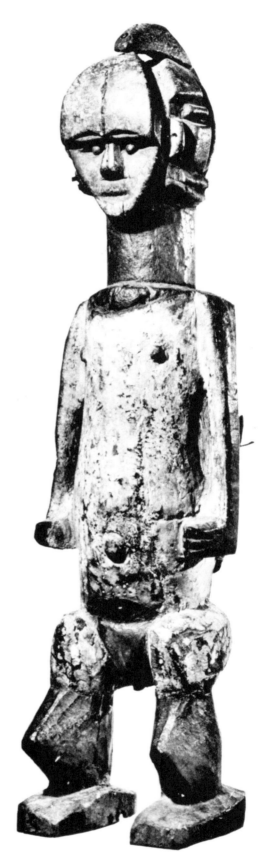

**199 above and opposite
AMBETE RELIQUARY FIGURES**

The hollowed trunks of these figures form box-like receptacles, with hinged lids at the back, for the relics of deceased society members. Ambete style, although related to Bakota, stresses pigment rather than metal as the decorative medium.

the Master of Buli (figs. 288–290) from the internal
evidence alone, just as in early Flemish painting; we
may even learn to recognize the hand of a decorative
artist such as Pongo, the Mukele carver of fine boxes in
the classical style of the Bushongo, and that not only in
the characteristic profile of a head cup such as one
illustrated in this book (fig. 266), but also in the subtle
relativities of ancient geometric patterns which he
combines on the incised sides and lids of boxes for the
Bakele housewives.

The Belgian Congo has been conveniently divided by
Olbrechts into five art areas which we may now briefly
examine, together with the neighbouring areas of other
territories. His areas are: the Lower Congo, the Bakuba
or Bushongo country, the Baluba country, the north-
western tribes, and the north-eastern tribes—the last
two, however, being less readily divisible from each
other than the others.

With Olbrechts's Lower Congo area—which com-
prises the Bakongo and other peoples of the Congo
mouth and the peoples of the Kwango, Kwilu and inter-
vening rivers up to and including the Bapende tribe on
the Loange (figs. 253, 254)—we must include the
remaining groups of the Bakongo–Kakongo–Mayombe
complex in the French Congo (including the Loango
coastal area, but not the Balumbo, Mpongwe and
related tribes), Cabinda and northern Angola. The
French Congo Bateke, Babembe and Baladi around
Brazzaville must also be included, their figure sculpture
(figs. 233, 237) having clear affinities with that of their
brothers south of the border, and also with that of the
Bayanzi, Bahuana (fig. 202), Bambala, Basuku (fig. 200)
and Bayaka (fig. 250). While this large group of peoples
is a convenient unit of study, there is no marked identity
of basic style among them, except in the coastal area,
where a strong tendency to naturalism is evident (see,
for example, figs. 238, 245, 246). The high level of
sophistication which obtains in much of the best Bakongo
sculpture must certainly be connected with their con-
tinuous exposure to European influences during the past
four and a half centuries. The aesthetic fusion which
resulted was a most successful one; the level of European
taste in art which made itself felt on the coast in the early
days must have been that chiefly of the Portuguese
nobility and gentry, and the 'tourist art' which that taste
stimulated was free of the meretricious vulgarity which,
almost universally in Africa, marks that of the era of
mass communication. It is difficult, however, to tell how
far the restraint, refinement and fine craftsmanship so
often found in Bakongo wood and ivory carving are due
to the admixture of European values, since we have no
means of knowing what Bakongo art was like before the
fifteenth century. It is not impossible that it was a con-
vergence of Bakongo and Portuguese aesthetics before
the first contact took place which made the fusion feasible
and successful. Some writers have argued that certain
constant subjects of Bakongo sculpture were direct
importations from Europe, notably the mother and
child (thought to be suggested by statues of the Madonna;
see figs. 238, 241) and the 'nail fetish' (connected with the
wax figures of European superstition; see figs. 242, 244);
but it is more probable that there was superficial
European influence on concepts already well established
in African tradition, and in the case of the mother-and-

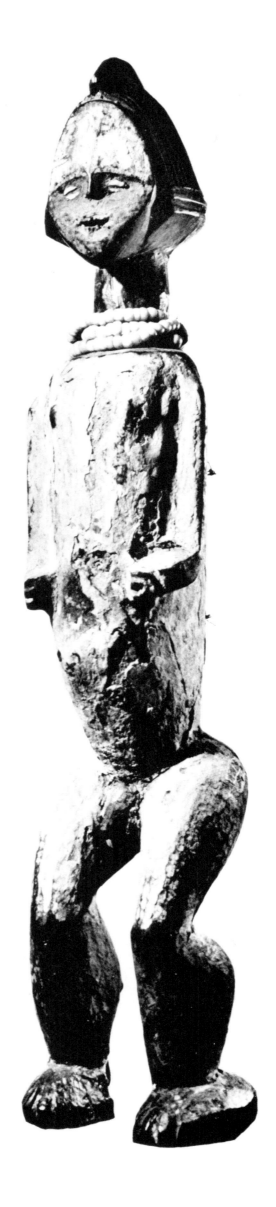

child motive we must note, first, that this relationship is a more strikingly obvious part of the African than of the European way of life, and secondly, that the subject occurs in art in areas—such as Northern Nigeria (see fig. 192) and also the eastern Belgian Congo—where it is most unlikely to have been due to influences from Europe. The European influence probably took a subtler form than this, working on the surface of sculpture in the direction of greater sensitivity and finish; it is also not impossible that, as so often happened in the Portuguese empire, exotic influences were brought to the Congo from the Orient. In the hinterland of the Lower Congo region, Bakongo influence in art is perhaps less evident than it seems to be somewhat farther afield in the Bushongo country to the east, which we must now proceed to consider.

The Bushongo rival the Baule of the Ivory Coast in their devotion to conscious artistry (compare, for example, figs. 267, 268 with figs. 124–129, 133), though like them they now increasingly exercise their talents for gain rather than for their own satisfaction. Some remarkable parallels may be drawn between their art and its setting on the one hand and those of Benin on the other, and it will be worth our while to consider briefly not only these parallels but also the still more significant divergences between them. Both are, or were, powerful states ruled by a divine king at the head of an elaborately stratified court. These are the two African tribes most addicted to the preservation of their long history by means of oral tradition: that of the Bushongo has a presumptive length of some 1500 years, or considerably more than that claimed by the Bini; in both tribes a court historian or official remembrancer was a chief instrument of the maintenance of history; and in both the tradition, while purporting to be that of the tribe as a whole, is in fact devoted to the dynasty and its supporting aristocracy, which shows signs of being a superimposed stratum. Most striking of all, in both—and in few if any other tribes—the art falls neatly into two styles, patrician and plebeian, the first being concerned with perpetuation of the memory of the Oba and the Nyimi, or king. But the Bushongo way of life is oriented towards peace rather than war: even though some kings went to war, the wars were of pacification rather than aggrandizement; and even if the stories told about the greatest of their culture heroes, the Nyimi Shamba Bolongongo (supposedly c. A.D. 1600), are largely untrue or transferred from other personages, they still provide most valuable evidence of the ideal behaviour of the tribe, with their constant emphasis on harmless substitutions for social evils such as murder and gambling. Shamba (fig. 256) is portrayed as a paragon of nearly all the virtues and a great pioneer of the idea—a somewhat unusual one in tribal Africa—of progress; though a devotee of peace, he was no pacifist, and was ready to back morality with force on occasion. It is no doubt temerarious, on such a basis, to argue from political factors to artistic trends, but we must note that Bushongo art, unlike that of Benin, tends towards aestheticism rather than philistinism, and that, although decoration is applied to everything in all-over patterns (and apparently has been for centuries), a consummate taste informs nearly all their work: even enemas are as beautifully decorated with relief carving in traditional

patterns as are the ceremonial drinking cups of a chief (figs. 262, 266). In general, since Bushongo art has relied almost wholly on perishable materials, no such diachronic correlation of art and history is possible as we have attempted for Benin; but some hypotheses about the past may yet be offered. Torday, the first recorder of Bushongo tradition, followed the 'authorized version' in holding that the tribe was a Sudanic-speaking one which migrated early in the Christian era from the Nile Valley by way of Lake Chad to their present habitat between the Kasai and Sankuru Rivers: but it is becoming increasingly clear from linguistic and ethnological researches that this view is less than a half-truth. Only the ancestors of the ruling families are likely to have come from the north, bringing with them and imposing their traditions and some other traits; for the rest, Bushongo culture seems by no means out of place in the context of the other southern Congo tribes. More specifically, a number of the characteristic forms of artifacts, such as ceremonial wooden cups (see, for example, fig. 264) and bowls, appear to be related to early Mediterranean and Nile Valley shapes: their elaborate decorative art (see especially figs. 267, 271), on the other hand, appears to derive from the Kingdom of Congo on the coast. In the early sixteenth century, travellers were bringing back to Europe some of the most admirable textiles which Africa has produced; they were woven from raphia fibre and closely embroidered in the same material with a soft pile arranged in geometrical patterns; a similar style of design is found on certain old ivory hunting horns from the same coastal region. Now the great Shamba is said to have travelled far to the west as a preparation for the Bushongo kingship, to which he succeeded about A.D. 1600, and to have brought back with him the art of weaving in raphia, while his wife Kashashi is said to have invented that of embroidering designs upon the cloths. That the legend commemorates a real diffusion of culture is suggested by the occurrence of the same embroidery technique among the western Bapende. Among the Bushongo the technique was developed in an extraordinary profusion of beautiful patterns, the names given to which in some cases harked back to tribal proto-history, as in *ikuni na Woto*, 'the belly of Woto' (seen, in wood, on fig. 271)—one of the founders of the tribe—; the same patterns were translated unchanged on to the surfaces of their cups, boxes and other utensils and furniture. If this interpretation is correct, we may say that influences from the north and the west have formed, so to speak, the warp and weft of the Bushongo tribal style. The court style, however, seems more or less independent of this pattern; it takes the form of the royal portrait statues (figs. 255, 257), again said to have been invented by Shamba (although the present Nyimi holds that one of them, that of a king's son called Ntulachadi Matako, dates from fifty years before Shamba's time); the ears (see fig. 257) and some other features were carved in a special way. Very similar cross-legged figures are found, in stone and in wood, among the Bakongo of the Congo mouth, including some which seem to be some centuries old, and there can be little or no doubt that the Bushongo practice was introduced from the Kingdom of Congo. We may note before leaving the Bushongo area that the Bena Lulua, whose art (figs. 274, 281) and that of the southern

Bushongo are inter-dependent and in some respects assimilated, formerly carved human figures—probably owing something to the Baluba—which are among the most graceful of African works and exhibit a remarkable equilibrium between their form and the relief enhancement of their surface.

The third region of the Belgian Congo comprises not only the Baluba (figs. 289, 298), but also the Basonge (figs. 299, 303) and Batetela (fig. 304) (whose art and culture deserve to be more clearly distinguished from those of the Basonge than is usual in Belgian works); and Olbrechts included with them the Lunda and Bajokwe peoples (figs. 282, 287), although they are in fact also found through the southern parts of his first two regions and over a large area of northern Angola and the north-western areas of Northern Rhodesia. Baluba and Baluba-influenced peoples are found in the eastern parts of Northern Rhodesia and their influence extends well into Southern Rhodesia and Nyasaland. Finally we may reasonably associate with this group the Makonde peoples of the east coast, astride the Tanganyika-Mozambique border; that they are, in point of style, outliers of the great Baluba complex is strongly indicated by the forms which they carve, including standing figures, helmet masks (fig. 320) and caryatid stools, as well as by some affinity of treatment. The great Baluba style region is a signal example—Yorubaland is another—of the way in which many local 'schools' of carvers, working within the framework of a major style which reflects the political or cultural unity of the tribe, or in this case confederation of tribes, may produce a wonderfully rich variety of local and individual interpretations of the same kind of subject—here chiefly the human figure. In the museums of Europe and America we may discern the hands of many Baluba and Basonge masters, though there can be few still at their traditional work in the Congo today. If we compare the Basonge style with that of the central Baluba we find an aesthetic variation between almost opposite poles: the one is uncompromisingly cubistic, the figure being expressed in hard, faceted planes, while the other is undulant, fleshly and humanistic. And in between these styles (for they are not sub-styles, but rather styles within a 'super-style') occur marginal sub-styles which reconcile and synthetize them in a bold and convincing way, as Olbrechts has well shown in his book.

We shall here treat the whole northern part of the Belgian Congo—north, that is, of the Bushongo-influenced peoples (see, for instance, figs. 272, 273) along the Lukenye—as a single style region, partly because known sculpture is so sparse there, and partly because, as we shall see, certain styles of the north-eastern portion can be tentatively related to styles found a thousand miles to the west far beyond the French Congo border. We shall, in fact, add to this region the whole of French Equatorial Africa north of Loango as far as the Sanga River in the Cameroons and as far east as the Nile-Congo

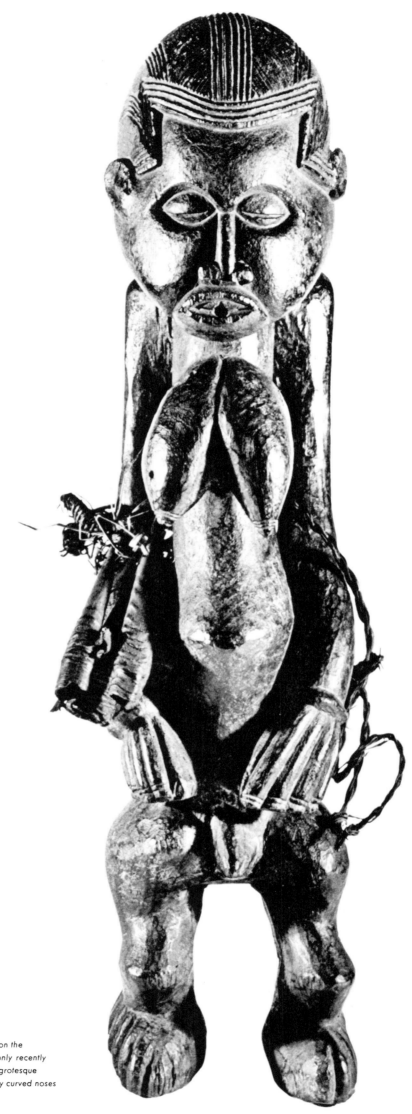

200

BASUKU FIGURE

The Basuku live with the Bayaka on the Kwango, and their art style has only recently been distinguished from the more grotesque Bayaka work with its exponentially curved noses (see figs. 248–252).

watershed, as well as the small group of tribes in the neighbouring parts of the (eastern) Sudan who a century ago were still practising the most rudimentary pole sculpture in Africa. Over this enormous tract from Lake Tanganyika to the western sea little consonance of style can be found; the arts are perhaps the most diverse in Africa, and if a parallel can be drawn between two styles they are usually found to be widely separated in space. In these conditions there is but little scope for art history or indeed for any conclusions except admiration for the originality and diversity of invention which is found in the region and particularly west of the Congo River. One tenuous chain of hypothesis may be briefly examined as an illustration of the difficulties. In the Gaboon and the nearby parts of Moyen Congo are found two groups of tribes, those whom we here subsume under the name of Fang, and the Bakota. Their principal works of art are figures placed as guardians over the receptacles of the ancestors' bones: the Fang carved comparatively naturalistic bodies with plump, rounded forms (figs. 211, 215) from heavy wood, blackened and highly finished, while the Bakota devised flat, highly abstract figures (figs. 224, 232) consisting essentially of an oval face covered with strips or sheets of copper and brass over a body reduced to an open lozenge. In short they are as dissimilar as any two concepts of the human figure in Africa. But besides these apotropaic figures, the Fang also made masks, coloured white, of an extremely simplified kind (see figs. 216, 217), having a concave heart-shaped face, which bear little apparent relation to their figures. These may possibly be related to certain masks of the Bakwele (figs. 218, 220), somewhat nearer to the Congo; but their most striking affinity is with the little-known wooden figures of the Bambole tribe (fig. 313), who dwell 1000 miles away to the south of Stanleyville on the upper Congo. Indeed, Bambole figures have commonly been attributed to the Fang. Further, many

of the wooden and ivory masks of the Balega (or Warega), still farther to the east, display the same form of face (figs. 307, 311). The intervening cultures, so far as they are known, provide no further clues, and it would normally be considered rash to postulate any connection between the Fang mask style and the Bambole figure style. But the Fang appear to be very late comers to the West Coast, having according to their own traditions arrived within the last three centuries after a very long journey from the east; and it is by no means impossible that before then the two tribes were much nearer neighbours. Some elements of Fang material culture are quite consistent with this; many others seem rather to be shared with other West Coast tribes, and the Fang figure style itself does not seem likely to have undergone so recent a transplantation. The Fang may prove to be a mixture of a migrant with a sedentary tribe, but much more linguistic and ethnological research is needed throughout the area before such questions can be answered, or even correctly posed.

The Congo basin, lastly, is the most convenient field in which to examine briefly the present state and uncertain future of African art. The old traditional sculpture has on the whole disappeared and died out there to a greater extent than in western Africa. This has been due to two main causes: first, that instead of making use of indirect rule as in the British colonies (where art, like other indigenous institutions, has consequently been left very much to its own devices), the Belgian philosophy of government has tended rather to encourage, with the help of the Church, the elimination of paganism and the pagan art which was its most tangible expression, except in so far as it could be usefully maintained in a purified form as a tourist attraction; and secondly, that individual Belgian and French administrators and travellers have been much more actively interested in African art, under the influence of the modern art movement, than have the British and have collected works of art so assiduously that in most parts none, or only inferior modern copies, are left. Moreover, most of the art, as elsewhere in Africa, served religious purposes, and these inevitably lost in importance when not only a more 'powerful' religion, but an efficient and paternalistic government came upon the scene to relieve the gods and spirits of their responsibilities.

Well-meaning efforts have been made on a great scale in the Congo to foster 'native art', but these efforts bear little relation to the old traditions, and are in all cases oriented towards European buyers: the carvers are not in fact producing works of traditional art, but their own imperfect approximations to the average European's erroneous idea of what native art is or ought to be. Such efforts may be valuable and meritorious from the materialistic point of view of maintaining employment and prosperity, but they have nothing to do with art in the true sense. Often they are mass-produced, sometimes by power-driven tools, and the commonest materials are ebony and ivory; the subjects are commonly pale derivatives of European art, even if African people and scenes are represented. Certainly it must happen sometimes that a carver who would have been capable of masterly work in the traditional idiom takes up carving for the curio trade; but if he is required to conform to the taste of the Europeans who buy curios, his genius

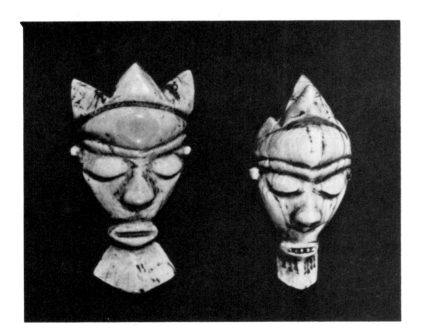

201
BAPENDE INITIATION BADGES

Among the Bapende groups on the Kwilu River, these badges, carved like the wooden initiation masks, are worn round the neck by initiated men of the tribe; they also have protective functions.

will surely be more severely inhibited than it would have been by the conventions of his own people, conventions which as a rule are in themselves conducive to the poetic expression of sculptural concepts. The great mission centre at Buta in the north-eastern Belgian Congo is probably the most prolific source of these aesthetically unsatisfying curios in all Africa, though there are many other centres (under mission or commercial influence) all round the coast of the continent where almost indistinguishable work is produced. This indistinguish-ability provides us with the best answer to those who believe that this export work carries on in some sense the great sculptural traditions of Africa: it would be absurd to suppose that some sea change of the mass unconscious had suddenly canalized into a single stylistic mould the inspiration of so many artists whose ancestors had practised such infinite variety of styles from immemorial time; the inspiration, such as it is, does not come from inside them at all, but from their alien patrons who have simply transferred from the Orient to Africa their demand for the familiar rows of diminishing elephants. From such foundations may arise a thriving export trade, but not a new African art.

A more favourable verdict can be passed on the aesthetic value of works of art—painting as well as sculpture—produced in European art schools in Africa. There are many of these in the Belgian Congo, the best-known being that founded by the late M. Romain-Desfossés. Yet even though the teachers are often most careful not to communicate their own or other European ideas on art directly, there are few if any cases where they have managed to avoid doing so indirectly. Here again there is a certain uniformity of style within each school and shared between different schools; the styles tend nowadays to approximate to those of the School of Paris, and some of the best examples are fit to be considered in that context. Again, the subject matter is commonly African, yet it is difficult to find essentially African aesthetic qualities in the work. Nearly always they might equally well have been done by a sympathetic European artist working in Africa. Painting and sculpture of this origin, therefore, are welcome evidence of the ability of educated Africans to work successfully in the 'contemporary' international style; but they do not carry on, either in the letter or so far as can be seen in the spirit, the artistic traditions which it is the function of this book to celebrate.

There would seem to be but little hope for the survival of the true African art, with its essentially dynamic and sculptural qualities, unless a market for the carver's work can be created or maintained within his own community. There are many places, even in the Congo, where this could still be attempted, but there is little hope of it without some very enlightened leadership, preferably from Africans. There are signs to suggest that such an attitude may be developing among the Yoruba of Nigeria, where commissions for the decoration of administrative and local public buildings have been given, by Yoruba politicians, to traditional carvers; but the steady support of individual patrons will be required too. It cannot be said that the prospects of African art remaining viable on any large scale are good; but some hope may be based on the surprising fact that, in certain parts of the Bushongo country at least, the same carvers

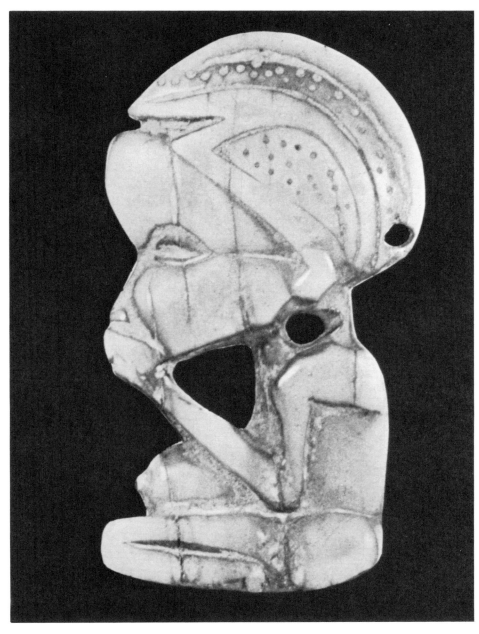

202
BAHUANA INITIATION BADGE

The Bahuana live near the confluence of the Kasai with the Congo. Their badges are sometimes, as here, carved in the round, sometimes flat, and seem related to the Basuku and Bambala styles.

have been able to maintain a dual standard of aesthetics. On the one hand, they make perfunctory and coarsely carved cups, boxes, 'royal' statues, etc., for sale to the Europeans; and on the other, they continue to carve utensils (fig. 267) in the fine old style for use in the village households, and these are so lovingly worked, not only by the carver himself but by the women of the household who rub palm oil and camwood into them, as to bear favourable comparison with the fine work which was collected there at the beginning of the century. In this tribe, therefore, one of the most sophisticated in the Congo, pride in the old traditions survives, beneath the surface, while a debasement of the tradition to the European taste flourishes on the surface; and the bad does not in this instance drive out the good.

In general, there is clearly more hope of the survival of secular than of religious traditions in art, because it is a matter of great difficulty to adapt pagan art to Christian uses. But enlightened experiments carried out in Nigeria suggest that it can be done, provided that exhaustive and profound research is first carried out into

the whole aesthetic, technical, social and economic basis of the art. The well-meaning efforts of European architects and designers to make use of traditional motifs in their work are too paternalistic and patronizing to be of much help. What is needed is to stimulate existing traditions, where the conditions are still favourable, both to maintain their secular output (in the form of carved doors or posts and other house furniture) and at the same time to adapt their subject matter to Christian liturgical needs. The obstacles are many: resistance may come, and not unnaturally, from within the Christian priesthood, or more commonly from the African converts, whose fervour often causes them to adopt an iconoclastic attitude to the appurtenances of paganism, and such attitudes can only be overcome by the search for and propagation of deeper knowledge of the real nature of African art. Undoubtedly pagan religious art, like Christian art, seeks to associate the most profound aesthetic feelings of man with the act of worship of God, and the common element should be capable of transfusion, to the enrichment of Christianity. The problems of the survival of African art are in fact in the last resort philosophical ones, and the researches of Father Tempels on the philosophical basis of life in the Belgian Congo (though hardly yet published in sufficient detail to satisfy the anthropologist in full) should be followed up as widely and deeply as possible in all parts of Negro Africa, with special attention to the little-understood relations between philosophy and art.

True art cannot arise or exist without the inspiration of belief—belief that is religious, even if (like William Blake's) it is not dependent on one of the accepted religions. In this sense art is religion, and conversely religion necessarily manifests itself through art. The integration, or rather the original unity, of religion and art is nowhere more signally demonstrated than in tribal Africa before the decay of traditional life under the influence of Western materialism: architecture and arboriculture set the scene of shrine and grove; music and dance, poetry and the drama provide between them the

outward signs of the inward grace; and the sculptor's art commonly reveals the mystical idea not indeed of the god himself but of service to the god. Certainly in such a continuum of art with its informing belief are the conditions in which the finest African sculpture has arisen; and in those tribes which produce secular as well as sacred sculpture, the carved doors and houseposts, boxes and bowls, though not themselves a part of worship, nevertheless seem to express the acceptance by the community of the same philosophical and religious values as the basis of tribal life.

It must be admitted that when the pagan faith gives way to Christianity, it most often loses profundity in the process, so that the convert's new belief is more superficial and transitory than the old, since the philosophical (and largely unconscious) basis of his thought has not been engaged by the conversion; and almost invariably the traditional arts through which the old faith was expressed are allowed to lapse, or are actively rejected, instead of being themselves 'converted' to the new faith. That this is as great a misfortune for Christianity as for art may come to be more widely recognized as our knowledge of Africa deepens; and those Churches, such as the Roman Catholic, which place prior emphasis upon faith rather than upon good works are no doubt in a better position both to understand the ancient and still viable unity of art and faith in Africa, and to apply that understanding for the greater glory of God, without compromising any essential truths of Christianity. The experimental research, already referred to, which Father Kevin Carroll carried out a few years ago among the Ekiti Yoruba in Nigeria demonstrated more clearly than any previous work how valuable such field study of African art in being (rather than when it is already fossilized in the world's museums) could be in enabling Christianity to penetrate deeply into the African way of life and to manifest itself through African forms. It is true that his chosen area is one of the most favourable in all West Africa for the purpose, since sculpture is still practised there and appreciated by the people, who seem

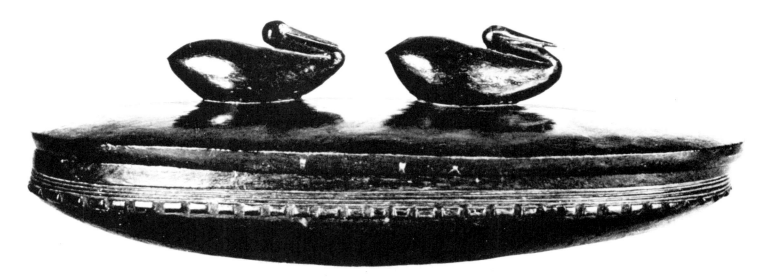

203
BAROTSE FOOD DISH

Among the Barotse of north-western Rhodesia these oval lidded dishes used to be ornamented with variegated animal, bird and genre subjects, perhaps under Bajokwe-Lunda influence.

to have a rather well developed critical faculty with a good descriptive and technical terminology. But tribal differences are likely, for better or for worse, to be progressively broken down in the coming years, and it is reasonable to suppose that if a recognizably African character can be given to forms of Christianity in a few specially favourable areas, it may prove possible to adapt these same forms for other areas where they might formerly have been rejected as alien. It is of course indispensable that Africans should play a leading part in any such revival of religious art; efforts which have been made by Europeans from time to time, in the Belgian Congo and elsewhere, to provide objects of liturgical art designed according to African traditional patterns have been too dilettante and too paternalistic in character even to take root.

Since the future of African art necessarily lies in the hands of Africans, we may, in conclusion, inquire briefly into the political conditions for its survival. The most immediate and serious obstacles to the future practice and appreciation of traditional art in Africa have been, and still are, found in the political field, and it is hardly too much to say that African art provides one of the most significant touchstones of African political maturity.

Let it first be noted that African sculpture has come during the past half-century to be regarded very highly among the world's great art traditions. Most of our art schools come constantly to the museums where tribal art is to be found and learn as much from it about the nature of sculpture as from the art of Egypt and the Etruscans, Greece and the Renaissance, the Orient, and modern art itself. And the production of a book such as this, as of many others in recent years, is a signal form of homage paid by the western world to what is undoubtedly one of Africa's greatest contributions to the enrichment of human culture.

Yet how is their traditional art regarded by Africans themselves? In those places where it survives as an activity—and there are few indeed where it can be said to flourish—it is still respected as a normal part of the life of the community, precisely because these communities are, in a political sense, backwaters. But among the 'politically conscious' Africans, the position is very different. The majority of them, when they hear Europeans praising African art and urging that it be encouraged to survive, show resentment on the assumption that an attempt is being made to 'hold them back', the better to perpetuate European domination; to them tribal art is of the bush and therefore to be discarded in favour of a westernized mess of pottage. There are indeed some among them whose attitude is extremely enlightened, and who have supported the efforts of dedicated Europeans to provide museums and other means of conserving the artistic heritage. It may be that under their influence, the naïvely defensive attitude towards art will fall away gradually as the African territories come to independence and full responsibility. Political progress is not enough and Africans themselves must develop a cultural balance between their ancient and honourable traditions and the needs of the modern world.

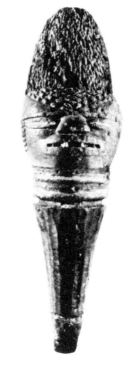

204
KUYU DANCE HEAD

This head, carved from a pithy wood, is slotted at the back for mounting on a stick, by which the fibre-enveloped dancer holds it above his head in the kebekebe dance. This is the old style, subsequently much debased.

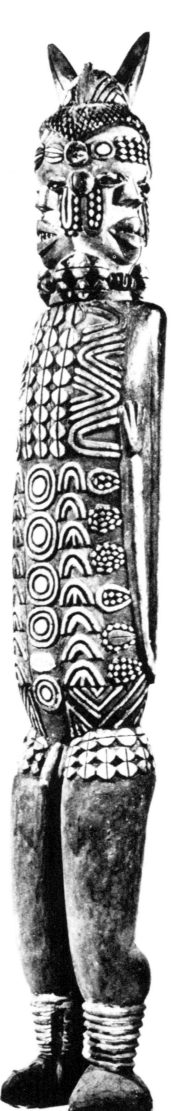

205
KUYU MULTIPLE-FACED FIGURE

Such figures appear to belong to the serpent cult of the chief men's society among the Kuyu of the French Congo. The emphasis is always on relief decoration rather than on bold forms.

FANG

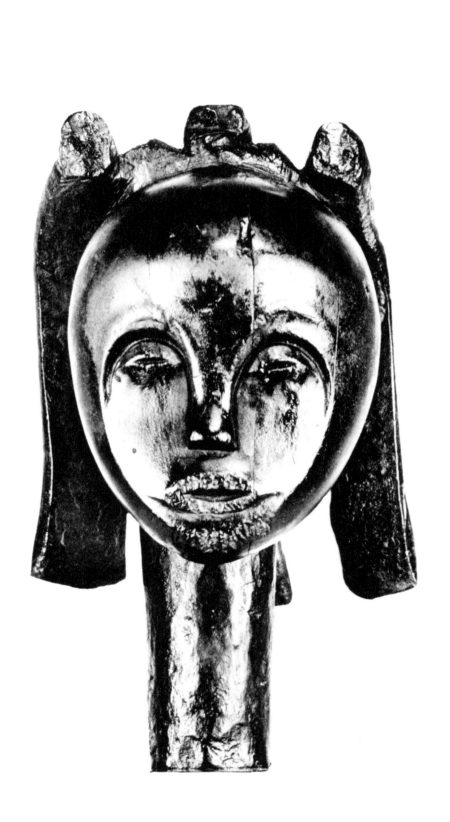

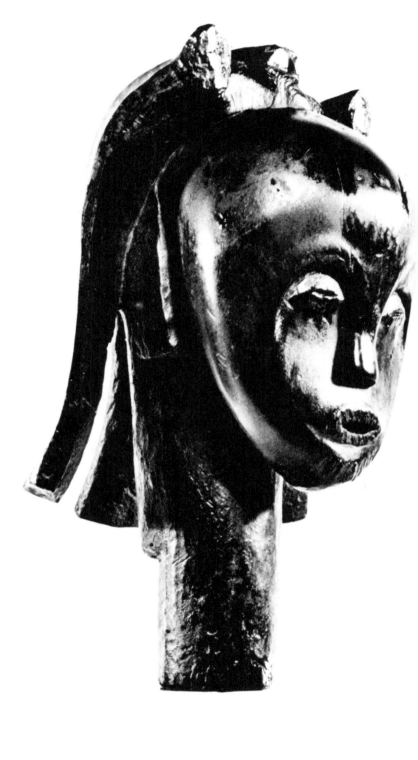

206
HEAD FOR A RELIQUARY

This and the following heads and figures are apotropaic or protective carvings designed to keep evil spirits, and also women, away from the cylindrical bark boxes in which the Fang

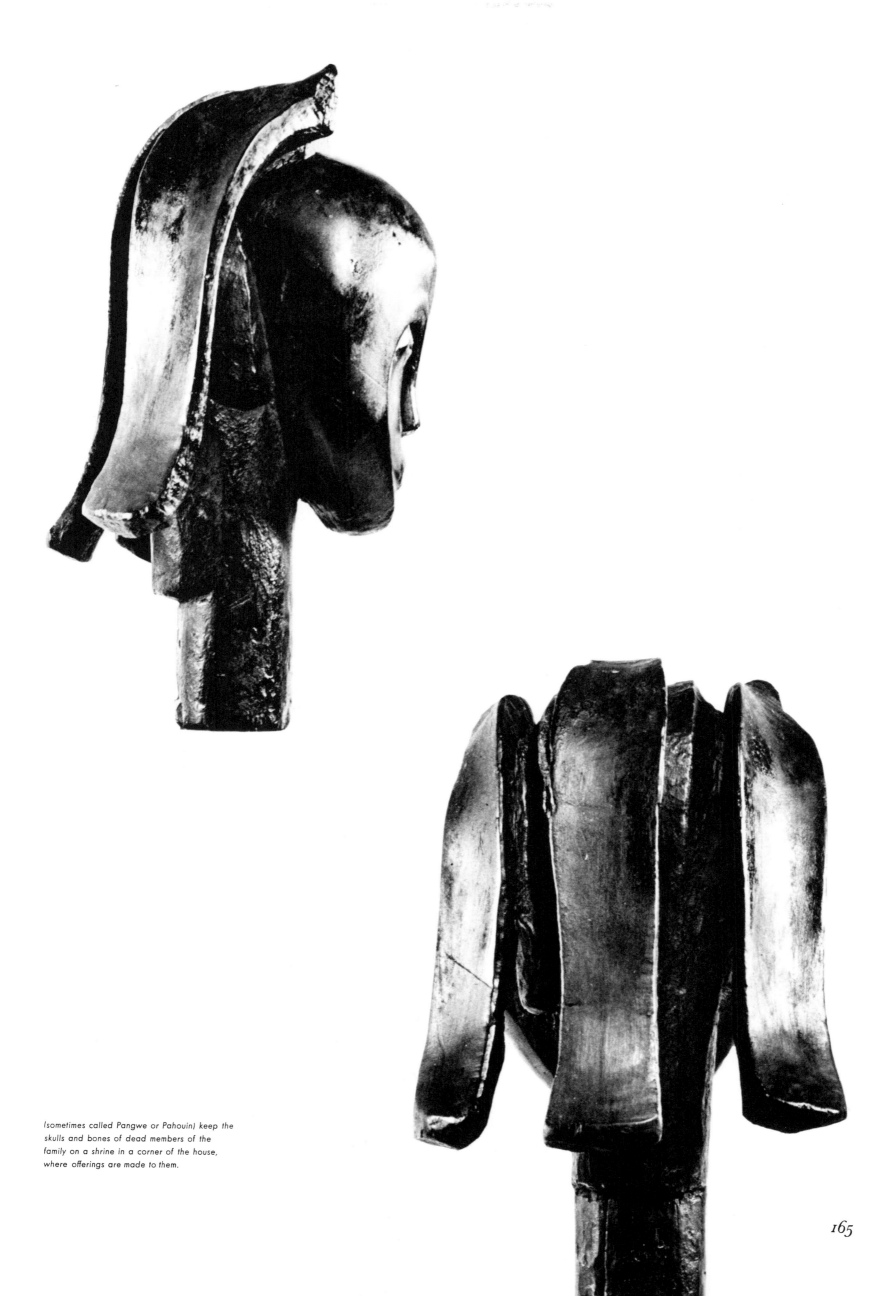

(sometimes called Pangwe or Pahouin) keep the skulls and bones of dead members of the family on a shrine in a corner of the house, where offerings are made to them.

FANG

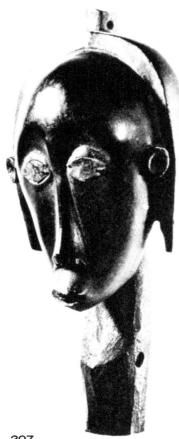

207

HEAD FOR A RELIQUARY

Heads on long necks are traditionally supposed to have been the first images carved to guard the skull bones of the Fang. But the surviving heads do not in fact seem to be any older than the full figures. Most examples appear to represent women, though the reliquaries were for both sexes.

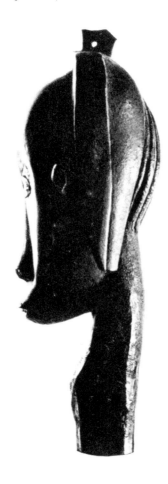

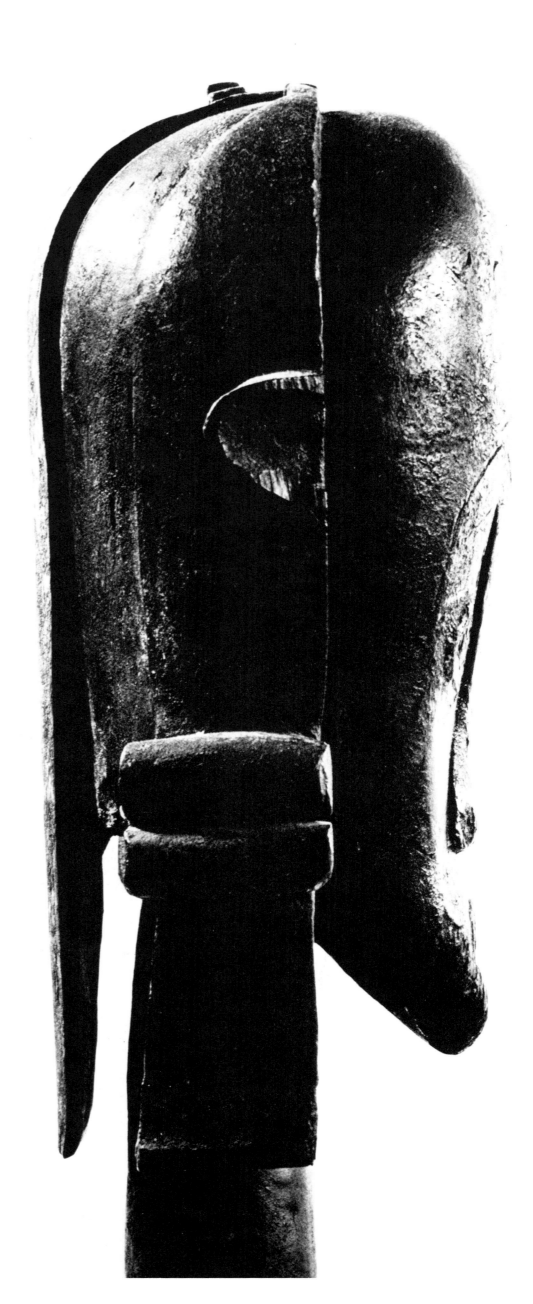

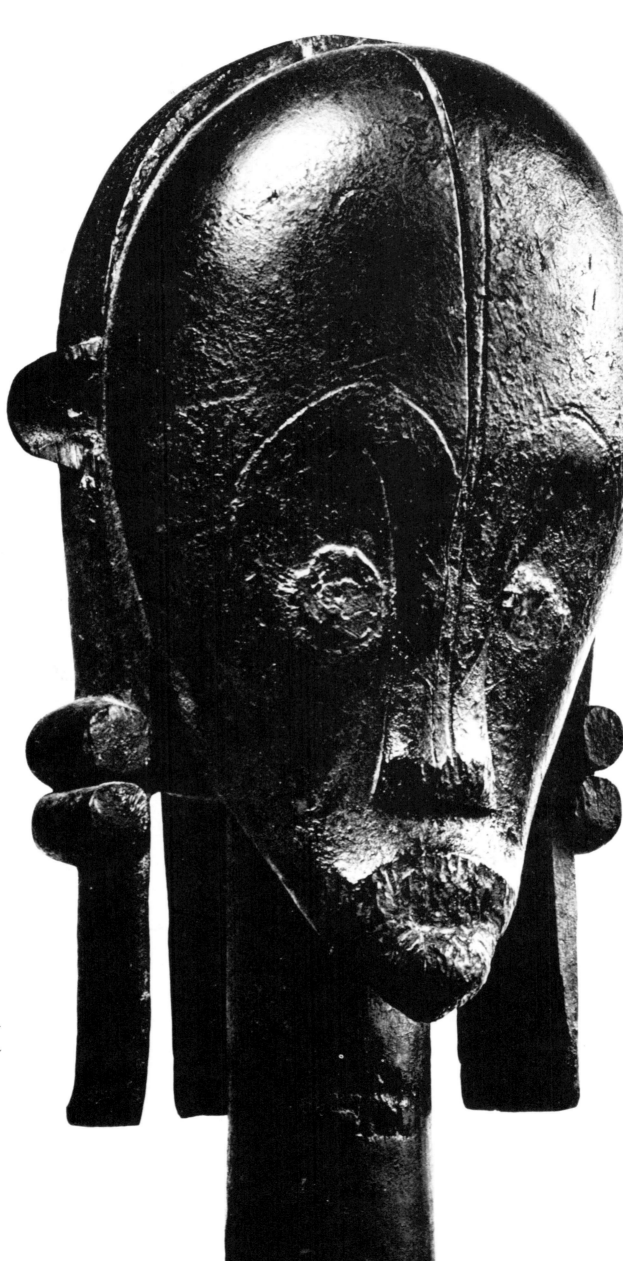

208
HEAD FOR A RELIQUARY

This famous head proves, in profile, to be surprisingly short from front to back—especially when compared with the marked dolichocephaly of figs. 231–236. The eyes are commonly represented by applied metal discs.

FANG

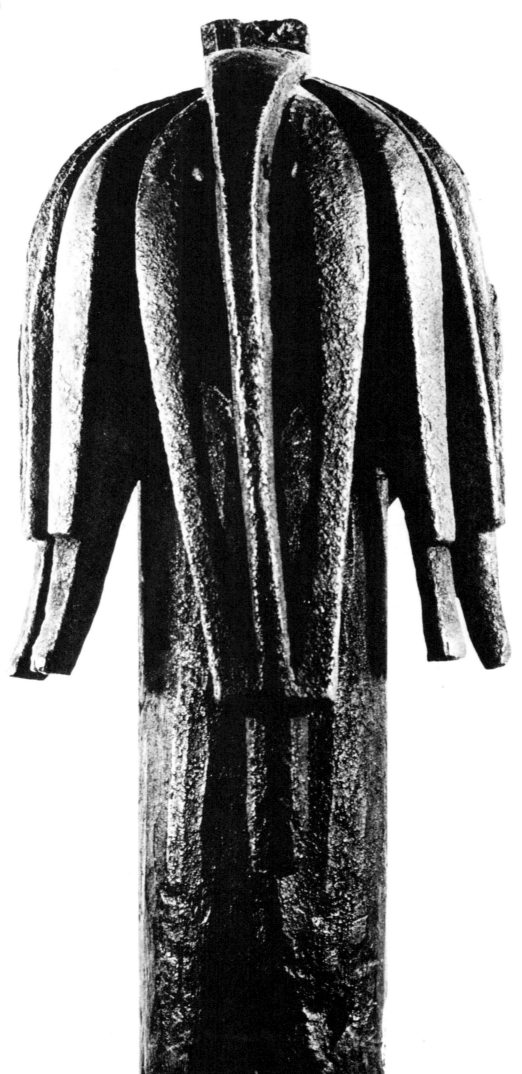

209
HEAD FOR A RELIQUARY

The hairdress of this piece is rather similar to the long braids which the explorer du Chaillu observed among the Fang before 1861; the fashion persisted among elderly notables seen early this century. The coiffures of some Fang carvings have holes for attachment of beads, braids of hair and other ornaments.

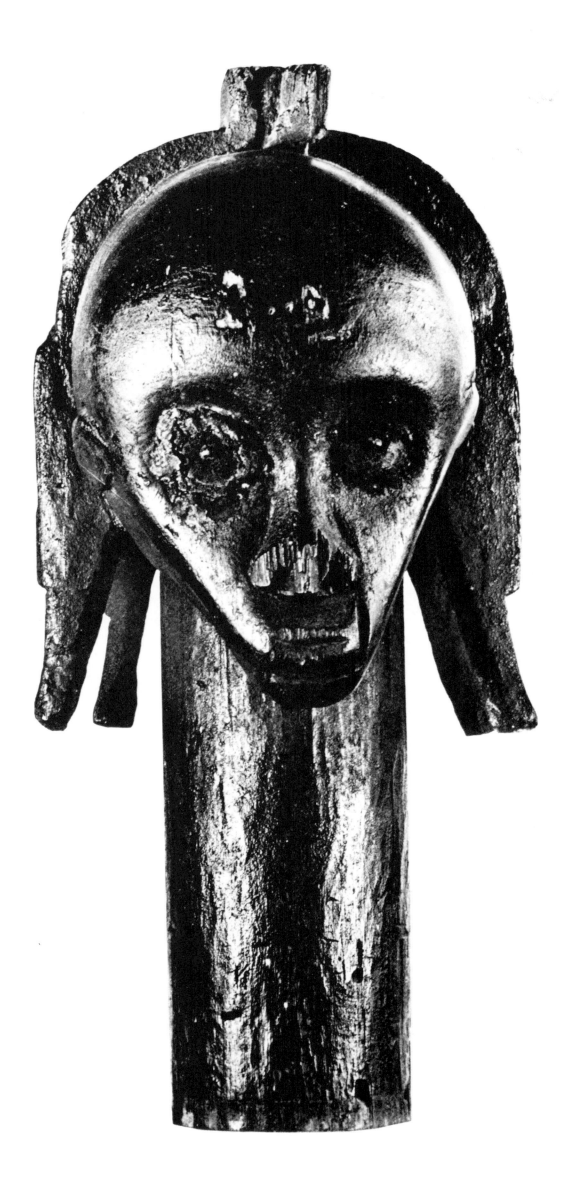

210
HEAD FOR A RELIQUARY

Fang carvings are among the most finely
conceived and executed of all African
sculptures and must surely have been
more than mere warning notices.
Originally at least they may have repre-
sented the ancestors themselves.

FANG

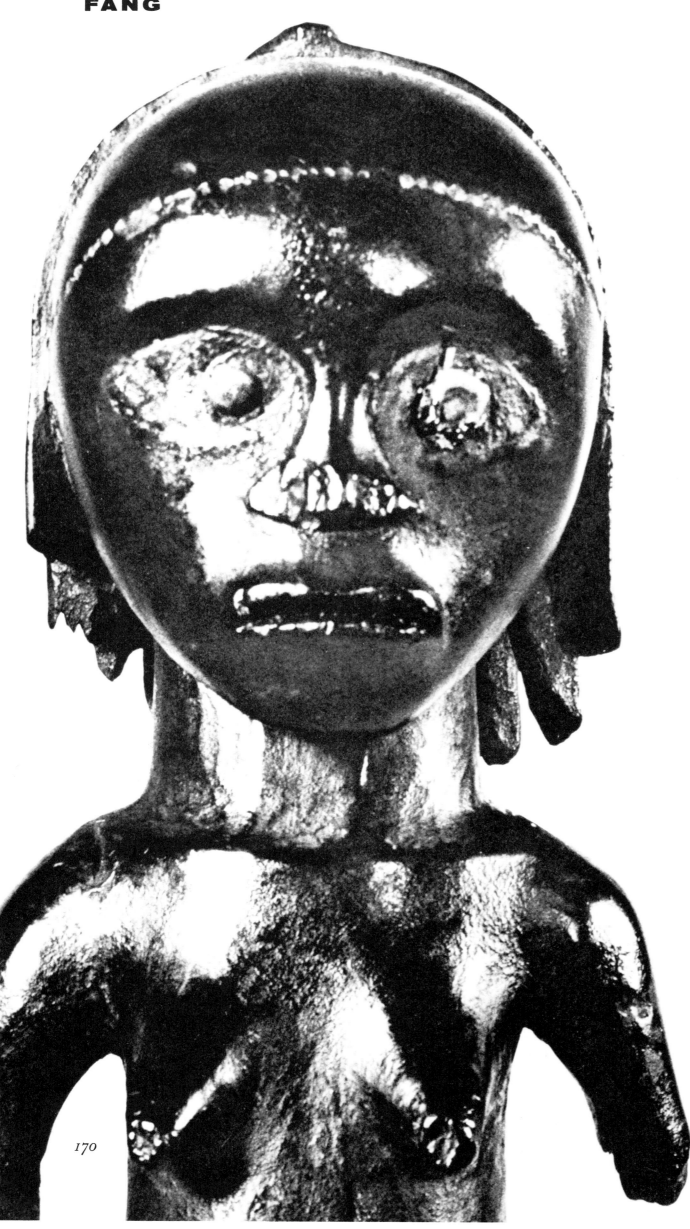

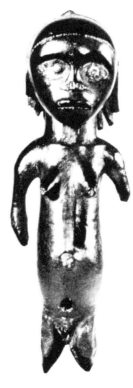

211
FIGURES FOR RELIQUARIES

Fang sculptures being of exceptionally hard wood, deeply impregnated with palm oil, may well have survived far beyond the normal maximum of a century. But they can hardly date before the Fang migration westward about 250 years ago.

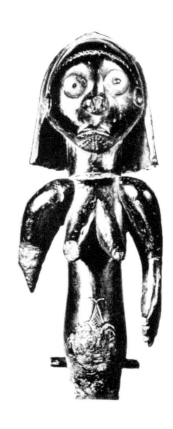

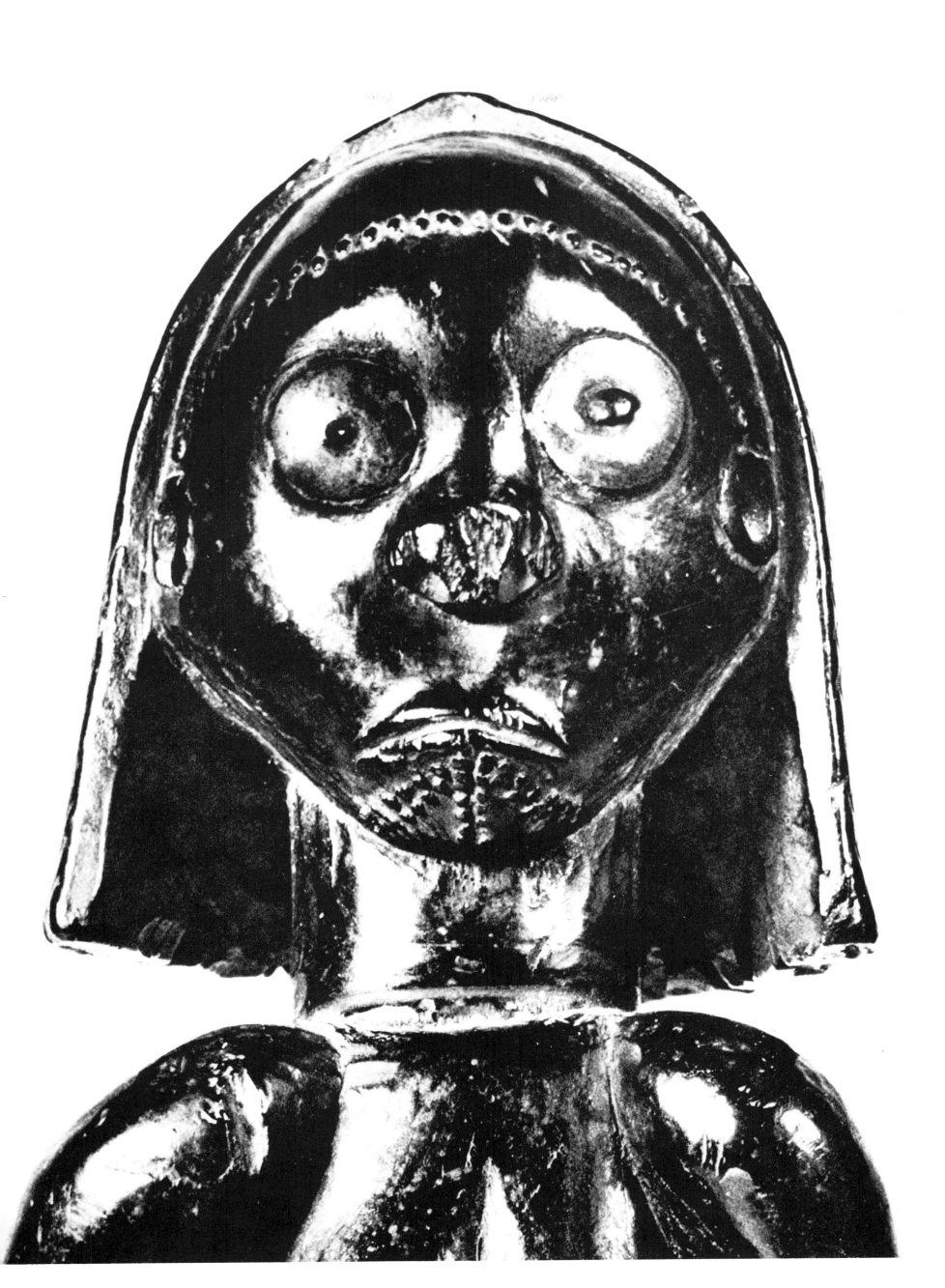

FANG

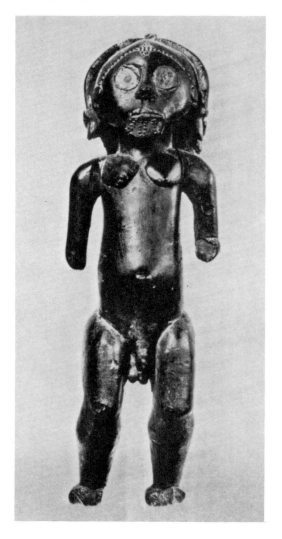 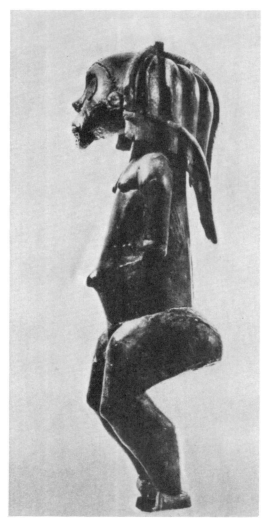

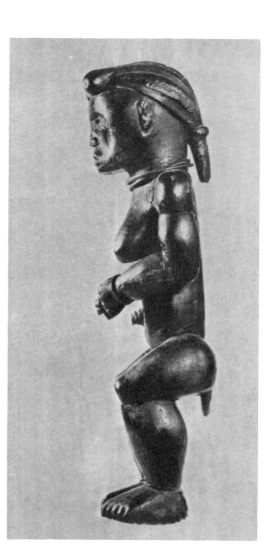

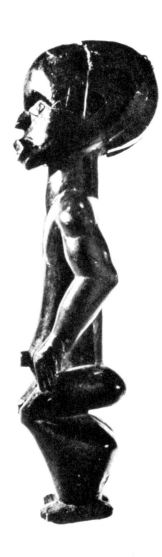

212
FIGURE FOR A RELIQUARY

*The great resemblance of this to the preceding piece
suggests that half and full figures were being carved
contemporaneously, though Fang told Tessmann that
the sequence was heads, half figures and full figures.
The greater age of the heads is perhaps suggested
by the absence among them of the more recent styles
of hairdress; and good figures were still being
made in this century.*

213
FIGURE FOR A RELIQUARY

*Most Fang figures have a vertical support carved
below the projecting buttocks for insertion into the lid
of the skull box; a vestige of it is seen here. Heads
were mounted in the centre of the lid.*

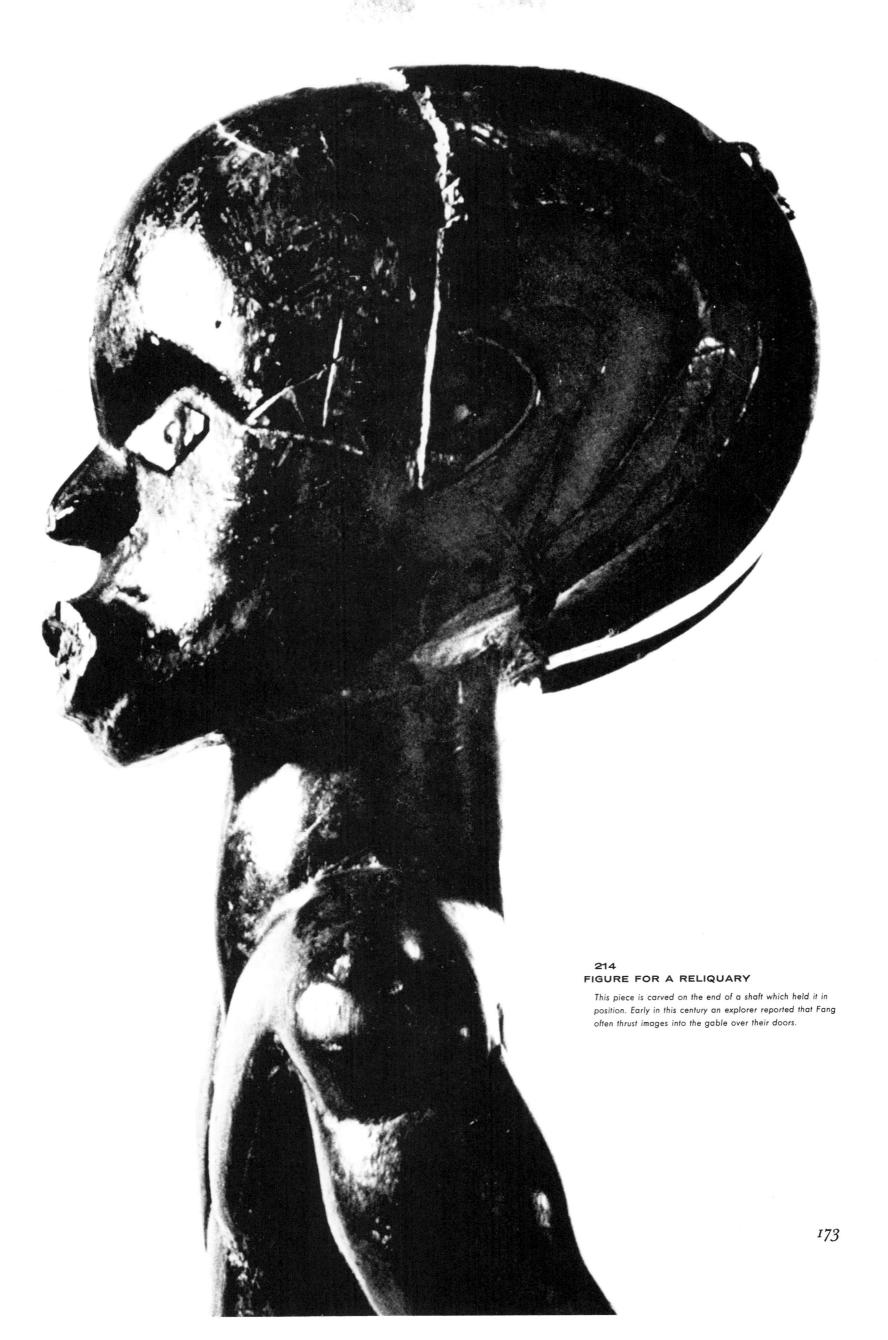

214
FIGURE FOR A RELIQUARY

This piece is carved on the end of a shaft which held it in position. Early in this century an explorer reported that Fang often thrust images into the gable over their doors.

FANG

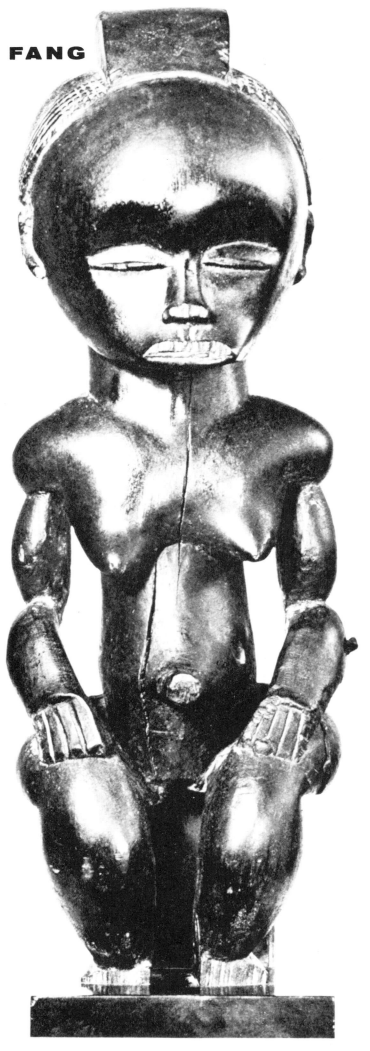

215
FIGURE FOR A RELIQUARY

This is a magnificent example of a style that has continued to be carved until quite recently. The headdress represented is a woven cap. At least in this century, the Fang did not regard these statues as ancestor images; they freely sold them, in contrast to the skulls, which could hardly be bought.

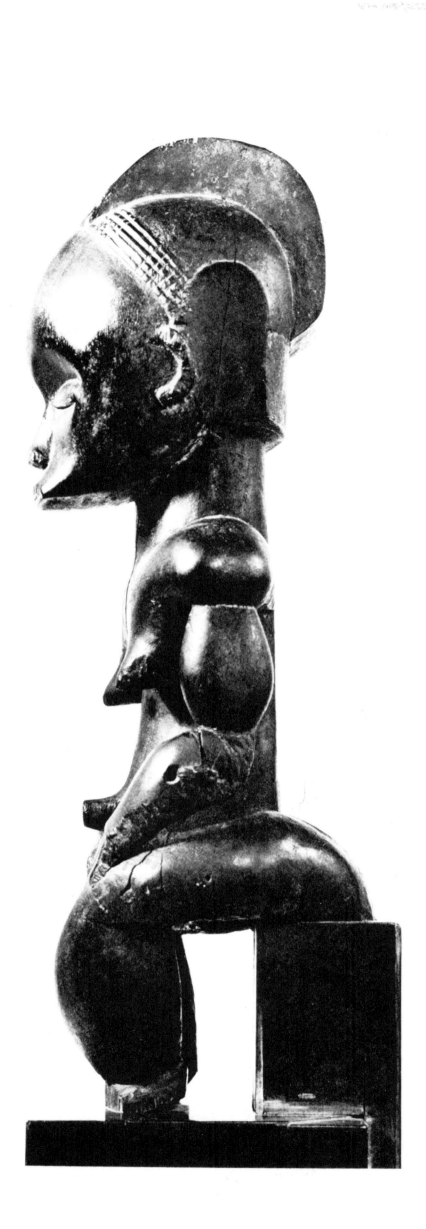
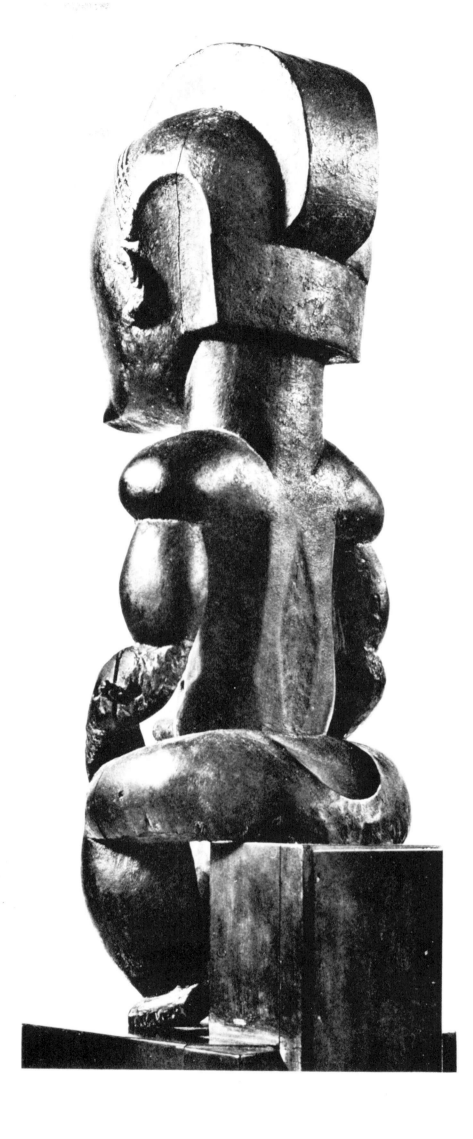

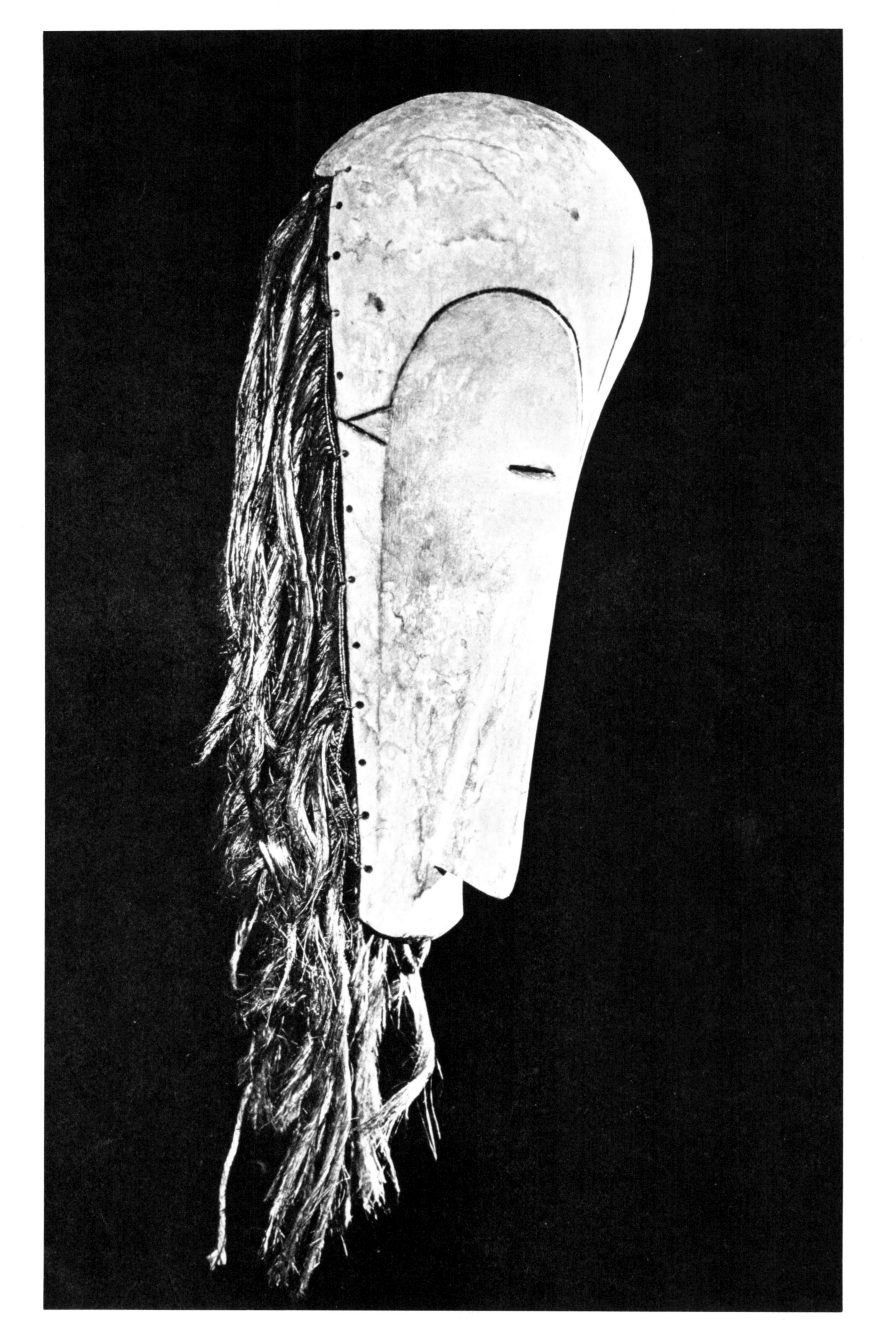

FANG

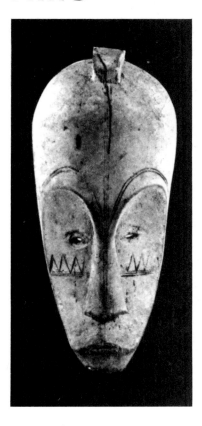

217
DANCE MASK

From its length and colouring, this mask also is probably for the Ngi society. There are many types of Fang masks, most of them coloured white, unlike the figures—a distinction which is widespread in African tribal culture.

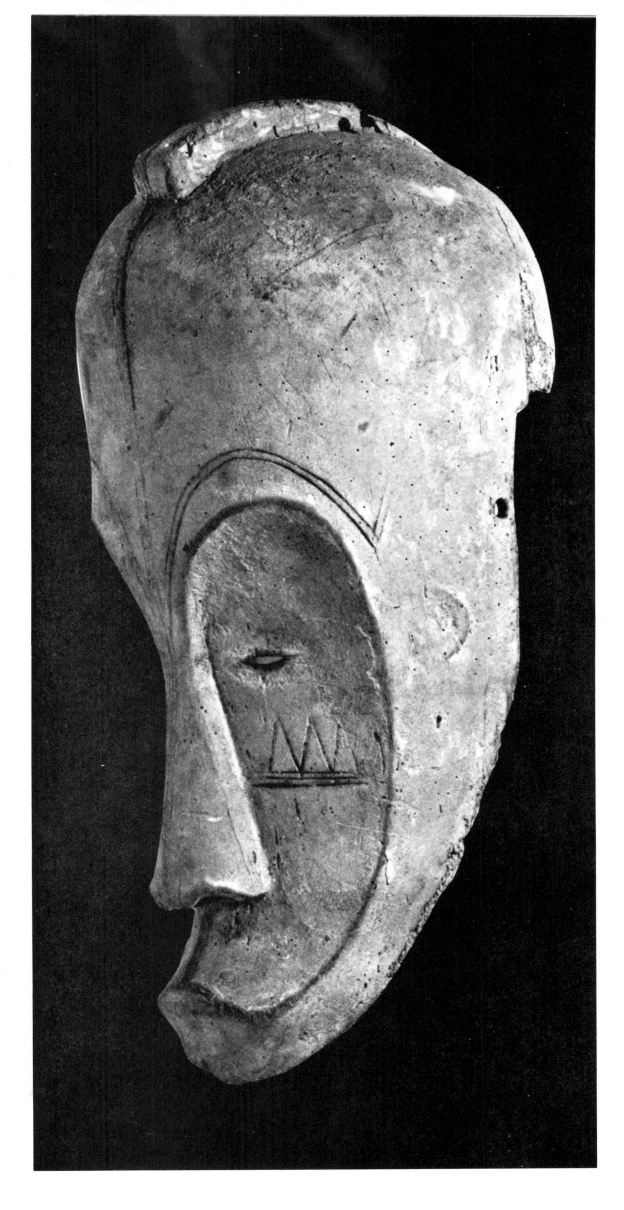

216
DANCE MASK

This is said to be a mask for the Ngi secret society, which was based upon a cult of fire and symbolized by the gorilla. Initiates, organized into several grades, kept order in villages by detecting and punishing sorcerers and lesser criminals.

BAKWELE

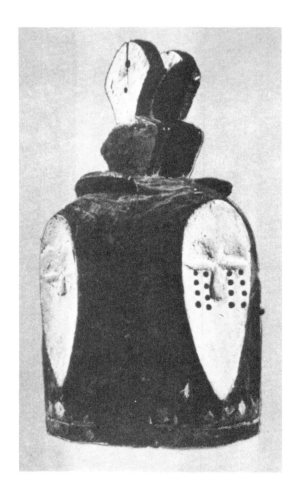

219
DANCE MASK

This four-faced helmet mask is of a type general in Bakwele country within the last few years. The long, narrow slit eyes in relief are typical.

218
DANCE MASK

The Bakwele of the French Congo are neighbours of the Fang and Bakota. Their highly simplified art forms seem to show affinity not only with Fang, but with Bambole and Balega work.

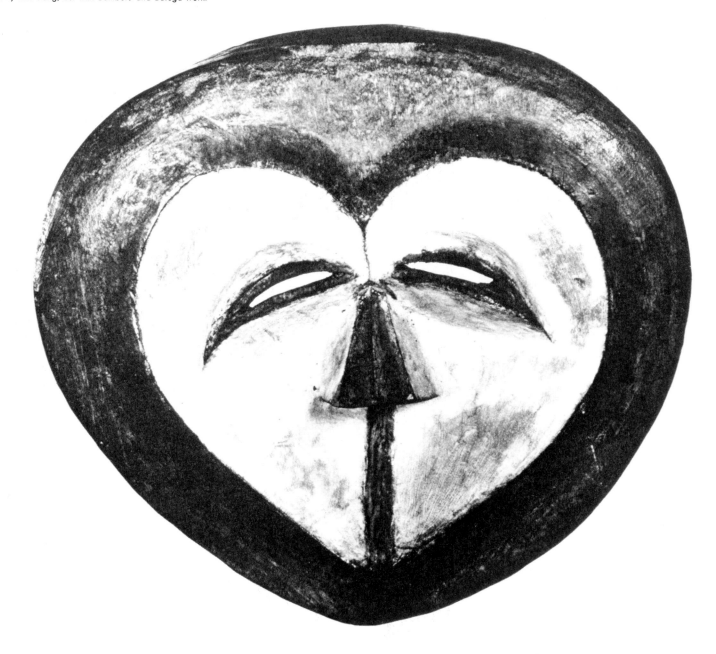

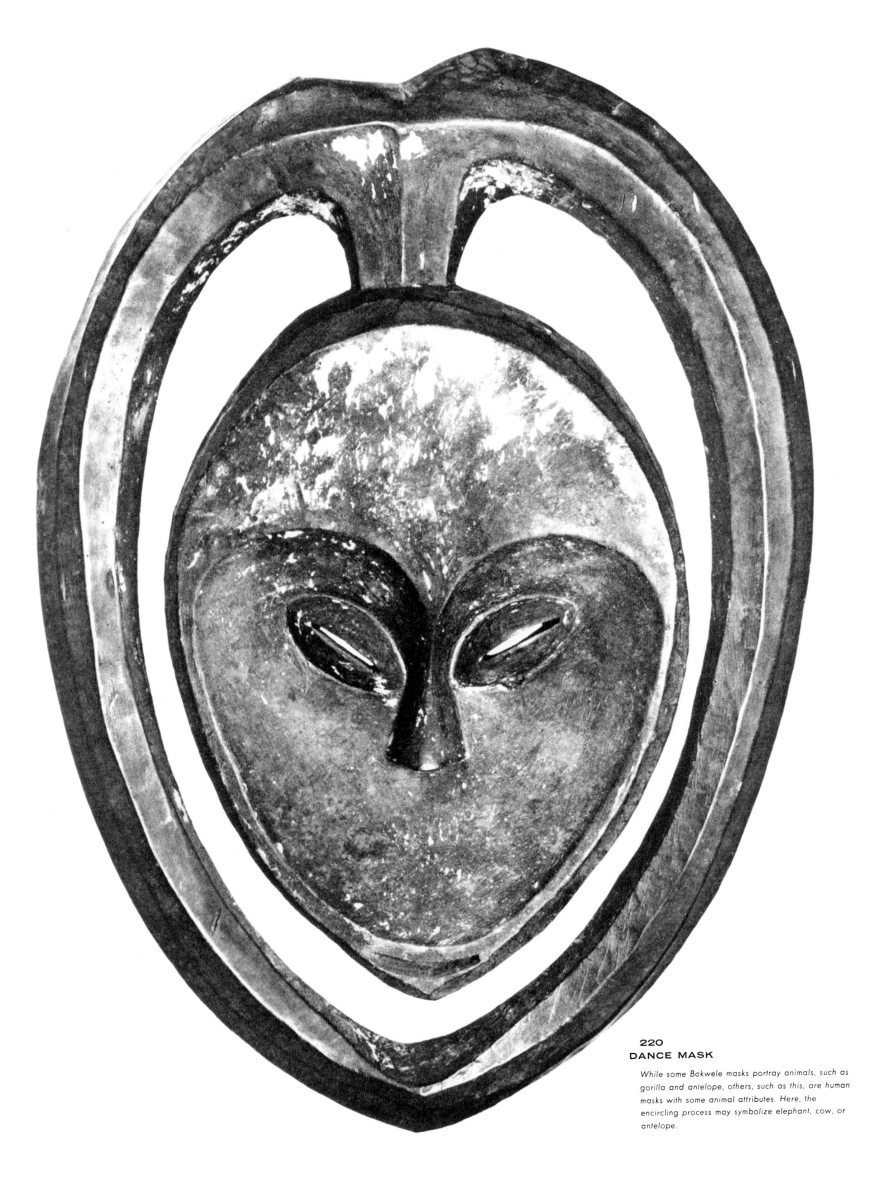

220
DANCE MASK

While some Bakwele masks portray animals, such as gorilla and antelope, others, such as this, are human masks with some animal attributes. Here, the encircling process may symbolize elephant, cow, or antelope.

BALUMBO

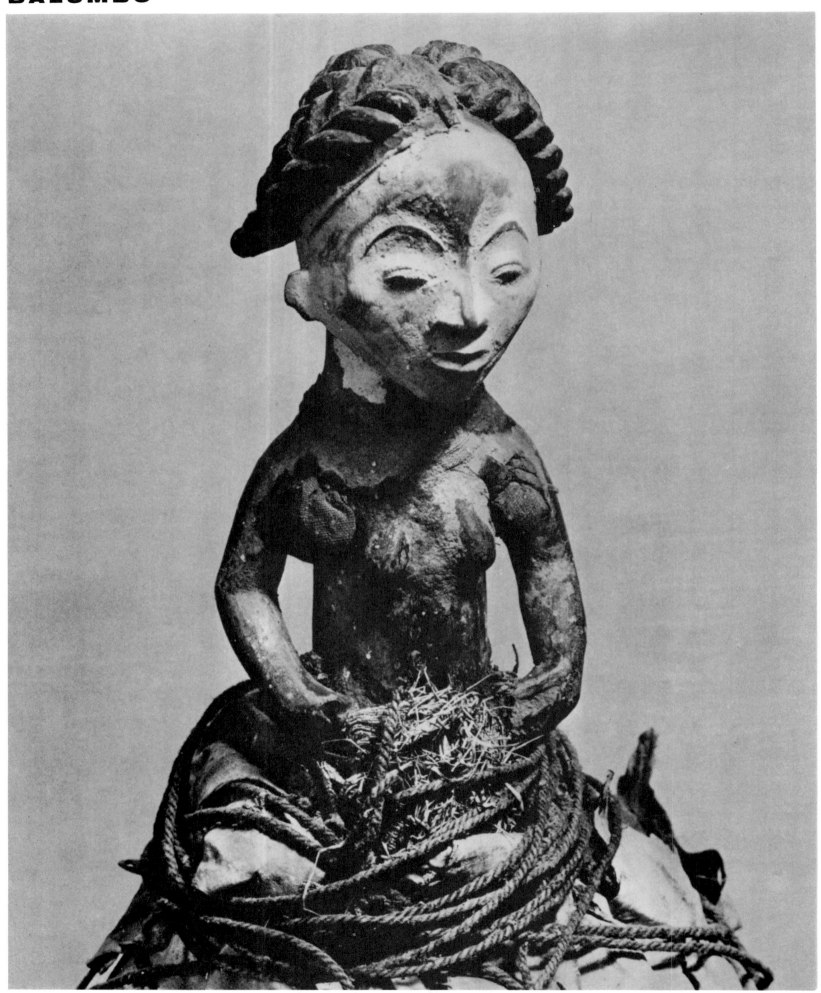

221
FETISH FIGURE

The Balumbo stand here for a group of tribes—
M'Pongwe, Mashango, Ashira, some Bakota, etc.—
who practise this style. To this rare half figure is
attached a bundle of magical 'fetish material'.

222
DANCE MASK

This widespread type of white-faced mask is
associated with the Mukui secret society of the
Mashango and other tribes. The masks are female,
represent ghosts of the dead, and are sometimes
used in stilt dances.

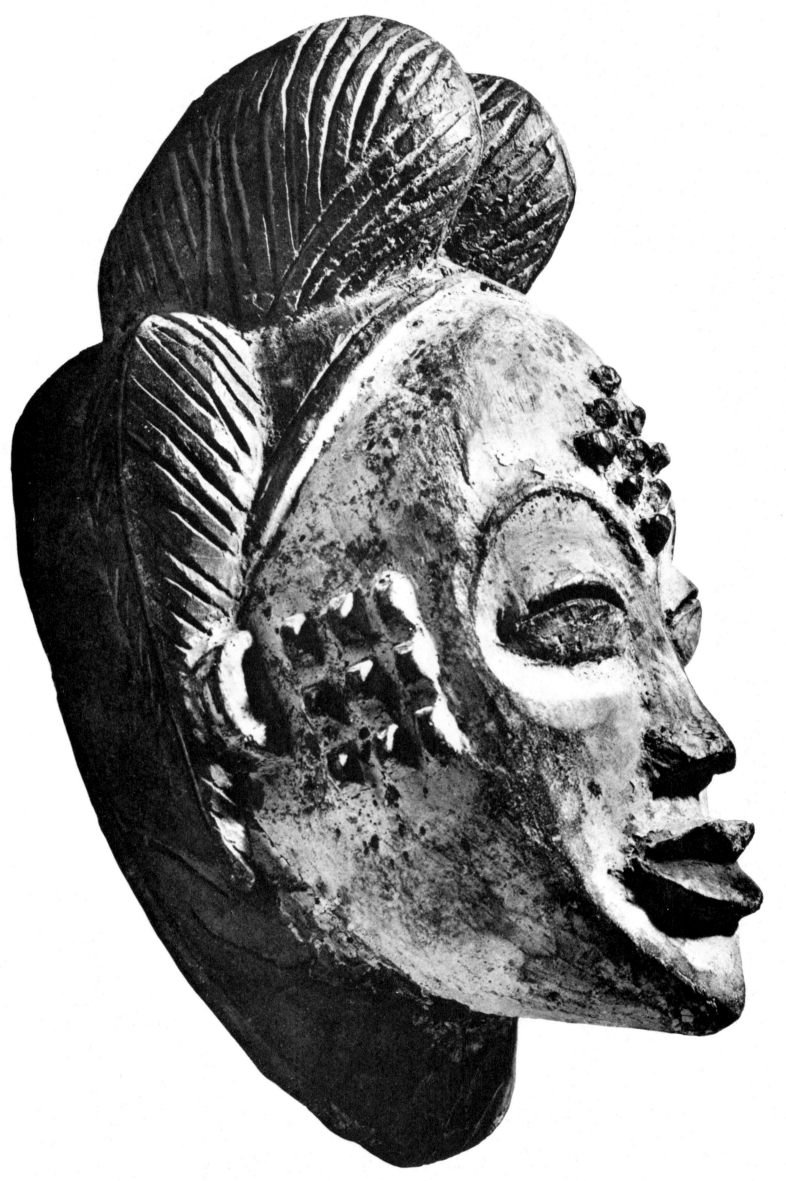

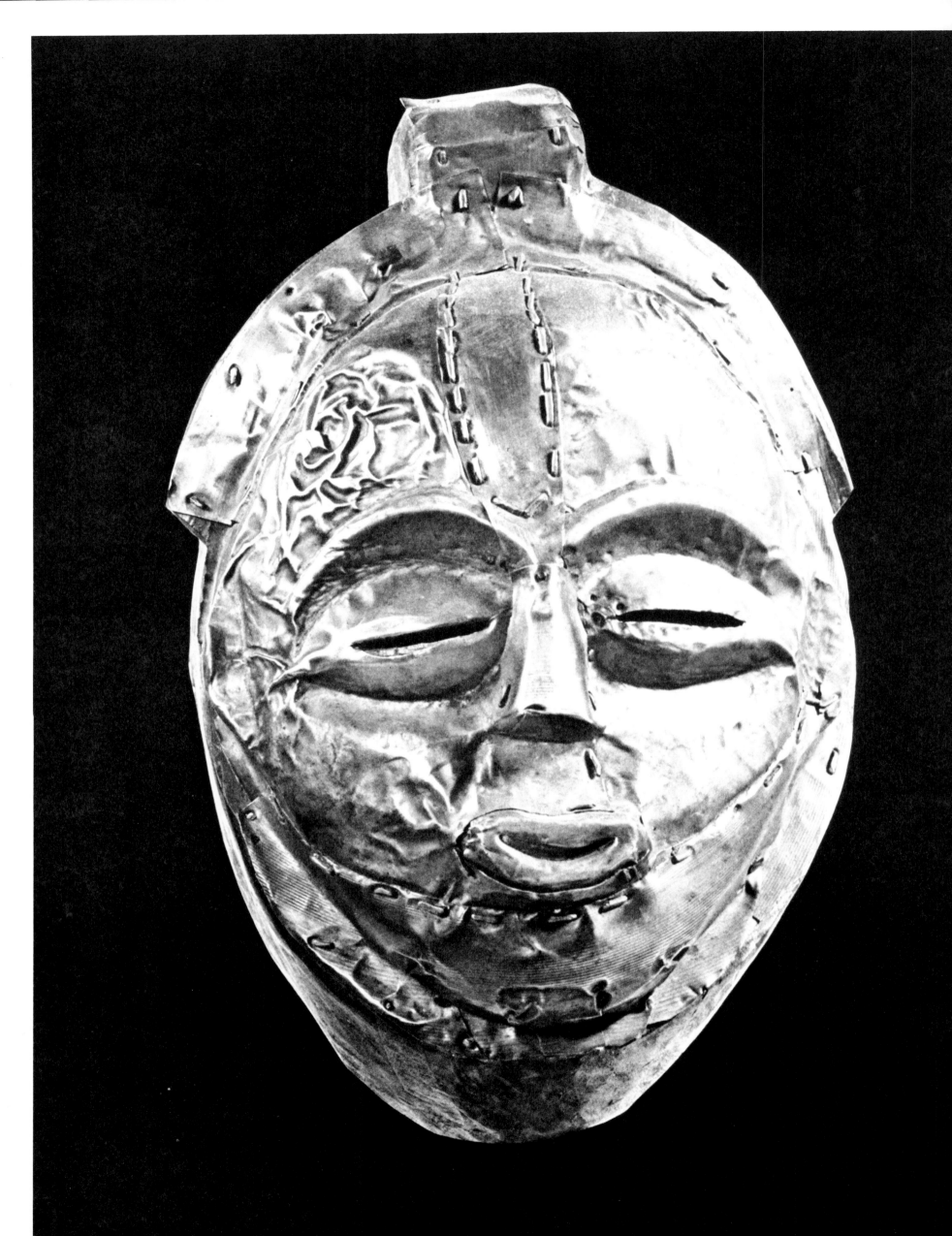

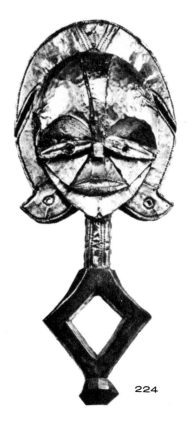

224

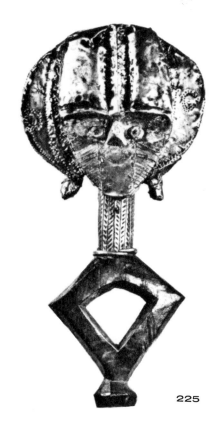

225

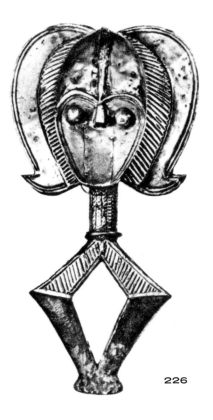

226

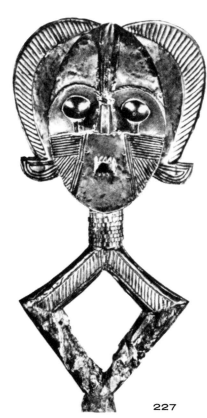

227

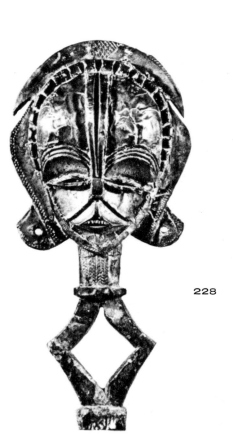

228

223-228
MASK AND FIGURES FOR RELIQUARIES

The Bakota tribes, like the Fang, keep skeletal remains of dead chiefs in bark boxes or baskets surmounted by apotropaic figures; but these are conceived in two rather than three dimensions. They are faced with brass or copper sheets or strips. According to some accounts, faces in convex relief are male, those in concave relief female; others are Janus figures, usually with convex and concave faces back to back. Brass-covered masks (fig. 223) are extremely rare.

223

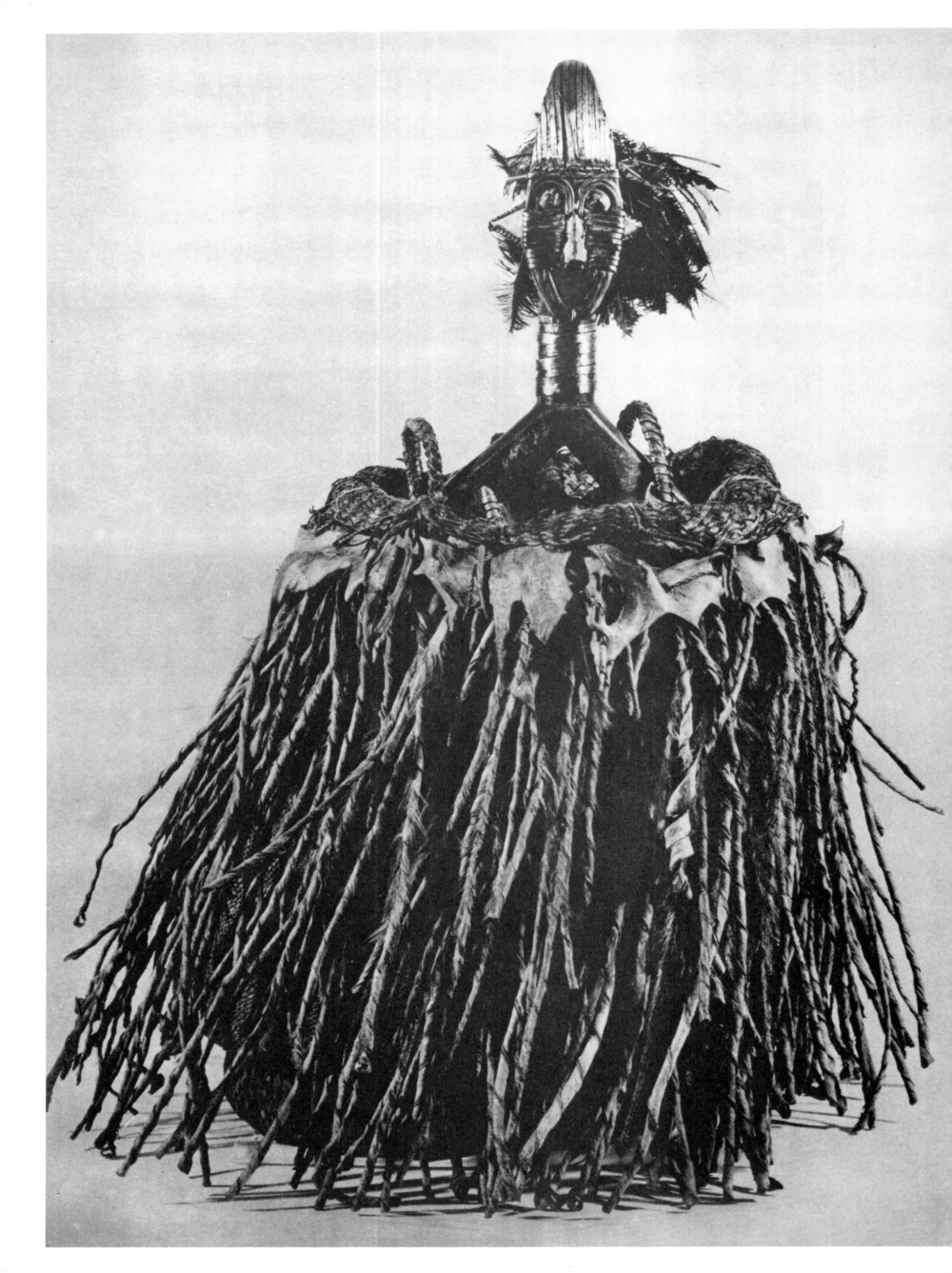

230
FIGURE FOR A RELIQUARY

This aberrant style is attributed, perhaps with little warrant, to the 'Osyeba' (a Middle Ogowe term of ridicule for the Fang). It clearly belongs to the Bakota complex, perhaps to an obscure group east of the Upper Ogowe.

231
FIGURE FOR A RELIQUARY

Small-headed images such as this appear to come from the northern Bakota. Except in the two-faced examples, the metal is applied only on the front.

229
FIGURE AND RELIQUARY

The lozenge-shaped base of Bakota figures probably derives from half figures with arms akimbo, shown in relief on a round trunk; a few such specimens exist. This example, complete with basket and relics, is from the Ondumbo tribe.

232
FIGURE FOR A RELIQUARY

Figures plated with brass sheeting are generally thought to be more recent than those with brass, copper and iron strips. Most examples have a simple relief design carved on the back.

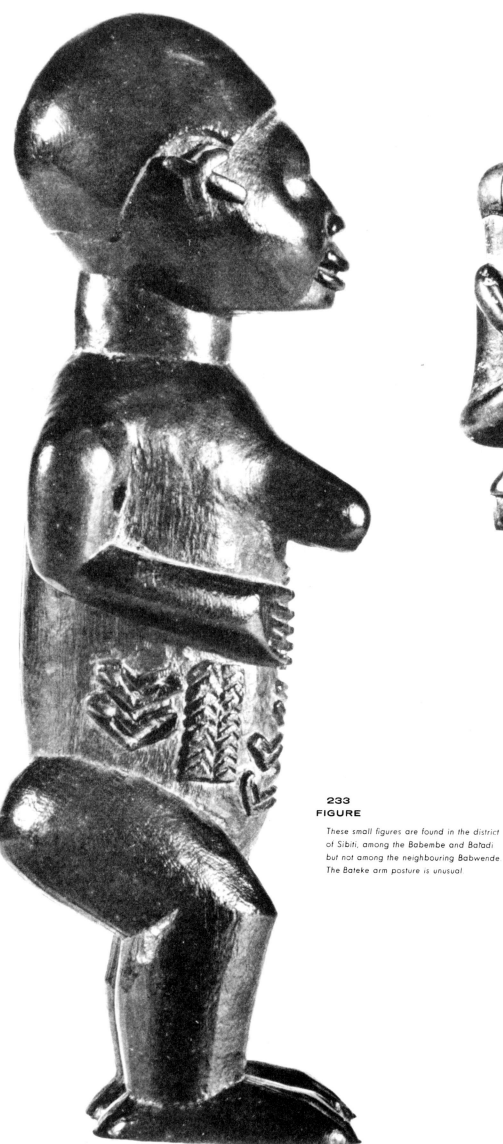

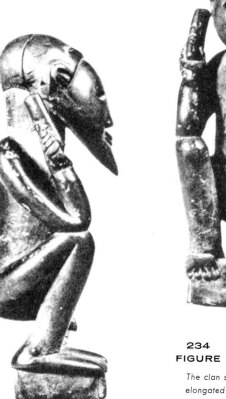

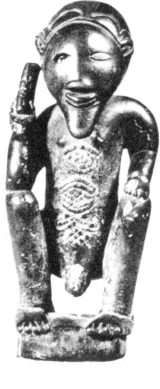

234
FIGURE

The clan scars on the often elongated trunks suggest that these are ancestor images, but they are reinforced with 'fetish' material inserted into the trunk through the buttocks.

233
FIGURE

These small figures are found in the district of Sibiti, among the Babembe and Batadi but not among the neighbouring Babwende. The Bateke arm posture is unusual.

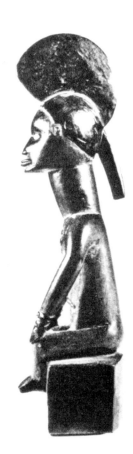

235
FIGURE

Many male figures have a high crest, sometimes suggesting the bony median ridge of the gorilla. The figures seem to act as household gods.

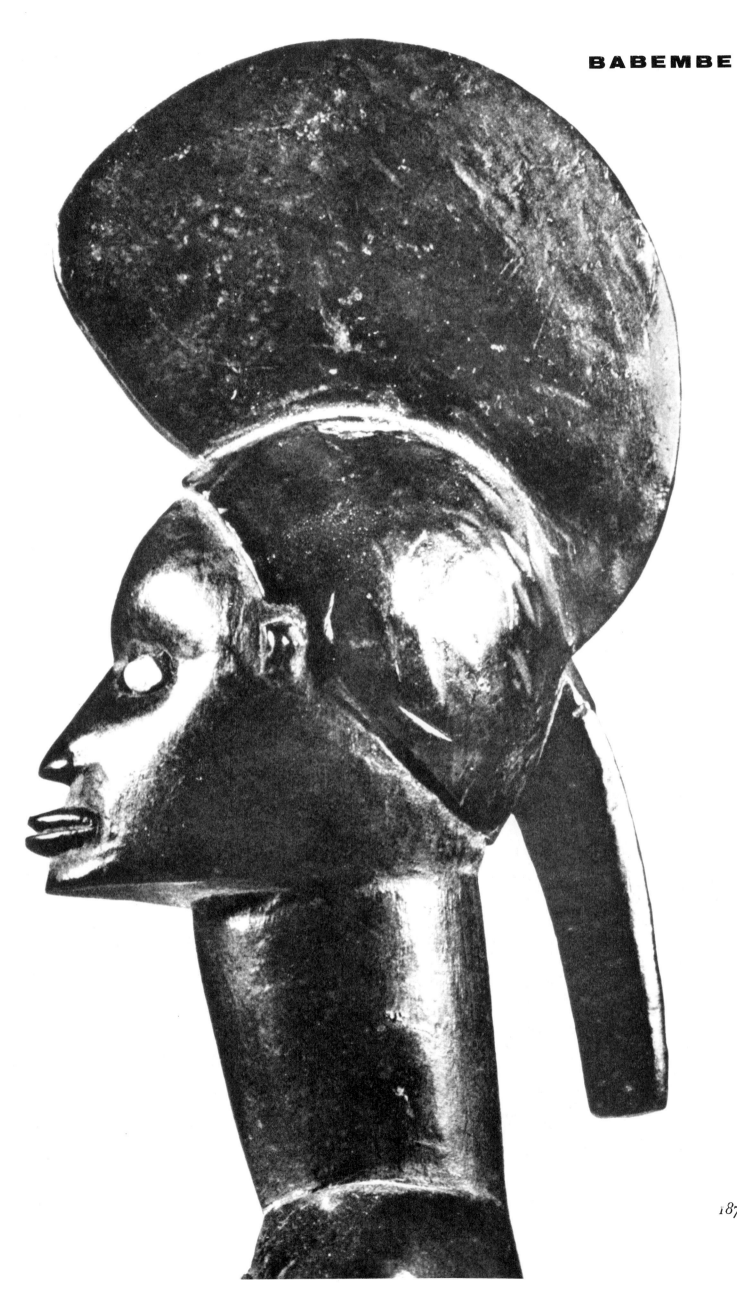

BATEKE

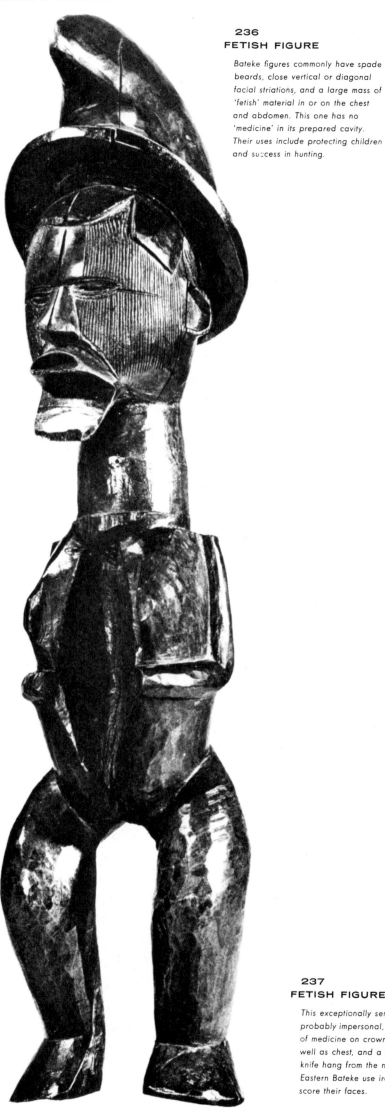

236
FETISH FIGURE

Bateke figures commonly have spade beards, close vertical or diagonal facial striations, and a large mass of 'fetish' material in or on the chest and abdomen. This one has no 'medicine' in its prepared cavity. Their uses include protecting children and success in hunting.

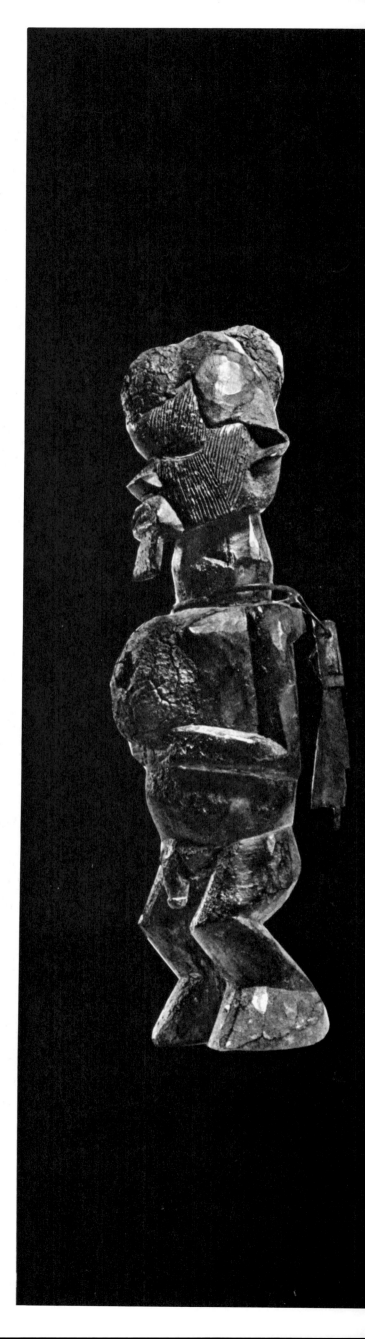

237
FETISH FIGURE

This exceptionally sensitive, though probably impersonal, fetish has lumps of medicine on crown and brow as well as chest, and a small bell and knife hang from the neck-ring. Eastern Bateke use iron combs to score their faces.

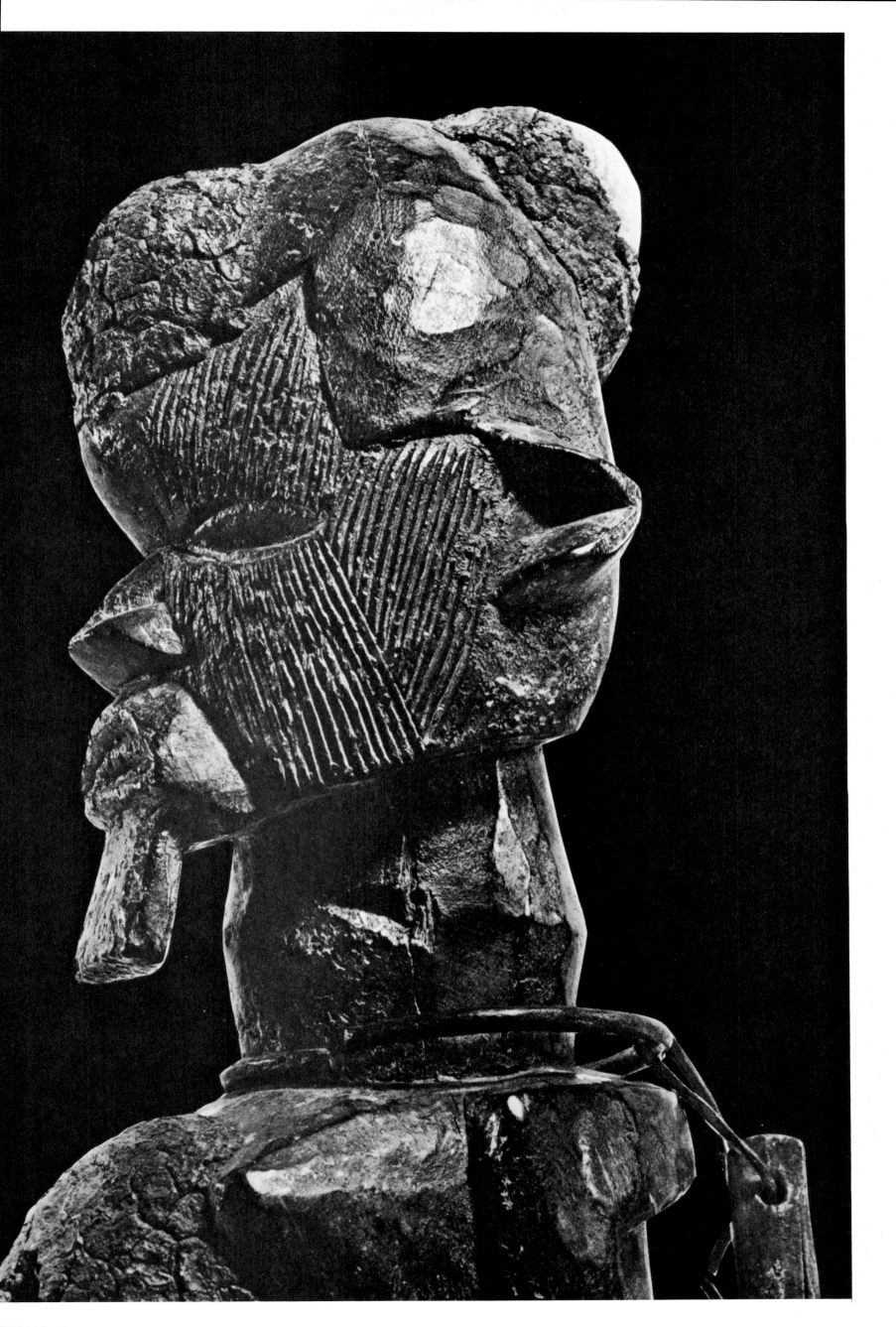

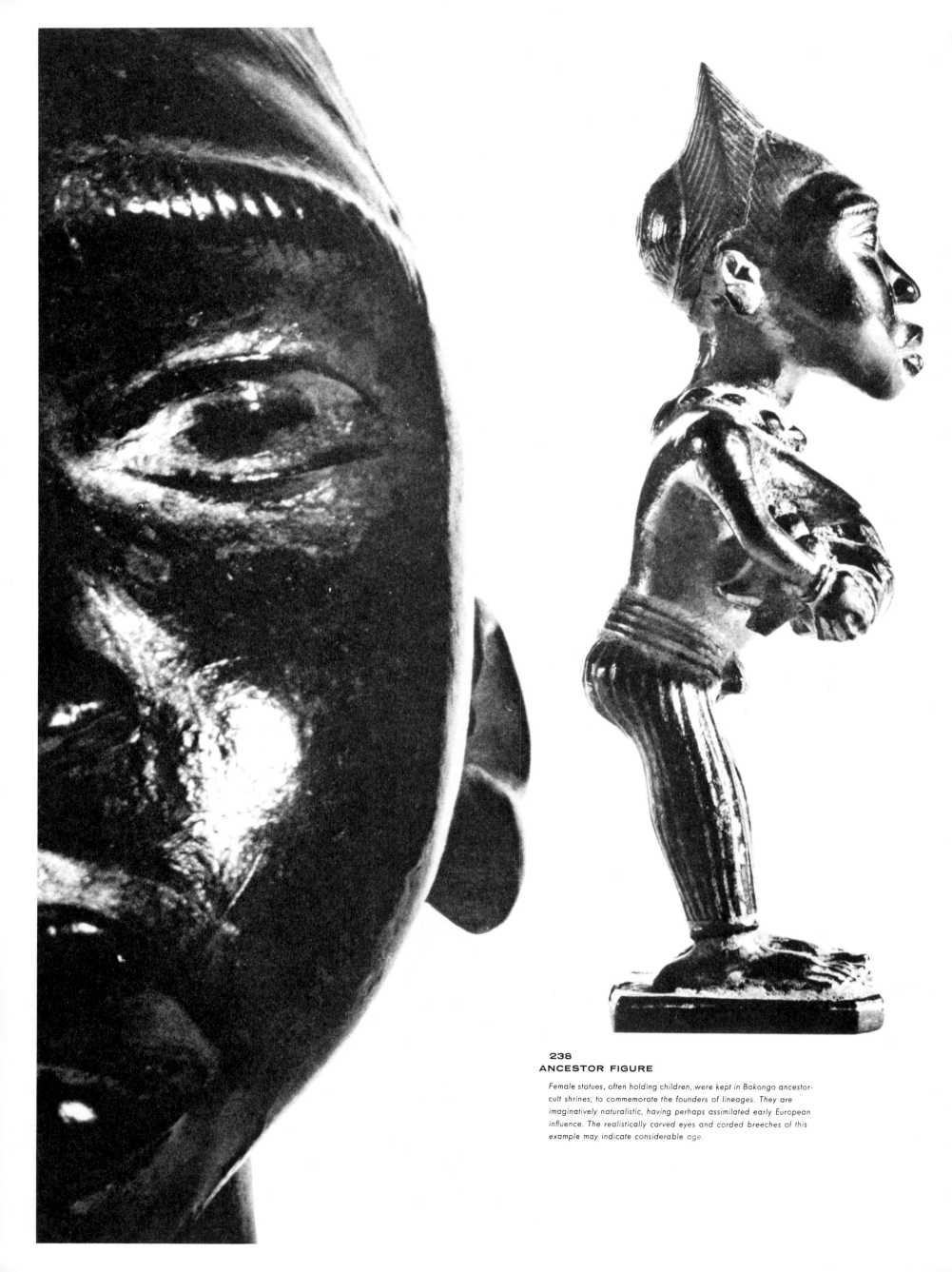

238
ANCESTOR FIGURE

Female statues, often holding children, were kept in Bakongo ancestor-cult shrines, to commemorate the founders of lineages. They are imaginatively naturalistic, having perhaps assimilated early European influence. The realistically carved eyes and corded breeches of this example may indicate considerable age.

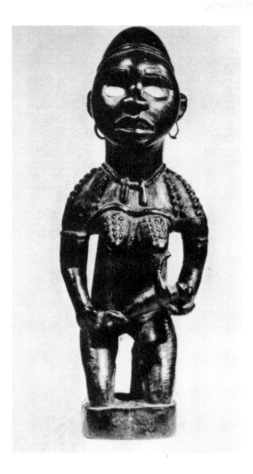

239
ANCESTOR FIGURE

*Many ancestor figures have elaborate body
cicatrization (usually in patterns suggesting
old Bakongo pile fabrics and ivory carving)
Aesthetic, religious and social motives
commonly combine to induce Africans to
such self-embellishment.*

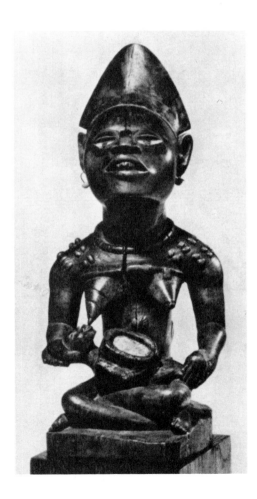

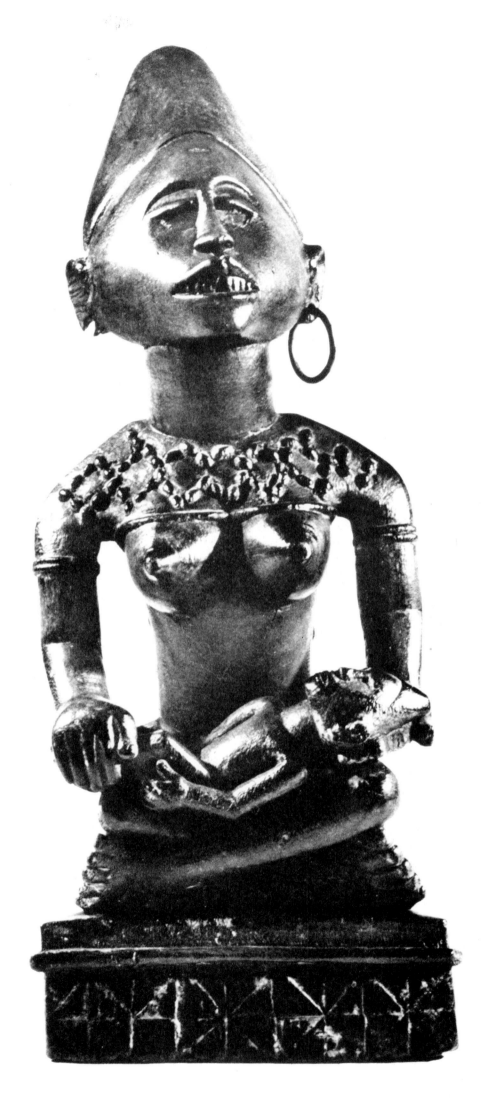

240-241
ANCESTOR FIGURES

*The intrusion of fetishist concepts into the ancestor cult is seen in the
magical box attached to the child's torso in fig. 240; this practice is
said to have commemorated the mother of an important fetishist
witch-doctor.*

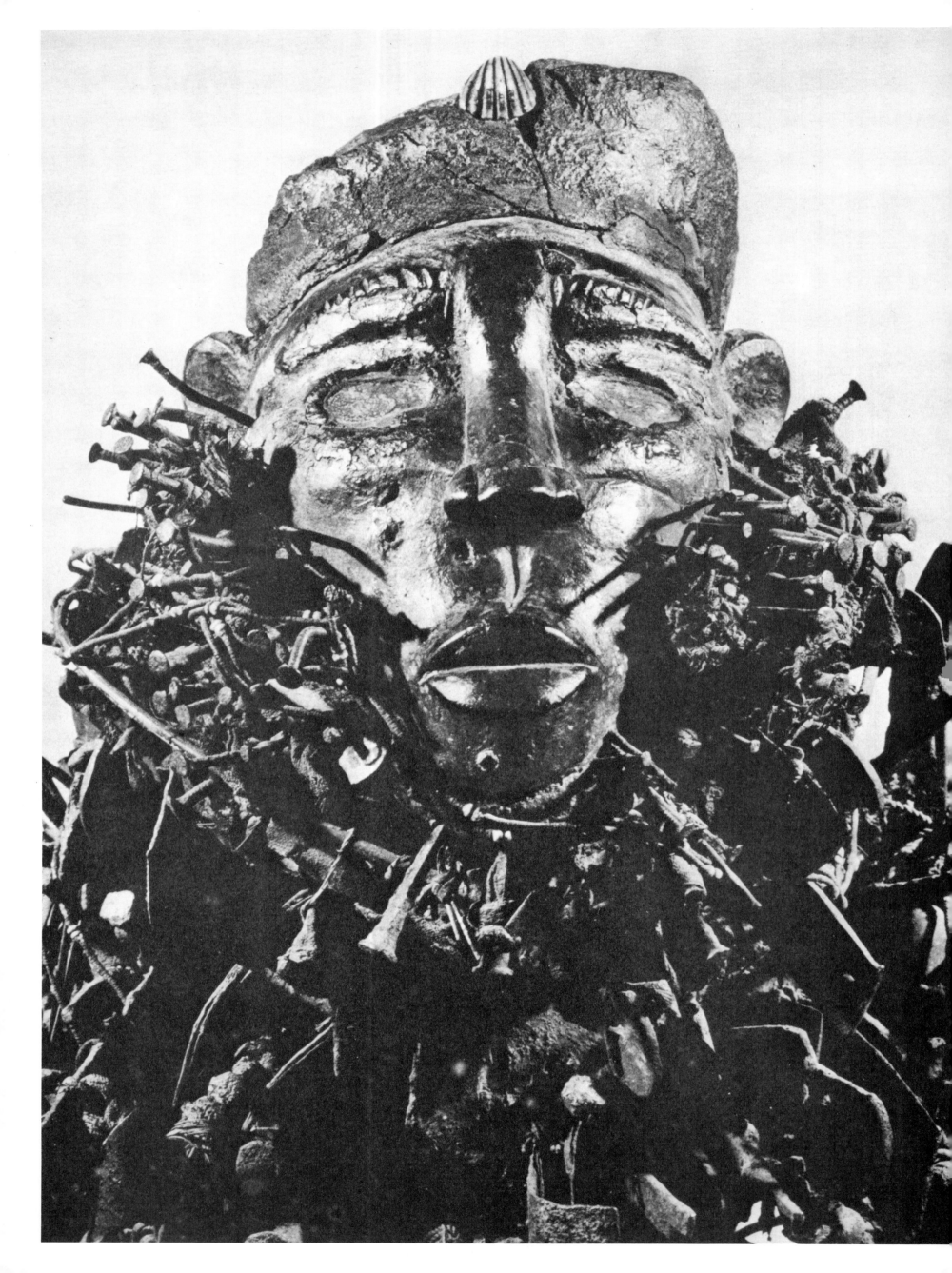

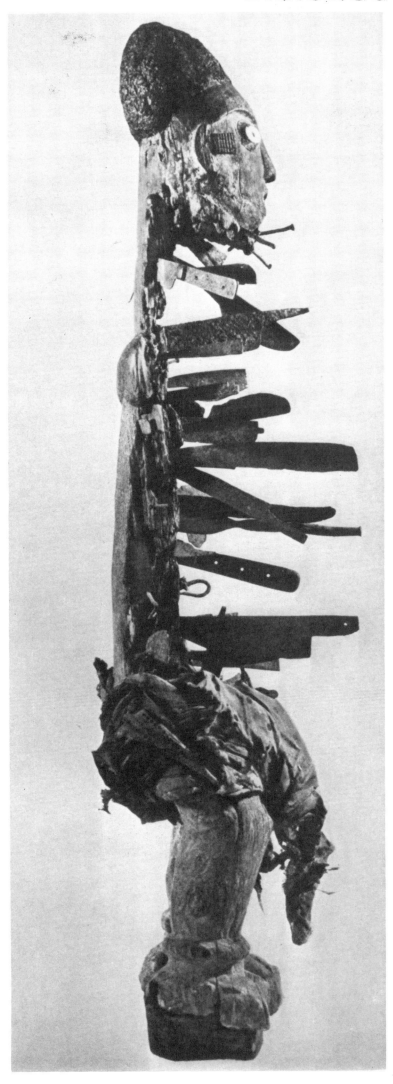

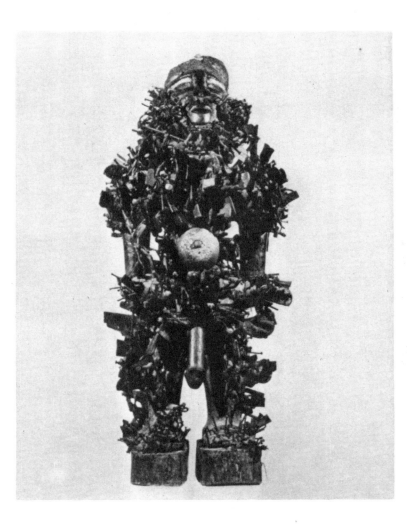

242
FETISH FIGURE

The fetish is a means of harnessing and directing the vital force or power of the universe—a means as practical within the African system of belief as the electrical circuit in ours. The nail fetish (konde) is peculiar to the Bakongo.

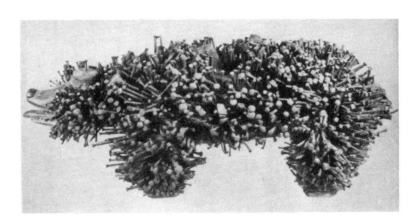

243-244
FETISH FIGURES

Nail fetishes, though in human or animal (chiefly dog) form, are completely impersonal. They are made for innumerable purposes, protective or offensive according to the witch-doctor's combination of spells and fetish ingredients; a nail or blade is driven in (as in European practice) on each occasion of use.

BAKONGO

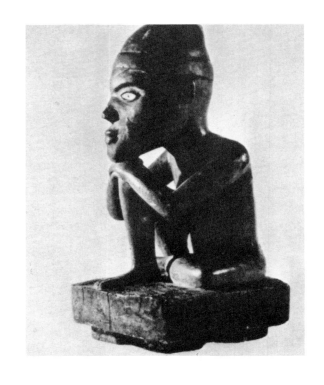

246
TOMB FIGURE

The tomb huts of Bakongo notables often contain polychromed wooden figures, depicting various subjects. These are perhaps symbols of prestige, alluding to attributes and attainments of the deceased, or may sometimes be purely ornamental.

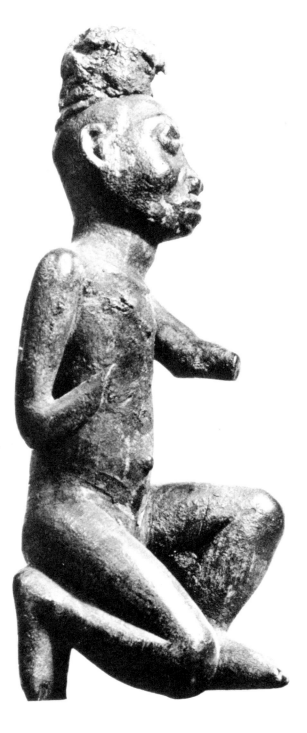

245
FIGURE

Both the figure and its posture are conceived with imaginative realism, more often found in ancestor than in fetish figures. The ancestor cult itself is another way of drawing on the life force, as in the worship of deities.

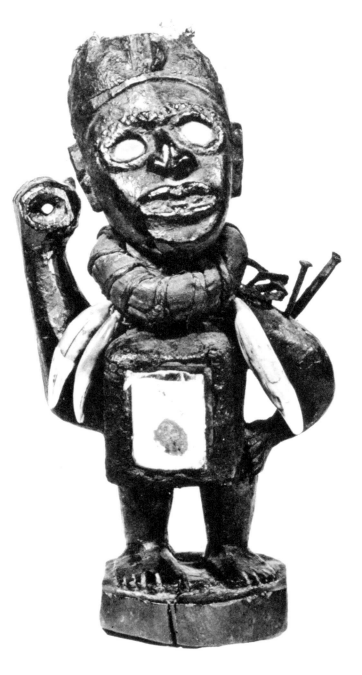

247
FETISH FIGURE

The upraised arm, bored to receive a miniature spear or reed, and the piece of mirror capping the 'medicine' on the abdomen, suggest a fetish used for inflicting ailments on an enemy. Mirror was much used for its illusion of life.

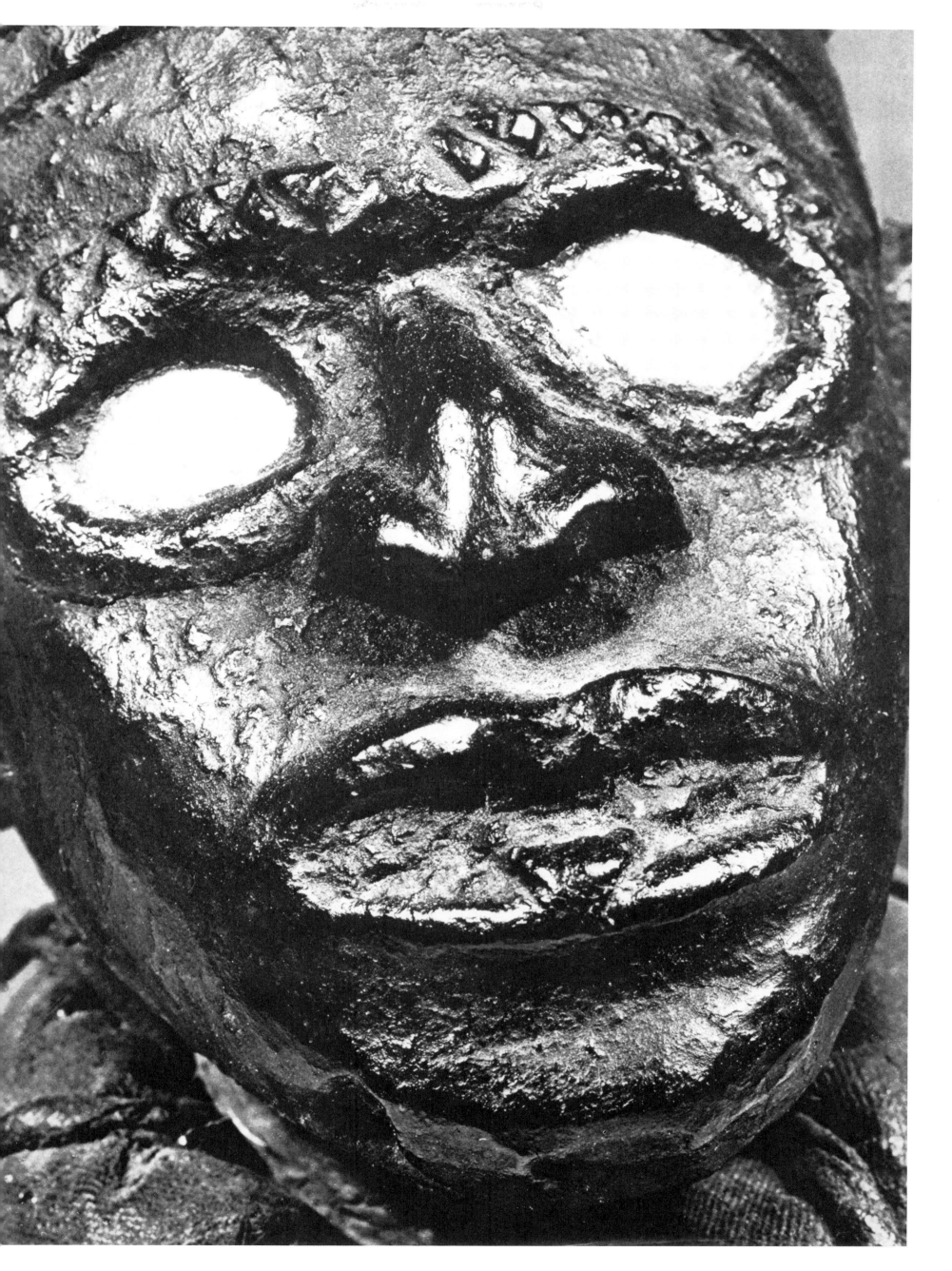

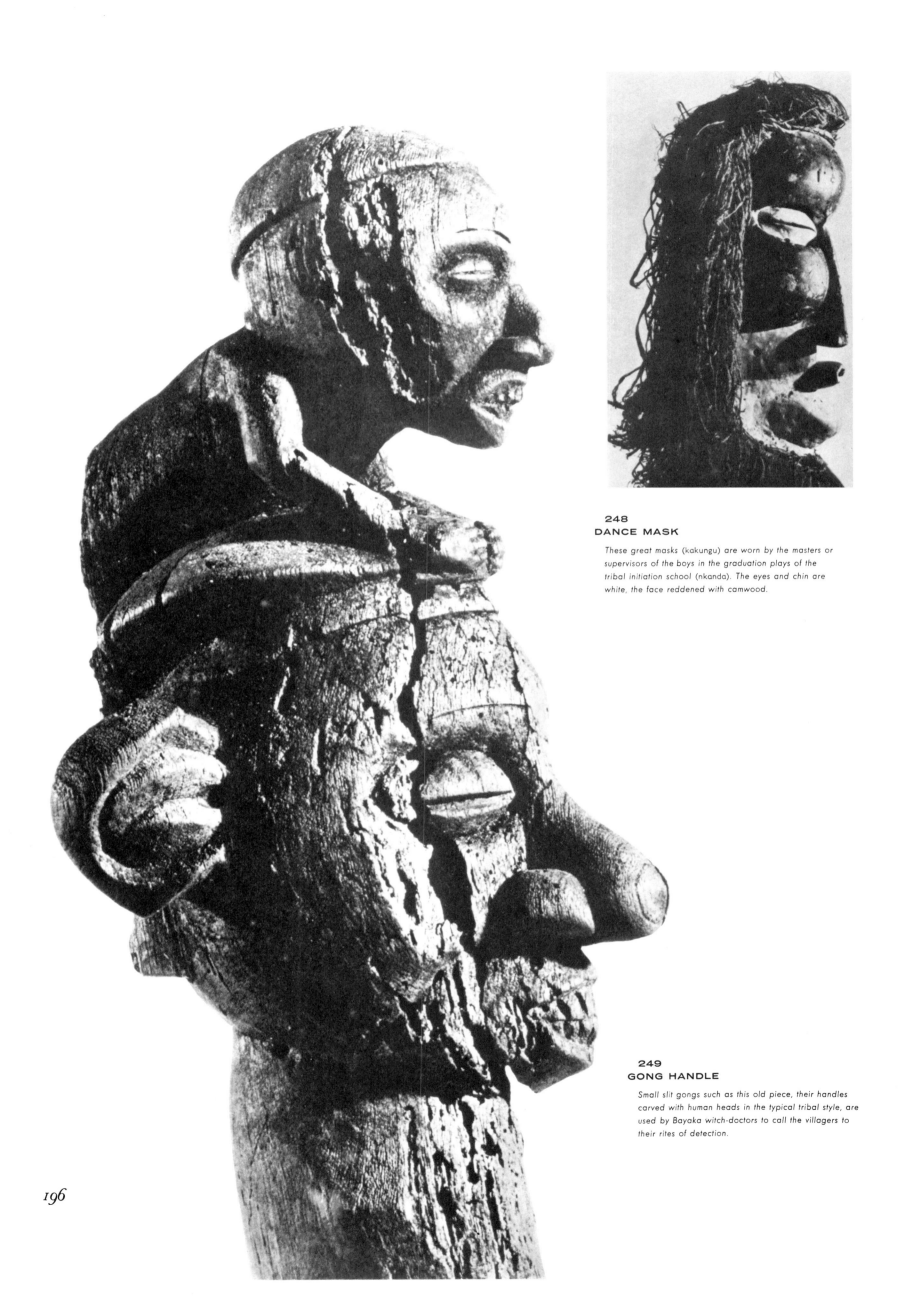

248
DANCE MASK

These great masks (kakungu) are worn by the masters or supervisors of the boys in the graduation plays of the tribal initiation school (nkanda). The eyes and chin are white, the face reddened with camwood.

249
GONG HANDLE

Small slit gongs such as this old piece, their handles carved with human heads in the typical tribal style, are used by Bayaka witch-doctors to call the villagers to their rites of detection.

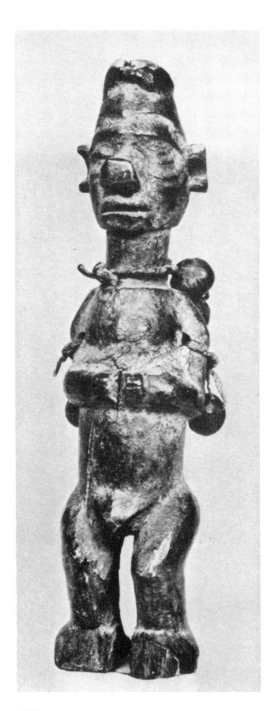

250
FETISH FIGURE

The bodies of Bayaka figures are often perfunctorily carved; here the characteristic elements of the style are exemplified in the face—the nose moderately upcurved, ears projecting, brow and eyes enclosed within a well marked border.

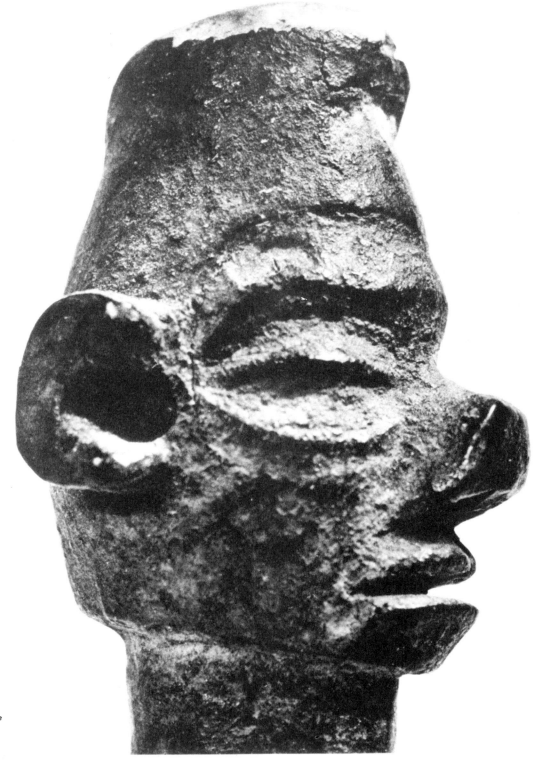

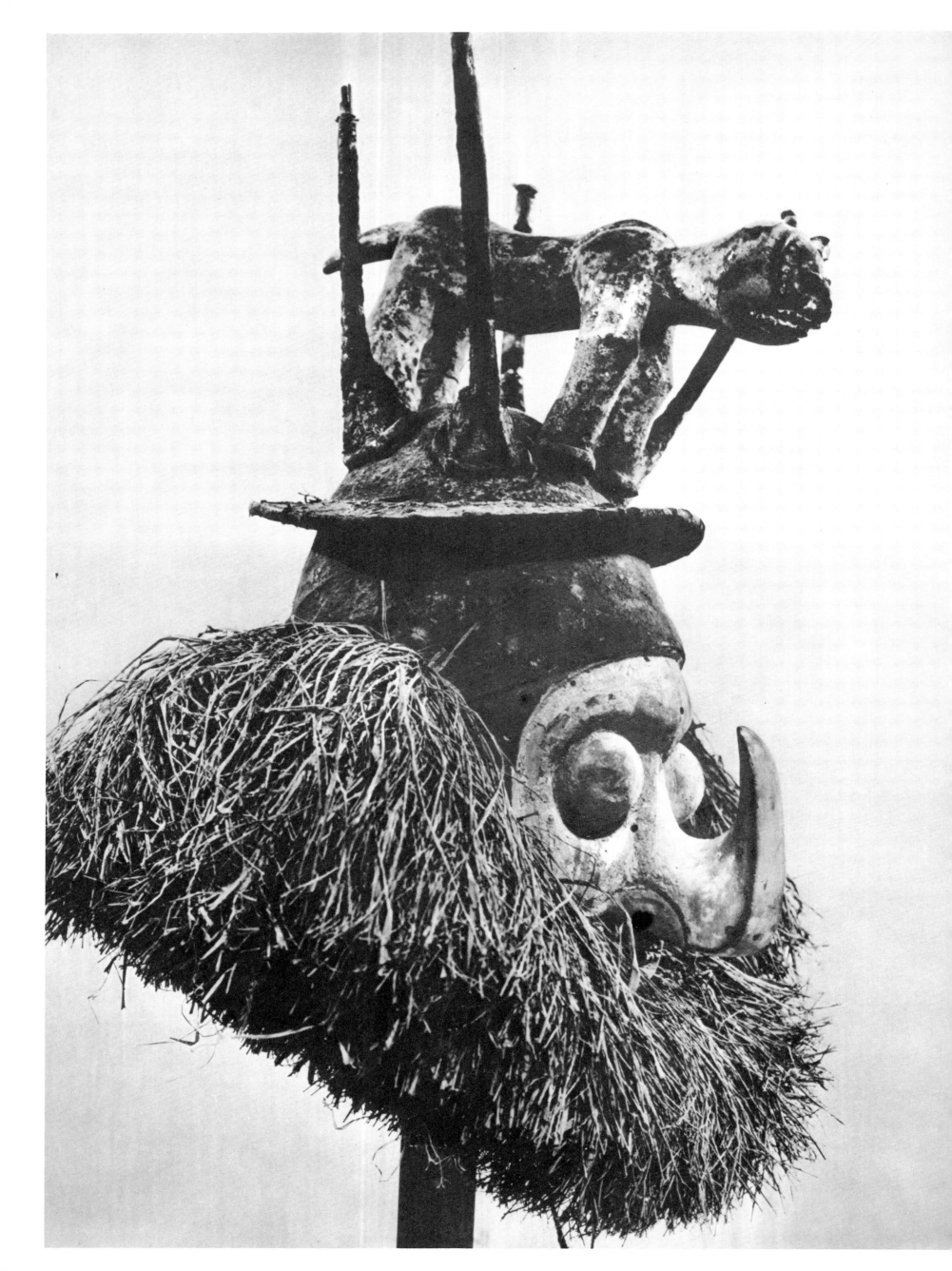

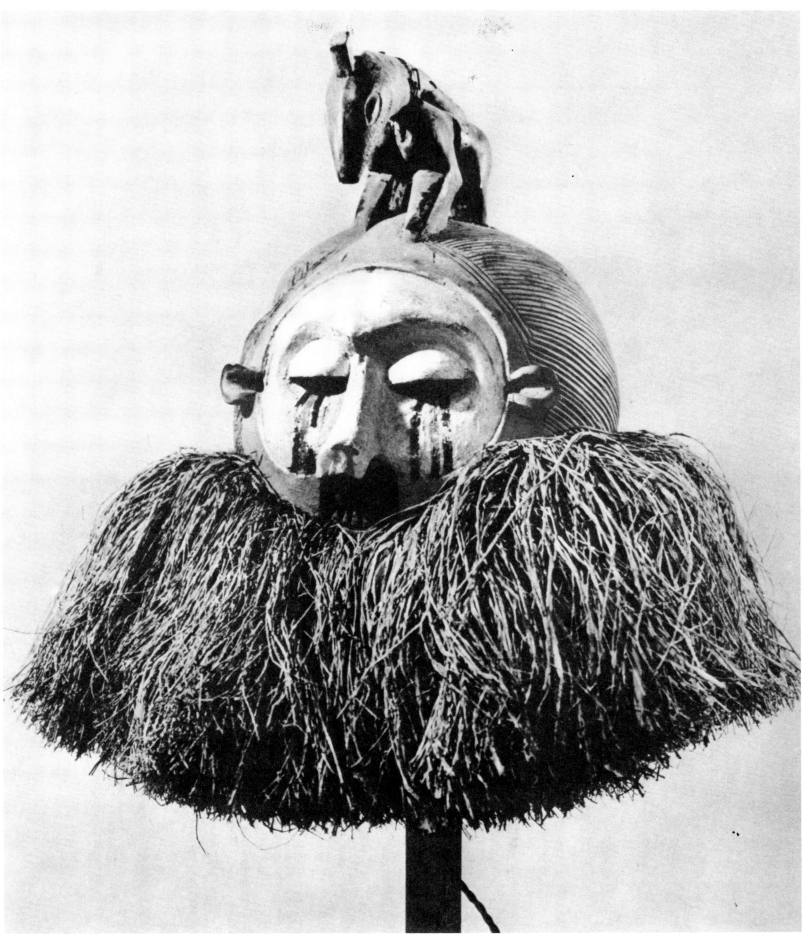

251
DANCE MASK

After circumcision, the tribal novices end their
seclusion with a triumphal return to the village,
dancing by daylight to amuse their families, and
going on tour to neighbouring villages. The usual
nasal exaggeration is here carried to great lengths.
The masks are publicly inspected on the ground
before the dance.

252
DANCE MASK

Among the Bayaka a small, flat, carved mask is
surmounted by large decorative forms of cloth-
covered canework and shredded fibre; Basuku
masks, although presumably for the same initiation
ceremony, were simple wooden helmets surmounted
by carved figures of birds or beasts. The features
and material of this mask suggest Bayaka
adaptation of those of their Basuku neighbours.

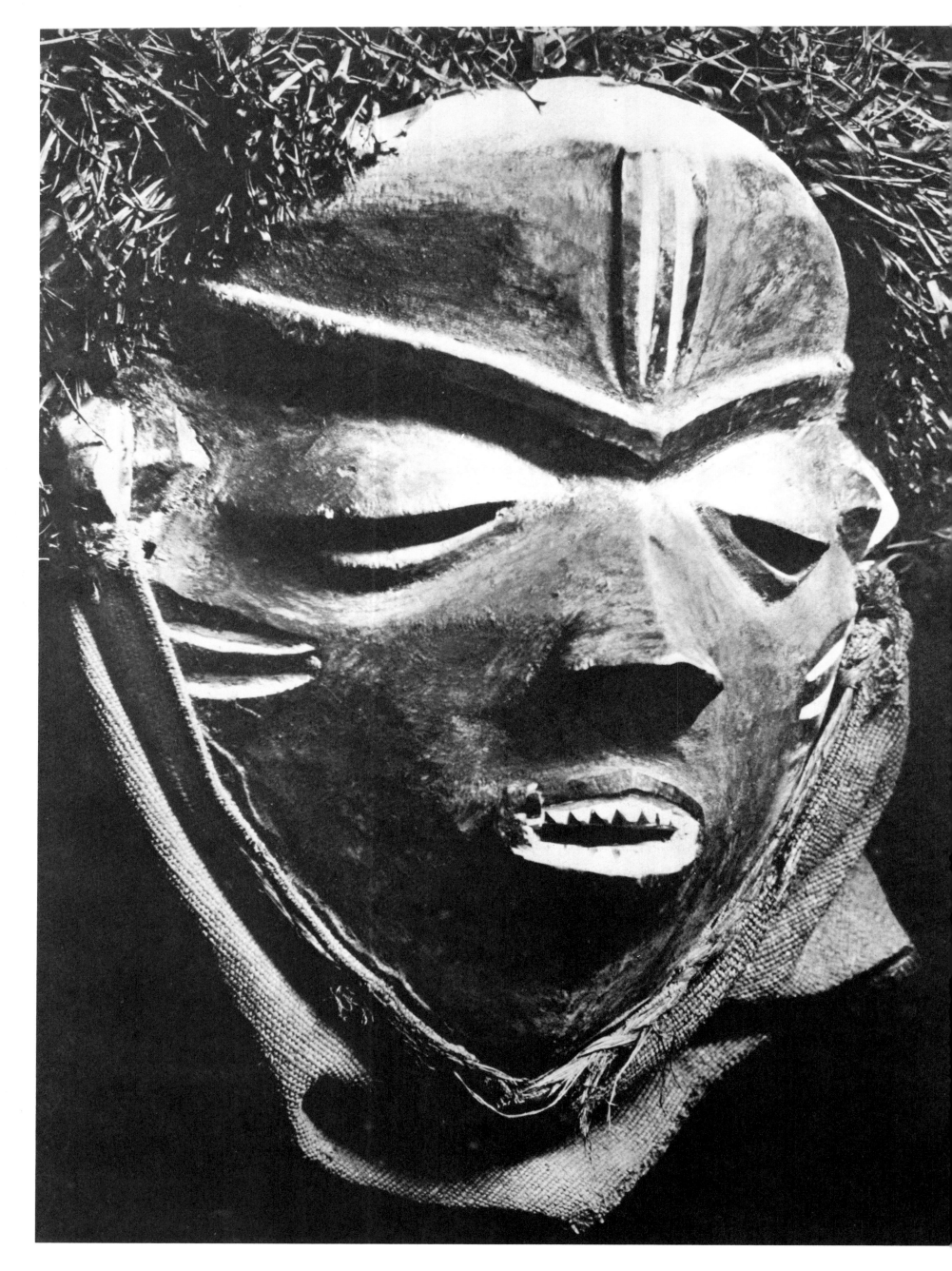

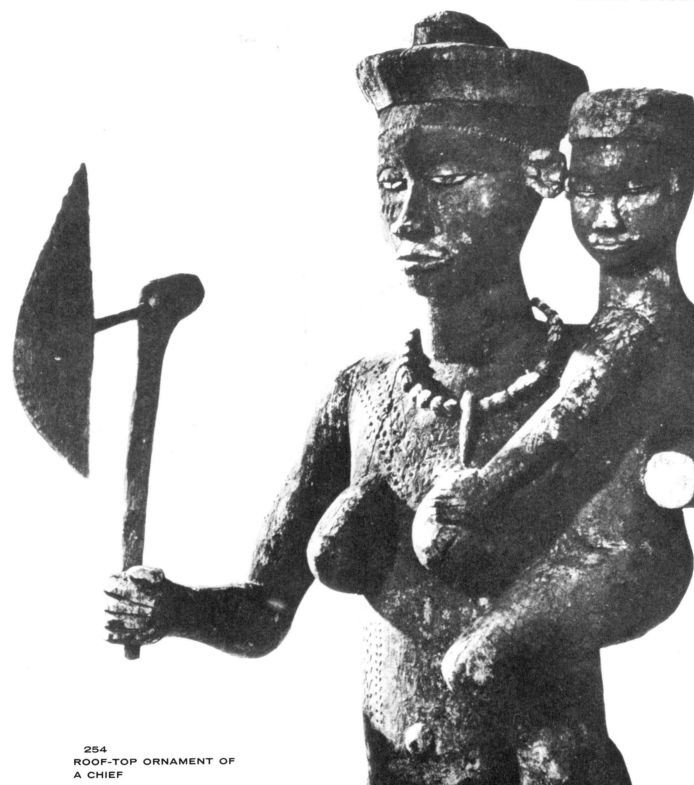

254
ROOF-TOP ORNAMENT OF
A CHIEF

The chief's hut (gisendu) among the Bapende on
the Kasai river is also a sacred repository of the
arcana of chieftainship. The large statue
surmounting the thatched roof represents the
chief's principal wife brandishing his axe of
office; a ritual cup held in the left hand is
usually missing, as here. The intrusion of the
child is a recent development.

253
DANCE MASK

As among the Bayaka, Bapende masks are worn
in plays celebrating the breaking-up of the
initiation school. Out of the sight of women,
about 20 masked characters, representing
culture heroes, animals and village notables,
dance in turn. Other masks, worn by the older
men, portray the ancestral spirits.

BUSHONGO

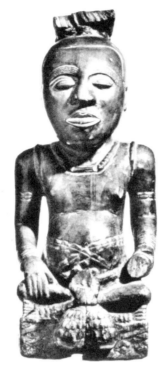

255
ROYAL STATUE

The Bushongo or Bakuba have an oral
tradition supposedly going back some 1500
years. This effigy represents Bope Pelenge,
108th king in the line (c. 1800), a great
smith; his anvil is carved at his feet.

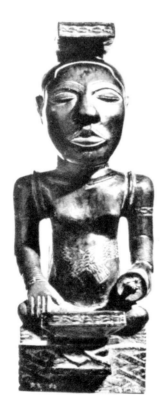

256
ROYAL STATUE

This effigy represents the 93rd and greatest
king, Shamba Bolongongo (c. 1600–20).
An enlightened reformer and peacemaker,
he is said to have introduced the game of
skill, mancala, whose board is shown at his
feet, in order to oust gambling.

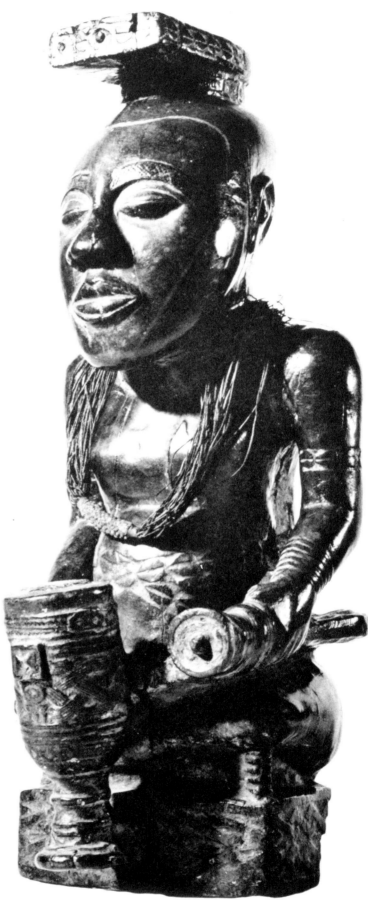

257
ROYAL STATUE

Kata Mbula (c. 1810), 109th king, is symbolized by a drum carved
with his favourite pattern. The statues are supposed to have been
carved in the lifetime of each king, but Shamba's may possibly be a
later copy by the sculptor of Bope's and Kata's. Bakongo influence
has been seen in the crossed legs of all the royal statues.

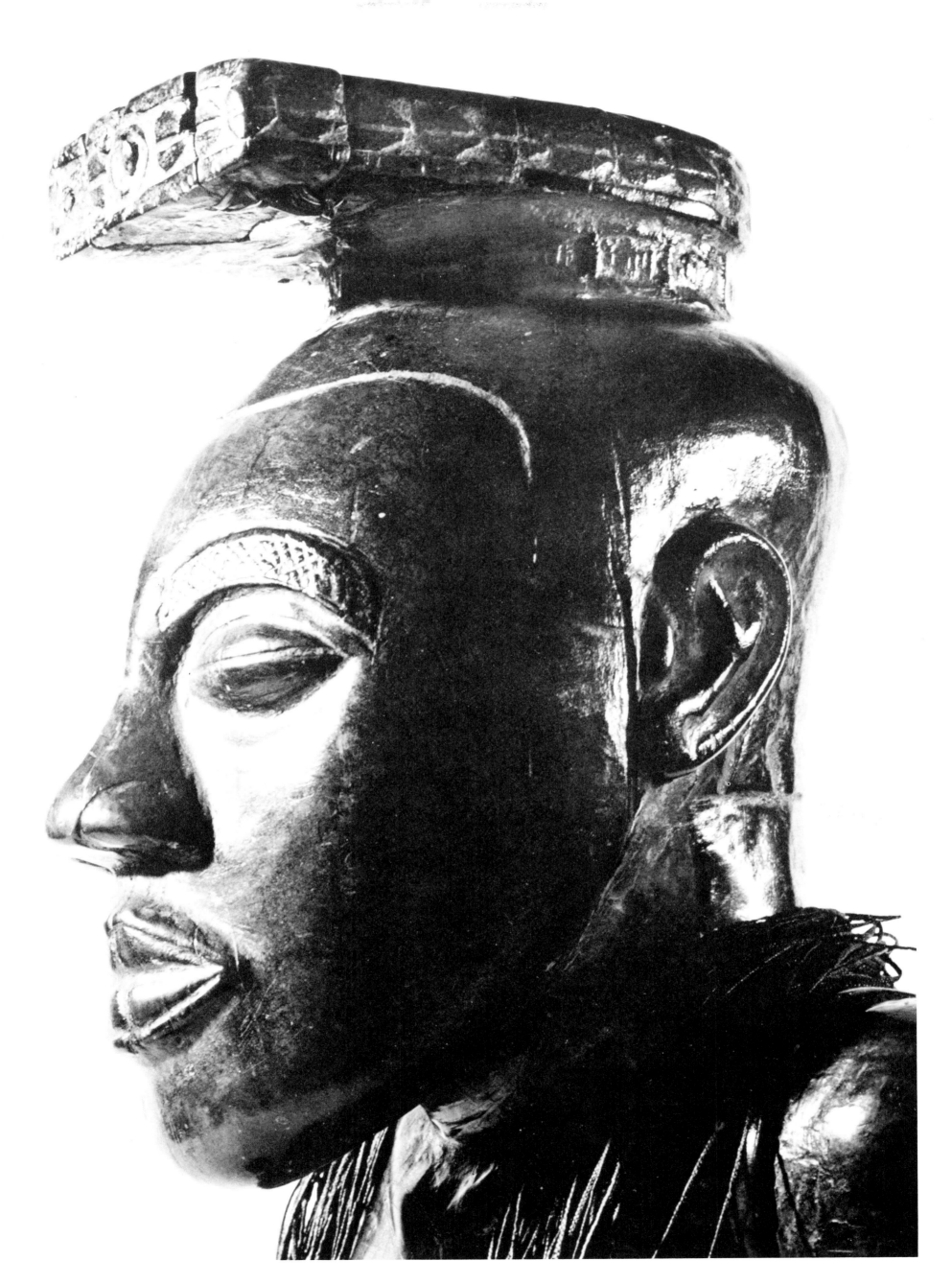

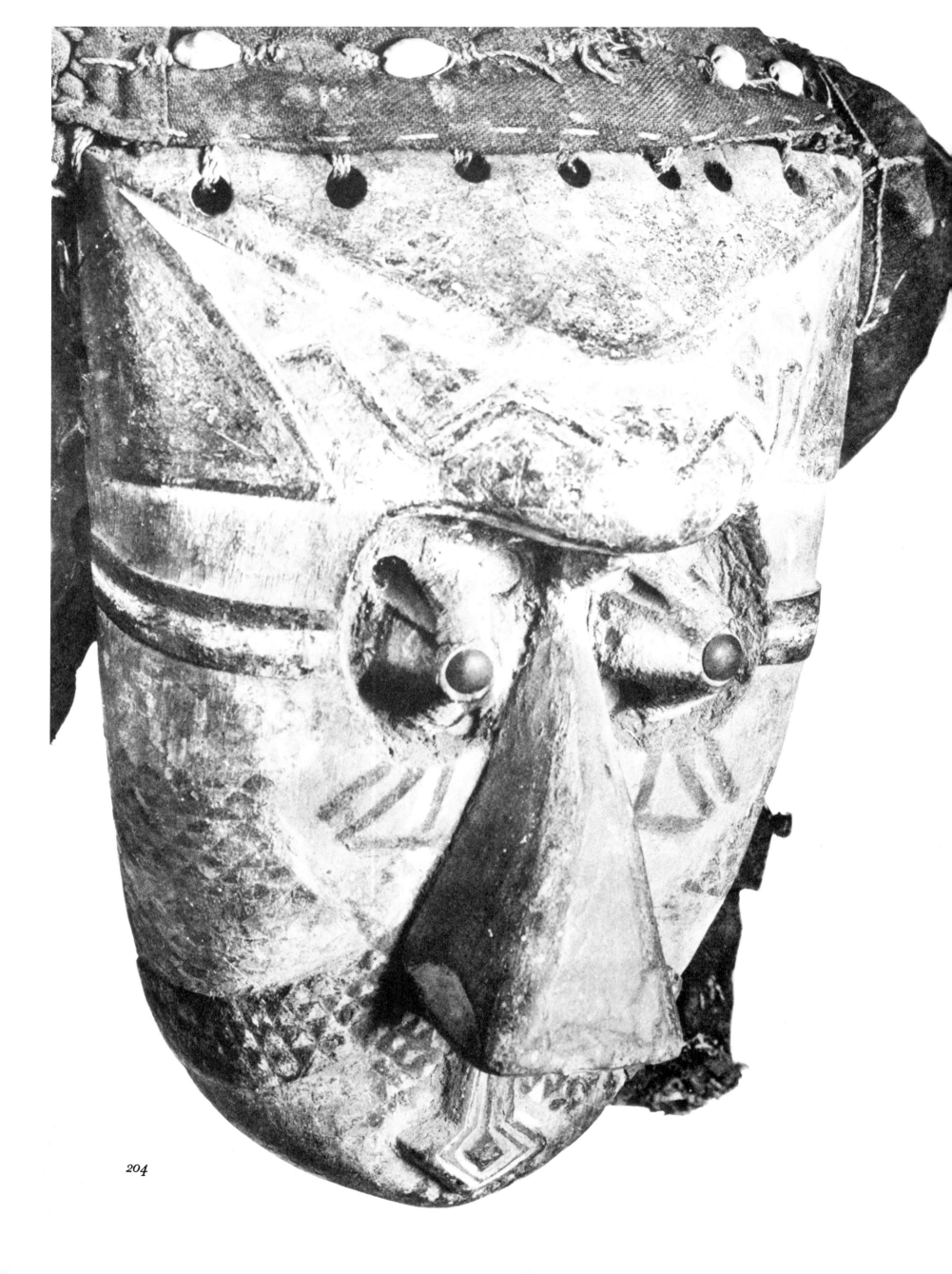

204

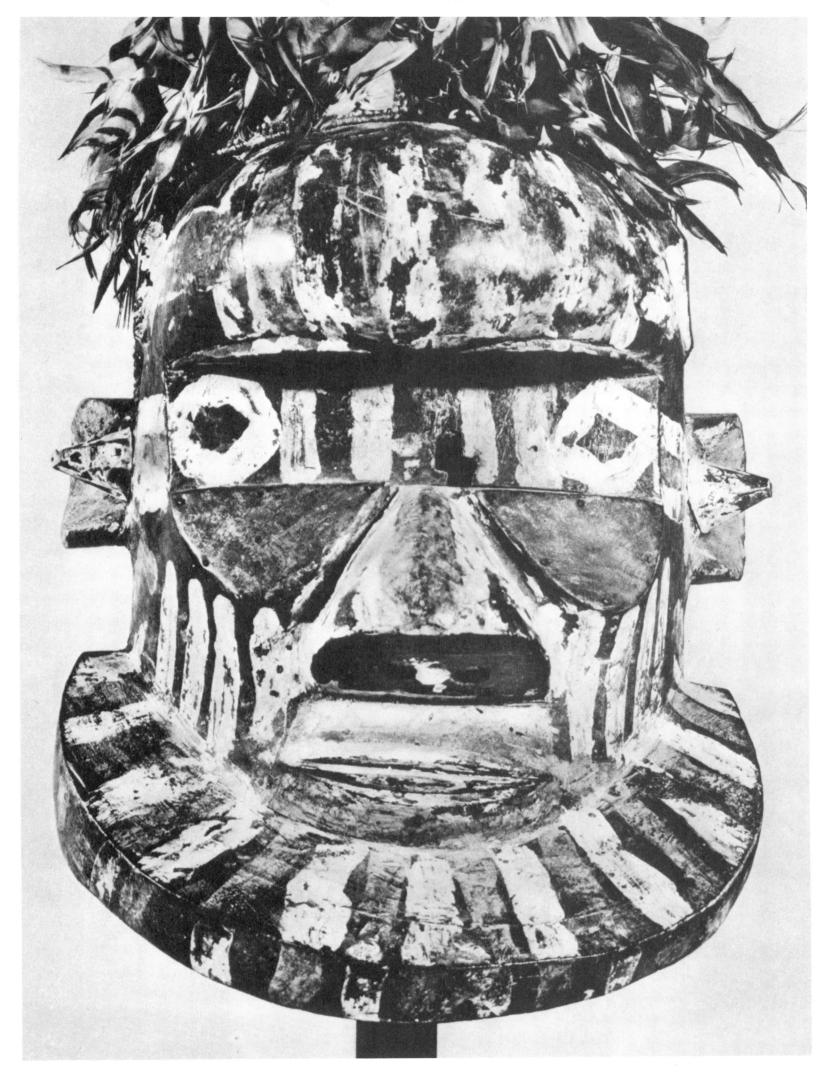

258
DANCE MASK

This type of mask, called gari moashi, belongs to
the Babende secret society, entrusted with police
functions since the time of Shamba, when masks are
also supposed to have been invented by his wife
Kashashi.

259
DANCE MASK

This rare and awe-inspiring mask, treated in
unusually cubistic style for the area, is known to
have been taken from a troublesome sorcerer, and
is probably to be assigned to the Babinji sub-tribe
of the Bushongo.

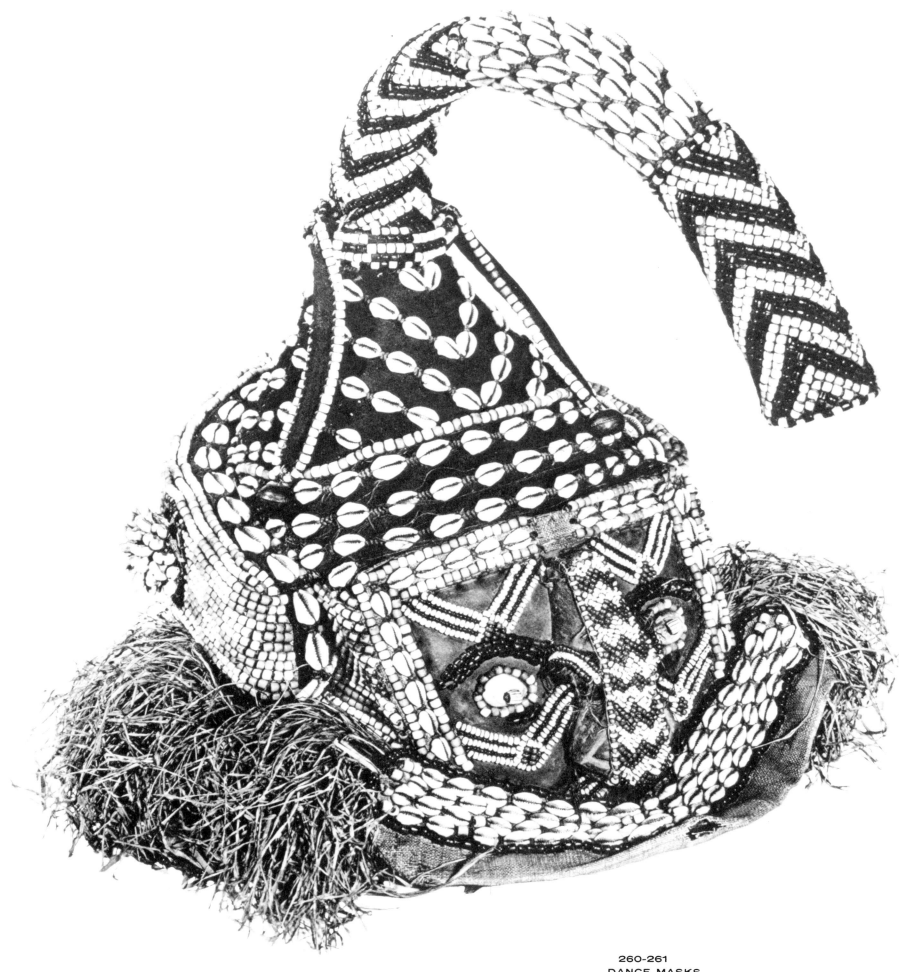

260-261
DANCE MASKS

*These composite masks of cane, skin, raphia cloth, beads and
cowries, with carved wooden nose, mouth and ears, and called
mashamboy by the Bambala sub-tribe and mokenge by the Bangongo,*

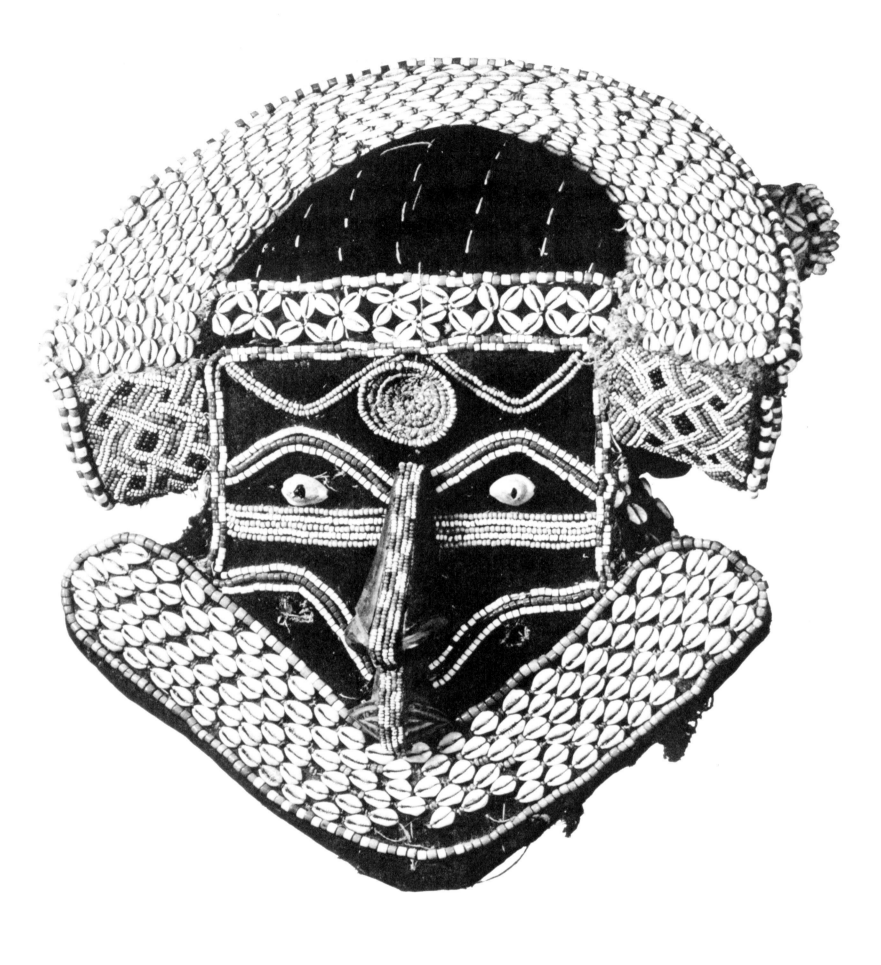

are peculiar to the Bushongo. According to an amusing story told to
Torday by King Kwete Peshanga Kena, they originally represented a
disease spirit and were utilized by the 73rd king, Bo Kena (c. 1400)
and later kings to keep the women under control.

BUSHONGO

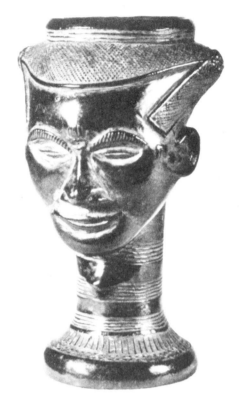

262

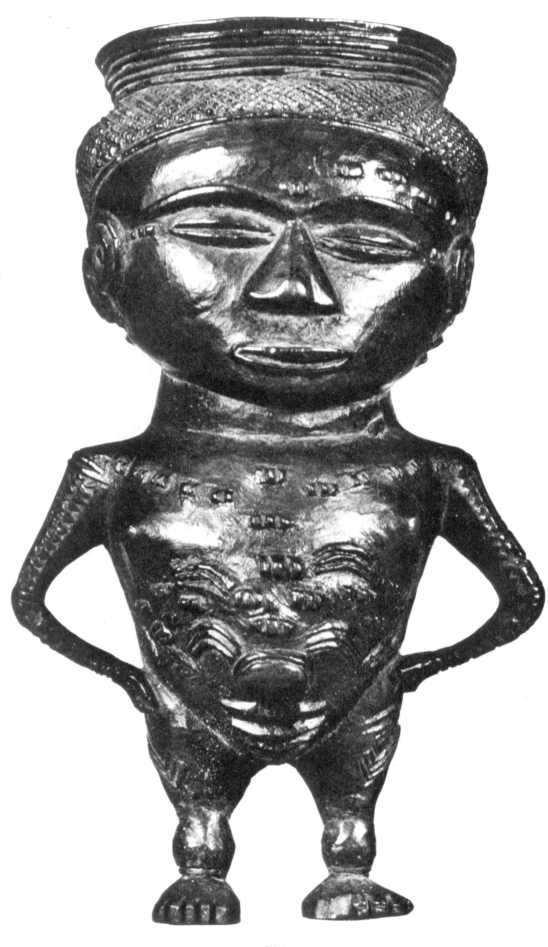

264

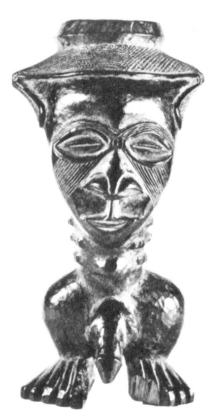

263

**262-266
PALM-WINE CUPS**

*Like the West Coast peoples, the Bushongo love palm
wine, which they tap from the raphia or wine palm; and
like ourselves they get together in clubs and societies to
drink it according to prescribed rituals. Among the
Bushongo proper, as certainly among the Bashilele, each
club and grade of member probably had a different
type of cup. Horned cups such as fig. 265 (which is
probably from the Pianga sub-tribe) are said to be
reserved to kings and chiefs; the independent Bawongo*

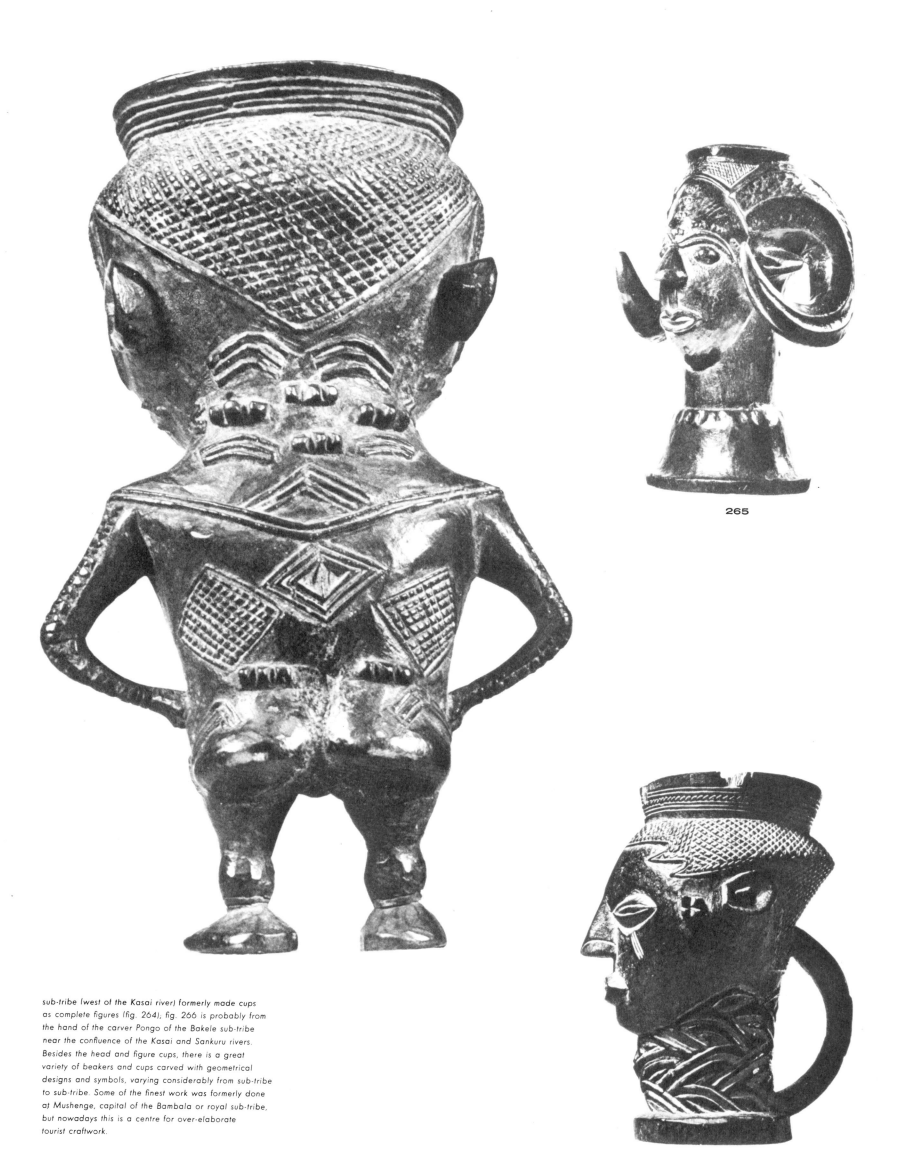

sub-tribe (west of the Kasai river) formerly made cups
as complete figures (fig. 264); fig. 266 is probably from
the hand of the carver Pongo of the Bakele sub-tribe
near the confluence of the Kasai and Sankuru rivers.
Besides the head and figure cups, there is a great
variety of beakers and cups carved with geometrical
designs and symbols, varying considerably from sub-tribe
to sub-tribe. Some of the finest work was formerly done
at Mushenge, capital of the Bambala or royal sub-tribe,
but nowadays this is a centre for over-elaborate
tourist craftwork.

265

266

BUSHONGO

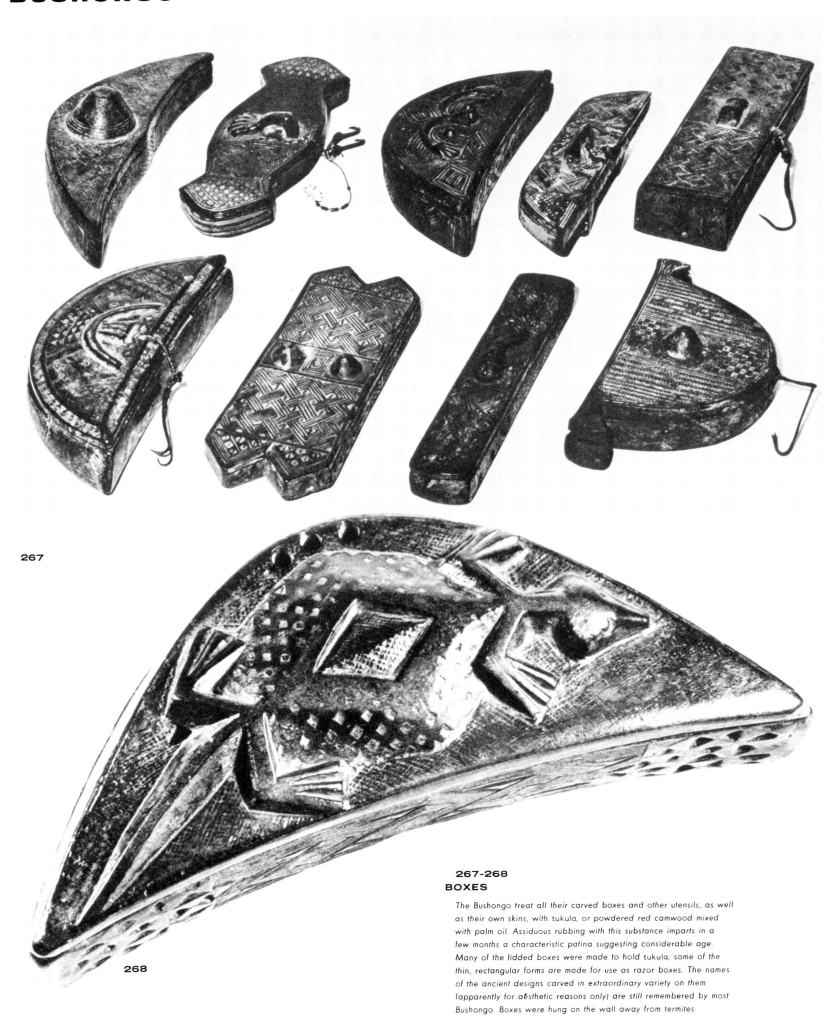

267

268

267-268
BOXES

*The Bushongo treat all their carved boxes and other utensils, as well
as their own skins, with tukula, or powdered red camwood mixed
with palm oil. Assiduous rubbing with this substance imparts in a
few months a characteristic patina suggesting considerable age.
Many of the lidded boxes were made to hold tukula; some of the
thin, rectangular forms are made for use as razor boxes. The names
of the ancient designs carved in extraordinary variety on them
(apparently for aesthetic reasons only) are still remembered by most
Bushongo. Boxes were hung on the wall away from termites.*

269
DIVINATORY CROCODILE FIGURE

A wooden disc was rubbed up and down the top of the
figure while the diviner mentioned possible answers to
the question at issue. The correct answer was known
when the disc stuck fast.

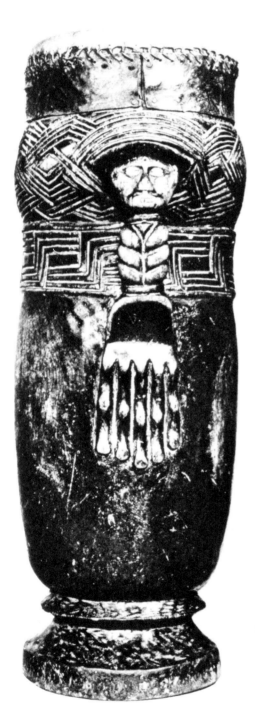

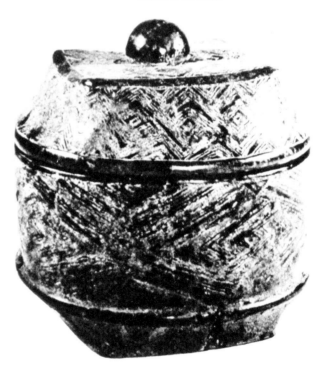

271
BOX

This old box from Mushenge imitates basket
form, and is decorated with the pattern ikuni
na Woto, the belly of Woto (a semi-divine
founder of the tribe).

270
DRUM

The handle of this Bangongo-style drum may refer to the
military society, Yolo, which required from its members
the left hand of a slain foe. Hands are common subjects
in Bushongo art.

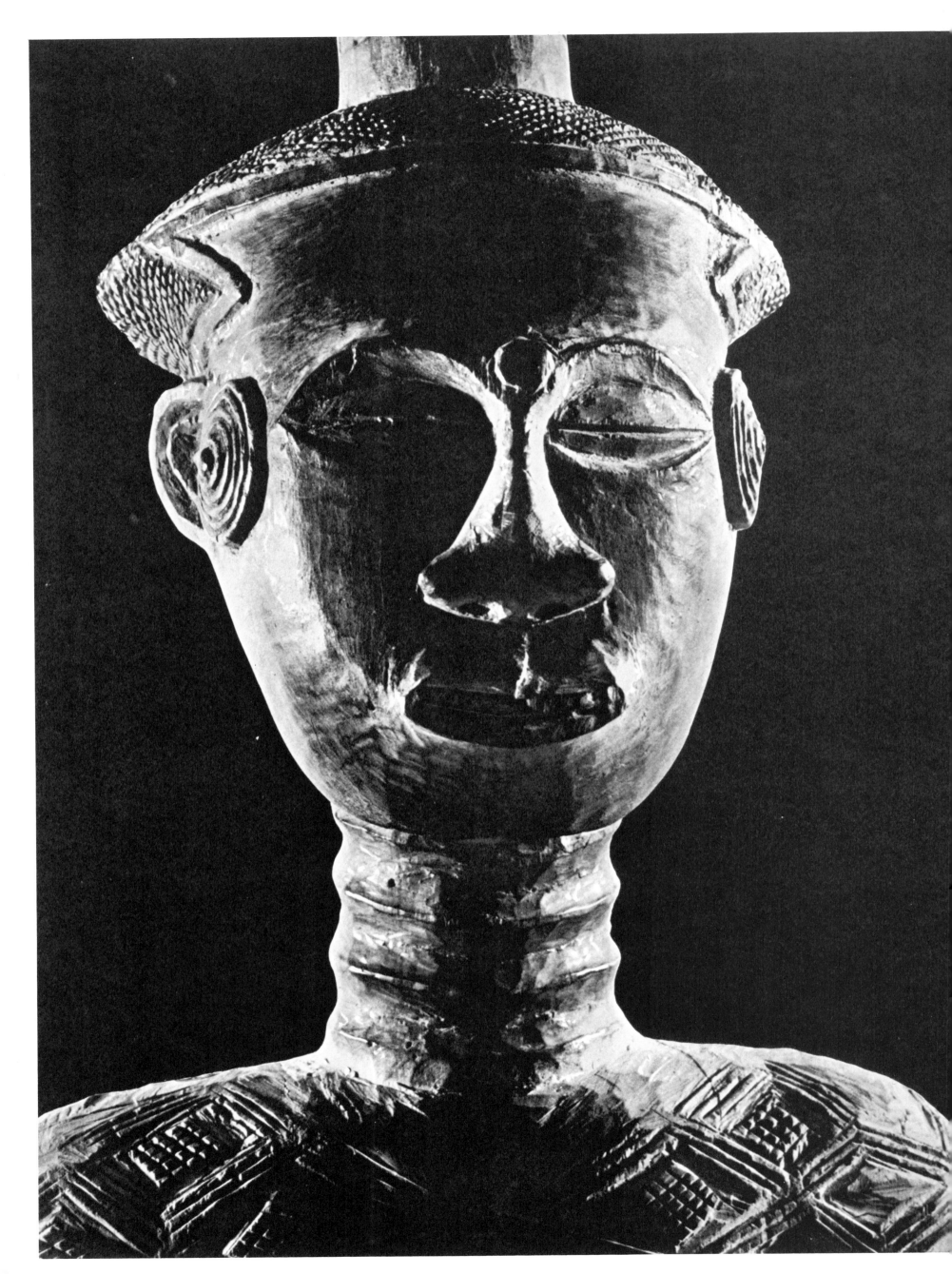

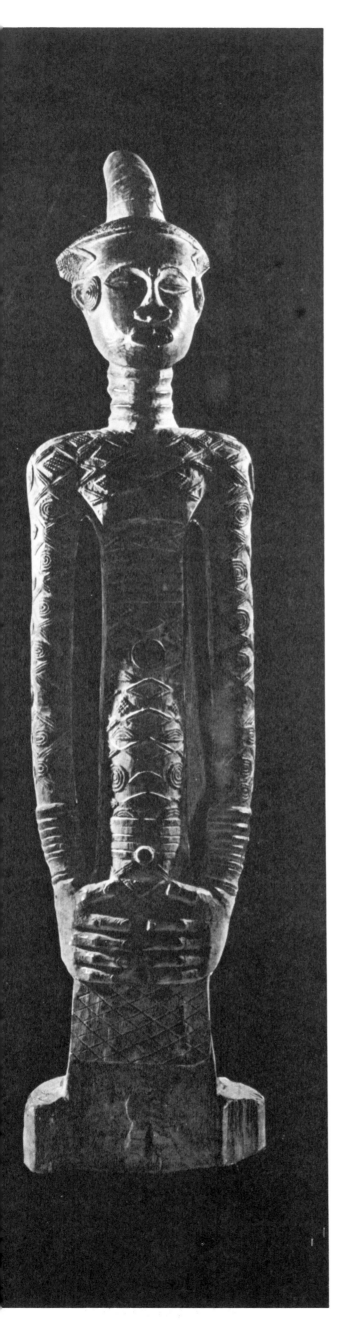

DENGESE

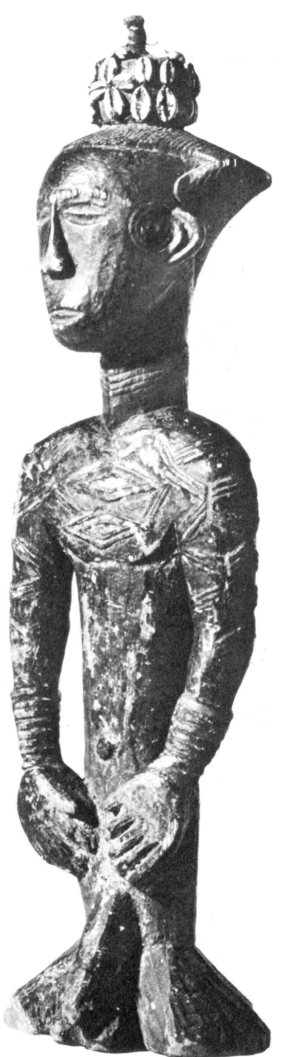

272
COMMEMORATIVE FIGURE

The Dengese and Yaelima are tribes, dwelling on
the Lukenie to the north of the Sankuru, whose
affinities, while chiefly with the Kundu-Mongo
tribes, include important elements shared with the
Bushongo culture. These monumental statues,
though they do not occur in Bushongo country,
belong in detail strictly to the Bushongo style,
most especially in the head form with splayed
brow.

273
COMMEMORATIVE FIGURE

These figures are more impressive—
perhaps because of the stylized
elongation of the body—than any
sculptures attempted among the
Bushongo proper, whose flair, with
rare exceptions, was for decoration
rather than form. They are said to be
placed on the tombs of chiefs or in
the house of the elders.

BENA LULUA

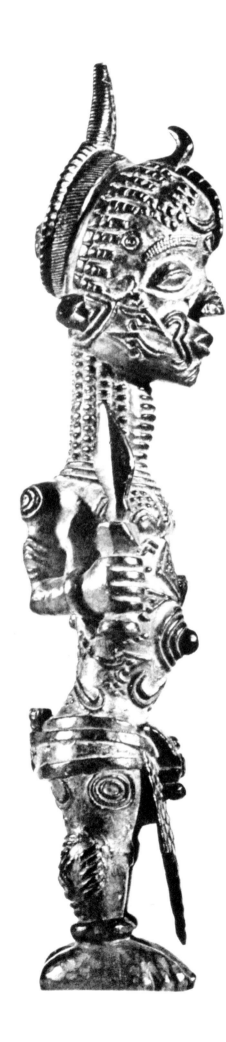

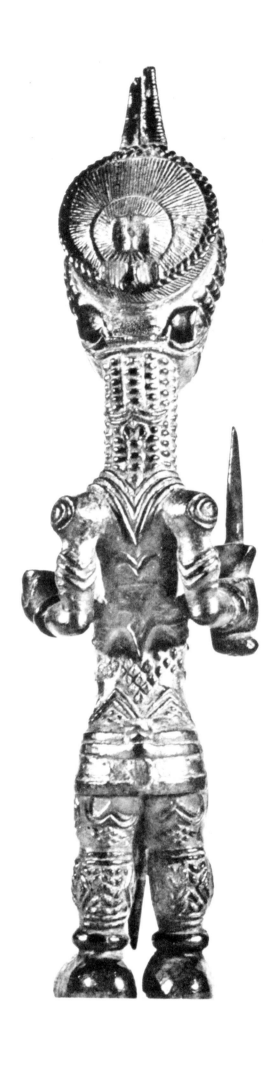

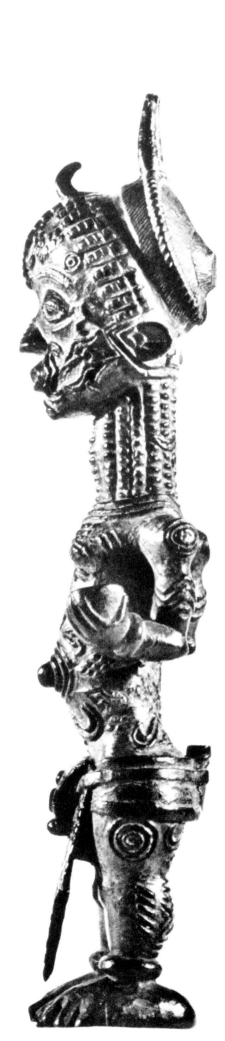

274
FIGURE

At their best, the carved figures of the Bena Lulua are perhaps
Africa's finest examples of the marriage of form and decoration.
Their artistic affinities seem to be partly with the Bushongo, partly
with the Bena Kanioka sub-tribe of the Baluba.

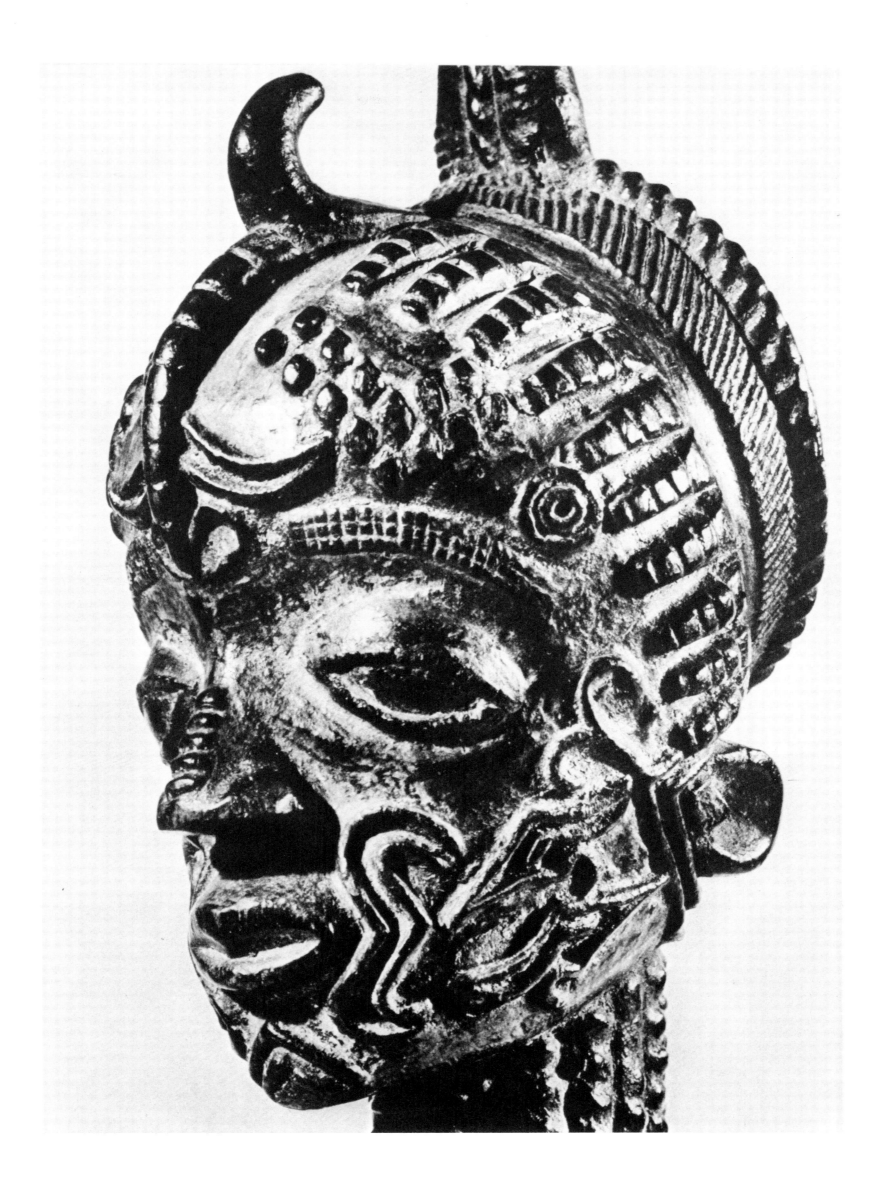

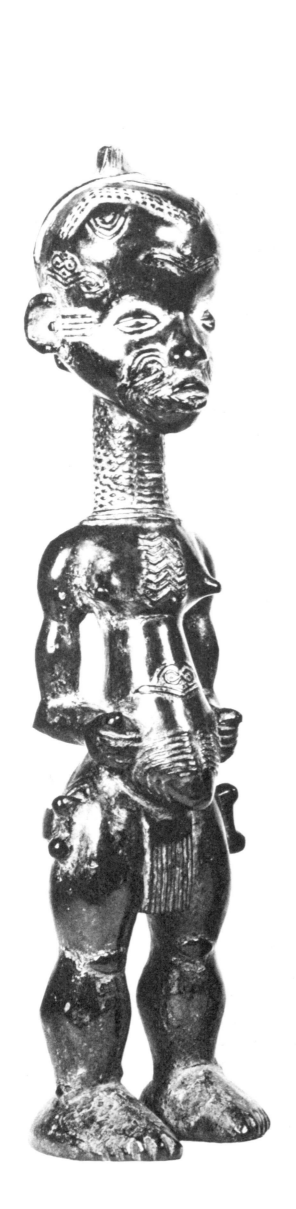
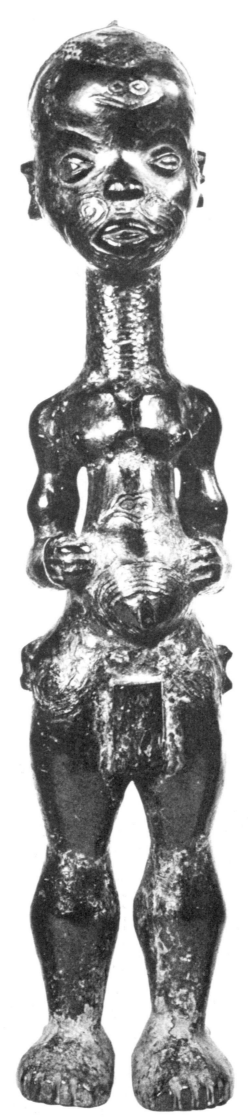
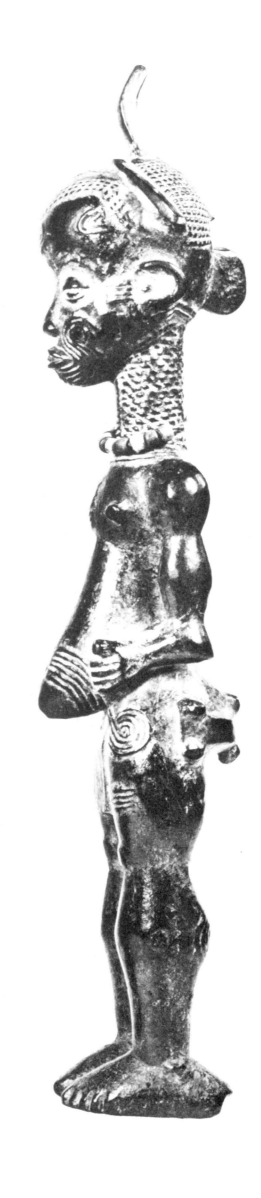

275-277

275-279
FIGURES

The three figures at the left seem to represent women with artistically exaggerated umbilical hernia (rather than signs of pregnancy). Figures of this type have a deep, rich patina comparable to that of the old Fang heads and figures. Some figures, such as fig. 274, are said to be protective, but some types such as the mother-and-child figures and those of chiefs, wearing the leopard-skin apron symbolic of kingship, have the aspect rather of ancestor or memorial figures.

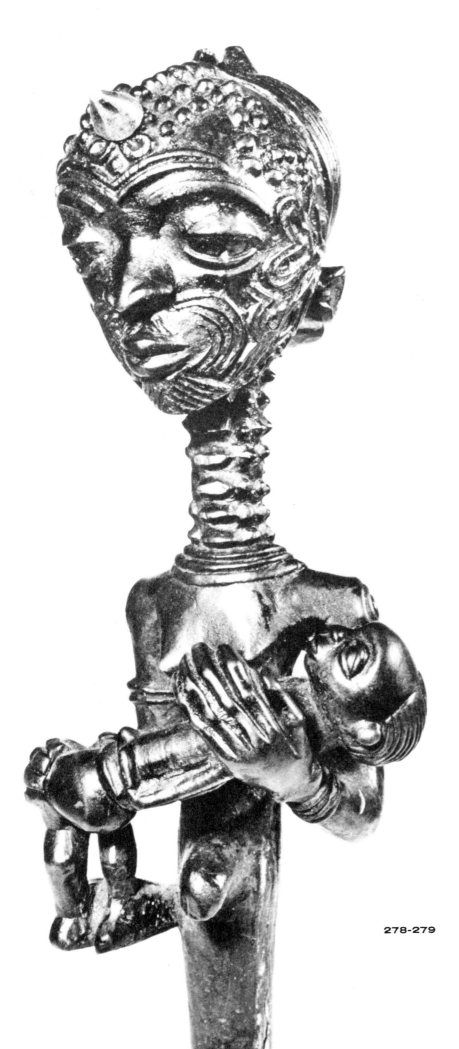

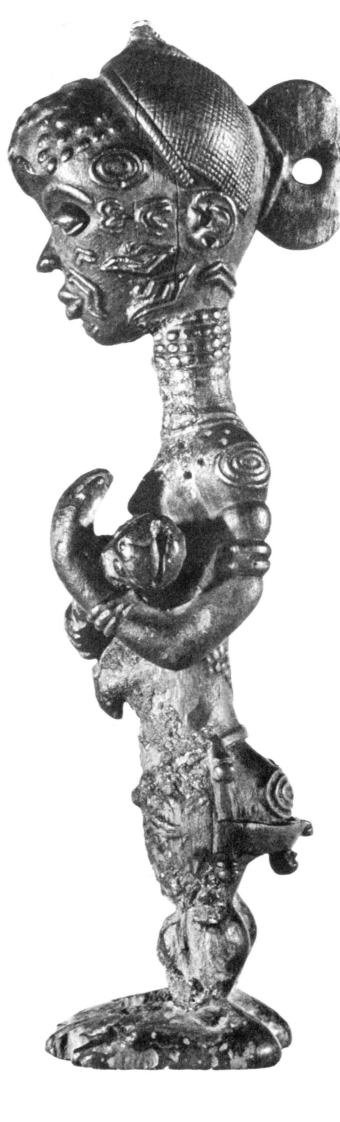

278-279

BENA LULUA

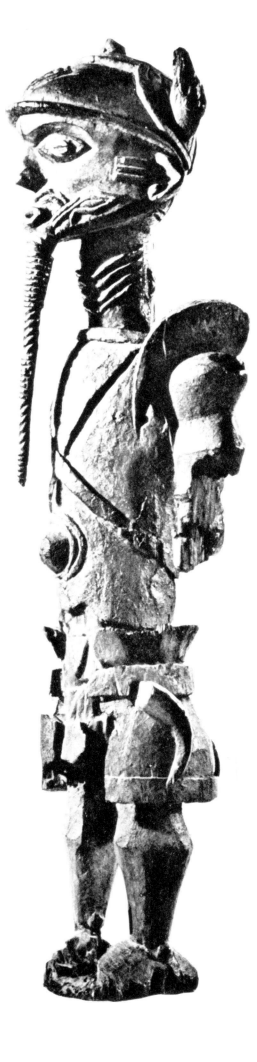

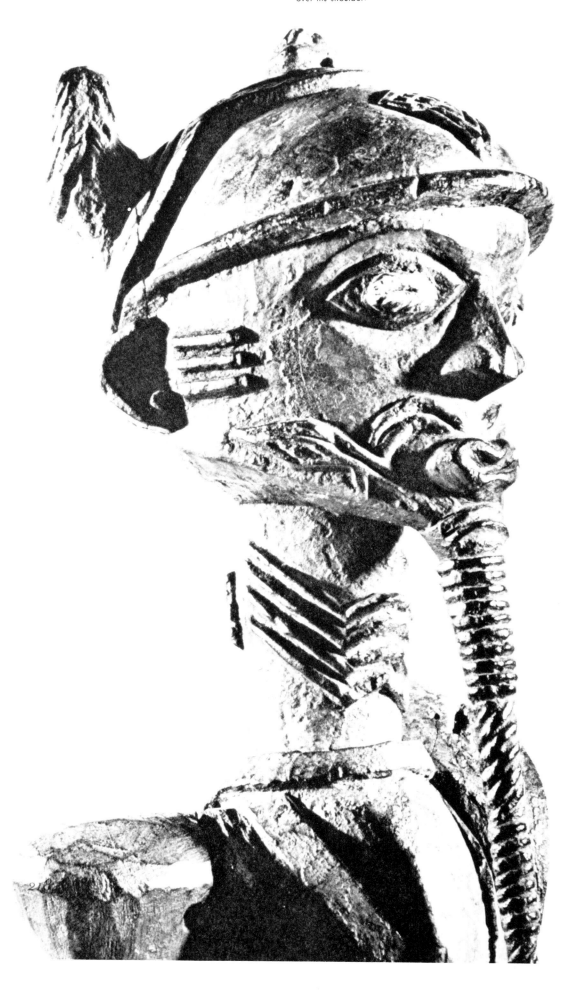

280
FIGURE

There is some evidence that few if any large figures were carved by the Bena Lulua after about 1880, when the hemp-smoking cult proscribed the making of graven images, as well as elaborate coiffure and scarification Small figures incorporating these characteristics have, however, been made up to the present day This figure apparently represents a bearded chief with a fly whisk over his shoulder.

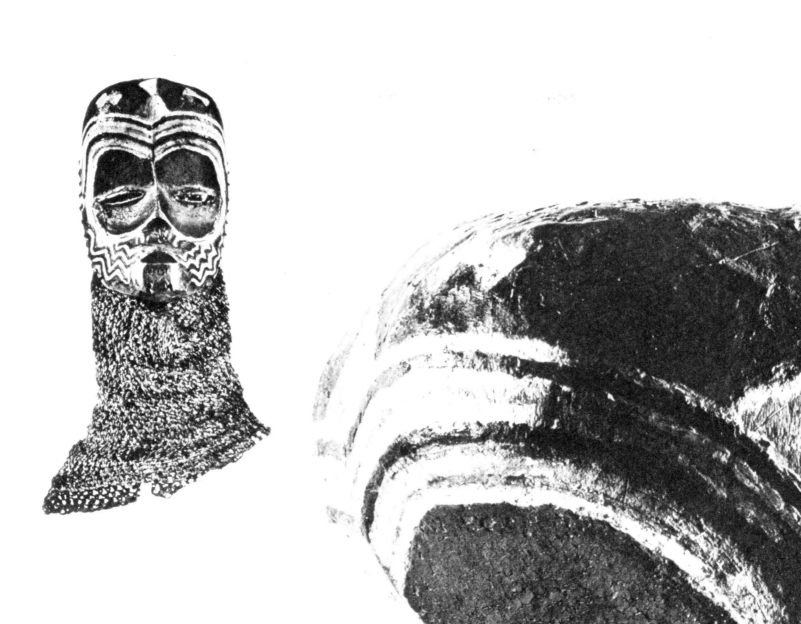

281
DANCE MASK

Many masks collected among the Bena Lulua seem to
have been borrowed, or possibly copied, from the
Bushongo, notably gari moashi masks such as fig. 258.
This example, however, seems to be in their own style,
though possibly a little influenced by that of the Bajokwe
(of whom the use of netted string garments with masks
is specially characteristic).

BAJOKWE

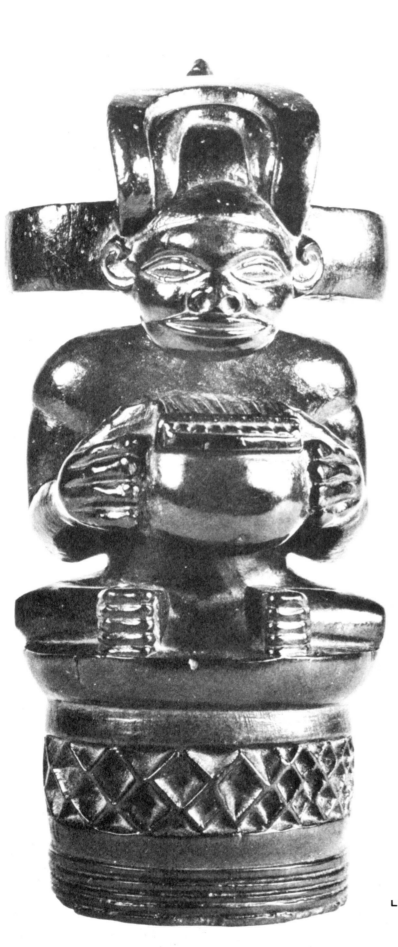

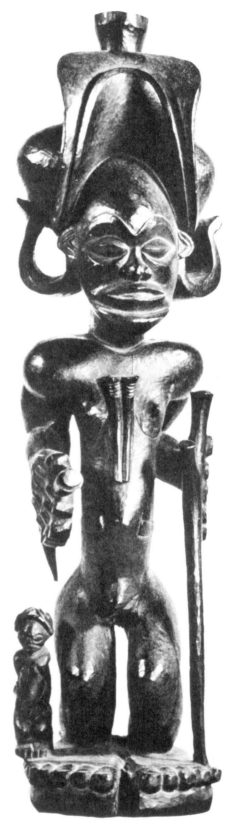

283
COMMEMORATIVE FIGURE

The bonnet-like headdress and 'medicine-horn' were reserved for chiefs and nobles. Numerous statues showing similar signs of rank speak for a court art. If it were found alone, the smaller figure would seem to be carved in a different style.

282
LID OF SNUFF MORTAR

This is the ornamental cover for a mortar carved in the top of a short staff or sceptre of a chief. The squatting figure wears the elaborate chief's hat or coiffure called chihongo, and plays the sansa or metal-tongued 'piano'.

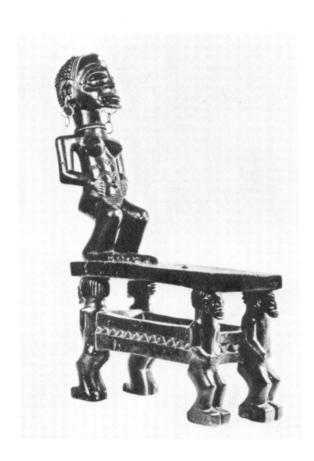

**284
CHAIR**

This is an unusual variation upon the well-known
Bajokwe chief's chairs, elaborated from a European
sixteenth-century form. Usually these are decorated
with smaller figures ranged in genre groups upon the
splats and braces.

**285
DETAIL OF FIGURE 284**

The female figure carved as the backrest of this seat
probably does not represent a particular woman, but
rather the idea of women serving the chief, as in
some Baluba stools.

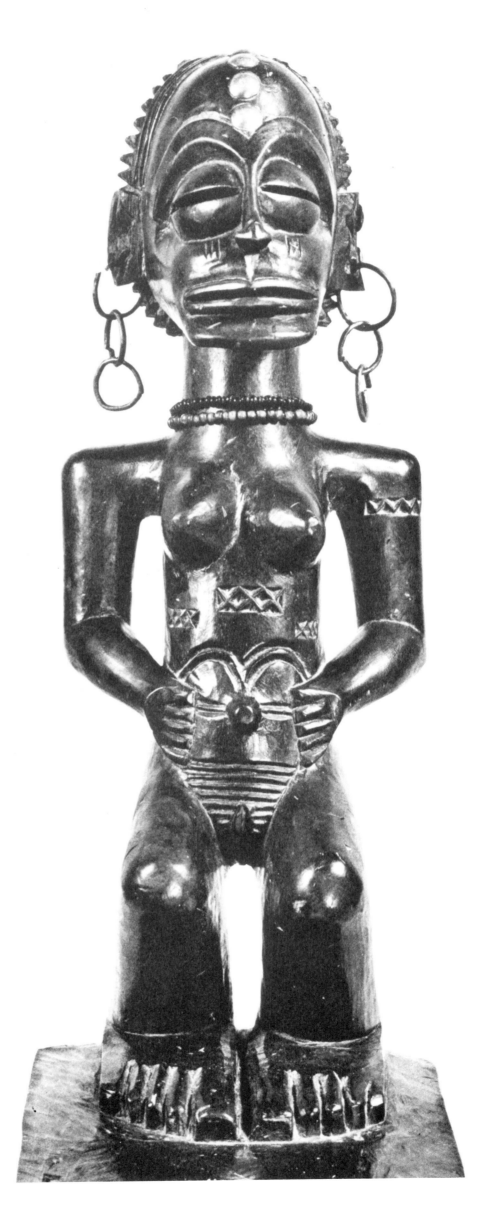

BAJOKWE

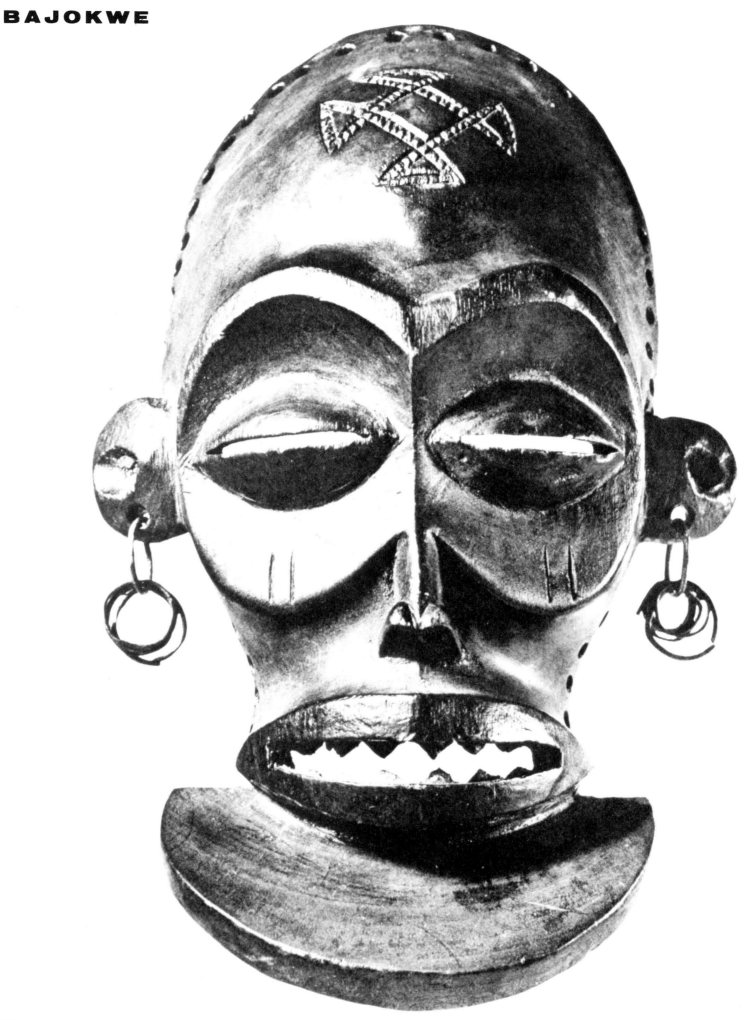

286
DANCE MASK

*This mask, representing a man, was worn in dances
performed to entertain the village. Male dancers in male
and female disguises ridiculed the foibles of the sexes.
The 'spectacles' are the hallmark of Bajokwe style.*

287
DANCE MASK

*This is the mask called mwana pwo or 'the maiden'. The
subjects of these masks and their dances suggest that
they were once used in celebrations of initiation, as
among the Bayaka and Bapende.*

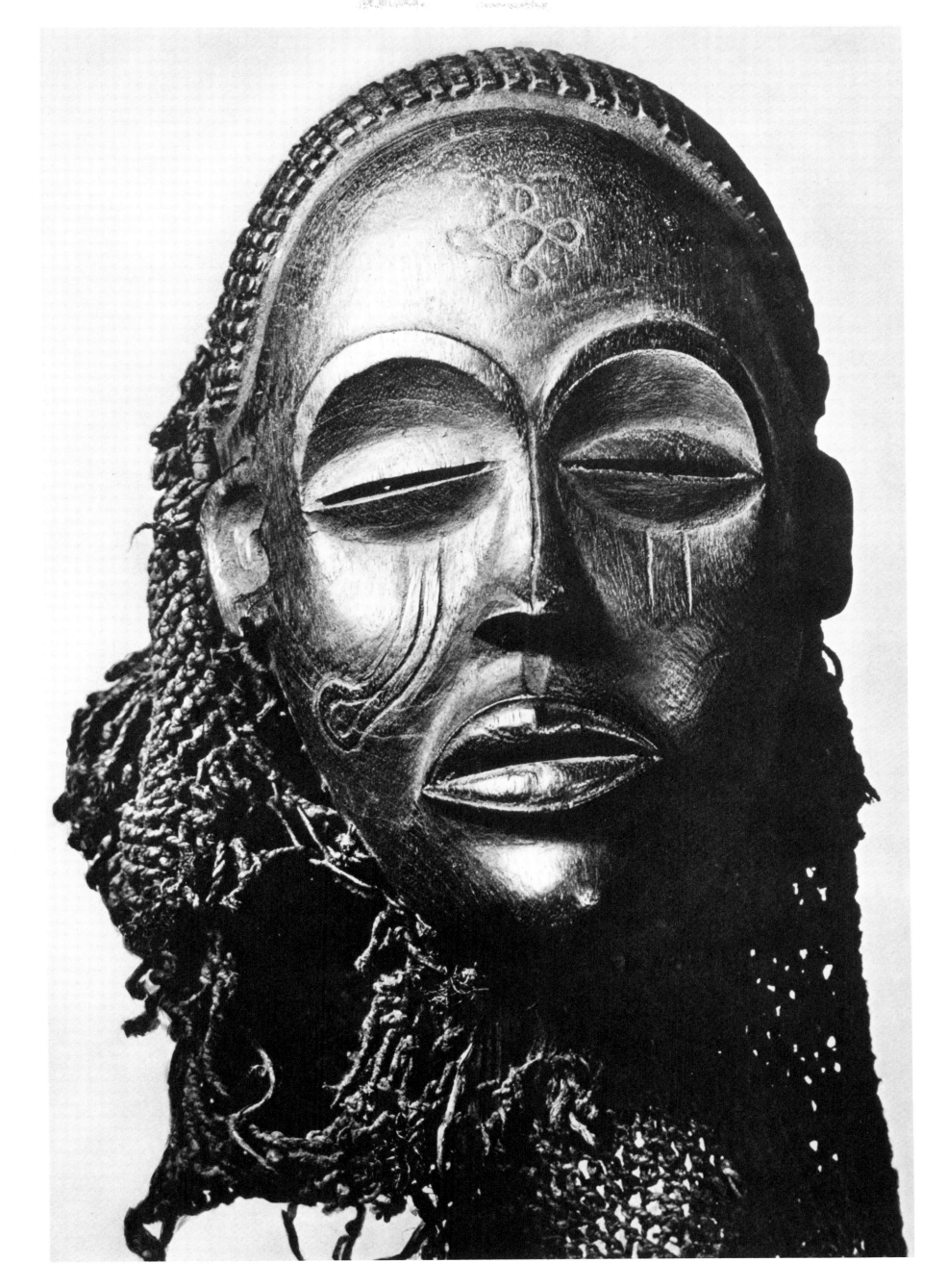

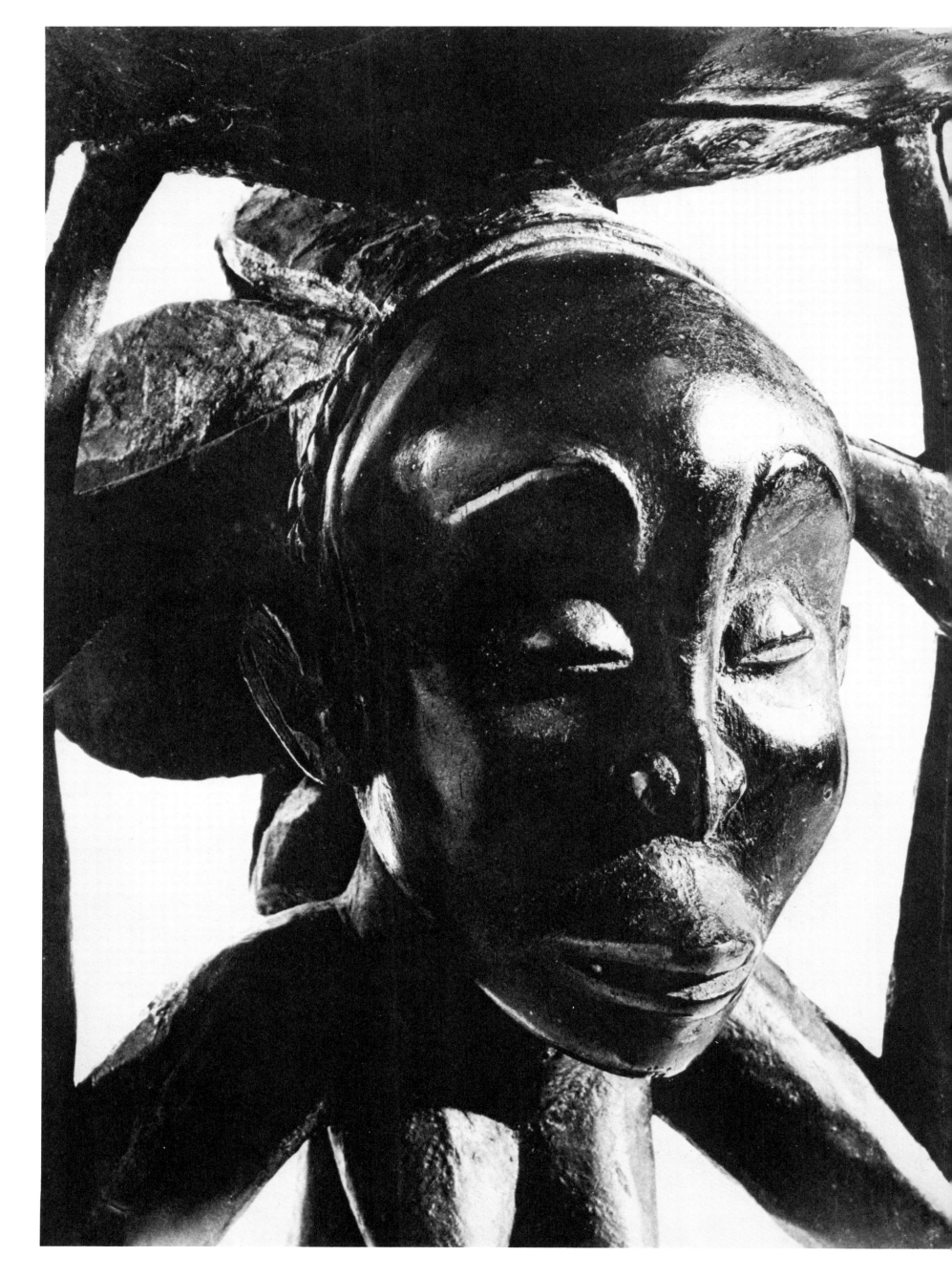

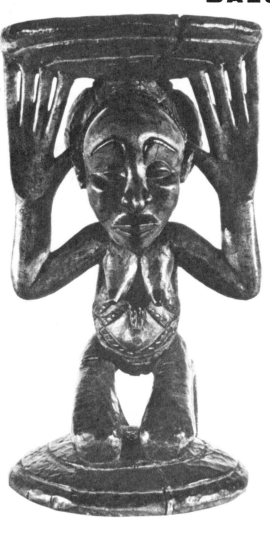

289
CHIEF'S STOOL

Of the eight stools attributed (on the strength of
two documented pieces) to the Master (or
Masters) of Buli, this and two or three others are
in hard wood and seem less subtly modelled
than those in soft wood such as fig. 288.

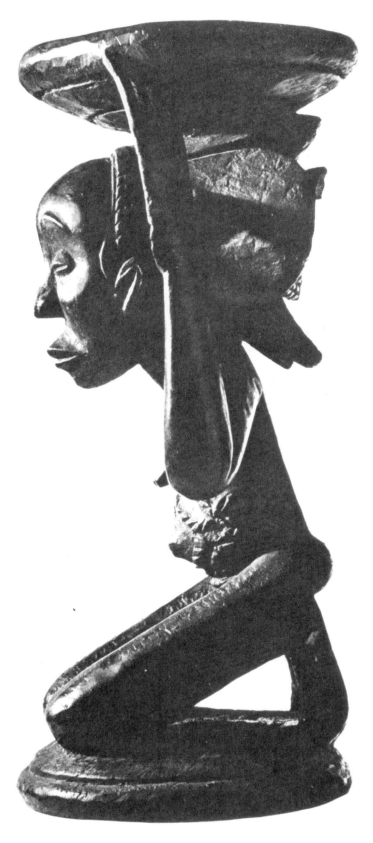

288
CHIEF'S STOOL

This is one of the twelve known pieces in the
'long-faced style of Buli' (a village in north-east
Balubaland), perhaps the most sensitive and
impressive of all the Baluba sub-styles. They
seem to be by one or at most two hands.

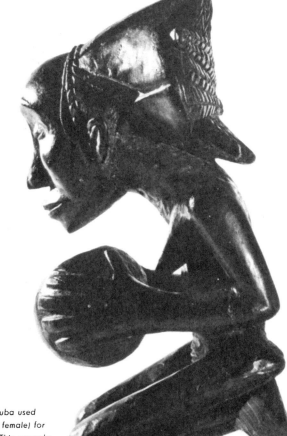

290
FIGURE WITH BOWL

Like the Yoruba of Nigeria, the Baluba used
bowls supported by figures (usually female) for
many purposes, ritual and secular. This example
in stained soft wood is one of the finest works by
the Master of Buli.

BALUBA

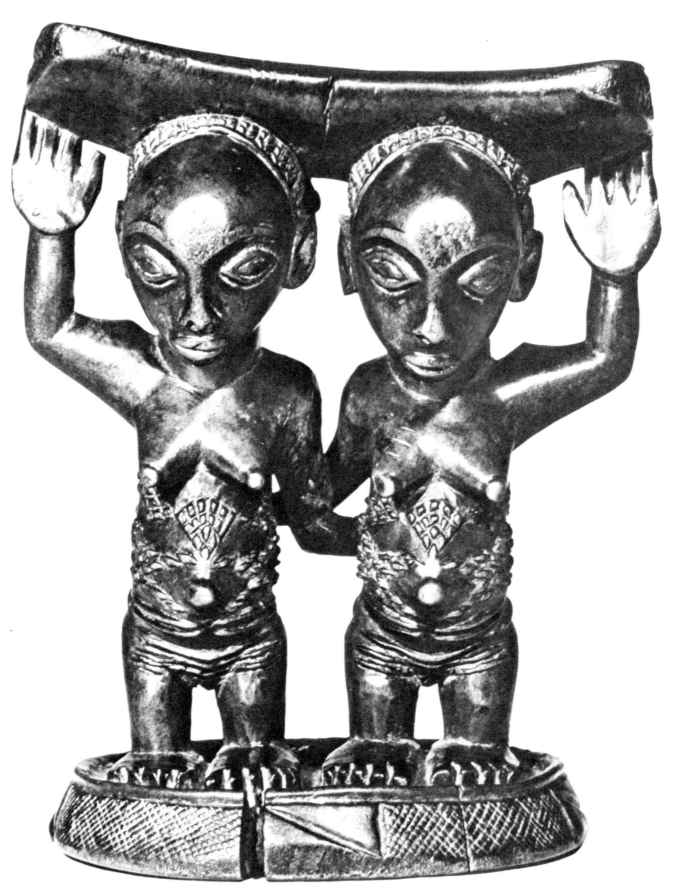

291
HEADREST

Wooden headrests are found in many parts of the world where elaborate coiffures are favoured; their distribution in tribal Africa shows that they are related to those of Ancient Egypt. The more

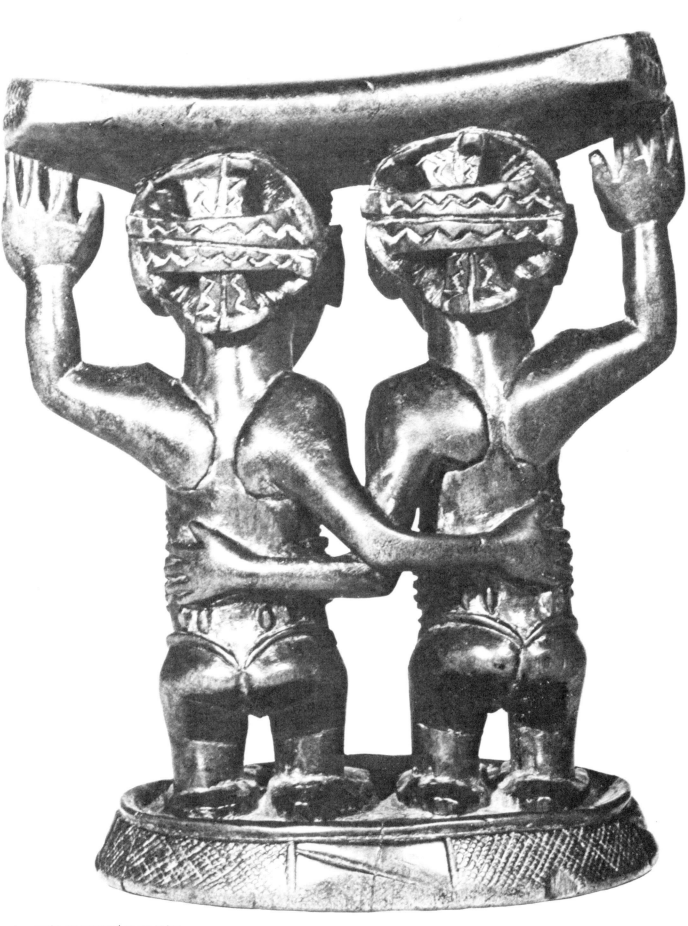

elaborate examples are supported on one or two
caryatid figures, both in this case being female with
identical body scars and hairdress. Baluba women
are often, as here, represented in art with their hair
worked up over a cruciform basketry framework.
Wear on the foreheads of these figures suggests that
the headrest was sometimes used on its side.

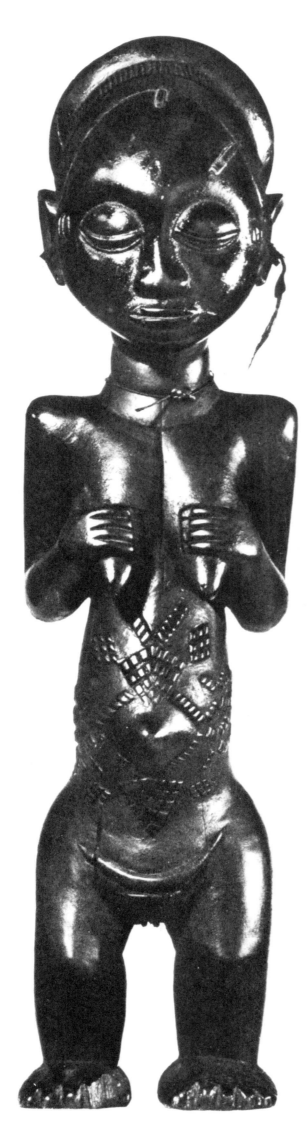

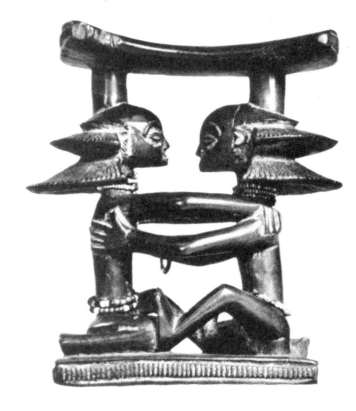

293
HEADREST

This is one of several known pieces in the rare 'cascade' style, perhaps all from a single hand, which delighted in ingenious compositions in space. The figures are shown without sexual characters.

292
ANCESTOR FIGURE

In Baluba belief, the ancestors are among the possible sources (gods and spirits, the human, animal, vegetable and mineral worlds) upon which a man can draw, by proper rituals, for the maintenance of his energy or life force

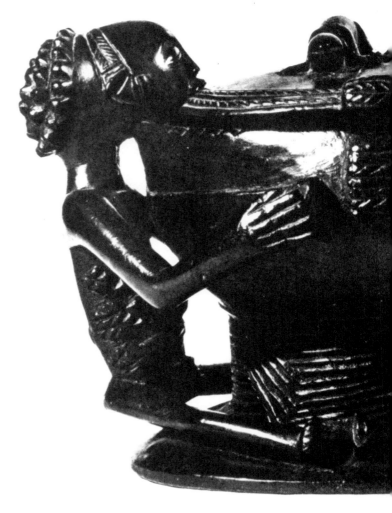

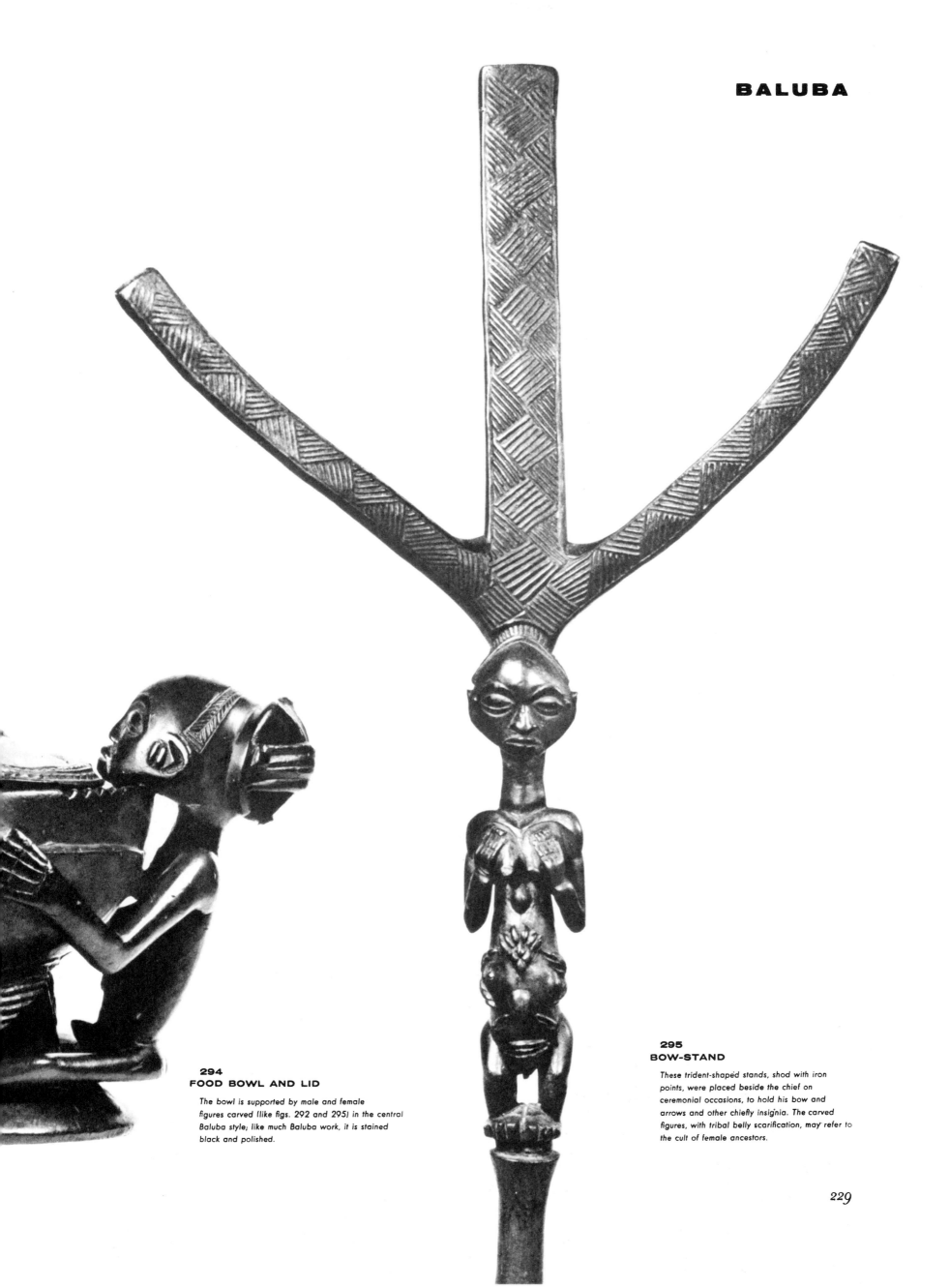

**294
FOOD BOWL AND LID**

The bowl is supported by male and female
figures carved (like figs. 292 and 295) in the central
Baluba style; like much Baluba work, it is stained
black and polished.

**295
BOW-STAND**

These trident-shaped stands, shod with iron
points, were placed beside the chief on
ceremonial occasions, to hold his bow and
arrows and other chiefly insignia. The carved
figures, with tribal belly scarification, may refer to
the cult of female ancestors.

229

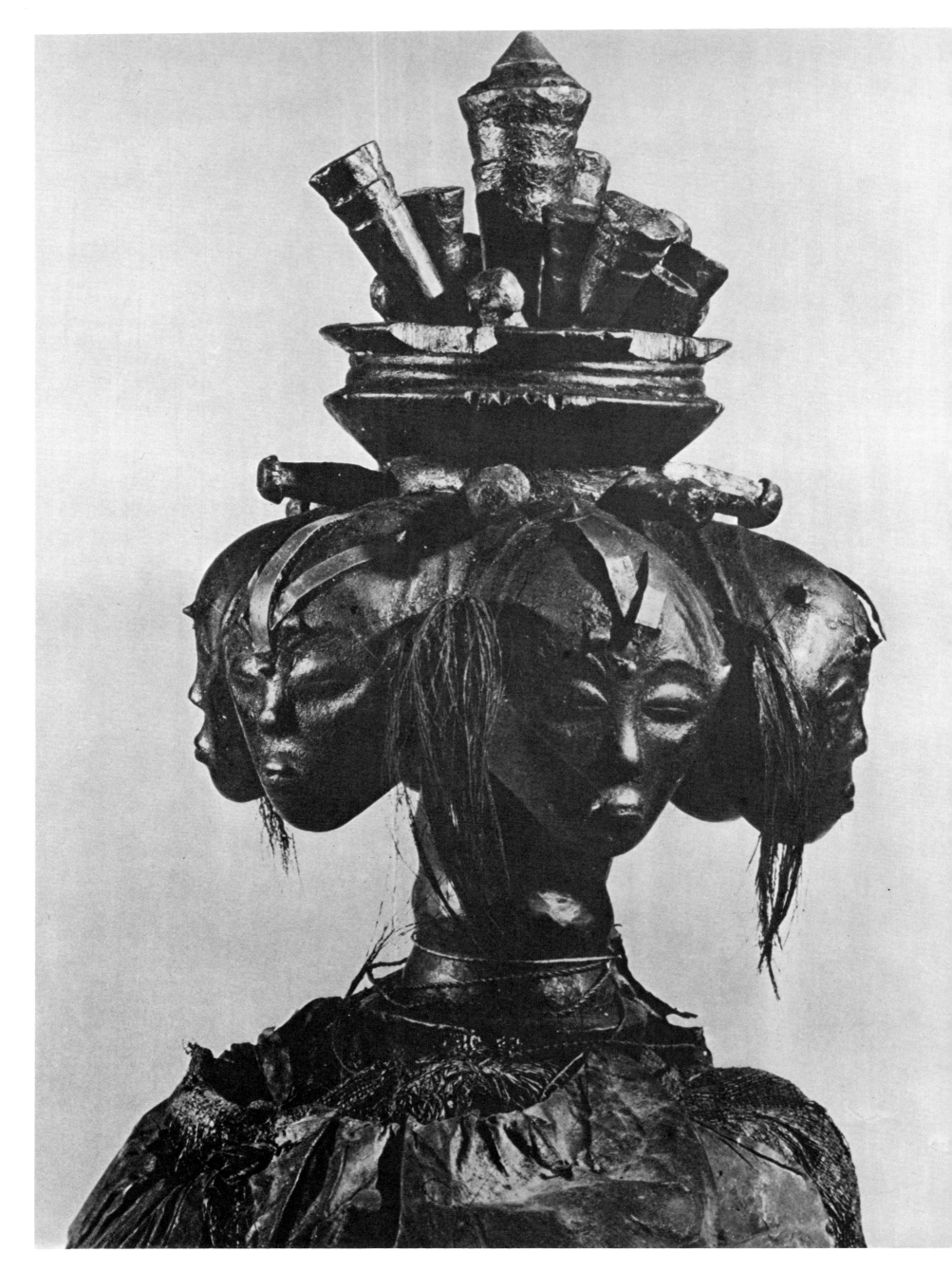

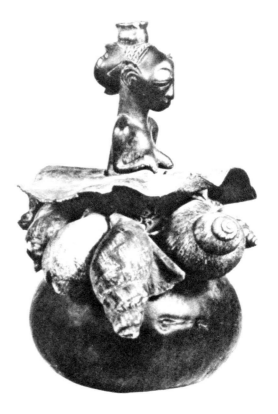

297
FETISH FIGURE

The Baluba predilection for soft, supple, graceful forms
is well seen here. That this is an increase fetish is
suggested by the attachment to the calabash of giant
snail shells, one of nature's clearest illustrations of the
growth process.

296
SIX-HEADED FETISH

This must have been an exceptionally important or
versatile fetish, to judge by the many and varied
objects—such as wooden imitations of antelope
horns, copper strips, animal skins and raphia cloth—
added to enhance its power.

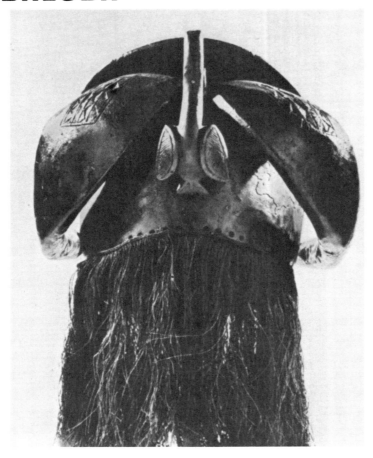

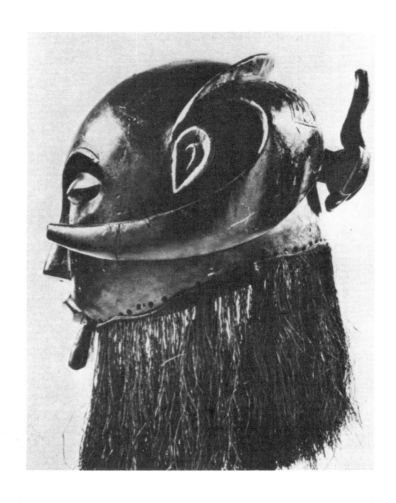

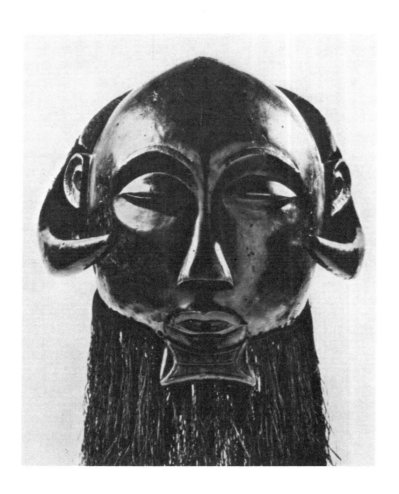

298
DANCE MASK

This magnificently imposing helmet mask, representing a bearded man with bovine horns, was collected in 1889. Although the style is essentially Baluba in its curvilinear emphasis, we may see Basonge influence in the treatment of the beard, and the anthropozoomorphic conception, uncommon in the Congo, is most closely paralleled among the Bushongo (see fig. 265); so a north-western Baluba origin seems probable.

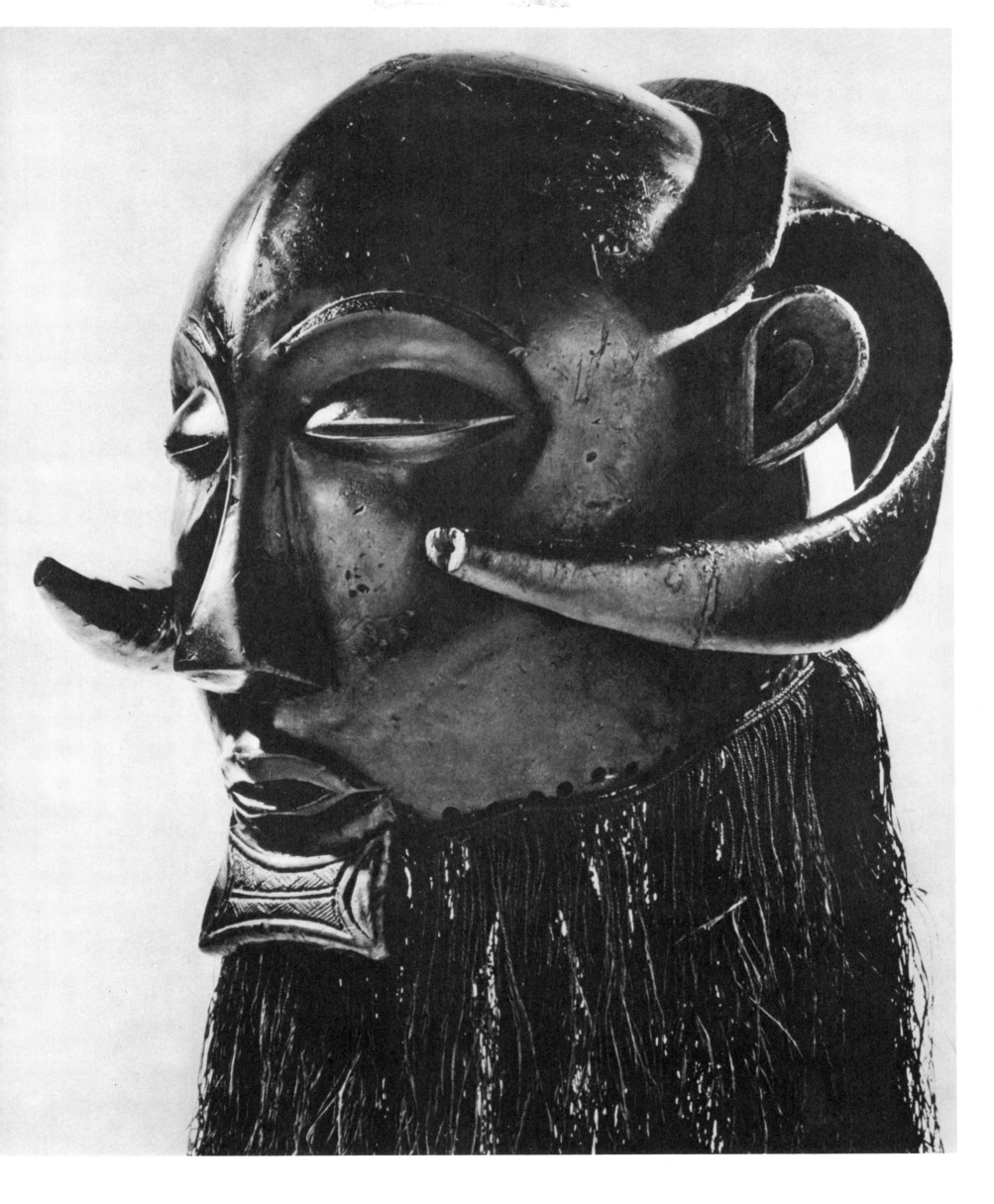

BASONGE

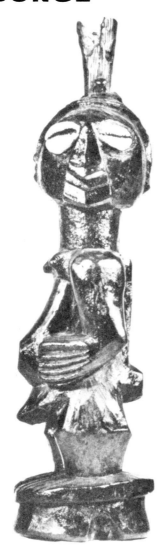

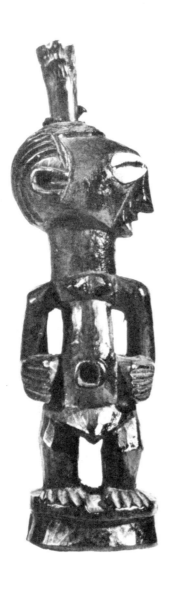

299
FETISH FIGURE

The Basonge are sometimes treated as part of
the Baluba complex; but the Baluba emphasis is
on the ancestor cult, while the Basonge make
chiefly fetishes. Correspondingly, in aesthetic
terms, Baluba sculpture is predominantly
humanistic and even sensuous, Basonge art is
rather cubistic and aggressive, interested in the
opposition of planes and forms rather than their
reconciliation. Diverse ingredients, usually
including the bile of sorcerers, were inserted into
the crown and paunch of Basonge fetishes. The
magical combinations were thought efficacious in
guarding wealth, curing illness, killing enemies
and similar needs. As a precautionary measure,
large harmful fetishes were housed outside of the
village. Figures two inches tall may have been
innocuous.

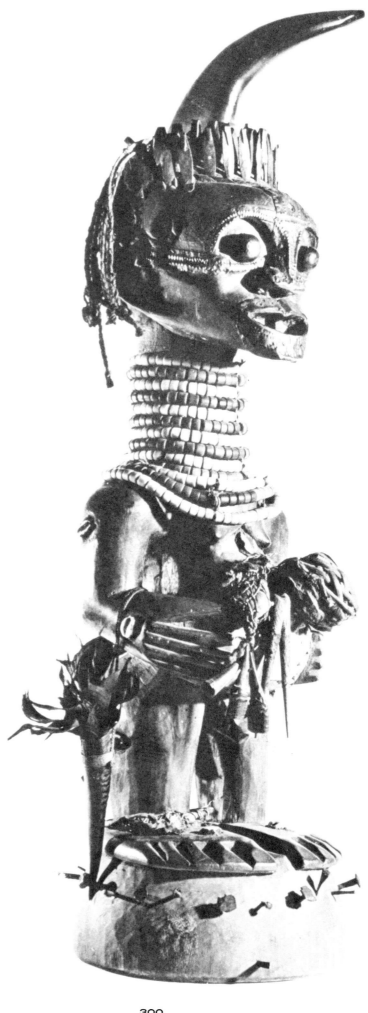

300
FETISH FIGURE

Animal horns holding powerful medicines were often
inserted in the crown. Additional units of magic were
added by the attachment of objects such as belts, furs,
teeth and metal blades.

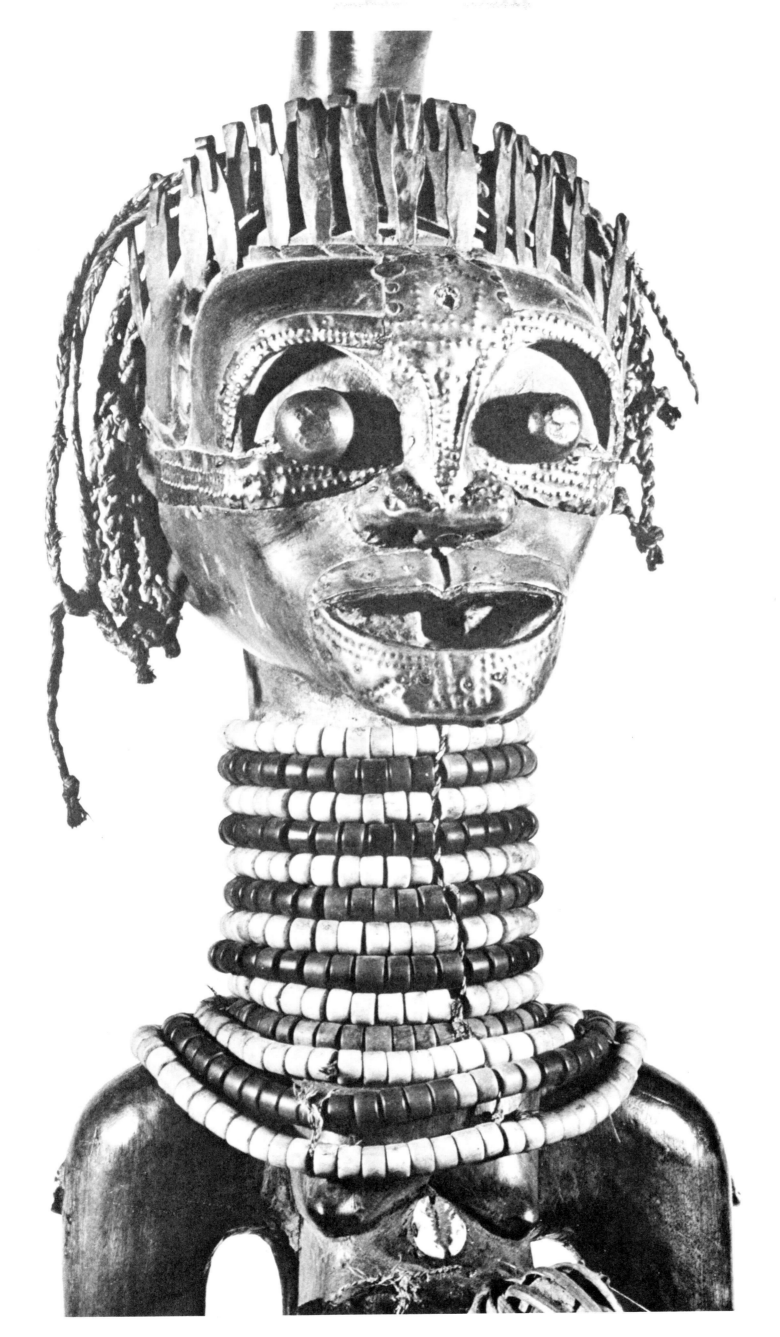

235

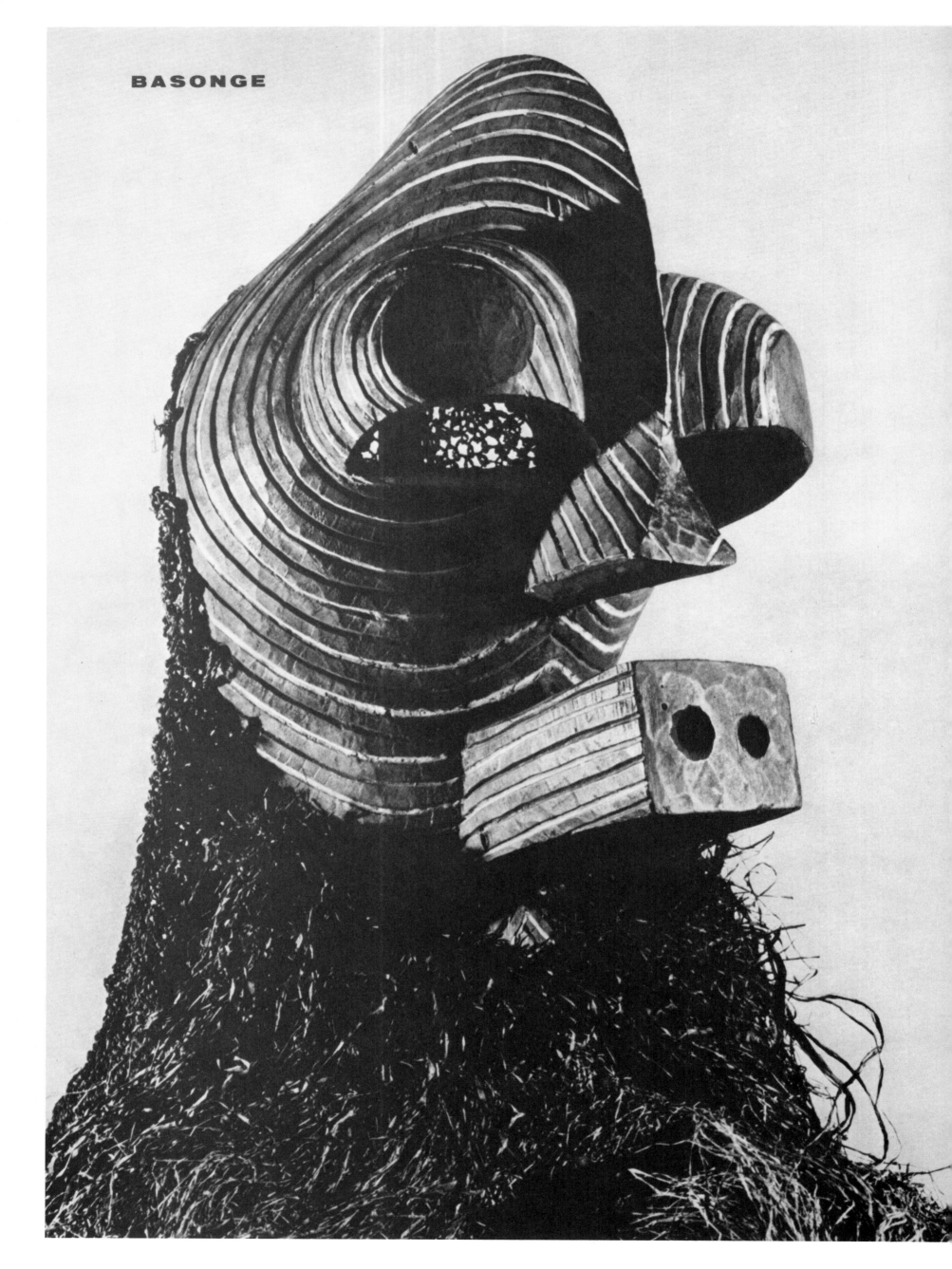

BASONGE

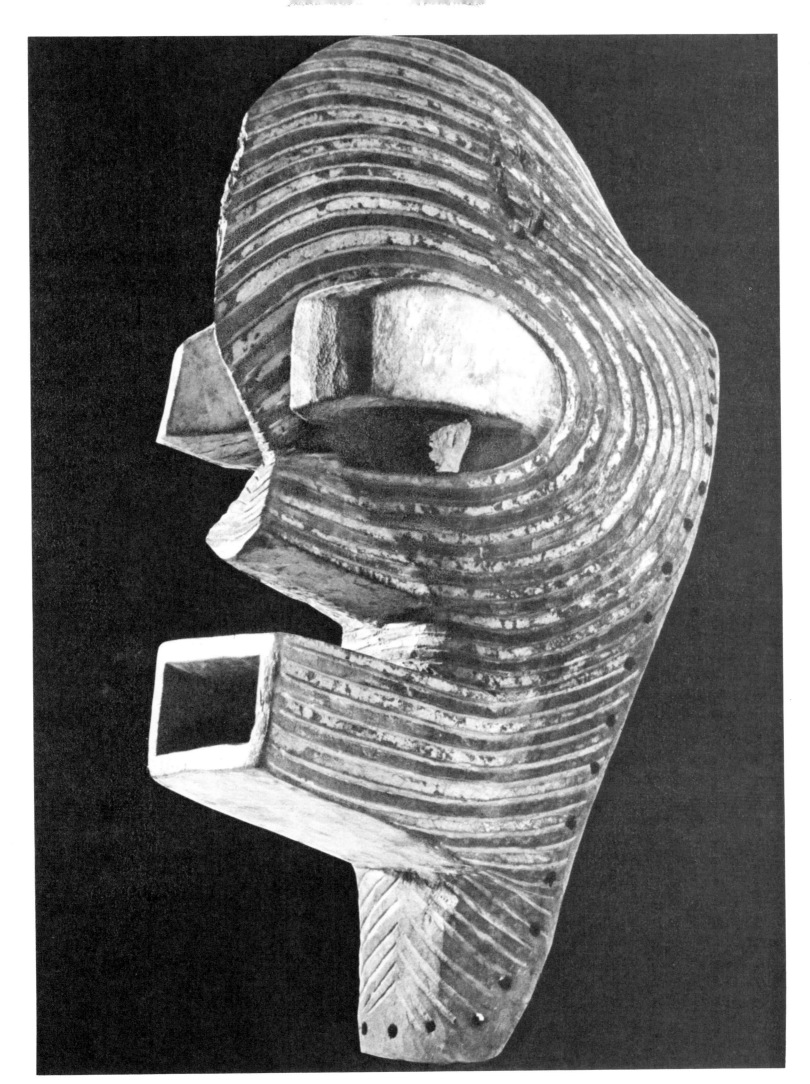

301
DANCE MASK

These extraordinary but harmonious projections of
the human face are the kifwebe masks used by witch-
doctors of the Lomami River, where Basonge style
often shows Baluba influence.

302
DANCE MASK

The concept of vital force seems especially prominent
in this kifwebe mask, thought to be used by witch-
doctors to embody impersonal spirits or forces. The
effect is greatly enhanced by movement.

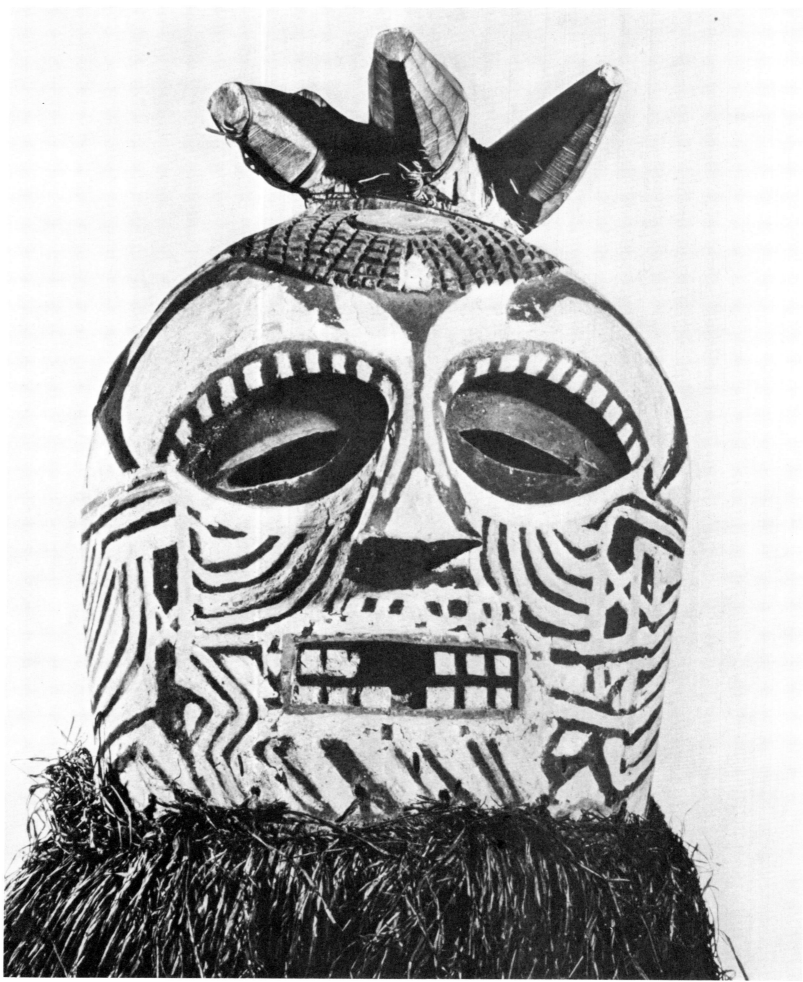

303
DANCE MASK

Youths of a northern Basonge village were seen
dancing nearby as this helmet mask stood on
the ground. The black and white decoration painted
upon an unsculptured surface is unusual in the area.

304
DANCE MASK

The Batetela live to the north of the Basonge and
are distinguished from them by small but definite
differences of art and culture. This three-horned
helmet mask is among their largest works.

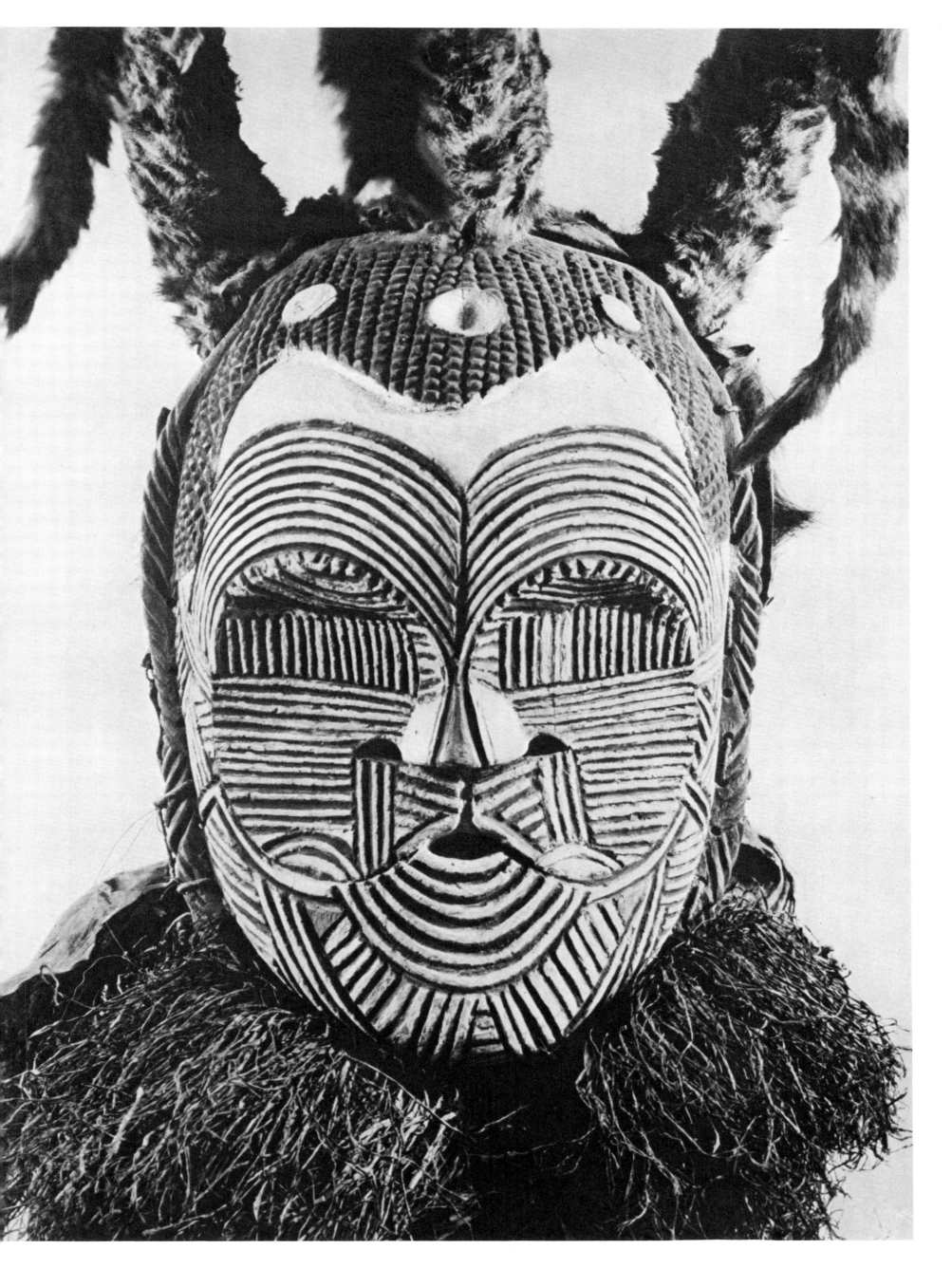

BALEGA

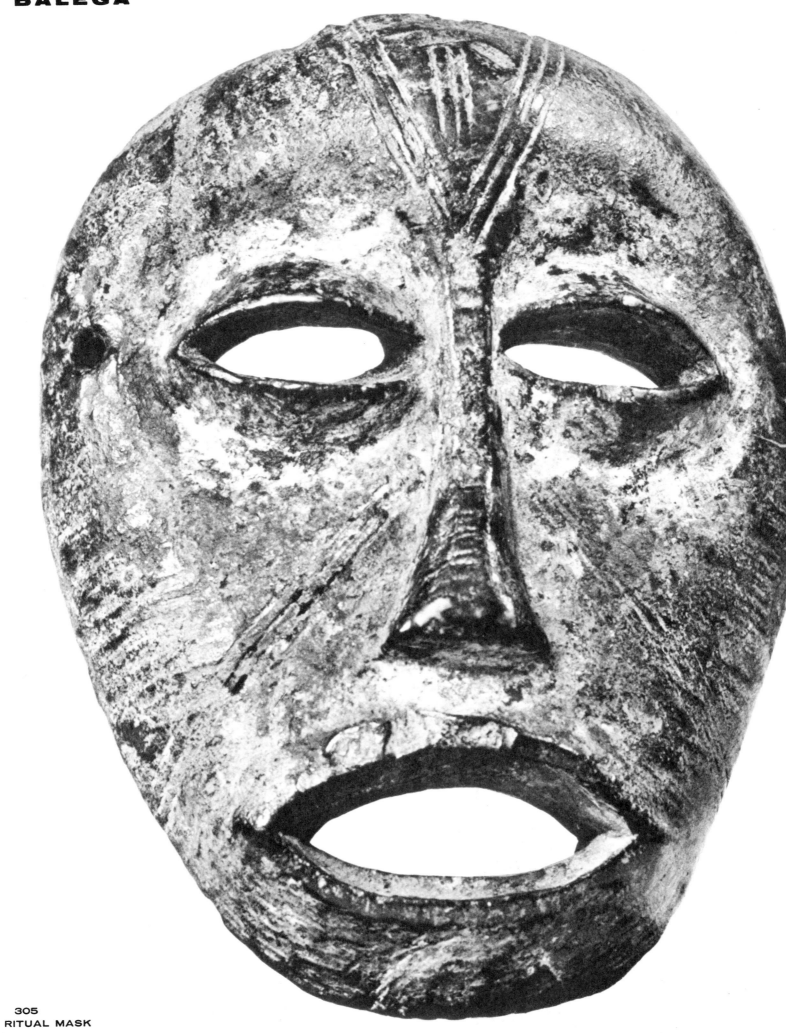

305
RITUAL MASK

The Balega (or Warega) are a complex of lineage groups
united by a graded initiation society, Bwame. Each grade
has special insignia; members of the highest grade may own
ivory masks.

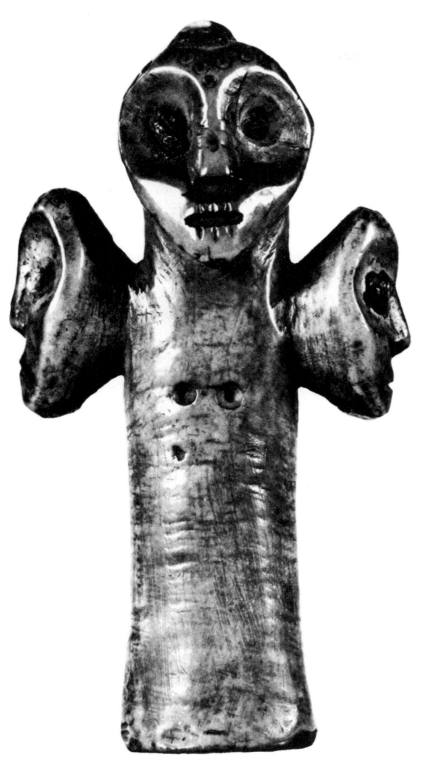

306
FIGURE

The Bwame society to which all Balega sculpture
seems to belong) comprises five grades for men and
three for women. Figures and masks are found in
both wood and ivory.

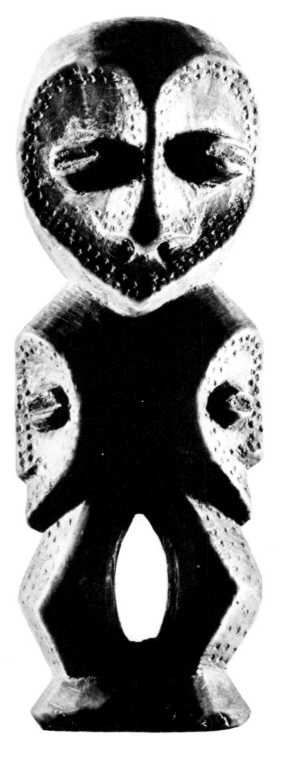

307
FIGURE

This stylized figure, with characteristic heart-shaped
face, represents the practice in certain dances of
wearing masks on one or both shoulders as well as
on the face.

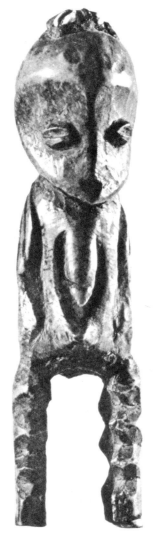

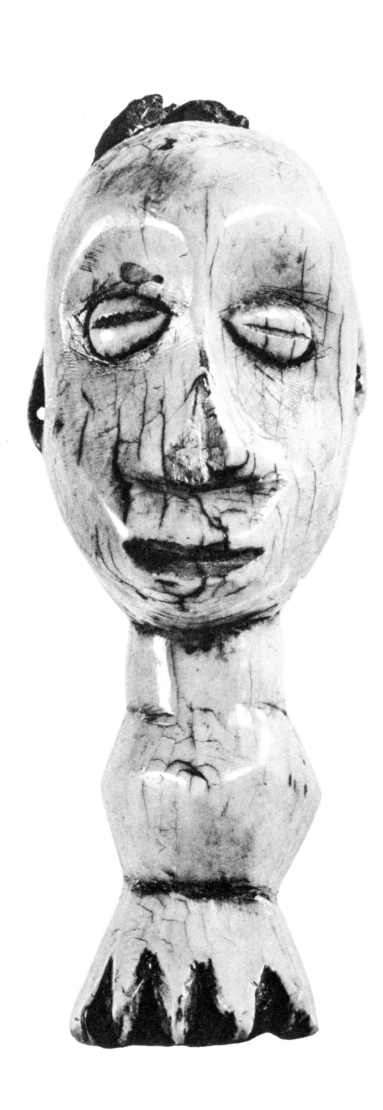

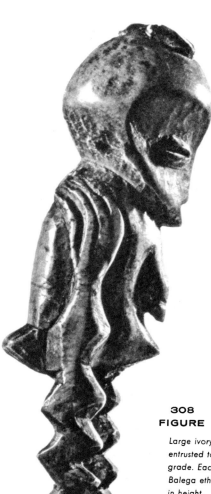

**308
FIGURE**

Large ivory figures, symbolic of lineage ties, are
entrusted to the clan member of the highest
grade. Each has some features alluding to
Balega ethics. Examples may reach over a foot
in height.

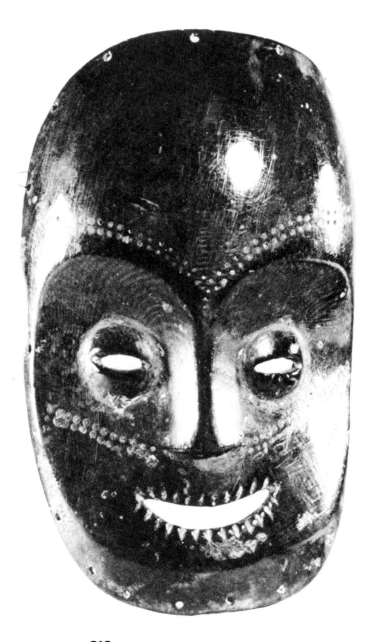

310
MASK

*This mask, carved from an exceptionally large tusk, has,
like many Balega ivories, a deep red patination due
probably to treatment with palm oil. Ivory and wooden
masks are still in active use.*

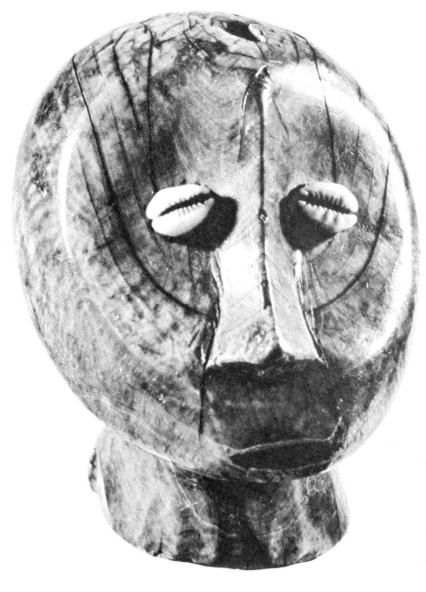

311
HEAD

*The expressive simplicity of this form might have inspired Brancusi.
The eyes are here formed by cowrie shells; more often imitations
of them are carved in the ivory as in fig. 309.*

309
FIGURE

*Grades in Bwame are attained through a
cycle of ritual and economic endeavour by
individuals and their families. During initiation
rites, many sculptures are shown in instructive
songs and dances.*

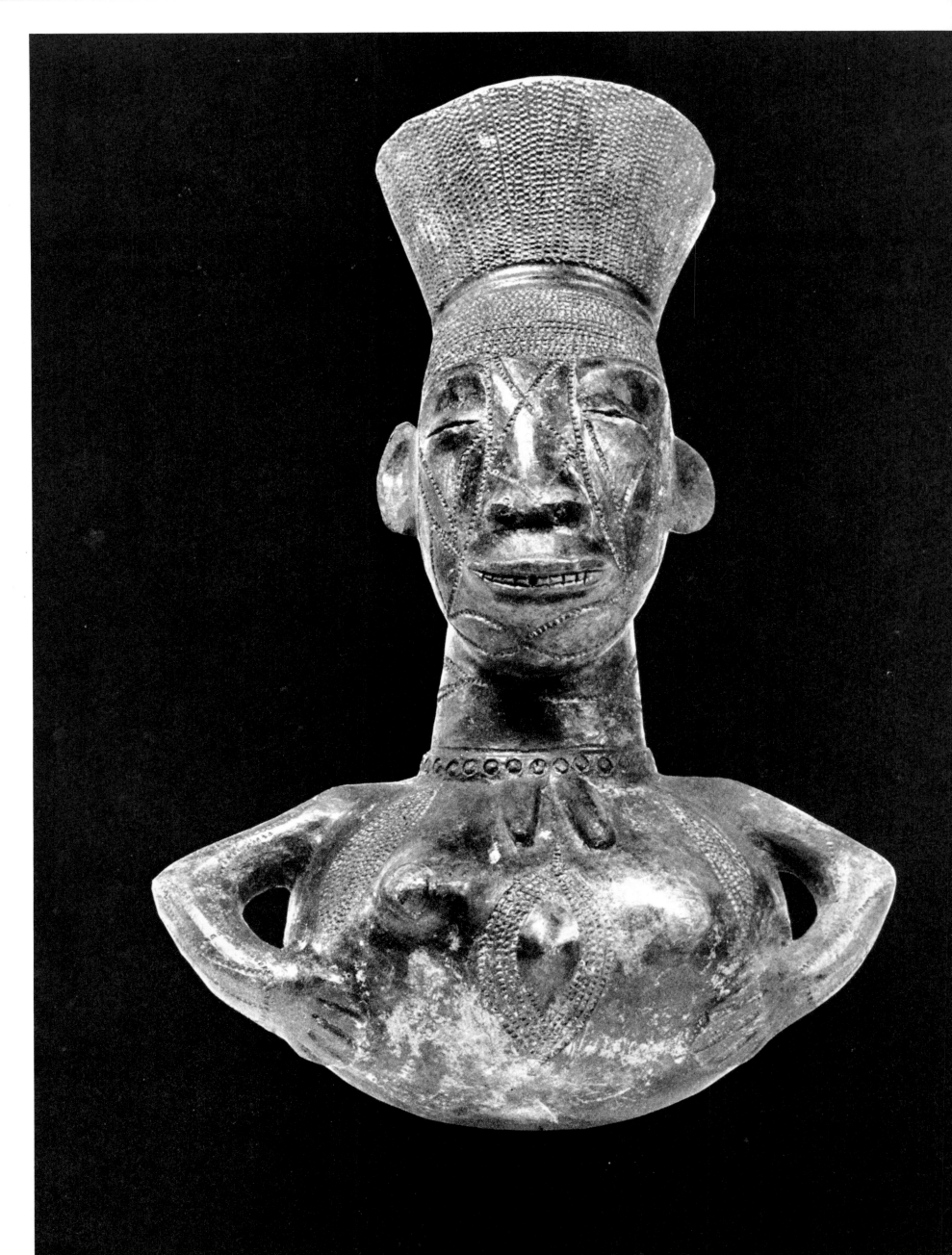

MANGBETU

BAMBOLE

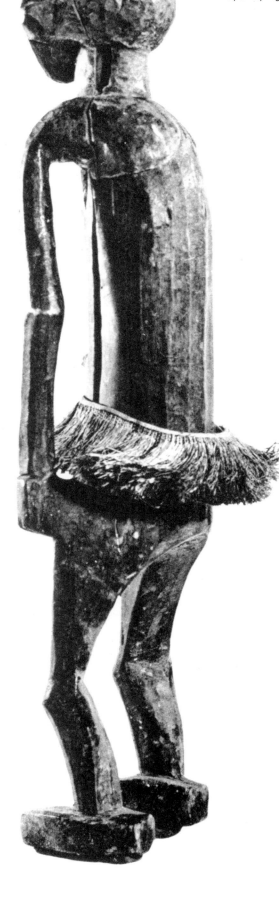

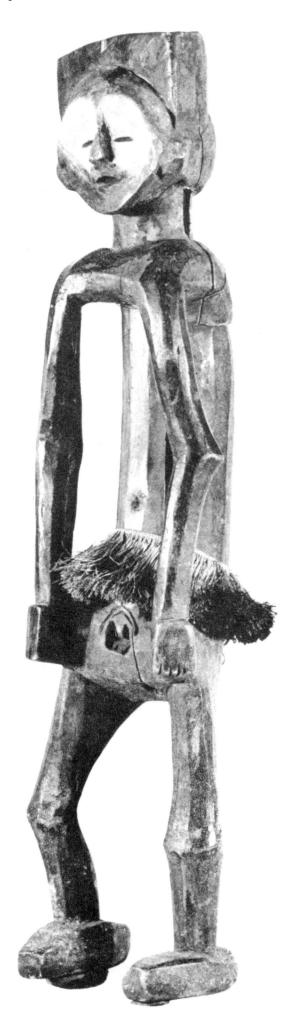

313
FIGURE

The Lilwa secret society executed malefactors and retained their power in effigies thought to watch over the community. During society meetings these figures were carried in dances. In style they suggest Fang, Bakwele and Balega work.

312
JAR

About 1870, Mangbetu water jars were non-representational and were made by women. More recently, jars of human form were made by men, supposedly for wine as well as water—perhaps in response to European interest in Mangbetu head deformation.

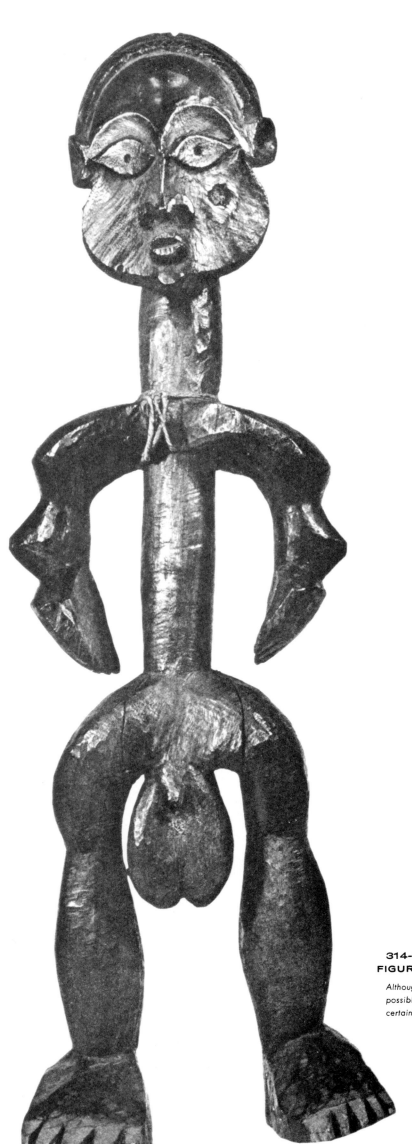

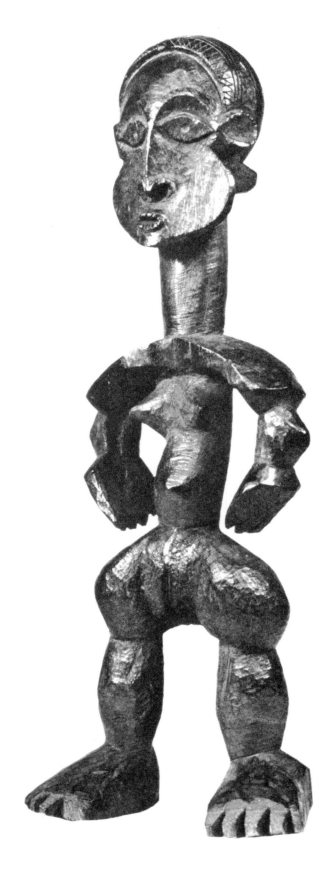

314-315
FIGURES

Although carvings in this style are found in Zandeland, it is possible that they are rather a sub-style of the Mangbetu, who certainly purvey some carvings to the Azande.

316
HARP

Travelling musicians accompanied their recitatives upon the harp, which was commonly made in human form in this area. In some examples the head is carved in the style of figs. 314,315.

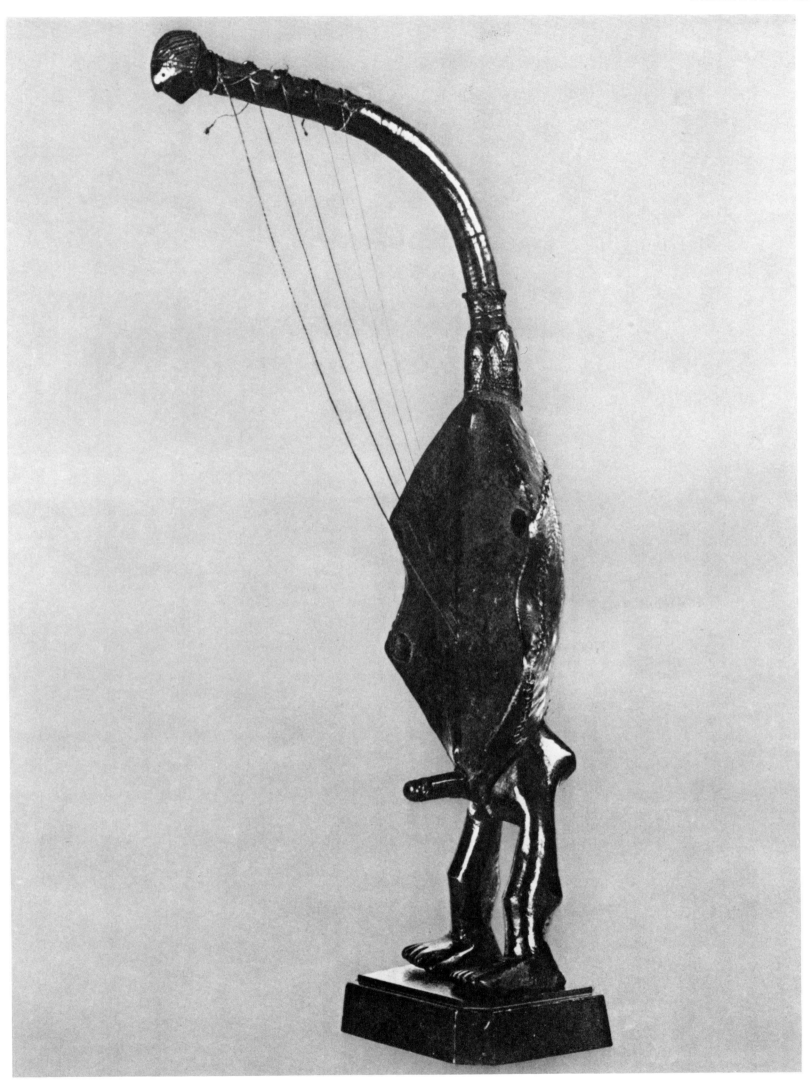

MASHONA

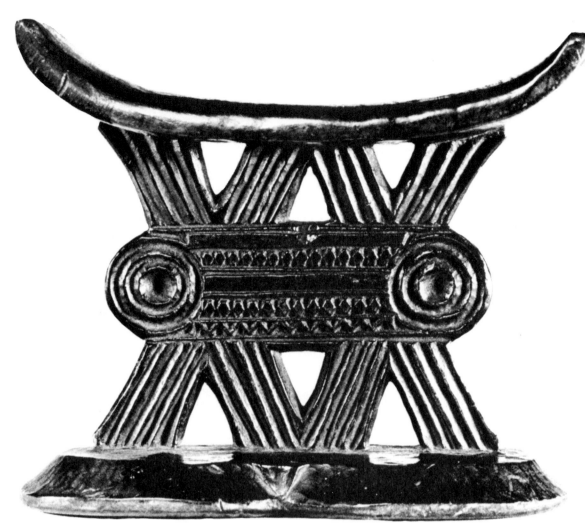

317, 319
HEADRESTS

The Mashona and Makalanga formerly produced headrests in abundance, though not because of particularly elaborate coiffures. Innumerable variations on this type of geometric design are found.

318
HEADREST

Although similar to a published example in the Musée Royal du Congo Belge, this rare headrest supported on a rather problematical quadruped seems clearly to belong to the Rhodesian complex.

248

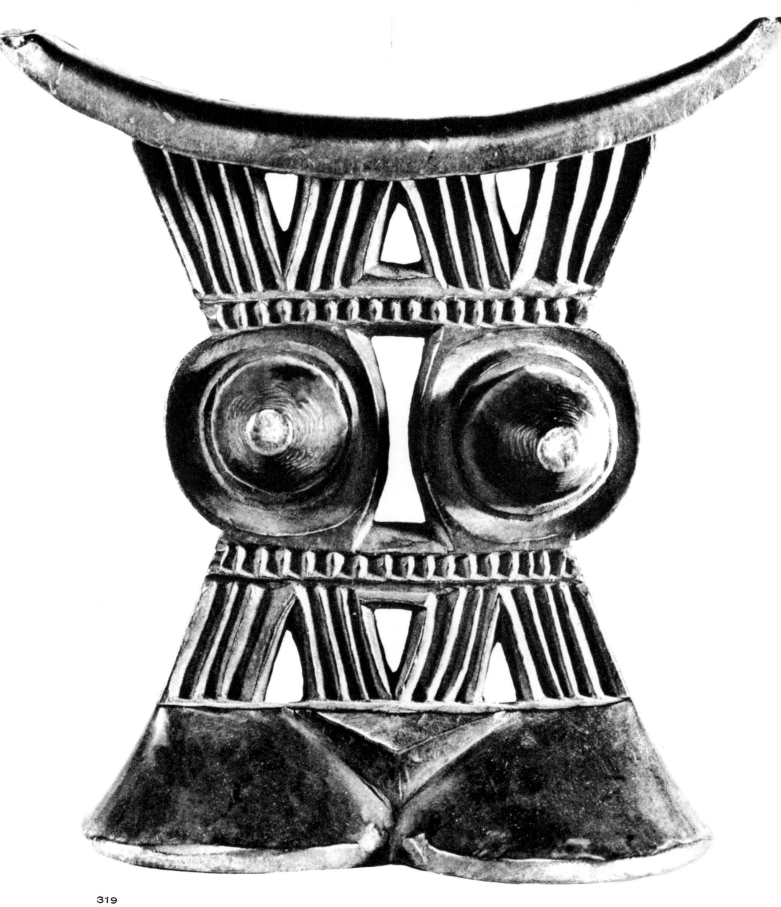

319

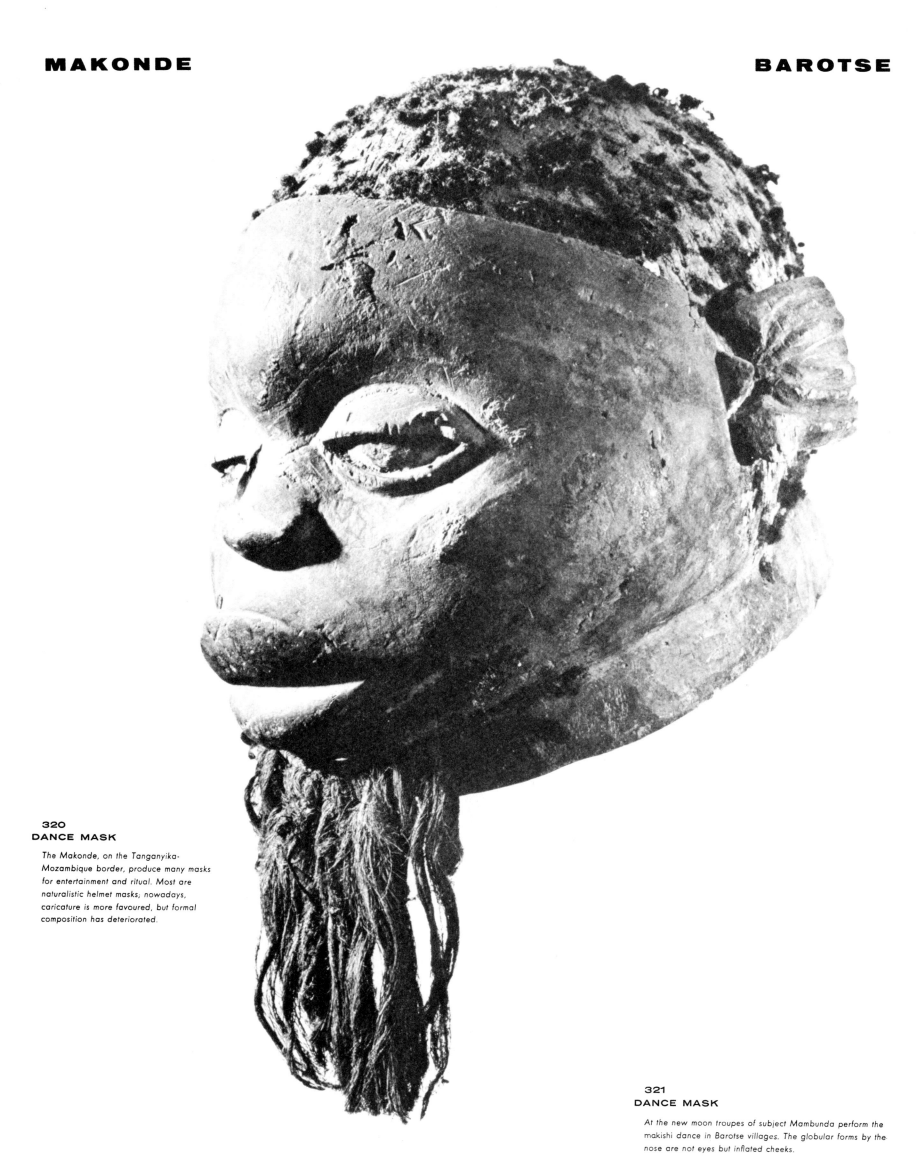

320
DANCE MASK

*The Makonde, on the Tanganyika-
Mozambique border, produce many masks
for entertainment and ritual. Most are
naturalistic helmet masks; nowadays,
caricature is more favoured, but formal
composition has deteriorated.*

321
DANCE MASK

*At the new moon troupes of subject Mambunda perform the
makishi dance in Barotse villages. The globular forms by the
nose are not eyes but inflated cheeks.*

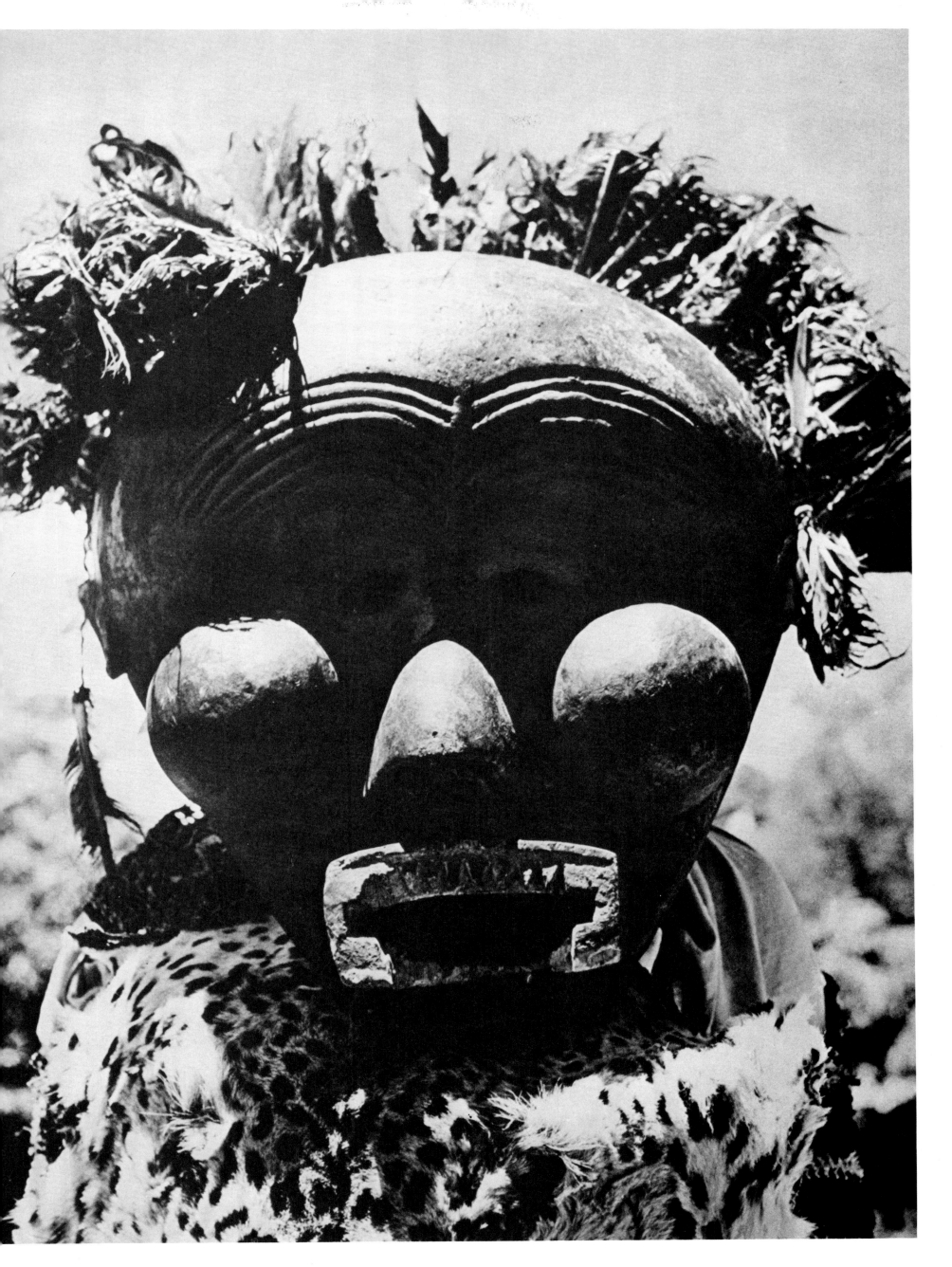

BIBLIOGRAPHICAL NOTES

Tribal Art in General:

Leonhard Adam, *Primitive Art* (3rd ed., London, 1954), is the soundest general introduction to tribal art, in spite of a few minor blemishes; another general account of broad scope, more copiously illustrated, is Erwin Christensen, *Primitive Art* (New York, 1955); a well illustrated German work of the same sort is Herbert Kühn, *Die Kunst der Primitives* (Munich, 1923), and another, with a more valuable text, is E. Vatter, *Religiöse Plastik der Naturvölker* (Frankfurt, 1926). Among the early theoretical works, Alfred Haddon, *Evolution in Art* (London, 1895), and Henry Balfour, *The Evolution of Decorative Art* (London, 1893), concerned themselves chiefly with the objective study of the mechanisms by which decorative designs change and develop, especially in the South-east Asian and Oceanic area; their work remains relevant to the study of tribal art today, although Franz Boas, *Primitive Art* (Oslo, London, and Cambridge, Mass. 1927; new ed., New York, 1955), may seem to some more obviously so. The earliest essay in the aesthetic study of tribal art was perhaps Ernst Grosse, *Die Anfänge der Kunst* (1893; English translation, *The Origins of Art*, New York, 1897). Many important contributions to the general study of tribal art, are to be found in articles in anthropological periodicals such as the *Journal of the Royal Anthropological Institute*, *Man* and the *American Anthropologist*, from the eighteen-nineties onwards.

African Art in General:

Two further essays by William Fagg may be found a useful complement to those included in this book: 'The Study of African Art', *Allen Memorial Art Museum Bulletin*, vol. xiii, no. 2 (Oberlin, Ohio, winter 1956); and 'On the Nature of African Art', *Memoirs and Procs. of the Manchester Lit. and Phil. Soc.* (1953). Professor M. J. Herskovits's *Backgrounds of African Art* (Denver Art Museum, 1945), though difficult to obtain, may be warmly recommended. Carl Kjersmeier's great work, *Centres de style de la sculpture nègre africaine* (4 vols., Paris and Copenhagen, 1935–8), provided the main foundations for the systematic study of African art, and because of its admirable documentation has lost none of its value to the student, though now extremely rare; the single volume of reproductions selected from it (*African Negro Sculptures*, Copenhagen, London and New York, 1948) is tantalizing by comparison. Three very various and more or less complementary approaches are provided in books by Griaule, Trowell and Wingert, the first two authors having field experience of the African artist (though in Griaule's case this led to a tendency to interpret all Africa in terms of the Dogon): Marcel Griaule, *Arts de l'Afrique noire* (Paris, 1947; English translation, *Arts of the African Native*, London, 1950, and *Folk Art of Black Africa*, New York, 1950); Margaret Trowell, *Classical African Sculpture* (London, 1954); Paul Wingert, *The Sculpture of Negro Africa* (New York, 1950). A sound and well-balanced account of African art has recently been given by Denise Paulme, *Les sculptures de l'Afrique noire* (Paris, 1956). Of these four, only *Classical African Sculpture* is greatly concerned with the aesthetic side. The most valuable contribution so far made to our understanding of African aesthetics is probably contained in three small books by the well-known sculptor Leon Underwood, *Figures in Wood of West Africa*, *Masks of West Africa* and *Bronzes of West Africa* (London, 1947, 1948 and 1949). Almost alone in the literature, they are works of independent and original judgment, often defective on matters of ethnological fact (other than technology), but offering to the perceptive reader a masterly insight, supported by a fine choice of illustrations which owes nothing to previous anthologists. For the basis of thought which may underlie African art (and other aspects of indigenous life), Father Placide Tempels, *Philosophie bantoue* (Paris, 1949; with some excellent plates of sculpture, though art is not treated in the text), provides a valuable and plausible synthesis, which is on the whole confirmed for their respective areas by the several authors of *African Worlds* (ed. by Daryll Forde, London, 1954) and of *African Ideas of God* (ed. by Edwin W. Smith, London, 1950).

With the volumes already mentioned, the following illustrated works will provide a very large corpus of African sculpture. H. Clouzot and A. Level, *L'art nègre et l'art océanien* and *Sculptures africaines et océaniennes* (Paris, 1919 and 1926); C. Einstein, *Negerplastik* (Munich, 1920) and *Afrikanische Plastik* (Berlin, [1921]); L. Frobenius, *Das unbekannte Afrika* (Munich, 1923) and *Kulturgeschichte Afrikas* (Zürich, 1933); P. Guillaume, *Sculptures nègres* (Paris, 1917); P. Guillaume and T. Munro, *Primitive Negro Sculpture* (New York, 1926); J. Maes and H. Lavachery, *L'art nègre* (Brussels, 1930); W. Muensterberger, *Sculpture of Primitive Man* (New York, 1955); A. Portier and F. Poncetton, *Les arts sauvages: Afrique* (Paris, 1930; reprinted 1956); P. Radin and J. J. Sweeney, *African Folktales and Sculpture* (New York, 1954); C. Ratton, *Masques africains* (Paris, 1931); *Arts of West Africa* (ed. by M. E. Sadler, Oxford, 1935); W. Schmalenbach, *African Art* (Basel, 1954); E. von Sydow, *Die Kunst der Naturvölker und der Vorzeit* (Berlin, 1923) and *Afrikanische Plastik* (ed. by G. Kutscher, Berlin, 1954). With many of these volumes the student must be on his guard against incorrect attributions and other errors of knowledge.

The Western Sudan:

The best general account of the art of the western Sudan is F. H. Lem, *Sudanese Sculpture* (Paris, 1948; translated, rather inadequately, from the French). The most intensive study so far of an art form in a single African tribe is M. Griaule, 'Masques Dogons', in *Travaux et Mémoires de l'Institut d'Ethnologie*, vol. xxxiii (Paris, 1938); this work is a model of ethnographical documentation. For the historical background, reference may be made to E. W. Bovill, *Caravans of the Old Sahara* (Oxford, 1933), and to Lady Lugard, *A Tropical Dependency* (London, 1905); and, for the ethnology in general, to the numerous works of Griaule and his assistants, notably Mmes Germaine Dieterlen and Solange de Ganay.

The Guinea Coast:

There is no comprehensive work devoted to the art of the Guinea Coast, and indeed some of its tribes are better represented in the art anthologies than in specialized articles or monographs. This is notably true of the Baga, one of the most important art-producing tribes, as indeed of the arts of Portuguese and French Guinea, Sierra Leone and Liberia, except for the Dan-Ngere tribes in

its north-east corner on which Dr Etta Becker Donner carried out an excellent study, 'Kunst und Handwerk in N.-O. Liberia', *Baessler-Archiv.*, vol. xxiii (Berlin, 1940). Valuable material on the same tribes has been collected over many years by Dr G. W. Harley (see, for instance, his 'Masks as Agents of Social Control in North-East Liberia', *Papers of the Peabody Museum*, vol. xxxii, no. 2, 1950, and G. Schwab, 'Tribes of the Liberian Hinterland', *ibidem*, vol. xxxi, 1947). Tribes of the same Dan-Ngere complex in the Ivory Coast and the nearby parts of French Guinea have been systematically studied by J. Vandenhoute, 'Classification stylistique du masque dan et guéré de la Côte d'Ivoire centrale, A.O.F.', *Mededeelingen van het Rijksmuseum voor Volkenkunde*, no. 4 (Leiden, 1948), and by B. Holas, *Masques kono* (Paris, 1952). The next group, the Baule, Ashanti and other related tribes, are represented by H. Himmelheber, *Negerkünstler* (Stuttgart, 1935), almost the only close study of African artists at work, and by R. S. Rattray, *Ashanti* and *Religion and Art in Ashanti* (Oxford, 1923 and 1927), now complemented by Mrs E. L. R. Meyerowitz, *Sacred State of the Akan* (London, 1951). The Fon, or Dahomey, tribe (whose art is in French books normally confounded with that of the western Yoruba who live near and among them) are the subject of one of the best of African tribal monographs, M. J. Herskovits, *Dahomey* (2 vols., New York, 1938). A remarkable insight into Fon and Yoruba culture (in South Africa as well as on the 'Slave Coast') is imparted by an extraordinary series of photographs in P. Verger, *Dieux d'Afrique* (Paris, 1954).

For the earliest sculpture in the Nigerian area (and, so far as is at present known, in all Negro Africa), that of the Nok Culture of the Benue valley region, no full account is yet available, but reference may be made to Bernard Fagg's notes in *Man*, 1946, article 48, and 1956, article 95, and in *Africa*, vol. xv, no. 1, pp. 20, 21 (London, 1945), as well as to William Fagg, 'L'art nigèrien avant Jésus-Christ', *L'art nègre* (Paris, 1951). Our knowledge of Ife art is summarized in a booklet, *The Art of Ife*, issued by the Nigerian Antiquities Service (Lagos, 1956), and also in William Fagg, 'The Antiquities of Ife', *Image* (London, 1949; reprinted in the American *Magazine of Art*, vol. xliii, 1950, pp. 129–33); most of the bronzes are reproduced in Underwood's *Bronzes of West Africa* (see above), and other reproductions are in H. V. and E. L. R. Meyerowitz, 'Bronzes and Terra-cottas from Ile-Ife', *Burlington Magazine*, vol. lxxv (London, 1939), pp. 150–5. The important new find of bronzes made in November 1957, is illustrated and briefly described in *Man*, 1958, plate A. L. Frobenius, *The Voice of Africa* (2 vols., London, 1913, translated from the German), is a valuable source of useful knowledge, as well as entertainment, on the subject of Ife. The Jebba and Tada figures were described and illustrated in articles by Sir Richmond Palmer and by S. W. Walker in *Man*, 1931, article 261, and 1934, article 193, and more fully by Mrs Meyerowitz in 'Ancient Nigerian Bronzes', *Burlington Magazine*, vol. lvii (1941), pp. 89–93 and 121–6.

Benin art (of the court style) is exceptionally well represented in the literature, the three most important collections outside Nigeria having all been published *in extenso*: the British Museum collection in C. H. Read and O. M. Dalton, *Antiquities from the City of Benin . . .*

(London, 1899); the collection at Farnham, Dorset, in A. H. L. F. Pitt-Rivers, *Antique Works of Art from Benin* (London, 1900); the Berlin collection in F. von Luschan, *Die Altertümer von Benin* (3 vols., Berlin, 1919), which also includes, in the text volume, a generous selection of illustrations of the other Benin works known to the author; and various lesser collections have also been published. The Nigerian Antiquities Service has within the past few years amassed a Benin collection which exceeds in size and quality all but those at the British Museum and at Berlin; see, for instance, William Fagg, 'The Allman Collection of Benin Antiquities', *Man*, 1955, article 261. Existing knowledge of Benin culture has been compendiously arranged by R. E. Bradbury (with much excellent new information of his own) in *The Benin Kingdom and the Edo-speaking Peoples* (London, 1957), a volume in the monumental *Ethnographic Survey of Africa*. It does not, however, deal in any detail with the art. The best account of Benin is probably still H. Ling Roth, *Great Benin* (Halifax, 1903), which quotes extensively from early European sources. A good deal of information on Benin history and culture (as well as those of other tribes) is given in P. A. Talbot, *Peoples of Southern Nigeria* (4 vols., Oxford, 1926), but the principal historical source is Chief J.U. Egharevba, *A Short History of Benin* (2nd ed., Lagos, 1953). Von Luschan's interpretation of Benin art history is most conveniently presented in B. Struck, 'Chronologie der Benin-Altertümer', *Zeitschrift für Ethnologie*, vol. lv (1923), pp. 113–66. The reinterpretation offered in the present work was adumbrated in William Fagg, 'Observations on Nigerian Art History', in *Masterpieces of African Art*, the catalogue of an exhibition at the Brooklyn Museum (1954). Bini wood-carvings in what is here termed the 'plebeian' style are rarely thought worthy to compete with the Benin bronzes and ivories in art books on Africa, but good examples may be seen, for example in Pitt-Rivers' above-mentioned *Antique Works . . .*, figs. 27, 258–60, 268–70, 277, 278, 314–19, 320, 321, 331–5, and in E. von Sydow, 'Ancient and Modern Art in Benin City', *Africa*, vol. xi (1938), fig. 4. The stylistic succession of the bronze heads here proposed is conveniently illustrated by reference to Underwood, *Bronzes . . .*, where plates 23 and 26 and, probably, 24 and 25, represent the early period, plate 30 is typical of the middle period, and plate 31 of the flamboyant decadence now assigned to the nineteenth century. (Plates 27–9, 32 and 33 all belong to non-Bini or marginal Bini traditions.)

The art of the Sao empire, which flourished east of Lake Chad at about the same time as the early and middle periods of Benin, has been described by J. P. Lebeuf and A. M. Detourbet, *La Civilisation du Tchad* (Paris, 1950), and finely illustrated in their article 'L'art ancien du Tchad,' in *Cahiers d'Art*, 26th year (1951) pp. 7–28. For the other medieval centres of bronze-casting which undoubtedly existed in the Niger and Benue valleys, no literature can be cited. The 800 or more stone figures of Esie in northern Yorubaland, which may be ancient Nupe work, were published by F. de F. Daniel in the *Journal of the Royal Anthropological Institute*, vol. lxvii (1937), and also by E. L. R. Meyerowitz in the *Burlington Magazine*, vol. lxxxii (1943), pp. 31–6.

In recent traditional wood-carving the Nigerian area is undoubtedly the most prolific in all Africa; it is there-

fore a matter for surprise and regret that it is so little known, to ethnologists as well as to the art world, because so little of it has been published. Yet field study of art and artists has probably been carried farther there than in any other region, and it could be transformed quickly into the most familiar field by the publication of a generous selection from the documentation and photographs amassed in the archives of the Nigerian Antiquities Service largely through the work of the former Surveyor of Antiquities, Mr Kenneth Murray. There is no book which covers the area comprehensively, though there is available (from the Royal Anthropological Institute in London) a set of photographs of the exhibition of over 100 Nigerian masks and headdresses organized by Mr Murray in London in 1949, together with the excellent documentation provided in his printed catalogue. A good deal of information and illustration, particularly on the tribes of the Delta and of eastern Nigeria, may be culled from the works of P. A. Talbot, *Peoples of Southern Nigeria* (4 vols., London, 1926); *Nigerian Fertility Cults* (London, 1927); *Tribes of the Niger Delta* (London, 1932); *In the Shadow of the Bush* (London, 1912); *Life in Southern Nigeria* (London, 1923). The fullest account of Yoruba art is given in William Fagg, 'De l'art des Yoruba', *L'art nègre* (Paris, 1951), but an extremely valuable and well-documented record of the sculptures to be found in one small Yoruba town, Ilobu, by H. U. Beier, has recently been published (Lagos, 1957) under the auspices of *Nigeria* magazine, itself a prolific source of short articles on the arts in Nigeria. An excellent account of the fine old ancestor figures of the Oron clan of the Ibibio near Calabar is K. C. Murray's article in the *Burlington Magazine*, vol. lxxxix (1947), pp. 310–14. Ijo art, at present hardly known, will be very well documented in a work now in preparation by W. R. G. Horton, based on intensive field work in the Delta.

The sculpture of the Grasslands of the British and French Cameroons is well known from the anthologies, but specialized literature is scanty. H. Labouret, *Cameroun* (Paris, 1934), is a suitable introduction, and R. Lecoq, *Les Bamiléké* (Paris, 1953), is perhaps the most successful attempt so far to present the culture of a single African tribe almost entirely through pictures, chiefly of sculpture. For a more informal account of the Bamileke, F. C. C. Egerton, *African Majesty* (London, 1938), may be recommended, as also Margaret Plass, *The King's Day* (Chicago, 1956), based on the magnificent but still largely unpublished Cameroons collection in the Chicago Natural History Museum.

The Congo:

With regard to the great Congo area, the Belgian Congo is far better served in the literature than the other territories. In the first place, its very numerous tribes are well listed and their territories delimited with reasonable accuracy in J. Maes and O. Boone, *Peuplades du Congo Belge* (Brussels, 1935, new edition in preparation). A more intensive work of somewhat the same kind, with considerable information on tribal history, has been devoted to the Baluba area; E. Verhulpen, *Baluba et balubaïsés* (Antwerp, 1936). The classical work on Belgian Congo sculpture is Frans M. Olbrechts, *Plastiek van Kongo* (Antwerp, 1946), the most systematic work yet produced for any large field of African art; it is copiously

illustrated with works almost entirely drawn from collections other than those at Tervuren.

For the Lower Congo area, there is, first, a comprehensive and fully illustrated account of the soapstone grave or memorial figures, probably made over a period of several centuries, of the Bakongo on the left bank of the Congo in Angola: R. Verly, 'La statuaire de pierre du Bas-Congo (Bamboma-Mussurongo)', *Zaïre*, vol. ix, part 5 (Brussels, 1955). There is a great need for a detailed and systematic account of the material culture of the tribes which once formed part of the Kingdom of Congo; at present the student must consult very numerous sources for any comparative study. The best documented tribes are those on the French side of the river, for which, however, the essential authorities are Swedish missionaries: K. Laman, *Kongo* (2 vols., *Studia Ethnographica Upsaliensia*, Upsala, 1953, 1957; to be followed by a third volume), and E. Manker, *Bland Kristallbergens Folk* (Stockholm, 1929; based on information supplied to the author by a number of missionaries). These, and the missionary collections in the museums at Stockholm and Göteborg, provide the best hope of disentangling the complex of tribal styles found in the area. For the Bateke tribe, reference should also be made to R. Hottot, 'Teke Fetishes', *Journal of the Royal Anthropological Institute*, vol. lxxxvi (1956). A good account of the initiation masks of the Bayaka is given by H. Himmelheber, 'Les masques bayaka et leurs sculpteurs', *Brousse*, no. 1 (Léopoldville, 1939), pp. 19–39.

For the Bushongo or Bakuba area, the basic authority is E. Torday and T. A. Joyce, *Les Bushongo* (Tervuren, 1913), in which the great collection made by Torday for the British Museum is treated at length; but has proved open to correction in some respects by the recent work of J. Vansina (see, for instance, *Les tribus bakuba*, Ethnographical Survey of Africa, Brussels, 1954).

No specialized authorities can be quoted for the art of the Baluba–Basonge area, apart from P. Colle, *Les Baluba*, (2 vols., Brussels, 1913), which includes some pictures and information about sculpture.

For the vast tract stretching from the mid-Cameroons to the northern end of Lake Tanganyika, there are but few good authorities. For the Fang of the Gaboon, G. Tessmann, *Die Pangwe* (2 vols., Berlin, 1913), is the most important, and for the Bakota tribal complex E. Andersson, *Contribution à l'ethnographie des Kuta*, vol. i (*Studia Ethnographica Upsaliensia*, Upsala, 1953); this demonstrates among other things that masks of the 'Balumbo' or 'M'Pongwe' type are also made among Bakota groups. The Bakwele have not yet been described, although a Swedish missionary has collected much information among them, and made the largest extant collection of their masks and material culture (now in the Göteborg Ethnographical Museum). For the Ngombe, one of the 'Bangala' tribes, A. W. Wolfe has written a valuable article, 'Art and the Supernatural in the Ubangi District', *Man*, 1955, article 75. The Balega (less well called Warega) have been admirably studied in the last few years by Olbrechts's pupil D. Biebuyck; see his 'Function of a Lega Mask', *Internationales Archiv für Ethnographie*, vol. xlvii, part 1 (Leiden, 1954), pp. 108–20. Some further observations on the future of Negro sculpture will be found in William Fagg, 'The Sibylline Books of Tribal Art', *Blackfriars*, vol. xxxiii, no. 382 (London, 1952).

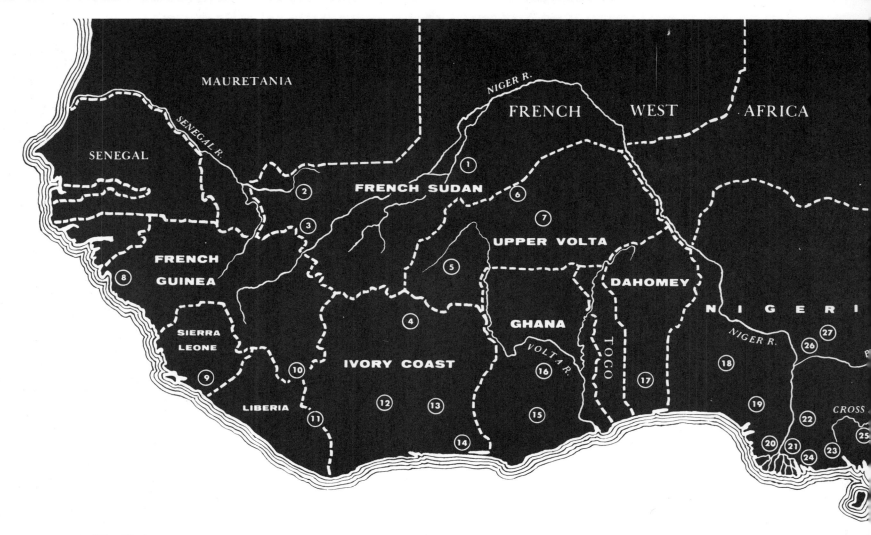

The Western SUDAN

1 DOGON
2 BAMBARA
3 MALINKE
4 SENUFO
5 BOBO
6 KURUMBA
7 MOSSI

The GUINEA Coast

8 BAGA
9 MENDI
10 DAN
11 NGERE
12 GURO
13 BAULE
14 AGNI
15 ASHANTI
16 BRON
17 FON
18 YORUBA & IFE
19 BENIN
20 IJO
21 ABUAN
22 IBO
23 IBIBIO
24 OGONI
25 EKOI
26 AFO
27 NOK
28 SAO
29 GRASSLAND
 TRIBES

On this map the Senufo are shown geographically as Western Sudan but are treated in the text as part of the culture of the Guinea Coast

The CONGO

30 FANG
31 BAKWELE
32 KUYU
33 AMBETE
34 BAKOTA
35 BALUMBO
36 BATEKE
37 BABEMBE
38 BAKONGO
39 BAYAKA
40 BASUKU
41 BAHUANA
42 BAPENDE
43 BUSHONGO
44 DENGESE
45 BENA LULUA
46 BAJOKWE
47 BALUBA
48 BASONGE
49 BATETELA
50 WABEMBE
51 BALEGA
52 MANGBETU
53 BAMBOLE
54 AZANDE
55 MASHONA
56 MAKONDE
57 MAMBUNDA
 AND BAROTS

AFRICA